Landscapes: the Arts, Aesthetics, and Education

Volume 17

Scope

This series aims to provide conceptual and empirical research in arts education, (including music, visual arts, drama, dance, media, and poetry), in a variety of areas related to the post-modern paradigm shift. The changing cultural, historical, and political contexts of arts education are recognized to be central to learning, experience, and knowledge. The books in this series present theories and methodological approaches used in arts education research as well as related disciplines – including philosophy, sociology, anthropology and psychology of arts education.

More information about this series at http://www.springer.com/series/6199

Susan W. Stinson

Embodied Curriculum Theory and Research in Arts Education

A Dance Scholar's Search for Meaning

 Springer

Susan W. Stinson
University of North Carolina
Greensboro, NC, USA

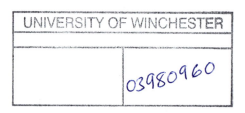

ISSN 1573-4528 ISSN 2214-0069 (electronic)
Landscapes: the Arts, Aesthetics, and Education
ISBN 978-3-319-20785-8 ISBN 978-3-319-20786-5 (eBook)
DOI 10.1007/978-3-319-20786-5

Library of Congress Control Number: 2015944192

Springer Cham Heidelberg New York Dordrecht London

Printed on acid-free paper

Springer International Publishing AG Switzerland is part of Springer Science+Business Media (www.
springer.com)

Foreword

We have always had to struggle to find and keep a place for the arts in schools. So no one could blame art educators if we are passionate, if defensive, advocates for the presence of music, art, theatre, and dance in the curriculum. Sue Stinson's avoidance of this righteous indignation distinguishes this collection of her writings from the self-satisfied proclamations that burden so many works in the field of art education. For this is, as she tells us, a book about questions, rather than answers: questions that became more compelling as her experience as a dance educator advanced.

Stinson knows dance as a way of being and moving in the world. She understands the meanings of the art form in relation to its cultural and historical moments of choreography and performance.

And she loves to dance.

Nevertheless, in these essays Stinson interrogates the conventions of dance education, as well as her own taken for granted assumptions and practices. In this abstention she achieves a consonance of form and pedagogy, for she claims dance as a way of asking questions about our lives in the world.

The world, Merleau-Ponty said, is the answer to the body's question.[1] It is the world we find when we reach, when we run, and when we stumble. It is the world we yearn for, the world we taste, and the world that fills us, or leaves us wanting. Marrying her scholarship in curriculum theory to her art, Stinson has developed dance as inquiry into relationships, as well as habits and customs. Her deep understanding of Merleau-Ponty's phrase "the body subject" resonates through all these chapters. Most often the body subject shows up in work that disparages the split–off subjectivity of the Cartesian *cogito*, as theorists hoping to ground their work in sensuousness and worldliness struggle to get beyond their computer screens. But Stinson approaches the body subject from another direction. Immersed in dance, doing it and teaching it, and teaching others how to teach it for decades, she relentlessly opposes a preoccupation with embodiment that separates movement, skill, grace and novelty from the moments of life that matter. This is a wise art and an

[1] Remy Kwant (1963) *The phenomenological philosophy of Merleau-Ponty.* Pittsburgh: Duquesne University Press.

artful pedagogy, for she engages her students, who will themselves be teachers of dance, at the level of their own curiosity.

As she tells us in "Questioning our Past and Building a Future: Teacher Education in Dance for the 21st Century," finding curiosity in preservice teachers is pretty tricky. For our students are not leaning back in their chairs, exchanging opinions and fantasies of the world they would like to see. Like Stinson, they seek teaching because they want to change the world, and then they realize that teachers who change the world work in schools, where change is anathema. Visionary practice soon retreats to cautious convention and method becomes the reassurance that all seek.

But Stinson jettisons modelling best practices as she moves beyond how to teach dance to questions about what dance is and why teach it. She challenges the romanticism of creative dance for children and the expectations that it is always a source of joy and happiness as she recognizes that creative expression opens channels to rage as well as delight. On the other hand, she demurs from the Discipline Based Art Education model of the Getty Foundation that overemphasized the formal properties of art. And she embraces the tensions between the expressivity of creativity and the interest that skill and technique can bring to it, between individual dancers' artfulness and the cultural legacies of dance forms.

For teacher educators of any art or discipline, these essays form a path of ethical inquiry as Stinson recovers the moments when her work opened the world to her and her students. "Change is often terrifying," she tell us, "especially when we are not absolutely certain we are right – but we can be courageous. As dancers, we know that each of us must start where we are, but stay flexible, taking one step and then another into the unknown."

Columbia, MA, USA Madeleine R. Grumet

Acknowledgements

I am deeply grateful to Dr. Liora Bresler, who has been a steadfast supporter of my scholarly work for decades, and who has believed in me when I didn't believe in myself. This book would not have happened without her.

Also deserving of particular thanks are Dr. Doug Risner, my co-authors listed in the Biographies, other colleagues and former students who have helped shaped my career, and Jim Stinson for his technical assistance, moral support and sharp eyes.

Previous Publications of Chapters

Some chapters have already been published in the form of journal articles or book chapters either by Springer or by another publisher. (See the list below.)

Chapter 2: Stinson, S. W. (1985). Curriculum and the morality of aesthetics. *Journal of Curriculum Theorizing, 6*(3), 66–83.

Chapter 3: Stinson, S. W. (1991). Reflections on teacher education in dance. *Design for Arts in Education, 92*(3), 23–30.

Chapter 4: Stinson, S. W. (1998). Adapted, with permission, from Seeking a feminist pedagogy for children's dance. In S.B. Shapiro (Ed.), *Dance, power, and difference: Critical and feminist perspectives on dance education* (pp. 23–47). Champaign, IL: Human Kinetics.

Chapter 5: Stinson, S. W. (2001). Choreographing a life: Reflections on curriculum design, consciousness, and possibility. *Journal of Dance Education, 1*(1), 26–33.

Chapter 6: Stinson, S. W. (2002). What we teach is who we are: The stories of our lives. In L. Bresler & C. Thompson (Eds.), *The arts in children's lives* (pp. 157–168). Dordrecht: Kluwer.

Chapter 7: Stinson, S. W. (2004). My body/myself: Lessons from dance education. In L. Bresler (Ed.), *Knowing bodies, moving minds: Embodied knowledge in arts education and schooling* (pp. 153–168). London: Kluwer.

Chapter 8: Stinson, S. W. (2005). The hidden curriculum of gender in dance education. *Journal of Dance Education, 5*(2), 51–57. Reprinted in *Sexuality, Gender and Identity: Critical Issues in Dance Education* (Routledge, April, 2015).

Chapter 9: Stinson, S. W. (2006). Dance in schools: Valuing the questions. In L. Wildschut (Ed.), *Colouring senses: Dance and the Child International conference proceedings: Keynotes* (pp. 48–53). The Hague: The Netherlands.

Chapter 10: Stinson, S. W. (2010). Questioning our past and building a future: Teacher education in dance for the 21st century. *Journal of Dance Education, 10*(4), 136–144.

Chapter 11: Stinson, S. W. (2015). Rethinking standards and assessment. In S. Burridge & C. Svendler Nielsen (Eds.), *Dance education around the world: Perspectives on dance, young people, and change* (pp. 107–116). Abingdon: Routledge.

Chapter 12: Stinson, S. W. (1985). Research as art: New directions for dance educators. In *Dance: The New Zealand Experience, Papers and Proceedings* (pp. 217–238). Auckland: Dance and the Child. Republished: (1) Stinson, S. W. (1986). Research as art: New directions for dance educators. *Drama/Dance*, *5*(2), 78–90, and (2) Stinson, S. W. (2012). Research as art: New directions for dance educators. In Brown, A. K., Manley, M. E. & Nielsen, C. S. (Eds.), *Rich returns: daCi's first 30 years, Vol. I: In search of our own dance knowledges* (pp. 20–33). Taipei: Dance and the Child: International, Taiwan chapter.

Chapter 13: Stinson, S. W. (1995). Body of knowledge. *Educational Theory*, *45*(1), 43–54.

Chapter 14: Dils, A. H. & Stinson, S. W. with Risner, D. (2009). Teaching research and writing to dance artists and educators. In T. Randall (Ed.), *Global perspectives on dance pedagogy: Research and practice. Proceedings of the Congress on Research in Dance 2009 Special Conference* (pp. 151–165). Leicester: DeMontfort University.

Chapter 15: Stinson, S. W. (2015). Searching for evidence: Continuing issues in dance education research. *Research in Dance Education*, *16*(1), 5–15.

Chapter 16: Stinson, S. W., Blumenfeld-Jones, D., and Van Dyke, J. (1990). Voices of young women dance students: An interpretive study of meaning in dance. *Dance Research Journal*, *22*(2), 13–22.

Chapter 17: Stinson, S. W. (1993). Meaning and value: Reflecting on what students say about school. *Journal of Curriculum & Supervision*, *8*(3), 216–238.

Chapter 18: Stinson, S. W. (1997). A question of fun: Adolescent engagement in dance education. *Dance Research Journal*, *29*(2), 49–69.

Chapter 19: Bond, K. and Stinson, S. W. (2007). "It's work, work, work, work": Young people's experiences of effort and engagement in dance. *Research in Dance Education*, *8*(2), 155–183.

Contents

Biographies

Dr. Sue W. Stinson retired in 2013 as Emeritus Professor of Dance at the University of North Carolina Greensboro, where she taught courses in dance education and research for 34 years and served one year as Interim Dean of the School of Music, Theatre and Dance. Dr. Stinson has published her scholarly work in multiple journals and book chapters, and has taught and presented her work throughout the USA and in a number of countries in the Americas, Europe, Asia, and the Pacific. Her international service has included positions in Dance and the Child: International, as Chair, Research Officer, international conference co-chair, and Proceedings Editor. She has served on international advisory boards for publications in Dance and Arts Education. Awards include National Dance Association Scholar (1994), National Dance Education Organization Lifetime Achievement Award (2012), and Congress on Research in Dance award for Outstanding Scholarly Research in Dance (2012).

Co-authors of Chapters

Dr. Donald Blumenfield-Jones, Professor of Curriculum Studies, Ethics, and Education at Arizona State University, is a widely published scholar in the areas of curriculum studies and ethics, curriculum studies and aesthetics and philosophy of education, including his new book *Curriculum and the Aesthetic Life*. He has given keynote addresses in Canada, Brazil and the USA, and is a past Vice-President of Division B (Curriculum Studies) of the American Education Research Association. He has also held the Lincoln Chair in Ethics and Education connected to ASU's Lincoln Center for Applied Ethics.

Dr. Karen E. Bond is Director of the National Dance Education Organization/ Temple University Center for Research in Dance Education (NDEO/TU CRDE). Her career in higher education dance was launched in Australia (1977), where she was privileged to work with dance education pioneer Hanny Exiner at the State

College of Victoria, Melbourne. As a faculty member in Temple University's department of dance, she teaches graduate courses in qualitative research methodology, dance philosophy, and educational inquiry. She is known internationally for her research into participant meanings of dance and is widely published on these topics. She was international chair of Dance and the Child International (2003–2006) and co-editor of NDEO conference proceedings (2008–2010). In 2013 she was the inaugural recipient of NDEO's Award for Outstanding Contribution to Dance Education Research.

Dr. Ann H. Dils, Professor and Chair of the Department of Dance at the University of North Carolina at Charlotte, is a dance historian with interests in movement analysis, feminist theory and research methods, and cultural studies. Her recent essays appear in the edited collection *Dance on its Own Terms: Histories and Methodologies* (2013) and the forthcoming *Oxford Handbook of Dance and Theatre.* She is co-director of Accelerated Motion: Towards a New Dance Literacy, a National Endowment for the Arts-funded digital collection of materials about dance (http://acceleratedmotion.org) and co-editor of *Moving History/ Dancing Cultures: A Dance History Reader* (2001), now available as an ebook. She is a past president of the Congress on Research in Dance and past editor of *Dance Research Journal.*

Dr. Jan Van Dyke is Professor Emerita on the UNC Greensboro dance faculty where she was Department Head from 2006 to 2011. She has wide experience as a producer and administrator, as well as an artist, and has set her choreography on a variety of groups ranging from the Washington Ballet to students at the Western Australia Academy for the Performing Arts in Perth. Her work has earned support from agencies including the National Endowment for the Arts, the California Arts Council, and the D.C. Commission on the Arts and Humanities. A 1993 Fulbright Scholar, she spent one semester teaching dance in Portugal. Her book *Modern Dance in a Postmodern World*, about the interaction between public policy and dance, was published in 1992.

Chapter 1
Introduction

Susan W. Stinson

"Why am I doing this?" is a good question to ask ourselves now and then, and it lived with me throughout the process of creating this book. The idea for such a volume first arose when colleagues were asking what my plans were after retirement; this is rather like asking students what they plan to do after graduation. Most assumed I had some major research projects in mind. But after 34 years of being a faculty member in Dance at the University of North Carolina at Greensboro and a year as Interim Dean, I was feeling pretty "used up," questioning whether I had any new ideas to write about, and ready to get on with creating the next chapter of my life. Saying that I was considering an edited collection of my work meant I didn't have to have anything else figured out for the time being. In addition, it drew enthusiastic response from some, which provided encouragement to formally begin "considering."

At the same time, it seemed rather egocentric to assume that any collection of my previously published work might be important enough to be printed between hard covers. One family member told me he thought such books were organized as tributes by one's followers. I have read enough collections by other scholars to know this is not always the case, but questioning the arrogance of this project slowed me down for a while, as did writing some new work that I had not thought I had in me.

I suppose what pushed me over the edge to begin the project was thinking about legacy. Writing is always, to some extent, a reach towards immortality. While I am ready to turn the scholarly enterprise over to the next generation of scholars, and find much that excites me in their work, perhaps this is one last attempt to keep my own ideas alive in "the literature" for a little while longer, by collecting in one place some which may have enduring value.

But while I began this project with some reluctance, I soon realized that it was an important task for me, regardless of whether or not the book was accepted for publication. In reading through work from all these years, I started to understand it, and myself, more deeply. Because my thinking often reflected issues in dance education current at the time, I also was revisiting the historical development of the field.

© Springer International Publishing Switzerland 2016
S.W. Stinson, *Embodied Curriculum Theory and Research in Arts Education*,
Landscapes: the Arts, Aesthetics, and Education 17,
DOI 10.1007/978-3-319-20786-5_1

Ever an interpretive researcher, I of course looked for themes, eventually identifying these interconnected ones:

- *Voice*: Many of the pieces were written initially as conference presentations, which meant they were meant to be spoken without leaving me tongue-twisted. I always practice reading my work aloud, trying to use language people can understand by listening, not just reading. My collegial feedback on other people's work has often included a suggestion to do the same, even when papers are not intended to be spoken. I knew no one would walk out of a room singing the words from one of my papers, but wanted at least some of the language to resonate deeply. I also wanted listeners and readers to understand the ideas, though sometimes I have questioned whether my work was too "simple-minded." I recall a conversation with a colleague who told me she needed to use specialized academic language to show others she was smart and an "insider"; I consciously tried to connect to people rather than exclude them from the conversation or make them feel stupid. Patricia Collins reinforced this desire, when she wrote in 2000 of using language that the black women she was writing about would understand. I wanted to write in a way that my undergraduate students would understand, although I only rarely assigned my work for them to read.
- *Story*: I have always considered stories to be a primary way that we learn, much more likely to have impact than a well-reasoned argument, and this also gives some of my work a style that is more conversational than much academic writing. I recall when my doctoral advisor David Purpel told me as I began writing my dissertation to "stop reading" except for novels, which would help me in the writing process. Many of the stories in these chapters are from my own life as a dance educator, scholar, administrator, member of a departmental community, mother, and eventually grandmother, and include my questions and struggles as much as my insights. Madeline Grumet (1988) was a role model in this regard, and gave me courage to incorporate stories from personal life into public scholarship. I sometimes have described this as making myself vulnerable—even feeling "naked"—in public. I was always worried, though, about being self-indulgent, so edited out many of the stories before a final version. (I recall David Purpel's advice to "kill the little darlings," meaning those phrases and stories one was in love with that did not belong in this particular piece of work.)
- *Body*: Grumet (1988) also introduced me to Merleau-Ponty's concept of "body-subject." I know the world through my lived experience of it, so embodied images are woven throughout my writing, as part of what feels like my native language. Using such images is also an intentional choice: a way, I hope, of touching readers with words and ideas, hoping they will be moved, not just understand intellectually.
- *Search for meaning*: As a scholar, I have sought not only to find personal meaning, but also to create work that others would find meaningful—work that would touch them "where they live." (I borrowed this phrase from a wonderful teacher in an undergraduate poetry class, who shared on the last day of the semester, "I hope, more than anything else, you have found something that has touched you where you live.") I have hoped for my whole professional life that I was making a difference, making the small part of the world I inhabit better than it would

have been otherwise. Perhaps I have been trying to rid myself of guilt arising from my undeserved privilege. But my greatest joy as a scholar was hearing from someone I did not know that something I wrote had meant something to them and contributed to their own journey.

- *Reflexivity*: In my scholarship, I have attempted to be as critical in thinking about my own ideas as I am thinking about the ideas of others. My former students will recognize this standard as a criterion for many assignments. I have never been a very good debater because I could always see limitations in my arguments. Perhaps I was trying to protect my ego from my critics by identifying my shortcomings first, but I also know that others will recognize flaws that I have missed.

- *Evolution (and sometimes "recycling")*: Many of the same ideas appear in different forms over time, evolving as I continued to read, dialogue with others, and reflect, along with teaching and supervising students. In some cases, I have been surprised in re-reading older pieces to realize that some concerns had been part of my consciousness so early in my career, even appearing in a paper that was, on the surface, about another topic. For example, my concerns about assessment of student learning were there in some of my earliest work, even though I was not writing specifically about the subject until the last few years of my career, when it became a significant issue for dance educators and indeed all educators in institutional settings. Occasionally a story or phrase appears in more than one work, if I found that it resonated especially well with others. Such recycling made the selection process for this book more challenging. Madeline Grumet reminds us that "the choice of what to put in and what to leave out is the choice that haunts all art-making and all curriculum" (2007, p. 985). I have wrestled with the same issue here. Many of my personal favorites did not make the cut, but I hope that the comments following each chapter provide justification as well as context.

I wrestled as well with organization for this volume, finally settling on only two primary Parts and one concluding chapter. Part One includes ten essays on curriculum, pedagogy, and practice. The second focuses on research, with four chapters relating to research methodology and pedagogy followed by four studies investigating voices of young people. Papers are ordered chronologically within Part One and within each half of Part Two, revealing not just my own history but the history of the field. The volume concludes with my most recent work, reflecting on dance, teaching, and research as the art of living. Unless noted, all works appear without change from their original form, except for correction of errors, formatting, and updating of references.

References

Collins, P. H. (2000). *Black feminist thought: Knowledge, consciousness, and the politics of empowerment*. New York: Routledge.

Grumet, M. (1988). *Bitter milk: Women and teaching*. Amherst: University of Massachusetts Press.

Grumet, M. (2007). The pulse of art: What is and what might be. In L. Bresler (Ed.), *International handbook of research in arts education* (pp. 985–988). Dordrecht: Springer.

Part I
Essays on Curriculum, Pedagogy, and Practice

Prelude to Part I

Most of the chapters in this section are a duet between theory and practice: looking at theory and finding implications for practice, or critically reflecting on practice through the lens of theory. They reflect the struggle I felt throughout most of my career between my theoretical values, especially those related to issues of social justice, and the practical reality of my job leading a teacher education program in dance at a university. With one foot in each world, I never felt that I fully lived up to my highest aspirations, including the ideals I articulated early on, in Chap. 2. Like all universities, the one where I spent the vast majority of my career is a bureaucratic institution, where well-meaning policies are made by those at the top, often far removed from those carrying them out at middle and lower levels of the hierarchy. The world of teacher education is even more bureaucratic, and there is still more separation between those making the rules and those expected to implement them. It is tempting to simply blame the bureaucracy for imposing policies designed to facilitate efficiency and order rather than creativity and compassion. Yet it is always easier to imagine a better world than to actually create it, and easier to judge others than to encounter our own limitations.

Many of the chapters in this section contain details that chronicle issues at the time in arts education generally and dance education in particular. While these particular moments may be of significance to historians in the field, they are also testament to the value of challenges in helping us to identify what matters and imagine new possibilities. They further reveal reason for my conviction that, as I state in Chap. 9, "there are no final answers, only temporary decisions made within specific contexts."

In preparing this volume for publication, rereading all of my publications since 1975 (even before my career in academe), I became aware of my evolution as a scholar and educator, an evolution that is perhaps as much spiritual as it is academic. At the beginning, my language was more declarative, full of words like *should* and *must*: I thought my own positions were right and others should agree with me. I do

not necessarily disagree with any of the positions I took in the chapters reprinted here, but the change in my language reveals the important journey I was on. I began to recognize not only my failure to act consistently in ways that reflected my deepest values, but also the limitations of my values and the actions that derived from them. In such reflections, I did not usually decide I had been "wrong," but that there were other reasonable ways to perceive the same situation. I expressed less interest in convincing others to agree with me than to encourage, as I stated in Chap. 4, "ongoing reflection about what we believe and why, and about the consequences of the choices we make as persons and as educators." This "softer" persona was closer to the kind of person I wanted to be. I cannot claim to have always lived this value, especially in leadership roles where prompt and confident decisions were more appreciated than my preferred reflective stance. But I hope that it will be considered my legacy as a curriculum theorist and an educator.

Chapter 2
Curriculum and the Morality of Aesthetics (1985)

Susan W. Stinson

Abstract Beginning with a desire to develop an aesthetic model for curriculum and teaching in the arts, the author was challenged by an awakening of her moral concerns within arts education. First considering multiple sources who found a connection between morality and art or the aesthetic dimension, she finds limitations to each of their arguments, realizing further exploration of both the moral dimension and the aesthetic dimension was called for. The work of Martin Buber, Carol Gilligan, and James Macdonald is used to illuminate the significance of relationship as central to understanding the moral dimension. In probing the significance of relationship to the aesthetic dimension, the author identifies three particular views of relationship in art, each with quite different implications when applied to curriculum. Finding moral limitations to the first two (the objectivist approach emphasizing relationships within the work of art, and a second emphasizing relationship between the perceiver and the art work), the author proposes a third. An emphasis on the relationship between the perceiver and the larger world, with the aesthetic object as the lens through which we see/make sense of the reality of being a person-in-the-world, is suggested as the only kind of aesthetic model which sufficiently responds to moral concerns in curriculum.

As an arts educator, much of my study has focused on the meaning of the aesthetic dimension as it relates to the arts curriculum. Beardsley (1958) distinguishes the aesthetic and the artistic by indicating that the aesthetic has to do with apprehending, and the artistic with making and creating. Yet surely aesthetic apprehension is—or ought to be—part of the process of creation, because judgments based on apprehending the product-in-the-making guide the process. For a long time my major concern was that the aesthetic dimension seemed largely missing from much of the curriculum in arts education, particularly below the University level: as long as something was created or performed, there seemed to be little concern with quality, or with awareness of the process or product. In fact, even original creation seemed hard to find. I despaired when my own child brought home from art period the orange pumpkin (cut out by the teacher) onto which he had glued, into the appropriate places, black triangles (cut out by the teacher). In my own field of dance, I despaired of the many classes I observed which made no attempt to deal with

© Springer International Publishing Switzerland 2016
S.W. Stinson, *Embodied Curriculum Theory and Research in Arts Education*,
Landscapes: the Arts, Aesthetics, and Education 17,
DOI 10.1007/978-3-319-20786-5_2

quality, either quality of the dance or the qualitative aspects of dancing; classes instead became a rote repetition of steps and exercises. I decided my calling lay in the development of an aesthetic model for curriculum and teaching in the arts.

The work of Elliot Eisner (1979) encouraged me to think more broadly than just the arts curriculum. Coming from his background as an educator in the visual arts, he noted that teaching in any area can be regarded as an art when it is engaged in with sensitivity, intelligence, and creativity. Further, he found art criticism a useful model for educational evaluation; such a model can help us see and understand the quality of classroom life. It seemed to me that, if one could use aesthetic awareness to evaluate curriculum and teaching, it should be equally valuable as a guide to curriculum design.

But fortunately, just as my purpose was becoming so clear to me, I had some very compelling encounters which muddled my vision, forcing me to re-examine my position. One came with my advisor and now colleague David Purpel, whose commitment to moral concerns gradually began to touch my aesthetic ones. His question to me was only somewhat facetious: whether or not it was really trivial to spend one's time prancing around in leotards and tights, confined to a dance studio or theater. Thus compelled to look more deeply, I recognized there was much in dance education that was not only trivial, but also dehumanizing and even dangerous. Furthermore, such practices seemed to occur most frequently among those who produced the greatest art.

> There were adults using children, distorting their bodies and driving from them their native language of movement, to be replaced by one the adults prefer to see.
> There were teachers who believed that practice of the arts was the prerogative of only a talented elite, and dismissed the right of all others, belittling their attempts.
> There were dance students who starved themselves to conform to a narrow vision of beauty of the human body, or whose bodies became permanently damaged through improper instruction or overuse.
> There were teachers using the arts not to liberate students but to manipulate them, and students learning primarily passivity, obedience, and rigid thinking.
> There were people using the arts as a way to avoid the challenge and responsibility of living in the world, such as those for whom the image in the mirror and their own pleasures in sweating and achieving became the sole ends in their lives, and those for whom purely personal growth in the arts shielded them from social awareness. It was here that I recognized myself.

I had to face the realization that in the work I loved and had defended for so many years, there was something wrong. I could no longer omit moral concerns in examining arts education or the aesthetic dimension.

This realization coincided with the beginning of a period of questioning in my own life, an early mid-life crisis regarding the meaning of my work and my life. The crisis was further enhanced through my encounters with Jim Macdonald and his work. Macdonald (1977, p. 20) noted two questions he saw as essential for curriculum theorists; they have stayed with me, giving a focus to all of my personal reflection and curricular thinking:

> What is the meaning of human life?
> How shall we live together?

I realized that only if my work responded to those questions could it be other than trivial.

Macdonald and Purpel (1983) wrote about their high regard for the aesthetic dimension of existence, because the aesthetic attitude includes a valuing of something in and of itself, without regard for its usefulness: the aesthetic object is an end in itself. They defended the importance of such an attitude in education, in contrast to the prevailing technical view that sees things—children, teachers, studies—only as means to an end, as things to be used. The valuing of an activity as an end in itself is shared with the moral attitude: An act cannot be considered moral simply because it will produce a good result, but must be moral in and of itself. This shared value seemed to offer the convergence of the aesthetic and the moral, and the thought that, if arts education were not a moral enterprise, it was because of its divergence from the aesthetic attitude. It seemed I had found the resolution to my conflict.

Other sources confirmed the connection between morality and art or the aesthetic dimension and added further bases for support. Dewey (1934) noted that imagination is the basis for not only art but also morality, writing that "Imagination is the chief instrument of the good…a person's ideas and treatment of his fellows are dependent upon his power to put himself imaginatively into their place" (p. 348).

Marcuse (1978) acknowledged the value of art in helping us see beyond the limits of a pre-established reality to find what is really real. In this aesthetic dimension of existence, the locus of the individual's realization shifts "from the domain of the performance principle and the profit motive to that of the inner resources of the human being: passion, imagination, and conscience" (p. 4). Yet Marcuse noted that art exists not only in this transcendent dimension, but also in the everyday world. It therefore has the capacity to return us from inwardness with an expanded consciousness and strengthened drive for changing the world to become one in which freedom and happiness are possible.

Kupfer (1978) noted that aesthetic experiences contribute to moral instruction, because relationships found in aesthetic objects serve as a model for moral relationships; the relationship of parts to whole in an aesthetic object is akin to the relationship of community: "We are given practice in activity involving discrimination, economy, venture, and integration, and are induced to respond to others as free responsive beings" (p. 22).

Newman (1980) found further congruence between the aesthetic and the moral attitude. He noted that aesthetic sensitizing involves five aspects which are relevant to Kohlberg's sixth (ultimate) stage of moral development: nonstereotyping (removal of prejudice), genuineness (integrity and authenticity), an openness to varying perspectives, a sense of what is fitting (an awareness of internal relationship among the parts of a whole), and empathy. While Newman saw that rational intellectual process is also important in moral judgment making, he suggested that the fostering of aesthetic sensibility can enhance moral education because the aesthetic is not only instrumental to the process of moral development, but is an essential dimension of the moral.

Ross (1981) agreed that the five aspects of aesthetic apprehension noted by Newman are inherently of value. However, he extended Newman's ideas further,

stating that "Aesthetic experience—and hence aesthetic education—is centered upon our capacity to act and perceive with love: Love of life, of living, of lives—our own and the lives of others known and unknown to us" (p. 157).

Yet despite the convictions of these authors, and my agreement with them that aesthetic sensibility might be related to living a moral and even loving life, I still faced some nagging concerns, grounded in my own reality with the arts. In regarding a dance, for example, as an end in itself, the dancers become a means to an end. I knew of too many times that persons were dehumanized and destroyed by others in the process of creating a grand work of art. Further, I have found that, all too often, the love generated for the aesthetic object ends with the object, rather than extending to transform our relationships with others. When anything receives our attention as only an end, complete in and of itself, it is too easy to "fall in love" with it, and thereby lose contact with the broader perspective in which it also has meaning. To love my children, valuing them as persons in and of themselves, is a moral act—but not if I lose my capacity to be touched by the humanity and personhood of other children, and respond to their needs as well. For some parents, having a child narrows their vision and their concern rather than extending it. Similarly, to care about and appreciate beautiful music may lead me to care about beauty in the world, but not if all of my energy and attention is given to music. And valuing the child in the classroom as a person rather than as a future worker seems a moral stance, but not if it blinds me to the very real pain suffered by those who are unemployed. Apprehension and appreciation of the individual, the personal, the unique—and valuing it in and of itself—cannot be a moral attitude if it keeps me from recognizing other persons and larger social problems. A double vision is necessary.

With this realization, it became apparent that further exploration of the meaning(s) of both *morality* and *aesthetics* was necessary, in terms of both the validity of arts education and the validity of an aesthetic model for curriculum.

2.1 Meanings of the Moral Dimension

The work of Martin Buber was central in my exploration of the moral dimension. For Buber, morality is grounded in relationship. In fact, Buber (1958) pointed out that the idea of morality as such would be unnecessary if we would live with others as subject with subject instead of treating others as objects. He referred to the latter relationship as an *I/It* relation. In an *I/It* relationship, I relate to others as things which can be classified or coordinated, used or experienced, regarded only in terms of their function. In contrast, the relation of subject with subject he called an *I/Thou* relationship. I do not experience or use the other, but become bound up in relation with it. A *Thou* cannot be classified or coordinated, or observed objectively. I am in the realm of *Thou* when I regard things in their essential life.

In these two kinds of relation, not only is the *other* different, but also the *I*. The *I* of the *I/It* is an individual, differentiating himself from others. The *I* of the *I/Thou* is a person with others, feeling from the side of the other as well as one's own side.

Buber describes the phenomenon of feeling from the other side in words that speak to my whole self:

> A man belabours another, who remains quite still.
> Then let us assume that the striker suddenly receives in his soul the blow which he strikes: the same blow; that he receives it as the other who remains still.
> A man caresses a woman, who lets herself be caressed.
> Then let us assume that he feels the contact from two sides—with the palm of his hand still, and also with the woman's skin. (1955, p. 96)

If we truly feel the pain of another as our own, and simultaneously feel our own part in causing that pain, we are less inclined to cause it: few people intentionally hurt themselves. If we truly feel the pleasure of another as our own, and simultaneously feel our own capacity to generate that pleasure, we are likely to seek to increase it. When we realize we are connected with another, we are responsible for the other as we are also responsible for ourselves. Thus, Buber notes, "Love is the responsibility of an *I* for a *Thou*" (1958, p. 15), so if we would love, then separate moral guidelines would be unnecessary.

In Carol Gilligan's work (1982), I found further clues to a deeper understanding of morality. Gilligan notes that traditional moral concerns—private rights, equality, justice—are grounded in a view of the world as consisting of autonomous individuals. She identifies this perspective as a masculine one, encouraged by traditional childrearing practices which make the mother the primary caregiver. Separation (from the mother) is the primary reality of growing up for boys. For girls, however, identification and connection (with mother) form the primary reality. As a result, the predominant view of the world for women tends not to be one of autonomous individuals, standing alone, connected by rules, but rather a world composed of human relationships, cohering through human connection, sustained by activities of care. A conception of morality in this view revolves around the idea of responsibility for others, making sure that we help one another when we can.

I recognized that this "feminine voice" of morality has largely guided my own moral development and still is central. Yet I see that such a view has sometimes served as a trap for both men and women: To care for only that which is close to us, providing us with a sense of goodness and well-being, may keep us from recognizing that we are related with all persons, all creatures, all life with which we share the world, and thus have a responsibility to care for them as well. It is so easy to care for that which we have created—a child, a home, a work of art—and sometimes difficult to recognize our relatedness with that which we have not created, that which is so fully Other.

It is a sin of commission to abuse a child. Yet is it not a sin of omission to, in loving my child or my art, fail to care for others? What is important, then, is not just responding to relationships of which I am aware, but extending my awareness of relationships that are more difficult to recognize, and responding to them.

Gilligan suggests that the fullest development of our moral sense comes when men extend their recognition of universal ethical principles to include an awareness of their relation to individual persons in need of care, and when women extend their responsibility to individuals to include a recognition of universal principles. It became clear to me that both the masculine and the feminine voice are necessary for

living a moral life: the feminine voice that feels touched by others and responds with care, and the masculine voice that steps away to see the larger social picture, recognizing what may otherwise get left out. For me as a woman, the acknowledgement of my masculine voice—the need to be a social critic as well as a person with persons—represented a powerful awakening. With this dual voice, close personal relationships serve not to close me off from broader concerns, but to illuminate and remind me of the larger relationships of which we are a part.

The acknowledgement of this dual voice reminds me of Macdonald's (1974) calling for a dual dialectic as the basis for a transcendental developmental ideology in education. He suggested that we must not only look at the consequences of an action in the world, but also sound the depths of our inner selves. Values are thus articulated on two levels, both in our actions and in an inner dialogue of reflection. Without the former, we all too easily become people who think about living a moral life but take no action; without the latter, we risk cutting off our actions from the inner self that is the ultimate judge of those actions. Both personal awareness and social awareness are necessary.

2.2 Meanings of the Aesthetic Dimension

Recognition of relationship is also essential in aesthetic apprehension, although there is more than one way of looking at such relationships. From my deepened understanding of the moral dimension, I have found myself identifying three particular views of relationship in art. Each leads to a different meaning of the aesthetic relationship and a different implication for curriculum. Each represents a place in my own development—a place I have lived and, to a certain extent, still do.

The first of these views emphasizes the relationships within the aesthetic object. The beauty of the aesthetic object, and hence its value, comes from its internal cohesiveness, the relation of parts to a whole in revelation of aesthetic qualities. That some objects or experiences are more aesthetic than others is a result of the distinct qualities revealed in the relationship of elements. Because the work is complete in and of itself, its meaning is to be found solely in the qualities it possesses—its robustness, delicacy, or wit, for example—and is there to be described, not interpreted. Apprehension of art rests entirely on identification of perceived qualities, and is devoid of emotion and personal meaning. Redfern (1983) names this the objectivist view.

Even objectivists, however, recognize that not all people perceive a given work of art the same way. Individuals must have special ability or training in order to recognize the qualities of a work of art. This view assumes that understanding what a work of art means is the unique prerogative of specially talented or trained individuals, an elite group who possess more than normal eyes, ears, and intelligence.

If this view of the aesthetic dimension is applied to arts education, the emphasis of the curriculum becomes acquiring the training to perceive the relationships and qualities of the art object, and understanding how and why it is accepted as good art.

Success of the curriculum is determined by whether works created by students dem-
onstrate aesthetic qualities, and whether students perceive qualities and relationships
in works created by others. The ability to appreciate, if not also to create, the "finer
things in life" is the most significant outcome.

While I appreciate the sharpening of cognitive skills that come with this approach,
I also find it problematic. If the meaning of an aesthetic object is found only within
the object itself, and has no connection with what is essential in our lives, an extra,
a "frill," a way of decorating what is truly basic. Of course, the "finer things in life"
belong to a very small proportion of the world's population, those whose survival
needs have already been met and who have fairly large amounts of discretionary
income. Art in the objectivist account, and aesthetic literacy, become simply another
way to identify the haves from the have-nots, the "privileged elite" from the "igno-
rant masses," those who decorate the world from those who endure it.

I also find it problematic that, in this view, only certain (predetermined) quali-
ties and relationships are considered to be aesthetically valid. Certainly many art-
ists have faced this limitation in having their work accepted by art critics, and,
over time, the definition of sought-after aesthetic qualities has broadened.
However, a child in this kind of art program is rarely in such a position of personal
strength to persist in defying prevailing definitions of acceptable quality. The
child most often accepts the standards of others, limiting his or her art to copying
forms of others, and limiting responsiveness to art works to recognizing those
qualities already identified by others. The child is thus denied the validity of per-
sonal response and personal meaning, and arts education becomes merely another
way to preserve the status quo.

When the objectivist view of the aesthetic dimension is applied to constructing a
curricular model, construction of a curriculum becomes similar to creating a work
of art, with an eye to its internal relationships and the qualities it possesses. The
curriculum planner following such an approach would seek unity of theme or pur-
pose, variety in choice of activities, grace in transition, economy, originality, and
elegance. The planner would attend to the rhythm of the day in the classroom, the
alternation of intensity and serenity, and would try to be sure each school or even
each classroom had its own distinct flavor or character, rather than aiming for homo-
geneity. There might be concern for congruence between form and content: One
should not teach about creativity uncreatively, or teach about democracy undemo-
cratically. Evaluation of such a curriculum would be akin to art criticism, seeking to
describe the qualities found by the trained observer.

I find much that is appealing in such a model, certainly an improvement over the
factory model of curriculum that is so prevalent. Yet I also find it incomplete. Just
like the artist or art critic who looks at an art work in and of itself, the curriculum
planner in this view may omit the social and political context in which a gem of a
curriculum may be seen to be seriously deficient. Without such a context, one opens
oneself to the possibility of doing something which is very wrong, very well.

A second idea about the aesthetic dimension focuses not on internal relationships
within the work of art, but on the relationship between the observer and the aesthetic
object. In this view, what the observer brings to the encounter—the aesthetic

attitude—is just as important as the inherent relationships within an object. Many avant-garde artists would say that relationships exist anywhere, and the responsibility of the apprehender is to look aesthetically. Yet looking aesthetically in this view does not mean looking for inherent qualities, but opening oneself to responding to the work of art. We regard an object as aesthetic not just in terms of what it is, but according to how it moves us. As Redfern (1983) notes, this view would find quite absurd a statement such as "It's a great work of art, but it doesn't do anything for me." While some objects may be easier to respond to than others, what matters is the aesthetic experience.

Descriptions of the aesthetic experience vary, reflecting the individual response of the apprehender. However, it is often described in mystical terms, as a heightened state in which we lose track of space and time, becoming one with the aesthetic object. Csikszentmihalyi (1975) defines characteristics of what he calls the "flow experience" as including a merging of action with awareness, centering of attention on a limited stimulus field, and loss of ego through fusion with the world. Such experiences are very powerful. Many would suggest they are a source of knowledge of God and a major source of meaning in life. I do not necessarily disagree, and I have found in discussion with my students that it is such transcendent experiences that have drawn them to choose dance as their life's work.

Transcendent experiences occur rarely in schooling, I expect, even in arts classes. While it is never possible to guarantee that aesthetic experience will occur, it is possible to structure the arts curriculum to make it more likely. Whether activity involves creating, performing, or observing, teachers must ensure psychological as well as physical safety for children. In order to increase concentration, they may even lead a meditation prior to the beginning of work. Content will be selected according to whatever holds the greatest possibility for stirring the child on a feeling level; the curriculum will be very child-centered.

If applied to a larger curriculum model, this view of the aesthetic dimension emphasizes children's participation in curriculum, and helps children learn to open themselves to new experiences and respond to them. The basis for content selection is "whatever turns kids on"; methodology emphasizes hands on participation and total involvement. Arts activities may be an important aspect of the curriculum because of their capacity to stimulate aesthetic experience.

It should be mentioned that many serious artists, while acknowledging the existence and the power of the transcendent state, may deny it as the basis or goal for curriculum, because it seems to make art a means to the end of a transcendent state, or even a form of therapy, rather than an end in itself. As one of my colleagues, a serious artist, told me, "Art is not to serve people. People should serve art."

My concerns with this view are different, and exist simultaneously with a valuing of transcendent experiences as a path to knowledge of ourselves as well as the Source of ourselves. However, I recognize a significant danger as well: Aesthetic experience, in transporting us to another, more beautiful realm, may just become a way to escape from living in a difficult and often ugly world. Transcendent experiences may too often simply refresh us—like a mini-vacation—making us better able to tolerate some things which we ought not tolerate.

As I mentioned earlier, even the most satisfying relationships may become problematic if they cause us to lose the capacity to look with a critical consciousness at our actions. There are too many instances when relationships which may be positive in themselves become harmful because they blind us from seeing beyond the satisfaction. I think of the S.S. officers who carried out such horrors during working hours and then spent the evening listen to Wagner. Did the experience of beautiful music make them feel so beautiful that they could avoid recognizing the evil and ugliness of their work?

Furthermore, people can have powerful, transcendent responses to murder, rape, and other violence, as well as to power, speed, and drugs. The transcendent quality of an experience is no guarantee that it is beneficial for human beings, or educationally valid. Without maintenance of a critical consciousness, transcendent experiences can be dangerous.

It would be easy to give up at this point, to conclude that the aesthetic dimension is moral in some respects but not in others, and is insufficient as a guide to curriculum. However, I wish to suggest a third view of the aesthetic dimension which I believe has considerable potential for curricular thinking. This view emphasizes the relationship of the observer/participant to the world; the aesthetic object is the lens through which we see/make sense of the reality of being a person-in-the-world.

This is the aesthetic vision I see reflected in the work of Maxine Greene. She notes (1978) that certain works of art are considered great primarily because of their capacity to bring us into conscious engagement with the world, into self-reflectiveness and critical awareness, and to a sense of moral agency, and that it is these works of art which ought to be central in curriculum. This suggests that an educationally valid work of art is not one that simply engages us as we sit in a theatre, concert hall, or gallery. Rather it is one that transforms our consciousness, so that when we leave we see ourselves and the world differently: Something has been revealed. Redfern (1983) also speaks of transformation: "there we may *realise* in a particularly vivid way what we already know, yet seem to learn for the first time… our experience is such that our knowledge gains a new dimension" (p. 96).

It is important to recognize that this new dimension is not merely a new piece of knowledge, a bit of information we can verbally define. We may already know, for example, that suffering is a consequence of war. What contemplation of Picasso's *Guernica* adds to this knowledge comes from allowing it to touch me. No longer is it distant and objective, like a newspaper report; I feel my relatedness to it.

This is not meant to imply that all significant works of art must deal with concrete subject matter. Even an abstract dance may stir us to feel ourselves as moving creatures, thereby related to other moving creatures. Choreographer Alwin Nikolais, whose works are so abstract that the human figure is often unrecognizable as anything other than pure design, speaks often of the theory which is behind his choreography, which I once heard him call the "theory of decentralization." This is actually a non-hierarchic vision of the world, in which humankind exists in partnership with other forms and other life, rather than in domination of them. Other choreographers celebrate the glory and uniqueness of the human form, but, in any case, participation as an observer or performer in

a work may offer us a deepened understanding of what it is to be human, what it is to be a person-in-the-world.

Dancer/choreographer Erick Hawkins (1969) reminds us that not all art serves this function. He points out that there is both sacred and secular art. Secular art uses the aesthetic materials for their own sake. It involves "forgetting about what the total world of man, nature, and God is, and deals with totality in a partial way leading to triviality and naïve realism" (p. 38). Sacred art, by contrast, reveals the harmony, the patterns of relationship in the world. Hawkins writes that

> This pattern of relationship is love, even the love to make the corn grow.... Periods of greatest love and faith are the periods of great creativity in art...the dance artist...must be a priest representing the noblest concept of what it is to be a man and a woman on this earth in all the fullness of body, mind, and heart. (p. 39)

As an arts educator, I can find my work personally and morally valid only if it is concerned with such relationship: only if experiences in creating, performing, and viewing art bring the student into conscious engagement with the world, to increased understanding of self and relation with others as subject with subject. Further, I see that in my role as educator I must go further than even the artist who creates sacred art; I must also help students recognize the responsibility that comes with relationship, a responsibility to respond that does not end when we leave studio or classroom.

This does not mean that students should not come to appreciate what makes a work of art successful, and how its parts fit together to create a whole. It does mean that they should carry this sharpened perception and understanding with them as they look at the larger world. As I discussed earlier, Kupfer (1978) suggested that aesthetic relationships can serve as a model for moral relationships, but this can happen only if observation and discussion of relationship are not limited to the poem, play, or symphony as subject matter. We must teach not only content, but also connections, and ask, "What does this mean for us as persons who live in the world?"

Neither does this view of the aesthetic mean that teachers should not seek to encourage possibilities for transcendent experiences for students as they create, perform, or observe art. It does mean that these experiences should not be a means to lose ourselves, but a means to recognize our power to transform ourselves and to transform reality through our total engagement with it.

This also does not mean that we should use art merely as a means to teach moral behavior and social awareness. It is important not to change a work of art or a creative, aesthetic experience into a moral lesson or propaganda; the power of art to move us comes only when we relate to it as art. However, the arts have been significant throughout history not because they make our lives prettier, but because they allow us to explore who we are and what is our relationship with the rest of existence. Choosing to teach the arts from this perspective is not using them as a means to an end, but allowing them a significance that is rightfully theirs.

As a curriculum theorist, I find an aesthetic model for curriculum to be valid only if it sensitizes, rather than anesthetizes, us to moral concerns. It is not enough to have a beautiful classroom and harmonious relationships within curriculum, even if it is personally meaningful. Curriculum must function as art, serving as a means for the child to connect not only with self but with the larger world, becoming the link between self-understanding and social awareness. Content and methodology are

selected according to their possibility for facilitating connections: teacher/student, student/student, student/self, and student to the world. Certain kinds of arts activities may be an important dimension of the curriculum not only because they may allow students to transcend the here and now, but because they may return students to the world able to think more clearly, feel more deeply, respond more humanly. It is only this conception of an aesthetic model that will allow curriculum to extend the student's consciousness to those significant questions (Macdonald,1977):

> What does it mean to be human?
> How shall we live together?

It is only with such a model that students may come to recognize their power to create not only works of art, but also their lives and the world.

Commentary

Although I had published a little before this piece, this is one that made me realize I was a scholar. My advisor David Purpel had encouraged me to attend "The Bergamo Conference" in Ohio upon completion of my doctoral degree in May 1984, so I made plans to attend that fall. At this conference, the first annual James B. Macdonald award was to be given, named after a member of my doctoral committee who had been quite influential in my thinking; he had written a question for my qualifying exams but, sadly, died before the oral. Without any sense that I deserved an award, I submitted my paper for consideration as an acknowledgement of his impact on my development. When I presented my paper at the conference, I was thrilled that Maxine Greene and Madeline Grumet, two of my scholarly "heroes," were in the room—after all, I was a "nobody" at this conference where so many brilliant people seemed to know each other. I found out later that they were two of the judges for the award, and that I was the winner in the inaugural year. The prize was $1000 and publication in the *Journal of Curriculum Theorizing*. Before submitting the paper for publication, I incorporated a brief response, found in the next to the last paragraph, to some well-founded critique Grumet had offered at the conference, regarding the difference between propaganda and art. However, I now think this response was too facile, reflecting a desire to defend my position rather than to acknowledge the complexity of the issue. I wish I had added that the lines between the ethical and the aesthetic are not always clear, especially in socially-conscious art.

References

Beardsley, M. C. (1958). *Aesthetics: Problems in the philosophy of criticism*. New York: Harcourt, Brace & World.
Buber, M. (1955). *Between man and man* (M. Friedman, Trans.). New York: Harper.
Buber, M. (1958). *I and Thou* (2nd ed.) (R. G. Smith, Trans.). New York: Charles Scribner's.
Csikszentmihalyi, M. (1975). *Beyond boredom and anxiety*. San Francisco: Jossey-Bass.

Dewey, J. (1934). *Art as experience*. New York: Minton Balch.

Eisner, E. W. (1979). *The educational imagination*. New York: Macmillan.

Gilligan, C. (1982). *In a different voice: Psychological theory and women's development*. Cambridge, MA: Harvard University Press.

Greene, M. (1978). *Landscapes of learning*. New York: Teachers College Press.

Hawkins, E. (1969). The body is a clear place. In M. Gray (Ed.), *Focus on dance V: Composition* (pp. 34–39). Washington, DC: American Association for Health, Physical Education & Recreation.

Kupfer, J. (1978). Aesthetic experience and moral education. *Journal of Aesthetic Education, 12*(3), 13–22.

Macdonald, J. B. (1974). A transcendental developmental ideology of education. In W. Pinar (Ed.), *Heightened consciousness, cultural revolution, and curriculum theory* (pp. 85–116). Berkeley: McCutchan.

Macdonald, J. B. (1977). Value bases and issues for curriculum. In A. Molnar & J. Zahorik (Eds.), *Curriculum theory* (pp. 10–21). Washington, DC: Association for Supervision and Curriculum Development.

Macdonald, J. B., & Purpel, D. E. (1983). Curriculum planning: Visions and metaphors. In Z. Lamm (Ed.), *New trends in education*. Tel Aviv: Yachdar United.

Marcuse, H. (1978). *The aesthetic dimension: Toward a critique of Marxist aesthetics*. Boston: Beacon.

Newman, A. J. (1980). Aesthetic sensitizing and moral education. *Journal of Aesthetic Education, 14*(2), 93–101.

Redfern, B. (1983). *Dance, art and aesthetics*. London: Dance Books.

Ross, M. (1981). You are the music. In M. Ross (Ed.), *The aesthetic imperative: Relevance and responsibility in arts education* (pp. 147–172). Oxford: Pergamon.

Chapter 3
Reflections on Teacher Education in Dance (1991)

Susan W. Stinson

Abstract Written at a time of peak prominence of a curricular approach known as discipline-based arts education (DBAE), this work acknowledges that most arts educators seem either to see DBAE as a savior, able to move arts education beyond the fringes of the curriculum into the central core where it will not be subject to the funding cuts that seem automatic with each economic downturn, or else as a sure way to destroy the arts as a personally meaningful experience. Rejecting both of these responses, the author explores her ambivalence toward DBAE (what makes it attractive and what raises concerns) and discusses two underlying issues that affect any approach to arts education. One is the inequity of our social structure, which is replicated in and through schooling. The second is oppositional behavior, the phenomenon in which young people respond to oppressive situations in ways that give them some sense of self-affirmation and solidarity with others, but maintain the oppression. The piece culminates with implications for teacher education in dance. The author suggests that teacher educators need to go beyond thinking about content and methodology to thinking about how students develop their identity within the social structure and, indeed, what that structure is and might be. She calls for dance educators to work together with other concerned educators, with students and parents, to create and construct schools in which participants can find justice, identity, meaning, and community.

It takes little if any imagination to recognize that today's schools are not working well for more than a small number of students. Statistics on low SAT scores and dropout rates are part of the daily news. There is little evidence, despite efforts at educational reform, that the situation has changed much since 1983, when Ernest Boyer wrote that American high schools provide an outstanding education for only 10–15 % of the students. Further, he noted that "a larger percentage of students—perhaps 20–30 %—mark time in school or drop out.... The majority of students are in the vast middle ground" (p. 39); "most secondary schools in the United States are—like the communities that surround them—surviving but not thriving" (p. 38).

Many people blame teachers, accusing them of not being bright enough or hard-working enough; my university now requires a second major for education students, as well as higher GPAs and higher scores on the National Teacher's Examination. Others blame students and/or they blame their families for raising students who are

© Springer International Publishing Switzerland 2016 19
S.W. Stinson, *Embodied Curriculum Theory and Research in Arts Education*,
Landscapes: the Arts, Aesthetics, and Education 17,
DOI 10.1007/978-3-319-20786-5_3

lazy or who are more interested in a job at McDonald's to support a car than they are in learning. The proposed remedies have included more of many things that now exist: more academics, more testing, more homework, more requirements.

This kind of thinking provides fertile ground for the latest movement in arts education, usually referred to as Discipline-Based Arts Education (DBAE). The term was popularized by the Getty Center for Education in the Arts, whose 1985 publication *Beyond Creating: The Place for Art in America's Schools*, called for a standardized, sequential program consisting of four disciplines: art history, criticism, aesthetics, and production. The Getty Center also supported standardized testing to measure curricular outcomes. Although using different language, the National Endowment for the Arts, in its 1988 report *Toward Civilization*, also called for a discipline-based approach. The four purposes for arts education cited in the report are

- to teach civilization (specifically, the great works);
- to foster creativity (including the vocabularies and basic skills that produced the great works of art);
- to teach effective communication (understanding the languages of the arts and analyzing their meanings); and
- to provide tools for critical assessment (so that people can make better choices about art, thus becoming better consumers).

A survey of recent issues of arts education publications makes clear that DBAE is a powerful trend in the field. The "old days" in arts education, when we spoke of creativity and self-expression in an activity in which there were no wrong answers and every student could find success, have given way to a language of standardization, sequential curriculum, and accountability. Rather than nurturing students to personhood and social development, arts educators today are asked primarily to challenge them intellectually. Under DBAE, dance becomes less an experience and more an object to be looked at, analyzed, and evaluated.

DBAE has significant implications for teacher preparation in the arts. The Getty Center tells us that teacher-education students need to spend more time thinking about the arts, meaning that they should spend less time creating and performing. Any reduction of creating and performing experience has been regarded by many university dance faculties, including my own, as anathema; they ask how one can teach *any* art well if one is not accomplished at doing it. The only solution to this dilemma that our faculty has found has been to require more and more credit hours of dance within the 4-year curriculum. Consequently, very few hours are left for students to explore areas outside of dance and to develop their ability to think about and do things other than dance, things they will need to do as public school educators.

Most articles about DBAE seem to see it either as a savior, able to move arts education beyond the fringes of the curriculum into the central core where it will not be subject to the funding cuts that seem automatic with each economic downturn, or else as a sure way to destroy the arts as a personally meaningful experience. It is my intention here to reject both of these responses. Instead, I will explore my ambivalence toward DBAE, seek to reveal some underlying issues that affect any approach to arts education, and culminate with implications for teacher education in dance.

To begin with, I must note that much of DBAE's emphasis on the academic and scholarly side of dance feels right to me. For a long time I have felt concern at how frequently dance is taught as a mindless activity in which one must move and sometimes feel, but not think. ("Don't think about it; just do it" is often heard in dance classes.) My intellectual self is glad to be appreciated in dance, after feeling second-class too long in a field that has looked down upon those who create with words.

But there is much that troubles me within this reconceptualized vision of dance education. It is partly the recognition that those organizations leading the way "beyond creating" to an emphasis on the "great works" are the very ones that claim the right to declare what the great works are and how they should be judged. It is partly the recognition that the emphasis on looking at and judging art at the expense of making it furthers the already rampant consumerism of U.S. society and the way we rely on material goods for status. It is partly the way it celebrates mind over body, valuing art only as mental experience. Although I recognize the validity of the notion that art is an activity of the mind, I know I came to dance as an adolescent not to find intellectual challenge but to find a safe place in which I could reclaim my body and explore its possibilities as part of myself. I liked dance because of the way I felt when I did it. Over and over again, when I ask students and colleagues why they chose to make a career in dance, I hear the same answers: the sense of power and control over themselves, and the transcendence or "high."

But there are other voices that I know as well, those that I hear while I am in public schools, teaching young people and dancing with them, listening to their stories and those of the dance educators who face these students every day. It is important to share some of these voices as a context for what will follow, for they are the ones that call me to question teacher education in dance.

One of the schools in which I teach demonstration classes each year is a middle school for students who have been removed from their assigned schools because of either pregnancy or disruptive behavior. Most of these students have had years of school without experiencing much success. Many of the young women have children; there is a daycare center in the school. Before the first class, their teacher tells me about their lives. Last year she told me of Rosa,[1] who went to bed at 4:30 in the afternoon because this was the only way she would get to sleep in a bed; there were ten people in her family and only eight beds. Keisha lived in a shelter for abused women. Lynn was on parole and living in a halfway house, trying to be "good" so she could earn the right to regain custody of her child. She was married at 14 and was 15 when I met her; the very successful halfway house where she lived closed recently for lack of funds.

Each year, these young women's stories and those of their peers raise profound questions for me in relation to DBAE. How can I talk to them about Martha Graham? Is this what they need in their lives? Do they even need dance? Who decides what they need? Each year I decide that the only thing I can help them find in a brief unit is the knowledge that they are strong and beautiful and can make choices that will have good outcomes for them and that others will also admire. Last year we worked on some basic movement

[1] All names of students have been changed to protect their privacy.

concepts and skills, allowing them to experience themselves moving well; I then gave them choices in how to vary the movement, changing speed, level, direction, and so forth. We explored the difference between just moving and dancing: the focus, the intensity, the different state of consciousness. Over four classes, we created a group dance, which we videotaped and they proudly shared with their teacher and peers. They danced and helped make a dance; it was a small accomplishment in their lives.

I see similar accomplishments while engaged in my current research in progress, an ethnographic study of how students make meaning of their dance experience in schools. I participate in two beginning-level high school dance classes each week, dancing with students, hanging out in the dressing rooms, attending their informal performances, and interviewing them at the end of the semester. Dance is an elective course and classes are small; the focus is on creative experience and choreographic and movement skills. I leave my days interviewing them overwhelmed by the pain in their lives, pain far greater than one would assume is normal for adolescence. Several have moved out of their homes or been kicked out. A few stories involve various forms of abuse. Anna was in her third foster home at the time of her interview; a month later she was in her fourth. Several students have been suspended from school for misbehavior in other classes during the year, even though they were quite cooperative in dance. Two frequently miss school to care for an alcoholic parent. Last semester only one student (that I knew of) out of 16 became pregnant, and only one already had a child; some years, the dance educators tell me, as many as one-fourth of their students have been or become pregnant. The mother of Linda confided to the dance educator that she was concerned about AIDS because her daughter's boyfriend was an intravenous drug user. Very few live in two-parent families.

These are stories that most public school teachers know. In 1988, 19.8 % of the children in my state were living in poverty, and over 15,500 babies were born to mothers between the ages of 11 and 19 (Children's Index 1990). Only 68.5 % of all ninth-grade students were graduating 4 years later (Ibid); nearly 7 % failed kindergarten.[2] As more and more students do not have a parent at home to help with homework or have a parent who does not have the skills to help with homework that gets harder and harder, as more children have parents who are themselves children, these children who are so intimately acquainted with failure will make up a larger and larger percentage of public school classes.

I wonder what the critical reader is probably wondering at this point: Maybe I should leave teaching and become a social worker. Education is about teaching, not dealing with students' personal problems. But these are the children my dance education students will teach, and I cannot think about teacher education without giving names and faces to the statistics about dropouts and failures and SAT scores.

In my research, when I see the degree of engagement that students have in their dance classes, and their level of success, it is easy to believe that creative experience in a caring environment is the solution to these students' problems, and all that is needed is more of the same. But I continue to have questions: Do these at-risk students

[2] Data obtained from Information Center, North Carolina Department of Public Instruction, Raleigh.

not have as much right as my own teenage daughter to know who Martha Graham is? Are proponents correct when they argue that DBAE can be a way for disadvantaged students to gain the "cultural capital" they need to make it into the middle class?

Each time I face such students, whose stories change only in their details, I end up deciding that they first need to appreciate themselves, not as a step toward appreciating Graham, but as an end in itself. Certainly appreciation for oneself can be gained through academic skills as well as movement skills, through what one has written as well as what one has created in space and time. But to first tell them about Martha Graham, as one more piece of information that someone else decided they should know, one more piece of information they do not value enough to learn, is to ensure that they will fail in dance like they have failed in so many other courses.

I know that, in the case of my colleagues and me, interest in the *field* of dance, in learning history, criticism, and aesthetics, came *after* we learned we loved to dance. Perhaps, I wonder, is this kind of sequencing a way out of the conflict between the approach of "creative arts experience" and that of DBAE? One could start with the former, and then, once appetites were whetted, move to the latter. This would seem to offer what is necessary for the at-risk students I cannot ignore: first self-esteem and motivation achieved through doing and making the art, then a chance to obtain the "cultural capital" that might allow them the same kinds of opportunities my own daughter has.

It seems to me that, once students are interested in dance, it should be possible for DBAE to be satisfying and meaningful for many of them. I know that I can and do find satisfaction and meaning in the kinds of discussions about art that are described in *Beyond Creating*. Why, then, am I not hopeful that DBAE will actually exist in ways meaningful for many students other than the 10–20 % who are already motivated, who already see themselves as competent learners, who want to learn what the teachers are teaching?

The basis for my pessimism becomes clearer whenever I go into schools or ask students to describe what goes on there. For the most part, the only high school classrooms in which I hear the kind of talk described in *Beyond Creating* are those for the academically gifted. In my current research, when I asked students to tell me what school is like, I heard almost nothing about school as an interesting and exciting place to be, other than socially. Even many students not classified as at-risk had withdrawn emotionally, not particularly caring whether or not they failed. Almost all students said they had a hard time staying awake in classes other than dance; at most they had one other course in which they were allowed to move around, make things, solve problems, come up with their own ideas, work together with others in the class, and share their creations and accomplishments with others. Almost always, the other course was an experientially-based arts course (open to all students) or a course for those designated academically gifted (containing few poor, minority, and working-class students). This situation is the basis for my fear that DBAE will end up leaving the privileged few in advanced or honors courses to deal with questions of meaning that will excite them about school and about learning, while the majority—particularly those not already successful in school—will end up memorizing the dates of Graham's birth and when she choreographed "Night Journey," thus following the same pattern as other academic subjects.

Svi Shapiro suggests that the boredom most students experience in schools may function as preparation for the kind of work they will face after their formal education. He notes that even white collar labor

is increasingly fragmented, monotonous, and bureaucratized. While the opportunity to "work downtown" and wear a suit and tie still hold their attraction over the conditions of manual work, the former is less and less associated with the kind of autonomy or intellectual opportunity suggested by long years of educational training. (1990, pp. 37–38)

Despite the fact that the rewards for being a "good student" (i.e., being respectful, obedient, and diligent) often do not measure up to expectations, many students accept the terms given them; school is seen as boring, yet necessary. But we cannot understand the problems and frustrations that teachers face unless we look at the students who do not engage themselves in school and its underlying belief system. These are students who, instead of accepting their powerlessness in the face of an environment they find meaningless, choose to engage in oppositional behaviors. Openly defiant and hostile students are more obvious examples; apathetic ones—those who do not try and do not care—demonstrate a more subtle version. They may not attempt even the "easy" assignments, or may refuse to "dress out" for dance or gym class.

The term *resistance* is often applied to all oppositional behaviors. Aronowitz and Giroux (1985) argue that this term should be reserved for those behaviors that reflect moral and political indignation at the underlying ideology of schooling and express hope for radical transformation and liberation. They find that many oppositional behaviors are more about a display of power, indicating that students have rejected some aspects of a repressive ideology but adopted others. The theorists do note, however, that even those oppositional behaviors that they would not call resistance have "an oppositional moment" (p. 100).

Oppositional behavior, whether or not it reflects moral and political indignation, gives students a sense of self-affirmation in rejecting the dominant school culture. It also gives a sense of identity and community, because the alternative norms chosen indicate that the students belong to a subculture that shares those norms. In short, it gives students a chance to find meaning in a situation that otherwise seems meaningless.

Unfortunately, oppositional behavior, while functioning as a way for students to resist oppression, also maintains the students' place in an oppressive situation rather than allowing them the skills necessary to transform it. It may give students a sense of power and identity in school, but ultimately leaves them powerless in the larger society.

As I look further into the relationship between school and social structure, additional disturbing complexities are revealed. Shapiro (1990) reminds me that the curricular and pedagogic changes of the 1960s and 1970s came closer to making school a place where anyone could succeed; this time was a heyday of creative arts experience in schools. As long as the economy was expanding, increased upward mobility through schooling was seen as desirable. With the declining economy of the 1980s and the increasing competition for professional jobs, the open door to success needed to close, particularly on poor, minority, and working-class students who were in competition with the middle class. Today, we need schools to restrict chances for such students to "make it"; one way we do this is by reducing student loans for

higher education. Another is by reducing curricular choices that connect to the lives of poor, minority, and working class students and replacing them with courses that are more likely to alienate these young people—and which they are more likely to fail—thus "proving" that they do not deserve to make it into the middle class.

Is DBAE a way to ensure that more students, particularly the "have-nots," will fail? Without empirical evidence, I draw on my own experience as parent of a child in a public high school. Although my daughter has been assigned labels that give her admittance to the more challenging and interesting courses, she not infrequently needs to seek assistance from teachers or parents. Seeking assistance from teachers requires going to school early or staying late, meaning that she cannot take the school bus to her distant, rural school. As I interrupt my normal work hours to make the long drive, I am grateful for the flexibility that my professional schedule allows, and I wonder how other students and their parents manage. When she seeks her father's assistance to explain a new concept in advanced mathematics courses, having long ago passed my expertise in this subject, I think about her school-mates whose parents did not finish high school. If she took a DBAE course, I could provide assistance similar to that her father now gives. Thinking about my own family makes clear one way that existing social structure is perpetuated, as parents pass on their privileges to their children. Despite our societal belief that schools provide equal opportunity to all students, the opportunities are *not* equal. Those who start out with more almost always end up with more. Of course, the occasional child of the ghetto does "make it" to the National Honor Society or to Harvard on a scholarship. But this one is held up as a shining example, convincing us that the system really does work, blinding us to the inequities that we are otherwise perpetuating.

By now, I have identified two factors that I see as essential in thinking about schools and teacher education. One is the inequity of our social structure, which is replicated in and through schooling. The most personally meaningful curricular choices among academic subjects—and those that tend to motivate students to be self-directed learners—are offered to students identified as gifted, who are disproportionately members of the upper middle class. Further, children from middle-class families have the resources that allow them to take the greatest advantage of public schooling. Children from poor, minority, and working-class families, denied those advantages, tend to be less successful. Because of our societal myth that rewards come to those who most deserve them, those who start out with less often come to believe that they deserve to end up on the bottom; this becomes a self-fulfilling prophecy.

The second factor is oppositional behavior, the phenomenon in which people respond to oppressive situations in ways that give them some sense of self-affirmation and solidarity with others, but maintain the oppression. Even when an individual teacher offers opportunities for learning that go beyond the routine and invites students to engage in personal meaning-making, students may not respond because of opposition to the larger system.

I do not believe that any curricular reform can be successful unless these two factors are dealt with. This means that we must go beyond thinking about how and what we teach in dance to thinking about how students develop their identity within

the social structure and, indeed, what that structure is and might be. It is not enough to change curricula; we must also transform schools and society.

This kind of call seems so enormous that it is easy to become overwhelmed and to conclude that the problems facing us are so large and complex that nothing can be done about them. It would be much less troublesome to read about dance history and criticism than about poverty, hunger, and homelessness; to go into a studio and dance, than to engage in social action; to think about only what is beautiful and not also about what is fair and right.

Can education even make a difference, or is it so embedded in the status quo that it is incapable of anything else? I can find cause for hope only when I acknowledge that there is not just an impulse in education to support and maintain the world as it is, but also one to provide stimulus and leadership for change. In this way, education functions similarly to art, which sometimes focuses on reproduction and transmission of culture and sometimes leads us to imagine how things might be different. After all, both art and education have attracted some people who are visionaries and prophets, people who wish to create new worlds.

I believe that all educators, including dance educators, must prepare students to imagine and create new worlds; to do this, educators must be able to create new worlds within schools. It would be presumptuous of me to try to detail here my own ideas of what such schools should look like: They must be created by people who will live and work and learn in them. For example, Paulo Freire (1983) offers a pedagogy that addresses issues of identity and social justice, based on his experiences as a Brazilian educator. He describes traditional educational practice as "banking education," in which knowledge is deposited by teachers ("who know") into students ("who know nothing") for storage and future use. The knowledge in banking education attempts to transmit culture but, Freire notes, "In the name of the 'preservation of culture and knowledge' we have a system which achieves neither true knowledge nor true culture" (p. 68). Freire contrasts banking education with "problem-posing education," in which students

> develop their power to perceive critically the way they exist in the world with which and in which they see themselves; they come to see the world not as a static reality but as a reality in process, in transformation. (pp. 70–71)

Freire does not speak directly to arts education, but it seems relevant to examine both DBAE and a creative-arts-experience approach in relation to what he calls problem-posing education. Certainly the justifications for DBAE have primarily been directed at the transmission and reproduction, more in line with banking education. It seems apparent to me, however, that studies in history, criticism, and aesthetics could be taught through the kind of pedagogy advocated by Freire, if material were dealt with through posing problems rather than assuming there are right answers. For example, students might look at their own social dance in contrast to forms identified as art, considering who makes the definitions and what that means. A host of other issues that might be present with the academic study of dance have the potential to engage students in ways that connect to their lives, including pleasure, the body, gender, and race. Maxine Green

(1978), although not identifying herself with DBAE, makes clear that looking at and thinking about dance can do far more than reproduce culture when she states,

> There are works of art…that were deliberately created to move people to critical awareness, to a sense of moral agency, and to a conscious engagement with the world. As I see it, they ought…to be central to any curriculum that is constructed today. (p. 162)

A creative-arts-experience approach seems easier for me to recognize as problem-posing education. However, creative dance is not an automatic route to freedom and power outside the walls of the studio. Without a connection between what goes on in the studio and in the world, dance becomes more of a feel-good drug than a path toward liberation.

Freire comes closest to speaking of arts education when he writes, "The oppressed must realize that they are fighting not merely for freedom from hunger, but for… freedom to create and construct, to wonder and to venture" (1983, p. 55). Similarly, I think that dance educators must be engaged in both freeing students from oppression and freeing them to engage in activities that will allow them to find personal meaning in their lives. How can teacher education programs in dance prepare students to contribute to these two kinds of freedom for their students, both the freedom *from* and the freedom *to?*

If prospective educators are going to provide freedom for their students, they need to experience freedom in their own classes. Students often think of freedom only in terms of having few restrictions, so that "anything goes." However, they also need knowledge and skills if they are truly to have the freedom to create and construct beyond the most superficial levels. Dance education students need to develop their own skills as dancers and choreographers in order to appreciate the sense of personal power that comes with competence, and they need to develop the pedagogic skills to help others find their own power. Courses in technique, improvisation, choreography, and pedagogy have traditionally developed these skills. However, teachers need to avoid methods that emphasize rote imitation. Instead they should use methods that encourage exploring and understanding the underlying concepts of dance movement, choreography, and teaching. Even dance technique should be taught as a way to empower students, allowing them to accomplish the artistic challenges they choose rather than training them to become obedient, unquestioning followers.

Courses in the social-cultural-historical context of dance should be designed to free students to make their own interpretations of dance and dances from a context of knowing the multiplicity of possible interpretations. All too often, dance history, like dance technique, is taught as though there were a single truth or a single set of right answers. Again, I do not wish to promote an anything-goes attitude; students also need to question their own interpretations and recognize the importance of supporting their interpretations, whether historical or critical.

Throughout their curriculum, teacher education students in dance need to learn to think critically rather than reverentially about their art and their chosen profession. They need to learn how dance is like other human ventures in that it can contribute to either freedom or oppression, personal meaning or alienation, community or isolation —and how different pedagogies offer them a choice of which they will

promote. Ideally they should be taught by teachers who see their students and themselves as equal partners in the learning process. Unfortunately, universities, like most other educational institutions, are constructed so that teachers, whether they like it or not, hold power over their students. In such a setting, it is natural that students wish to move up the hierarchy so that they can have power over their own students; this changes them from being among the oppressed to being among the oppressors. Although it is unlikely that sudden changes will occur in the power structures within educational institutions, we can work toward their evolution. We can also help students think critically about the structures in which they learn and will work, rather than accepting "the ways things are" as a given. Perhaps dance education can offer the most for prospective teachers if it includes both transcendence and critical thinking, so that students come to know that it is possible to go beyond the limits of what we accept as "reality," a reality that is a human construction.

But dance courses, no matter how well conceived and implemented, are not sufficient to prepare dance educators for the challenges they will face in today's schools and those of the future. Those of us who design teacher education programs in dance need to struggle against our own tendencies to be obsessive about our art and about the number of credit hours in dance required for majors. We might need to reconceive the particular courses into which we have traditionally divided dance education and begin to integrate multiple kinds of learning in dance within single courses. Such integration could free students to take more coursework other than dance.

In addition to taking general liberal arts courses, teacher education students need courses that encourage them to look at their own lives and their place in the social structure; they also need to examine the myths underlying the social structure. They need to move beyond seeing the have-nots of society as hopeless rejects and start seeing them as persons with rights and possibilities. As they consider the possibilities of others, they will need to appreciate the variety of forms of intelligence (see Gardner 1983) and what that means as we interpret Scholastic Aptitude Test scores and assign differential value to different kinds of work. Certainly these recommendations imply coursework in selected social science and education courses and in other courses that can help students both examine their own lives and go beyond the prisons of their own experience. They also imply time to volunteer in homeless shelters and soup kitchens as well as in schools. Here, prospective teachers can learn to meet opposition without despair, appreciating it as a cry for identity and personal meaning.

These few suggestions are clearly not a definitive prescription for teacher education in dance. Rather than seeking prescriptions, whether informed by DBAE or other approaches, we must allow ourselves to listen to and be touched by the stories of students in today's schools and to reflect upon deeper issues that affect these young people and ourselves. We cannot isolate ourselves in dance studios or with philosophy books and expect to make a real difference in what happens in the world. Dance educators must work together with other concerned educators, with students and parents, to create and construct schools in which participants can find justice, identity, meaning, and community.

Commentary

While Chap. 2 emphasizes philosophical aspects of morality, this one brings in concrete concerns I encountered working in schools, and emphasizes justice more than morality. This piece was part of a special journal section entitled "Teaching the Teachers of Dance: A Symposium on Advanced Graduate Study in Dance Education." As editor Sarah Hilsendager noted in her introduction, dance education in 1991 was at a crossroads, with much of dance in schools found within physical education. It was also a time when Discipline-Based Arts Education (DBAE) had become prominent within visual arts; DBAE was later to have significant influence in the development of the first National Standards for Arts Education (1994). For several years before I wrote this piece, I had been struggling with DBAE, but this is the first published piece in which I discussed it. I see here my inclination to look for compromises, what Kidder (1995) calls a "third way." Or, as I have often wondered in my life, maybe I am just wishy-washy? With chagrin, I also notice a lot of statements about what others should or need to do, as in much of my early work. While I am glad I have moved beyond it, I honor this place of self-righteousness as a step along my journey toward an expanded consciousness, as recorded in this volume.

References

Aronowitz, S., & Giroux, H. (1985). *Education under siege: The conservative, liberal, and radical debate over schooling*. Westport: Bergin & Garvey.

Boyer, E. L. (1983). *High school: A report on secondary education*. New York: Harper & Row.

Children's Index. (1990). Raleigh: North Carolina Child Advocacy Institute.

Freire, P. (1983). *Pedagogy of the oppressed* (M. B. Ramos, Trans.). New York: Continuum.

Gardner, H. (1983). *Frames of mind: The theory of multiple intelligences*. New York: Basic Books.

Getty Center for Education in the Arts. (1985). *Beyond creating: The place for art in America's schools*. Los Angeles: J. Paul Getty Trust.

Greene, M. (1978). *Landscapes of learning*. New York: Teachers College Press.

Kidder, R. M. (1995). *How good people make tough choices: Resolving the dilemmas of ethical living*. New York: Fireside (Simon & Schuster).

National Endowment for the Arts. (1988). *Toward civilization: A report on arts education*. Washington, DC: National Endowment for the Arts.

National Standards for Arts Education. (1994). Reston: Music Educators National Conference.

Shapiro, S. (1990). *Between capitalism and democracy: Educational policy and the crisis of the welfare state*. Westport: Bergin & Garvey.

Chapter 4
Seeking a Feminist Pedagogy for Children's Dance (1998, Revised)

Susan W. Stinson

Abstract The author narrates her own journey of becoming, and continuing to become, a dance educator and a feminist, weaving in theory which illuminates the changes in her thinking over time. In the discussion of multiple versions of feminism, she places herself in a category of socialist feminism. At the same time, she notes that deciding on basic positions of belief and value doesn't necessarily offer clear guidance for personal and professional decision-making, because "most of us have a great deal of inconsistency between what we say we believe and what we do, a conflict we are able to maintain only by not thinking about it too much." Engaging in a reflective process brings these conflicts to the forefront, the painful process that is necessary to generate growth. To that end, the author critically examines several approaches to teaching dance (traditional dance pedagogy, critical pedagogy, and gender models for pedagogy/creative dance), and their relationship to feminist pedagogies. She then describes and critiques her own developing vision, identifying three key points related to feminist pedagogies:

- Finding one's own voice and inner authority,
- Cultivating awareness of relationship (with others in class, with one's own body, between self and world), and
- Responsibility and power for change.

She concludes with the acknowledgement that her goal is not to persuade her students or others to teach as she does, but for educators to engage in ongoing reflection about what they believe and why, and about the consequences of choices they make as persons and as educators.

I can't remember when I first heard the truism, "What we teach is who we are." Both our shared social-cultural experiences and our unique personal experiences, construct the selves that we become and that we teach. Some educational theorists (Greene 1973, 1978; Pinar 1988) have written about the importance of reflecting upon how our experience has shaped what we believe and why, and how we both participate in and resist the shaping. Similarly, some feminist educators (e.g., Grumet 1988) advocate revealing our own subjectivity in our work, bringing the personal (often considered "feminine") into public discourse (which is often considered more "masculine").

© Springer International Publishing Switzerland 2016 31
S.W. Stinson, *Embodied Curriculum Theory and Research in Arts Education*,
Landscapes: the Arts, Aesthetics, and Education 17,
DOI 10.1007/978-3-319-20786-5_4

It is thus with the blessing of these authorities that I share my own story of becoming—and continuing to become—a dance educator and a feminist. Of course it is not my story alone, for many of the forces which have impacted my own experience and thinking have also affected other dance educators, regardless of whether they have come to the same conclusions. I hope that you will find your story somewhere within my comments, and will be stimulated as well to consider how your story differs.

4.1 Personal and Theoretical Context

Except for one year of ballet as a child, I began my dance study at the relatively late age of 16. A year later, when I started college, dance was taught in the physical education department; I alternated modern dance classes with various sports, primarily as a form of release from academic pressures. I had no plans for dance in my career, but continued classes for pleasure during my last two years of college while I pursued a major in sociology. I changed my mind about becoming a social worker close to graduation. As a white, middle class woman in 1968, I felt incapable of making a difference in the urban areas of the United States where riots were a regular weekend event. I decided to be a teacher instead of a social worker, and the only subject I loved enough to teach was dance. This led me to graduate school in dance, a modest amount of performing, and teaching children; eventually I was hired for a position in teacher preparation in dance on the university level.

I thus entered dance education out of a sense of powerlessness to change the larger world. When I danced, I could escape that world temporarily, and even feel some sense of personal power within the safe space of the studio. When I taught creative dance to children, I felt I was making a small contribution to the world without having to deal with the difficult problems outside my own small corner of it. Dance and dance education offered me a safe home, and it never occurred to me to be critical of home. I would have felt inadequate to criticize, anyway, since I had not reached the "pinnacle" of the field, professional performance.

Much later, during my doctoral program in cultural studies, I started to reexamine my experiences in learning and teaching dance, and became aware of what else students may be learning besides dance skills and knowledge—what curriculum theorists refer to as the "hidden curriculum." I also encountered two questions posed by curriculum theorist James B. Macdonald (1977), which he named as the essential questions for all educators. These were not questions about the most effective ways to teach children to read or do plies or anything else. Rather, he asked us to ask ourselves, "What does it mean to be human?" and "How shall we live together?" With these influences, I started asking questions not only about what pedagogical methods have the best chance of making good dancers, but about the kind of persons, the kind of art, and the kind of world produced in the process.

My ongoing questioning of dance pedagogy was occurring as I was also asking questions about what it meant to be a woman in the world. Betty Friedan's *The Feminine Mystique* was published in 1963; the same year I decided not to become a social worker, she was a guest speaker at the small women's college where I was a senior. I graduated feeling free to make many choices that had not been available to my own mother, yet, embarrassingly enough, most of mine were traditionally female ones anyway, including a conventional marriage that produced a daughter and a son. Although I took my career seriously, one could hardly pick a more traditionally feminine choice than being a dance teacher. My beliefs, however, were less traditional than my choices. As a charter subscriber to *Ms.* magazine and a self declared feminist, I attempted to figure out how to be a woman and a mother, as well as a dance teacher, in a changing world.

One of my most helpful realizations was that the term "feminism" was an oversimplification, hiding such great diversity that "feminisms" seemed a more appropriate word to use. I found Allison Jagger's (1983) definitions of different feminist perspectives helpful in clarifying this diversity.

The best known feminism, which Jagger defines as liberal feminism, focuses on opportunities that are systematically denied to women because they are women, and the imposed barriers that keep women from competing on an equal footing with men. The goal is equal opportunity for women to enter the power structure within society and move up its hierarchy, based on their abilities. Such feminists tend to deny any basic differences between men and women other than those which are created (unfairly) by society, leaving women at a disadvantage in a competitive world. This was the kind of feminism that I first encountered in the 1960s.

Other visions of feminism, instead of denying differences between men and women, emphasize them. They point out that certain qualities and characteristics are found more often in men or women; there is often controversy regarding whether these are biologically or culturally determined, although it is generally agreed that they do not apply to all women or all men. Regardless of the source of the differences, such feminists note that the qualities identified as feminine—and the tasks that capitalize on them, usually known as "women's work"—are not valued as highly in our patriarchal society as those identified as masculine. They note that structures of society—institutions such as religion and education as well as corporate capitalism—were created by men and embody masculine values. Such values include individualism, competition, objectivity, abstraction, rationality, and a valuing of mind over body, culture over nature. Masculinist institutions are problematic not just because women have been denied access to power within them, but because they have collectively created a world which is "not healthy for children and other living things," a popular t-shirt slogan reflecting this feminism. The goal is not just allowing women to compete in a man's world, but changing that world.

Some feminists, labeled by Jaggar (1983) as "radical feminists," believe that this different world should replace masculinist values and institutions with woman-centered ones. Others, whom Jaggar called "socialist feminists," believe we must create new structures, new forms that deal with oppression by race and class as well as gender, to have the best chance for providing a humane life for all persons.

This brief discussion doesn't exhaust the list of feminisms, either in Jaggar's book or other sources. It is relevant to reveal, however, that I position myself in the category of socialist feminism. I have chosen this stance because I don't think that a world dominated by women would necessarily be any better than one dominated by men; also, I dream of a world that liberates my son as well as my daughter from narrow perceptions of gender roles, a world that responds to similar wishes by mothers of color and those who live in poverty.

Deciding on basic positions of belief and value, however, doesn't necessarily tell us how to live our lives. Most of us have a great deal of inconsistency between what we say we believe and what we do, a conflict we are able to maintain only by not thinking about it too much. Engaging in a reflective process brings these conflicts to the forefront, the painful process that is necessary to generate growth.

In the following sections of this paper, I critically examine several approaches to teaching dance and their relationship to a feminist pedagogy. Along the way, I highlight my own thinking about how to be a feminist dance educator and what that means to me.

4.2 Traditional Dance Pedagogy

Education has traditionally been a way to acculturate the young, to socialize them into the larger community and thus perpetuate it; this is the reproductive function of education. Traditional methods for teaching dance technique fulfill this function. The traditional technique class is the primary kind of dance class taken by students, and is ordinarily the only kind of class that is referred to as a "dance class." (Other kinds are known by other names, such as choreography class and dance history class.) Like most dance students, I spent many hours in technique classes, finding satisfaction in my growing strength, flexibility, control, and skill. The traditional technique class was the first kind of class I taught, and the first kind I critiqued.

In most dance technique classes, the teacher is the authority and the only recognized source of knowledge. All students face the teacher and a mirror, and the teacher often faces the mirror too, seeing her students only as reflections. Interaction between students is frowned upon. The teacher's voice is expected to be the only one heard, except in the case of a well-focused question. The teacher tells and shows the students what to do and, in some classes, how to do it. Students attempt to replicate the movement done by the teacher. Then the teacher gives verbal "corrections," the students usually repeat the movement, and the teacher continues giving corrections until it is time to move on to the next sequence. Some teachers give directions and corrections that refer to internal sensation and artistic qualities, not just the mechanics of the movement. But in reality, most dance training consists of learning how to follow directions and how to follow them well. The model for traditional dance pedagogy seems to be the authoritarian father in an individualistic world of "every man for himself."

A field study carried out by Judith Alter (1986) reveals evidence of masculinist values in dance classes. In an advanced modern dance class in a private studio set-

ting, Alter discovered a number of strong but unspoken rules of behavior among dance students at that studio, including the following: "Never talk to each other during class….never show how bad or good you feel about yourself, your dancing, or the teacher" (pp. 69–70). Alter found a sense of hierarchy among students, with "old-timers" (the most skillful dancers, who were usually members of the dance company associated with the studio) having priority in choice of space and the amount of space claimed. Old-timers were allowed to take exception to the unspoken rules of the class. Further, Alter found that "the entire…atmosphere was…full of…tension and…most students felt unable to dance or dance their best" (p. 49). While this was a class for adults, similar pedagogy prevails in most professional preparation classes in dance, which may begin for children as young as age eight.

A 1990 publication by myself and colleagues Donald Blumenfeld-Jones and Jan Van Dyke further illuminates this model through interpretations of dance pedagogy by 16–18 year old women who studied a variety of forms of dance in studio and conservatory settings. The young women made it clear that the focus of the dance technique class is doing the movement as given by the teacher and getting it right. For example, one respondent described her thoughts in class as "I gotta get it. Oh God I did that wrong. I gotta do this right" (p. 17). Competition was revealed as another characteristic of the dance class, with most students regarding it as constructive. As one respondent said, feeling competitive "is good in a way because it makes you strive for more" (p. 18).

Even though authoritarian pedagogy for dance technique is used in classes populated by both men and women, I believe that it has different impact upon them. Most women begin dance training as little girls, usually between the ages of 3 and 8. Dance training teaches little girls to be silent and do as they are told, reinforcing cultural expectations for both young children and women. In their landmark work, *Women's Ways of Knowing*, Mary Belenky and her colleagues (1986) point out that adult women are silenced much more often than men. Their analysis reveals that "finding one's voice" is a metaphor that appears frequently when women describe their own journeys from silence to critical thinking; for women, learning to think means learning to speak with one's own voice. Traditional dance pedagogy, with its emphasis on silent conformity, does not facilitate such a journey. Dancers typically learn to reproduce what they receive, not to critique or create.

In contrast, most males in our society begin dance training later, at late adolescence or even early adulthood, when they have developed some sense of individual identity and "voice." Further, limits for males seem made to be broken, and dance is likely no exception. To a young man, dance training may seem comparable to military training in that the necessary obedience is a rite of passage but not a permanent state. Once he is good enough, he will then have the power to tell others what to do, to reconceptualize what he has learned, to create art and not just reproduce it. This differential impact of dance training may contribute to the differences that are observed in leadership within the dance field. Although men are a minority among dancers, they are overrepresented in positions of power and influence and as recipients of grants (particularly the largest grants) and national awards (Van Dyke 1992).

In addition to reinforcing the idea of the silent passive woman (or the "good little girl"), dance training also intensifies cultural expectations in relation to female body image. The current dance aesthetic demands a long, thin body, carried to the extreme in ballet; many choreographers and directors, usually male, encourage and even demand the "anorexic look." (See Brady 1982; Gordon 1983; Innes 1988; Kirkland with Lawrence 1986; Vincent 1979.) The same is increasingly true in modern dance, with many professional modern dancers now regarding the ballet class as their basic form of training and many modern dance choreographers setting their work on ballet companies. Even among young women in non-professional classes, criticism of one's body is part of the expected behavior. Alter (1986) noted that weight occurred as a topic in 18 of the 31 classes she studied. In the Stinson, Blumenfeld-Jones, and Van Dyke study (1990), the young respondents made such comments about their bodies as, "I don't like my body, the way it looks"; "Lots of time I think I'm too much of a brute to be a dancer"; and "If my legs matched my body then I'd be perfectly happy" (p. 17). Surely such feelings about the body are enhanced by a pedagogy in which the goal is an unattainable ideal and every attempt is met with corrections—indications of how one does not measure up—all the while dressed in clothing that reveals every flaw and looking in a mirror. In traditional dance classes, the body often seems to be regarded as an enemy to be overcome or an object to be judged. However, dance training merely intensifies the values of the larger social world to which both dance and women belong. In our society, while overweight is dreaded by all and the body is regarded as an enemy by both men and women who exercise compulsively and obsessively, women's bodies are more often identified as objects to be looked at and judged.

It seems clear that traditional dance pedagogy in many ways embraces values of a male-dominated society, such as separation and competition, despite the preponderance of women in dance. The goal is individual achievement—being on top— with little emphasis on community and caring, values more often regarded as feminine (Gilligan 1982). Another example of masculinist values in dance classes is the way the natural human body is denied in favor of a reshaped and highly trained body reflecting the cultural aesthetic. A number of feminist theorists have pointed out that the human body and Nature (as in Mother Nature and Mother Earth) are more closely connected with women, while the mind and Culture are regarded as the province of men (see Jaggar 1983). Further, in most dance technique classes, emotional feeling (again, regarded as feminine) is repressed, as students are required to leave any personal concerns outside the studio door; in some classes, even physical feeling is to be ignored ("no pain, no gain").

At this point, I think we have to ask why women as well as men continue to teach in a way that seems so contrary to feminist ideals. For example, my colleague Jan Van Dyke, who has found evidence that women do not get their share of awards and financial support in dance (1992), recognizes ways that traditional dance training inhibits the development of skills that could promote equality. She still teaches a fairly traditional technique class, albeit with a couple of "talk classes" each month, in which the students discuss professional issues. Her hope is that these opportunities to talk will balance the hours of silent obedience in technique. However, she

acknowledges that she doesn't know how to achieve a training effect—increasing strength and flexibility, as well as development of efficient movement habits—outside the atmosphere that characterizes the technique class. Power is not possible without competence, she would argue, and we are not doing our students a favor if we do not help them become skillful movers. Further, dance is one area in which physical strength for women is accepted and even encouraged. Jan is one feminist who thinks that we should leave the technique class pretty much as it has been, and seek to develop other skills in other kinds of classes.

I acknowledge that a dance technique class was the first place that I experienced physical strength as acceptable for women, and I loved the feeling. Although I don't take dance technique classes any more, I have recently begun some weight training, where I follow the directions of the book as an authority—at least, up to a point. The satisfaction of this experience is seductive. There is the pleasure of feeling my developing muscularity, which had fallen by the wayside when I became a scholar and administrator. There is also the pleasure of following someone else's directions—It reminds me of words I wrote about taking technique classes at an earlier time in my life, when my children and my university teaching career were both young:

> There is a kind of freedom in obedience, the freedom from responsibility. I appreciate it now when my days seem so full of responsibility, full of solving problems, making class assignments and grading scales as well as dentist appointments and carpool arrangements. What a relief to have someone tell me what to do. I take a dance technique class, and revel in the luxury of feeling active yet passive. She tells and shows everything I need to do. It is like having someone else feed me.
>
> It is surely no sin to recognize one's own weariness, and the need for sustenance for an arduous journey. But how easy it is to lose sight of the journey in those delicious moments, and begin to think that we have made a real accomplishment...in digesting someone else's milk (revised from Stinson 1984, pp. 89–90).

So I am not suggesting that we give up technique classes—but that we become aware of what we give up as well as what we gain—and what we want to do about it.

4.3 Critical Pedagogy

In contrast to its reproductive role, education has also been used as a way to challenge the status quo, by helping students question and proposing alternatives to "the way things are"; this is the critical or emancipatory function of education. Critical pedagogy has developed as one alternative to traditional authoritarian pedagogy. Such pedagogy has its roots in critical social theory, which calls for social and economic justice as well as fundamental changes in how we view the worth of individuals. Elizabeth Ellsworth (1992) states that critical pedagogy "supported classroom analysis and the rejection of oppression, injustice, inequality, silencing of marginalized voices, and authoritarian social structures.... The goal of critical pedagogy was...democracy, individual freedom, social justice, and social change" (p. 92). Critical pedagogues often cite the work of Paulo Freire (1983; Freire and

Macedo 1987) as an example of this approach. I first resonated with Freire's critique of what he calls the "banking concept" of education, because in it I recognized traditional dance pedagogy:

(a) the teacher teaches and the students are taught;
(b) the teacher knows everything and the students know nothing;
(c) the teacher thinks and the students are thought about;
(d) the teacher talks and the students listen—meekly;
(e) the teacher disciplines and the students are disciplined;
(f) the teacher chooses and enforces his choice, and the students comply;
(g) the teacher acts and the students have the illusion of acting through the action of the teacher;
(h) the teacher chooses the program content, and the students (who were not consulted) adapt to it;
(i) the teacher confuses the authority of knowledge with his own professional authority…. (Freire 1983, p. 59)

Freire's work as a critical educator with illiterate Brazilian peasants sought to replace banking education with a different approach, one that was designed to promote democratic change in the society as a whole. The literacy program Freire designed (Freire and Macedo 1987) taught his adult students not only to read in the literal sense, but also to name their own oppression and to recognize their capacity to remake society.

While Freire focused on class oppression and did not discuss gender, some critical theorists (Apple 1984; Giroux 1991) have included women as another example of an oppressed group, and many feminist educators have adopted critical pedagogy as a model for feminist pedagogy (Maher 1987). For example, Carolyn Shrewsbury, in a 1987 article in *Women's Studies Quarterly*, defines the vision of the feminist classroom as

> a liberatory environment in which we, teacher-student and student-teacher, act as subjects, not objects. Feminist pedagogy is engaged…with others in a struggle to get beyond our sexism and racism and homophobia and other destructive hatreds and to work together…with the community, with traditional organizations, and with movements for social change. (p. 6)

Shrewsbury notes three concepts that are central to feminist pedagogy: empowerment, community, and leadership. In some cases, however, these terms may be defined in a way different from common usage.

Leadership, for example, she defines as "the embodiment of our ability and our willingness to act on our beliefs" (p. 10). A feminist classroom, according to Shrewsbury, develops leadership skills such as planning, negotiating, and evaluating; understanding and articulating one's own needs and their relationship to the needs of others; and analyzing problems and finding alternative solutions.

Shrewsbury notes that feminists focus on power not as domination but as creative potential, and see power as "the glue holding a community together" (p. 8). She lists six strategies for achieving power in a feminist classroom, which include ways to move students toward greater autonomy and responsibility for their own learning, rather than dependence on the instructor. At the same time, students are encouraged to

connect with others in the class and support each other, and to recognize "the responsibility of all members of the class for the learning of all" (p. 9). In addition, a successful feminist pedagogy "expand[s] the students' understanding of the subject matter of the course and of the joy and difficulty of intense intellectual activity" (p. 9). If she were writing about dance, I expect that she would include physical activity as well.

Shrewsbury notes that community is important in a feminist pedagogy because "women seek to build connections" and to "maintain connections that have been built" (p. 10). In a feminist classroom community, decisions are made not just according to formal rules, but also by consensus.

On the surface it is difficult to argue with any of these points. Indeed, a reviewer for an earlier version of this paper questioned whether Shrewsbury's three principles can be claimed exclusively by feminist or critical pedagogy. What educator would admit to disagreement with the goal of helping students become independent learners who can work with others, or helping them learn to solve problems? And plenty of classrooms I go into today, even in elementary school, have posted a list of class rules developed by the students and teacher together. It is very easy for the strategies Shrewsbury outlines to become coopted by those without the more radical agenda of critical pedagogy, which is to change society by helping students recognize their power to become change agents.

When I first encountered critical pedagogy, it sounded to me like a noble endeavor not only in Brazil, but in my own country as well. I knew I wanted to teach prospective dance educators to critique their own educational experiences in dance and in schooling, and to recognize that they had the capacity to imagine and create a world that might be different. Within the fairly traditional boundaries of my dance education theory courses, I thought I was doing this to some extent. I also knew other educators attempting to integrate dance practice with ideas of critical theory.

Isabel Marques, a Brazilian dance educator, has applied the Freirian vision in a project to help classroom teachers (with little or no dance background) learn to use dance and movement with their young students (Marques 1995). She describes helping teachers learn to use what she calls "generative themes," ones in which dance structures can be learned in the context of questioning and transforming social reality. For example, she would start with the dance concept of space, and end up with a discussion of housing shortages and homelessness. The teachers with whom she worked, primarily kindergarten teachers, reported great difficulty in working with generative themes and bringing up social content in their classrooms. Although that particular project ended due to a political change in the country, Marques has continued to develop her work into an approach that she calls "context-based dance education," with promising outcomes (Marques 1997, 1998).

Sherry Shapiro (1996) practices critical pedagogy by integrating development of a choreographic work with helping students come to consciousness about their relationship to a particular theme. Shapiro selects a generative theme such as *eating*, for example, and encourages student dancers to journal about their relationship to the theme while she asks provocative questions that encourage them to challenge this relationship. The students' words as well as their movement suggestions are selected and formed by Shapiro to become a piece of choreography. Because her

students are all women, Shapiro's choices of themes have been ones of particular importance to women.

I find the model of critical pedagogy useful in helping us recognize women as an oppressed group in solidarity with other oppressed groups, and in helping empower women to make change. In my own teaching of prospective dance educators, I have not found it difficult to get students to be critical of educational structures and practices and to want to change them. A fair number of my students have also made the connection between oppressive educational practices and larger social structures which schooling is designed to support. For example, they can recognize that schooling as it currently exists helps perpetuate inequalities among people, and that it is a myth that all children have equal chance for success in school. They can even recognize that our system needs some people to fail in school, as a way to justify the unequal distribution of goods and services in our society. They have a harder time, however, in taking the next step: to imagine how things might be different than they are. This step produces fears of socialism or resignation at the impossibilities of utopias.

I, too, have a harder time finding answers than questions at this step in the process of critical pedagogy. At an earlier stage of my life, I could easily imagine a world in which people would live together in small communities where everyone's contributions were equally valued, everyone shared in the responsibility for the community as a whole, and decisions were made by consensus. At this point, however, I am all too aware that communities frequently end up in conflict when people have different visions of its purpose, or when some do not do their share of the work of the community and others become resentful. It doesn't help that in some communities, including my own department, these conflicts about "housework" end up with women on one side and men on the other. Would these kinds of conflicts still happen if everyone were educated through a feminist critical pedagogy? Or is human nature such that self interest will take priority over community for some people? To take this to a more global level, even if members of a particular community agree, will they inevitably have conflict with other communities? These are large questions, ones with which I'm still struggling.

I also have some questions about outcomes of critical pedagogy with students in public schools, especially if it is successful. I was an undergraduate student in 1968, when students took over administration buildings and closed a number of college campuses in making demands for change. What are the implications of inciting younger students to revolution, in institutions where they have even less power to make changes than they did in the 1960s? One of my former students, Karen Anijar (1992) reported a middle school student's problems with the administration following her consciousness-raising in a dance project with a goal of liberating student consciousness. Furthermore, when I talk with prospective teachers about serving as change agents in the schools they will enter, I sometimes worry whether I am taking the easy way out: trying to get others to be on the front lines of the revolution while I take the ivory tower role of the professorial advisor, safe in my own tenured chair. Although I work to make modest and incremental change in my own institution and community, I do so within the given power structures. I still use words more than actions to try to accomplish social change, knowing that taking more direct action might be more effective but would involve more risk. Clearly we need to make sure

our students are aware of the risks of becoming change agents, so that they are able to make informed choices; we also need to reflect on the morality of encouraging others to take risks we are not willing to assume ourselves.

Of course, many themes with pro-social content can be used with public school age students, ones that seem relatively risk-free. We can have students make dances about recycling or appreciating differences, and feel that we are doing good without taking chances. To have this kind of student work become critical pedagogy, however, I think that we have to go further. In going further, students may want to do more than dance about an issue. They may decide, for example, not just to recycle but to take on local industries that discharge pollutants; they may not only appreciate differences but want to protest local groups campaigning against gay rights—actions of which many administrators are likely to disapprove. Clearly, critical pedagogy is not for the faint-hearted.

There are also pragmatic limitations, I think, to using methods of critical pedagogy with younger students, particularly pre-adolescents. The discourse of critical pedagogy as described by Freire and Shrewsbury demands the capacity for rational and even abstract thought, which are capacities that develop only with age (Stinson 1985).

Some other limitations to critical pedagogy are also persuasive, having to do with its emphasis on rational dialogue in which all voices may be heard. Elizabeth Ellsworth, in an article discussing the "repressive myths of critical pedagogy" (1992, p. 90) notes that critical pedagogy's demand for rational dialogue can be problematic even for adults. This is because our narratives—the stories we tell in making sense of our lives—are partial and contradictory, and are grounded in our immediate social, emotional, and psychic experiences which are not always rational. Furthermore, she points out that in most situations, all voices cannot be heard equally; therefore, a demand to speak can be just as oppressive as a demand for silence. As Patti Lather reminds us, "We must be willing to learn from those who don't speak up in words. What are their silences telling us?" (Lather, cited in Orner 1992, p. 81).

These concerns with critical pedagogy do not mean that I'm willing to give it up completely, any more than I am willing to give up pliés because they are often taught through an oppressive pedagogy. But I take my concerns with me in my continuing construction of my own pedagogy.

4.4 Gender Models for Pedagogy: Creative Dance

A number of feminists have taken the image of the mother and used it as the basis for feminist pedagogy. Nel Noddings (1984, 1992) discusses caring, which she defines as receptivity, relatedness, and responsiveness, as an essential aspect of pedagogy. She believes that caring derives from the "language of the mother" (p. 1), a feeling-level responsiveness of mother to infant. Carol Gilligan (1982) also notes the particular importance of caring in the lives of women; she found that an "ethic of care" underlies the moral thinking of women, as contrasted with the ethic of individual rights that predominates among men. In my study (1992, 1993b, c) of public school dance students on

the high school level, student respondents told me that perceiving that the teacher cared about them was one of the most important factors in their engagement and learning in all subjects. It is true that the concept of caring can easily be sentimentalized, and can provide an excuse for making students overly dependent and denying them the opportunity to set and meet challenges. Certainly part of caring is encouraging students to ask for help when they need it and to help others when they can, but another part is encouraging them to find and develop their own capabilities. Like many women, I find myself too easily seduced into the role of self sacrificing surrogate mother to my students. I find the same conflict in teaching as in parenting, a struggle to figure out when to help and when to back off and allow my students or my children to discover that they can handle, on their own, the difficulty they face.

In addition to Noddings, other feminists have derived models for pedagogy based not on women's oppression, but on "those aspects of female identity that come from their roles as mothers of children and their occupancy of the so-called private sphere of life" (Maher 1987, p. 95); Maher refers to these as gender models for pedagogy, which not only offer a critique of critical pedagogy, but also emphasize "the relation of personal experiences, emotions, and values to what we know" (p. 96).

Mary Belenky appears to support a gender pedagogy in *Women's Ways of Knowing* (Belenky et al. 1986), which describes the difference between separate knowing and connected knowing. Belenky explains that separate knowing, found most often among men, begins with doubting one's own beliefs and those of others, then uses rational abstract thought to develop new beliefs; while authoritarian pedagogy values separate knowing, so does critical pedagogy, at least in its pre-feminist state. Connected knowing, found most often among women, involves listening to the voices of self and others, trying to perceive the world through a variety of lenses. While either of these routes culminates in the realization that Truth is relative and depends on the perspective from which one looks, the two are not equally valued in education. Because men have held primary power in academia, separate knowing has been more valued there. Belenky emphasizes relationship as essential in teaching girls and women.

The kind of educational approach advocated by Belenky makes so much sense to me as a woman that I have had to question why it has not been followed at least at the K-12 level, where women, many of whom are mothers, have predominated in the classroom for decades. Why do women teachers participate in what Madeline Grumet (1988) calls "delivering children to patriarchy," establishing classrooms which "cannot sustain human relationships of sufficient intimacy to support the risks, the trust, and the expression that learning requires" (p. 56)? Grumet offers an explanation through a historical look at women and teaching, in which she describes how women became teachers as a way to leave the hearth and gain access to at least some of the power and prerogatives of men that were denied to them in the home. No wonder that these women, educational pioneers in a man's world, resisted a definition in the role of teacher that replicated the nurturing role of the mother.

Today, several generations removed from these women pioneers, I see a similar explanation for why so many women teachers accept a pedagogy which denies their personal values: When one is trying to find power and influence, one often emulates those who already hold it. Women in the professional dance world, where men occupy more positions of power and influence, emulate those men by embodying masculinist values.

In contrast, I found myself attracted to what I see as a gender pedagogy for dance, one in which women are not only the primary occupants but also the ones with the most influence; this approach is known as creative dance for children. Indeed, this was where my own first attempt to find an alternative to traditional dance pedagogy led me. I felt at home when I read the words of Virginia Tanner, who was featured in the first international conference of Dance and the Child held in Alberta, Canada in 1979:

> [The child's] world is filled with fantasy, which is frequently dimmed when parents, teachers, and friends turn down the lights in his [sic] treasure house of imagination. A child quickly recognizes whether or not you offer warmth, understanding, and interest. Only when rapport is established will he unlock the facets of his heart and allow you to share your treasures with him and his with you. (1981, pp. 30–31)

Tanner shared with pride a review of her students in performance by dance critic Walter Terry:

> From the first there was beauty. But more important…was the vital innocence of the dancers themselves….the children danced as if they had faith in themselves, had love for those who were seeing them, actively believed in their God, and rejoiced in all these. (Terry, cited in Tanner 1981, p. 39)

Ruth Murray, regarded as one of the primary influences in the development of creative dance in the United States, wrote about self expression in "A Statement of Belief" for a 1981 publication produced by a national level Task Force on Children's Dance:

> Dance provides a primary medium for expression…Dance and the movement that produces it is "me," and as such, is the most intimate of expressive media. A child's self-concept, his [sic] own identity and self esteem are improved in relation to such use of his body's movement. (p. 5)

Murray described problem solving as the preferred methodology in teaching children's dance, because a "creative process can only be realized by a teaching method that is, in itself, creative" (p. 7).

Tanner, Murray, and other practitioners of creative dance reflected the philosophy of Margaret H'Doubler, regarded by many as the "Grandmother of Dance Education" in the United States for her success in establishing the first dance program in higher education and for teaching generations of dance educators. H'Doubler wrote about her vision of education in words first published in 1940:

> Education should be a building toward the integration of human capacities and powers resulting in well-adjusted, useful, balanced individuals. The desire to find peace within ourselves and to bring about an adequate adjustment to life around us is the basis for all mental and physical activity. (H'Doubler 1977, p. 60)

H'Doubler stated the beliefs of practically every creative dance teacher when she noted that every child has a right to dance just "as every child has a right to a box of crayons" (p. 66).

Creative dance at first seemed to me to provide all the good things I hoped to do for children. The methodology encourages self expression and teaches problem solving, not passivity. It is non-elitist, because "Everyone can dance." It is about education rather than training, and uses "natural" movement rather than stylistically contrived forms. The teacher is expected to be accepting and nurturing rather than demanding, because "there are no wrong answers" in creative dance. The model for such a pedagogue is the loving mother within a supportive family.

Certainly it had been difficult for me to speak critically of traditional dance pedagogy, which had helped me develop the physical power and skill I treasured. It has been even more difficult to speak critically of creative dance, a realm in which I have found love and acceptance among children and those who care for them. However, using the lens of critical pedagogy, I eventually started to see that the myth perpetuated by creative dance is populated by images of only bright and happy children, running and skipping joyfully, seemingly untouched by poverty, hunger, homelessness, or any of the other realities with which so many children live. The poster for a 1991 international conference on dance for children exemplified this, showing children with smiling faces and open arms, dressed like fairies, cavorting across a wooded background; all the children except one in a corner of the poster were Euro-American.

Creative dance all too often tries to create a make believe world for the child, fostering escapism. Certainly mental escape from problems that cannot be changed may be appropriate, and children easily create their own make believe worlds without any assistance from adults. I admit that I treasure the times I get invited into them. Yet, despite my concerns about critical pedagogy, I still think that eventually children need to grow into adults empowered to change those things in the world which should not be tolerated. Virginia Tanner thought that creative dance could help change the world: "If our children could have their creative selves always fed, their destructive selves would gradually starve" (1981, p. 38). I began to question, however, whether creative dance pedagogy went far enough.

Other problems, too, are embedded within the pedagogy of creative dance, which derives from the progressive values of Dewey (1970), Pestalozzi (1970), and Froebel (1970). Although progressive pedagogical methods avoid the coercion of authoritarian approaches, their goals are similar: producing docile, well-disciplined individuals who will fit into the way things are, rather than attempt to change them. H'Doubler's language regarding adjustment as a goal of education reflects this. Walkerdine (1992) notes that progressive education established the schoolroom (and, one might add, the children's dance studio) as

> a laboratory, where development could be watched, monitored and set along the right path. There was therefore no need for…discipline of the overt kind…. The classroom became the facilitating space for each individual, under the watchful and total gaze of the teacher, who was held responsible for the development of each individual….[In such a classroom] the children are only allowed happy sentiments and happy words…There is a denial of pain, oppression…There is also a denial of power, as though the helpful teacher didn't wield any. (pp. 17–20)

Thus, Walkerdine notes, when the nurturing mother figure replaced the authoritarian father figure in the classroom, both oppression and the powerlessness of the oppressed simply became invisible. Walkerdine suggests that the cost of the fantasy of liberation found in progressivism "is borne by the teacher, as it is borne by the mother.... She is the servant of the omnipotent child, whose needs she must meet at all times.... The servicing labor of women makes the child, the natural child, possible" (p. 21).

In recognizing that creative dance, too, was problematic, I felt much like Eve must have felt upon leaving the Garden of Eden. Creative dance offers a chance to live in a beautiful, loving, and joyful world. The world outside is difficult and often ugly, and there are times I wish I had never eaten the fruit from the tree of consciousness that made me recognize what was missing. Perhaps this is why I have looked for another model which preserves the image of the caring mother, yet expands it to fit the kind of mother and the kind of teacher that I want to be.

4.5 A Feminist's Pedagogy for Children's Dance: In Process

Maher (1987) notes the need for a synthesis between critical or liberatory pedagogy and gender pedagogy in order to have an adequate theory of feminist pedagogy. This may describe my current approach to teaching dance. My own vision of feminist pedagogy is concerned with both individuals and relationships, both liberation and caring. It is a vision that is still evolving, reflecting the partiality of my own experience and my attempts to expand it. It reflects my concerns about dance, about education, about girls and women, and about the world, but also contains the contradictions within my own values as well as my still-unanswered questions. I believe it most reflects the complexity and paradoxes of trying to make a new world when all that we are has been shaped by the old one. The vision I share here describes what I do and encourage other teachers to do, what I try to be doing, what I see others doing that I wish I were.

4.5.1 Finding One's Own Voice and Inner Authority

I encourage even very young children not to look to me as their only source of knowledge, but to find their own inner teacher and inner dancer, with words like, "Be your own teacher...Tell yourself when to change shapes." Instead of focusing on a mirror or on me as teacher, I try to encourage each student to listen to his or her own body. With young children, this involves such activities as listening to their own breath, and learning how to energize or calm themselves. With older students, it includes monitoring their own level of readiness for strenuous movement and recognizing how gently or vigorously to do a movement. I value language such as,

"Notice how you are using your feet" or "Find the tempo at which the movement feels most fulfilled on *your* body."

Internal awareness requires silence, an active silence in which one listens to the inner self. However, I also find it essential that students have opportunities to speak, to find their own voice in words as well as movement and to share with others. Although it's not possible for all voices to be heard equally, I believe in class-time discussion and personal reflection during which students may identify the sources of their own visions. To reduce the pressure to speak, I make opportunities in my university level classes for "written participation," an option appreciated by those students who take longer to think of what they want to say; I can then bring these ideas forward in a later class. Other teachers I know use journals for this purpose.

I also encourage students to suggest images for movement and to create their own movement. While some dance teachers believe that this kind of activity is only appropriate in choreography classes, my vision is for movement awareness, technical skills, improvisation, and composition/choreography to be integrated into a *dance* class.

4.5.2 Cultivating Awareness of Relationship

Because I see the world as a "web of relations" (Gilligan 1982), I look for ways to help students perceive relationship on several levels. One is relationships between and among students. As dance students discover their own skills and create their own knowledge, I encourage them to share these with peers as well as with me. When possible, students can help each other, serving as external "eyes" and offering suggestions; this kind of "partnering" is easily incorporated into a dance class, even a technique class, enhancing supportive student relationships.

I believe that emphasizing relationship can also enhance performance skill. It has always interested me that, although most performance opportunities require ensemble work, dance technique classes rarely cultivate the skills necessary to dance *with* another. Small-group work is common in creative dance classes for children, but even in technique classes, facings of students can be adjusted to facilitate relationship. When small groups of students move across the floor or do a combination, teachers can ask students to sense each other, to dance *together*. Such an approach can help dance class become not just preparation for dancing but dancing itself.

Another aspect of working toward relationship is reminding students of connections within their own bodies. In addition to facilitating more ease in movement and fewer injuries, such a relationship may have deeper implications. As noted previously, our bodies are a manifestation of nature and nature is personified as female (Mother Nature); some feminists have noted a connection between domination of nature and domination of women (see Jaggar 1983). While I am wary of some of the "back to nature" trends that I see among eco-feminists, I encourage dance students to care for and to cherish the body as a lovable and sensuous part of themselves,

rather than a beast to be brought under control, a machine to be well tuned, or an aesthetic object to be judged (Moore 1985).

A third kind of relationship I try to cultivate is that between what goes on in the studio and what happens outside it. Like traditional creative dance teachers, I structure many lessons for young children on themes from nature or other aspects of the child's world, in hopes that students will recognize their relationship with other life forms. As students get older, however, teachers can also connect issues faced within dance class (such as sexism, homophobia and fat phobia) with those outside of it by posing questions for discussion or journal-writing. We can question why most dance studios are populated primarily by white middle class students. We might explore why dance is considered a stereotypically female activity, and what girls have learned through dance about being female. When students study dance history, criticism, and aesthetics, they might reflect on such issues as why some forms of dance are considered art and others are considered recreation or entertainment, and who makes such decisions.

4.5.3 Responsibility and Power for Change

Exploring issues like those just mentioned can raise critical consciousness, which Kenway and Modra describe as enhancing "analysis of the context of problem situations for the purpose of enabling people together to transform their reality, rather than merely understand it or adapt to it with less discomfort" (1992, p. 156). Some choreographers are also able to use this kind of discussion as a springboard for socially conscious art, in which dancers' words and movement in relation to a particular issue are incorporated into the choreography. It may well be that socially conscious art, by presenting different images in society, may facilitate change. I am also aware, however, that recognizing a problem does not necessarily lead to a commitment to solve it. We must also recognize a responsibility for others and our own power to help make change.

Martin Buber (1955), in describing *I-Thou* relationships, helps me understand how relationships can lead to responsibility to care for that with which we are related. Buber speaks of "feeling from the other side," or feeling the results of our actions simultaneously with experiencing ourselves as causing them. He gives two examples, one of a man who strikes another and "suddenly receives in his soul the blow which he strikes" (p. 96). The second example involves a caress by a man who "feels the contact from two sides—with the palm of his hand still, and also with the woman's skin" (p. 96). If we truly feel the pain we cause others, we are less likely to cause it, and if we experience the pleasure we cause others, we are likely to increase it. To recognize relationship with another is to recognize the responsibility to care for the other as we care for ourselves. As Buber states, "love is the responsibility of an *I* for a *Thou*" (1958, p. 15). I hope that dealing in dance class with relationships on many levels, and extending class activity into discussion, can be a small part of bringing students to a sense of responsibility for themselves and others.

Power, skill, and courage are other essential ingredients for change. I know the sense of physical power that I have felt in dance, a sense that often evaporates as soon as I leave the security of the studio. I know the skills I have developed in dance, which have not always seemed to translate into life skills. I developed courage to express my own ideas in dance and to share them in public, courage that does not necessarily transfer to other situations. Can there be transfer from art to life, from studio or stage to the places we live our lives? I hope that, as we help students to find their own authority and voice, they will recognize that they can speak and act for more than dance. I think that Shrewsbury's (1987) ideas for helping students develop power and leadership skills, presented earlier in this paper, are part of the answer. Yet I still have more questions than answers about how to construct the bridge from dance to the rest of the world, and about how great an impact it can have.

4.6 Some Further Questions

Many dance educators may question whether the kind of pedagogy I propose is the most effective and efficient way to teach people to dance, to make dances, or to respond to dance. I don't think that it is. There are things that we give up, as well as things that we gain, with any approach.

Another issue for me is that my vision of feminist pedagogy is very clearly culturally bound, which concerns me as I educate dance teachers in an increasingly global society. At this point I am comfortable applying it only to teaching Western dance forms. Many non-Western forms are also taught using a pedagogy in which the teacher is master, and silent students receive knowledge. Yet I am uncomfortable critiquing a cultural tradition I can understand only as an outsider. I acknowledge my limitations in this regard, and hope that feminists within non-Western traditions may provide insight regarding a feminist approach to teaching dance forms from their cultures.

Another conflict I face even in critiquing Western dance pedagogy is my continuing ambivalence over the issue of professional training. I wonder if the whole concept of the "professional" reflects male-dominated, hierarchic thinking, leaving no room for a feminist pedagogy. But if I question hierarchy in dance, and argue that all of us are dancers by virtue of being human, I have to extend similar questioning to my role as a professional educator. How can I deny hierarchy in dance performance if I am one of those who possess position and prestige in dance education?

4.7 Conclusions

Changes in dance pedagogy will change the art, perhaps in very significant ways, and we do not really know what they might be. I can imagine that it might create greater diversity and more room in the field for individual visions. I can also imagine less technical virtuosity, more variety in shapes and sizes of dancers, and probably more "bad dance" (self indulgent, poorly crafted, and all of the other negatives

pointed out by critics) as well as more "good dance." Perhaps we would have less interest in judging dance as good or bad, and might see it less as an object and more as shared experience. Perhaps there would be more women in leadership positions in dance, and even new definitions of leadership. As someone who is an educator first and a dance educator second, I admit that my concerns are more for young people and the adults they will become, than for the art form.

As I continue to recognize ways that dance mirrors the larger culture, I find myself focused less on dance education specifically. Instead I am concerned more with structures both inside and outside dance that keep us from being the persons we wish to be and responding to the relationships that connect us with each other and the world we share. For me, dance education has become less an escape from the world than a laboratory for understanding it and understanding myself.

It is clear to me that traditional dance pedagogy, and even creative dance pedagogy, contributes to maintaining not just the dance world but the larger world as it is. It is less clear whether or not we can change the larger world through any changes we might make in dance. I cannot help but think of the words my mother wrote in a book of remembrances for my daughter, when she described me as someone who, when I was an adolescent, "wanted to change the world," and then noted that I "became a dance teacher instead."

Even if our pedagogy does not lead to changes in the world, however, reflecting on it does change those doing the reflecting. My own thinking about dance curriculum and pedagogy and their relationship to my values has clearly changed my consciousness. My goal, however, is not to persuade my students or others to teach as I do, but for each of us to engage in ongoing reflection about what we believe and why, and about the consequences of the choices we make as persons and as educators.

Commentary

This chapter evolved over many years, beginning with literature in my 1984 doctoral dissertation, when I first began seeing in feminist pedagogy a possibility for resolving the ethical/social justice issues with which I was struggling. I presented earlier versions of this work at two conferences. One was sponsored by the Congress on Research in Dance (CORD) in 1988; I was invited to submit a piece based on that presentation to *Women in Performance*, where it was published in 1993 (Stinson 1993a). The second was at a 1994 conference of Dance and the Child: International (daCi) Australia, on a panel about feminist pedagogy that included colleagues Isabel Marques and Sherry Shapiro; Sherry later edited the book in which this chapter appeared. At the Australian conference, I had created quite a stir and angered some distinguished creative dance teachers by my feminist critique of creative dance, especially my suggestion that it may foster escapism and docility as well as reinforce the oppression of women. The heated discussion continued after the session ended. I was invited to present this work at other international events in years following its publication, so there were further revisions (such as a short addition included in this version).

The final model for teaching children's dance presented here is one I was still trying to follow by the end of my teaching career, although an observer might have found it harder to recognize. By that time, standards for student achievement that were being mandated by the state, and the demand for rigorous assessment of student outcomes, were taking priority. I have addressed these issues in other chapters in this volume, especially in Chap. 10.

This chapter openly acknowledges that my concerns are more for young people and the adults they will become, than for any art form, a risky admission for a faculty member in a dance department, like myself. It also reveals my increasing willingness to see my own thinking as a continuing journey and to reveal my own uncertainties and my recognition that not all outcomes would necessarily lead to better art. The final sentence of this chapter could summarize my overall approach to writing and teaching, when I expressed less interest in convincing others to agree with me than to encourage "ongoing reflection about what we believe and why, and about the consequences of the choices we make as persons and as educators."

References

Alter, J. (1986). A field study of an advanced dance class in a private studio setting. *Dance Studies, 10*, 49–97. Published by Center for Dance Studies, Les Bois, St. Peter, Jersey, Channel Islands, Britain.

Anijar, K. (1992). *Listening in liberty*. Paper presented to the International Human Science Research Conference, Oakland, MI.

Apple, M. W. (1984). Teaching and "women's work": A comparative historical and ideological analysis. In E. B. Gumbert (Ed.), *Expressions of power in education: Studies of class, gender and race* (pp. 29–49). Atlanta: Center for Cross-cultural Education, Georgia State University.

Belenky, M. F., Clinchy, B. M., Goldberg, N. R., & Tarule, J. M. (1986). *Women's ways of knowing: The development of self, voice, and mind*. New York: Basic Books.

Brady, J. (1982). *The unmaking of a dancer: An unconventional life*. New York: Harper & Row.

Buber, M. (1955). *Between man and man* (M. Friedman, Trans.). New York: Harper.

Buber, M. (1958). *I and Thou* (2nd ed.) (R. G. Smith, Trans.). New York: Charles Scribner's.

Dewey, J. (1970). Experience and education: Traditional vs. progressive education. In J. W. Noll & S. P. Kelly (Eds.), *Foundations of education in America: An anthology of major thoughts and significant actions* (pp. 340–344). New York: Harper & Row.

Ellsworth, E. (1992). Why doesn't this feel empowering? Working through the repressive myths of critical pedagogy. In C. Luke & J. Gore (Eds.), *Feminisms and critical pedagogy* (pp. 90–119). New York: Routledge.

Freire, P. (1983). *Pedagogy of the oppressed* (M. B. Ramos, Trans.). New York: Continuum.

Freire, P., & Macedo, D. (1987). *Literacy: Reading the word and the world*. South Hadley: Bergin & Garvey.

Friedan, B. (1963). *The feminine mystique*. New York: Norton.

Froebel, F. (1970). The education of man: The law of self activity. In J. W. Noll & S. P. Kelly (Eds.), *Foundations of education in America: An anthology of major thoughts and significant actions* (pp. 196–199). New York: Harper & Row.

Gilligan, C. (1982). *In a different voice: Psychological theory and women's development*. Cambridge, MA: Harvard University Press.

Giroux, H. (1991). Modernism, postmodernism, and feminism: Rethinking the boundaries of educational discourse. In H. Giroux (Ed.), *Postmodernism, feminism and cultural politics: Redrawing educational boundaries* (pp. 1–59). Albany: State University of New York Press.

Gordon, S. (1983). *Off-balance: The real world of ballet.* New York: Pantheon.

Greene, M. (1973). *Teacher as stranger.* Belmont, CA: Wadsworth.

Greene, M. (1978). *Landscapes of learning.* New York: Teachers College Press.

Grumet, M. R. (1988). *Bitter milk: Women and teaching.* Amherst: University of Massachusetts Press.

H'Doubler, M. N. (1977). *Dance: A creative art experience.* Madison: University of Wisconsin Press.

Innes, S. (1988). The teaching of ballet. *Writings on Dance, 3*(Winter), 37–47.

Jaggar, A. M. (1983). *Feminist politics and human nature.* Totowa: Rowman & Allanheld.

Kenway, J., & Modra, H. (1992). Feminist pedagogy and emancipatory possibilities. In C. Luke & J. Gore (Eds.), *Feminisms and critical pedagogy* (pp. 138–166). New York: Routledge.

Kirkland, G., with Lawrence, G. (1986). *Dancing on my grave.* New York: Doubleday.

Macdonald, J. B. (1977). Value bases and issues for curriculum. In A. Molnar & J. Zahorik (Eds.), *Curriculum theory* (pp. 10–21). Washington, DC: Association for Supervision and Curriculum Development.

Maher, F. A. (1987). Toward a richer theory of feminist pedagogy: A comparison of "liberation" and "gender" models for teaching and learning. *Journal of Education, 169*(3), 91–100.

Marques, I. A. (1995). A partnership toward art in education: Approaching a relationship between theory and practice. *Impulse: The International Journal of Dance Science, Medicine, and Education, 3*(2), 86–101.

Marques, I. A. (1997). Context-based dance education. In E. Anttila (Ed.), *The 7th International Dance and the Child Conference Proceedings.* Kuopio: daCi.

Marques, I. A. (1998). Dance education in/and the postmodern. In S. Shapiro (Ed.), *Dance, power, and difference: Critical and feminist perspectives in dance education* (pp. 171–185). Champaign: Human Kinetics.

Moore, C. L. (1985, April). *Body metaphors and dance instruction.* Paper presented at the annual conference of the American Alliance for Health, Physical Education, Recreation & Dance, Cincinnati.

Murray, R. A. (1981). A statement of belief. In G. Fleming (Ed.). *Children's dance* (rev. ed.) (pp. 5–22). Reston: American Alliance for Health, Physical Education, Recreation & Dance.

Noddings, N. (1984). *Caring: A feminine approach to ethics and moral education.* Berkeley: University of California Press.

Noddings, N. (1992). *The challenge to care in schools: An alternative approach to education.* New York: Teachers College Press.

Orner, M. (1992). Interrupting the calls for the student voice in "liberatory" education: A feminist poststructuralist perspective. In C. Luke & J. Gore (Eds.), *Feminisms and critical pedagogy* (pp. 74–89). New York: Routledge.

Pestalozzi, J. H. (1970). How Gertrude teaches her children and the method. In J. W. Noll & S. P. Kelly (Eds.), *Foundations of education in America: An anthology of major thoughts and significant actions* (pp. 189–195). New York: Harper & Row.

Pinar, W. (1988). "Whole, bright, deep with understanding": Issues in qualitative research and autobiographical method. In W. Pinar (Ed.), *Contemporary curriculum discourses* (pp. 134–153). Scottsdale: Gorsuch Scarisbrick.

Shapiro, S. B. (1996). Toward transformative teachers: Critical and feminist perspectives in dance education. *Impulse: The International Journal of Dance Science, Medicine, and Education, 4*(1), 37–47.

Shrewsbury, C. (1987). What is feminist pedagogy? *Women's Studies Quarterly, XV*(3&4), 7–13.

Stinson, S. W. (1984). *Reflections and visions: A hermeneutic study of dangers and possibilities in dance education.* Unpublished doctoral dissertation. University of North Carolina, Greensboro.

Stinson, S. W. (1985). Piaget for dance educators: A theoretical study. *Dance Research Journal, 17*(1), 9–16.

Stinson, S. W. (1992). Reflections on student experience in dance education. *Design for Arts in Education, 93*(5), 21–27.

Stinson, S. W. (1993a). Journey toward a feminist pedagogy for dance. *Women in Performance, 6*(1), 131–146.

Stinson, S. W. (1993b). Meaning and value: Reflecting on what students say about school. *Journal of Curriculum and Supervision, 8*(3), 216–238.

Stinson, S. W. (1993c). A place called dance in school: Reflecting on what the students say. *Impulse: The International Journal for Dance Science, Medicine, and Education, 1*(2), 90–114.

Stinson, S. W., Blumenfeld-Jones, D., & Van Dyke, J. (1990). Voices of young women dance students: An interpretive study of meaning in dance. *Dance Research Journal, 22*(2), 13–22.

Tanner, V. (1981). Thoughts on the creative process. In N. McCaslin (Ed.), *Children and drama* (2nd ed., pp. 30–47). New York: Longman.

Van Dyke, J. E. (1992). *Modern dance in a postmodern world: An analysis of federal arts funding and its impact on the field of modern dance*. Reston: National Dance Association.

Vincent, L. M. (1979). *Competing with the sylph: Dancers and the pursuit of the ideal body form*. Kansas City: Andrews & McMeel.

Walkerdine, V. (1992). Progressive pedagogy and political struggle. In C. Luke & J. Gore (Eds.), *Feminisms and critical pedagogy* (pp. 15–24). New York: Routledge.

Chapter 5
Choreographing a Life: Reflections on Curriculum Design, Consciousness, and Possibility (2001)

Susan W. Stinson

Abstract This essay leads readers through a reflective process for curriculum planning, which differs from traditional planning in the kinds of questions raised. Instead of asking what students should know and be able to do or whether they are learning, much more difficult queries are posed: What do I believe in, and why? Am I living what I believe? Are these values embodied in the curriculum I teach? What kind of world am I creating/supporting in the decisions I have made? Whose interests are being served in this world—who gains and who loses?

The reflective essay uses examples from a graduate course in planning dance curriculum, ultimately identifying two emergent themes. "Towards wide-awakeness" has to do with becoming conscious of one's values, recognizing what is being given up and what is being gained with one's curricular choices. "Moving towards possibility" has to do with going beyond the curriculum as it is and imagining what might be. Throughout, the author models the process through rigorous critique of her own values and assumptions.

Over a decade ago, Mary Catherine Bateson (1989) published a book titled *Composing a Life*, in which she reflected upon various life decisions she and several other women in her generation had made about work, relationships, and other aspects of their lives as women in changing times. Several of these women had experience in the arts, and spoke of art-making as a metaphor for the creation of their lives. More recently, an 11-year-old I was interviewing in my research told me something similar. When asked if she thought what she was learning in dance would be important, even for people who would not be dancers. She thought a bit and replied, "Well, yeah, because all through life you're sort of choreographing, like I'm trying to choreograph what I'm going to live....You're basically choreographing your life."

Indeed, choreography makes a good metaphor for the decision-making process that we use in other parts of our lives. While some decisions may get made on the basis of a balance sheet, weighing pros and cons, most are more complex than that, a mixture of rationality and intuition, conscious and subconscious choices. Whether selecting a vacation site or a life partner, aesthetic criteria are usually part of the equation.

© Springer International Publishing Switzerland 2016
S.W. Stinson, *Embodied Curriculum Theory and Research in Arts Education*,
Landscapes: the Arts, Aesthetics, and Education 17,
DOI 10.1007/978-3-319-20786-5_5

The same is true of curricular decisions. A number of theorists, such as Elliot Eisner, Maxine Green, and Madeleine Grumet, have recognized the aesthetic dimensions of curriculum. In a 1991 book, *Reflections from the Heart of Educational Inquiry: Understanding Curriculum and Teaching through the Arts*, these individuals and other scholars wrote "personally about how they have come to understand curriculum and teaching through the influence of the arts in their own lives" (Willis and Schubert 1991, p. 5). The editors note that

> making decisions about curriculum…is no mere technical matter. Education at its best is the same as how to lead a life, and, therefore, decisions about curricula are microcosms of everything that goes into wise living…. Wise living, we believe, is not a matter of prudential calculation; it requires constantly extending ourselves through many acts of faith, and courage, and imagination. Hence, there are no simple answers about how or what to live, only opportunities continually to inquire reflectively into ourselves and the world around us as we continue to make decisions about how to act on what we believe. (pp. 5–6)

I agree with the editors that, "this kind of inquiry, which is the heart of living and education, is the same kind of imaginative inquiry that is the heart of creative art" (p. 6)

Much curriculum planning, by contrast, is more pragmatic than reflective. For example, we as curriculum designers may specify what we want students to know (i.e., Martha Graham's contributions to modern dance) and be able to do (i.e., pliés). This generally means that we are working within what we ourselves already know and can do. As we evaluate the curriculum we have developed, we may ask if students are meeting the objectives we have established for them. Even though we may be incorporating our aesthetic values, looking for unity and variety and smooth transitions between parts of a whole, we focus on decisions about what to teach and the most effective and efficient ways to do so; we rarely think outside the boundaries of what seems logical and possible.

Reflective thinking in the curriculum planning process takes us beyond these boundaries and leads us to different kinds of questions. Instead of asking what students should know and be able to do or whether they are learning, we pose much more difficult queries such as these: What do I believe in, and why? Am I living what I believe? Are these values embodied in the curriculum I teach? What kind of world am I creating/supporting in the decisions I have made? Whose interests are being served in this world—who gains and who loses?

My colleague Teija Löytönen (1999) refers to this as "troubling our work," having borrowed the term "troubling" from Lather and Smithies (1997). I like this phrase because reflection indeed raises troublesome issues, ones which we often would prefer not to face. In my own experience, I have found that such difficult issues are not limited to my work; rather, they weave together the personal and professional dimensions of my life as I try to figure out what I believe and how to live it. As Willis and Schubert remind me, these dimensions come together when we "inquire reflectively *into ourselves* and the world around us," (emphasis added) and this happens as "we continue to make decisions about how to act on what we believe" (1991, p. 6).

One place that I teach about this reflective process is in a graduate course that I have taught for some years, "Issues in Planning the Dance Curriculum." In this article, I will share some experiences from this course as a way of illustrating the process. I must warn the reader that what follows is not a linear presentation; I have allowed it to meander through different, often contradictory, thoughts and experiences as I "trouble" my positions on curriculum. I hope that, by sharing in this process, readers will be encouraged to similarly reflect on their own curricular decisions.

We begin the course with a definition of "curriculum." To some, a curriculum is what appears in a university catalogue: a list of courses. To others it looks like a syllabus, outlining all the topics to be covered in a course and the assignments for each.

Our thinking about the topic may be expanded by the concept of the "hidden curriculum," which refers to what students are learning besides what the teacher is explicitly teaching. Certainly a variety of lessons may be learned in a dance class, in addition to movement, processes, and principles of dance. Students may learn lessons about authority, about relationships, about their bodies, about themselves. Frequently, when I am introduced to someone outside the profession and they learn of my line of work, they confess to me a past that has included a dance class, and I hear of some of these other lessons. Through their stories, these friends and acquaintances have related learning that they were "just not creative," or did not have the kind of body (or even the kind of hairstyle) needed to become a dancer. Some learned that they had "two left feet." Some learned that "dance is a lot of fun," others, that "dance is a lot of work." Children may learn how to stay in straight lines or how to form a circle, how to take turns, how to keep going even when no one notices (or when they notice too much). It is clear that there are many possibilities for learning more than pliés, improvisation, and ABA form, which often are part of the explicit curriculum. Lessons may be learned not just from directions, demonstrations, and images, but from a tone of voice, a look, or no look at all; from peers, as well as teachers. The environment is also important; students may learn about the value of dance, for example, by comparing the space and time given to it in comparison to that allotted to other subjects. So I define curriculum as not just the course content, but also anything contributing to student learning. Going back to my artistic metaphor, this is like thinking about a choreographic work as consisting of not just the movement, but all the theatrical accouterments involved as well as the performance of the dancers.

In my graduate course, following this introduction, we spend about two-thirds of the semester reading and exploring a number of diverse visions for dance and arts curriculum, and a variety of theoretical issues which I hope will extend my students' thinking. I choose the "juiciest" reading I can find, and we have rich discussions. During the last part of the course, students must write a philosophy and curriculum design for a dance program. I insist that each articulate the values upon which their curriculum is based and the sources of these values, including personal as well as theoretical ones.

When I reflect on this course, I can identify two recurring themes that are not on the syllabus but have guided the way I have questioned my students and myself. The themes have to do with consciousness and possibility. I have borrowed words from Maxine Greene, who has served as a guide in my own journey, to title these themes in the discussion below.

5.1 "Towards Wide Awakeness"[1]

As a person who came of age in the 1960s, I have long been drawn to "consciousness-raising" as a goal for education. For some time, however, I thought of this process as rather like focusing a camera or cleaning my glasses. If only I could see more clearly, I thought, I could recognize the truth and follow it. There still are times in my life that what I pray for most is clarity: knowing for sure which path to take when two roads diverge.

As I see it now, however, consciousness is more about complexity than clarity. To become wide-awake is to move beyond yes/no and right/wrong, to recognize that every choice has consequences, both positive and negative. I can perhaps best illustrate this complexity through my own reflections on education and training, a topic we also explore in my course. There have long been tensions between dance education and dance training, between the arguments of "everyone can dance/dance is for everybody" and "it takes discipline and talent." Not surprisingly, this has been one of the continuing controversies in dance for decades, and my students and I struggle with it as well.

For more than half my life I have been an advocate for dance education. A latecomer to this art, compared to many readers of this journal, I began dancing as a teenager, with what I now think of as "closet dancing": moving back the furniture and closing the doors to the living room as I danced to music played on vinyl records that today's teens recognize only as antiques. A year or so later I began formal classes in modern dance, driven only by the sense that I felt so alive when dancing, and needed it to balance my otherwise heavily intellectual self. I discovered my creativity in dance, a sense of freedom, and my physicality. It is no wonder that I, along with many other dance educators, was a strong advocate for dance education for every child. We made claims based on our own experience, but without any rigorous scientific evidence, that dance was good for everybody, that it could help all children fulfill their human potential and develop incredible self-esteem, and even, in our most passionate moments, that it could promote universal peace, love, and happiness. (I exaggerate only slightly.) Such claims, and the self-indulgence they promoted, were occasionally challenged by those who considered themselves "real" dancers, those who aspired to dance professionally or had already done so.

Nevertheless, dance education advocates have promoted the idea that dance education should be available to all children, meaning that it should be taught in public schools just like mathematics and social studies, and not limited to the wealthy or the talented. Further, this perspective holds that dance education should focus on

[1] Greene 1978, p. 161.

needs of the individual, with creativity and self-expression as the primary goals, and that it should be a non-competitive, no-failure activity.

More recently, there has been a strong trend to incorporate education about dance—especially history, but also criticism and aesthetics—to more fully develop the mind as well as body and spirit. This perspective has its roots in what has been known as Discipline Based Arts Education, now referred to as comprehensive arts education (Hutchens and Pankrantz 2000). The goal of this approach is "to develop students' abilities to understand and appreciate art. This involves a knowledge of the theories and contexts of art and abilities to respond to as well as create art" (Clark et al. 1987, p. 135).

A vision of dance that includes creative work, some technique, and some dance history and appreciation is clear in the National Standards for Dance Education (1994). North Carolina, my home state, has been working to implement this vision for some time. By state mandate, every school in North Carolina is supposed to offer dance, along with the other arts, and schools are to require it of every child in the first six years of public education. Although North Carolina's mandate is very far from being fully implemented, we can already see positive outcomes at the university level. An increasing number of students arrive at my institution having spent several years in public school dance programs. These dancers bring our program more physical and cultural diversity, which we value.

Most public school dance students have seen a fair amount of dance, at least on videotape; most of our studio-trained dancers, in contrast, have seen only dance recitals and perhaps a performance of Nutcracker. Dance students from public schools usually know some dance history and principles of choreography, and are not afraid of improvisation, unlike other students who often know only how to replicate what they have been taught.

At the same time these students bring some important strengths, they also bring limitations. The state-mandated dance program is about educating students in dance, not training them; most students have fairly minimal technical skills in dance technique and are far behind their studio-trained peers in this regard. Except for those with an abundance of natural ability, or those who have attended one of the few arts magnet high schools in the state, they end up being placed at the lowest technique level; many become discouraged, decide that they are too far behind to catch up, and change their major before long. Those who do remain often feel marginalized as they watch their peers who are more skillful dancers receive the public acclaim on stage. They had loved dance classes in their high schools and felt successful there, but clearly their self-esteem takes a blow when they compare themselves to more highly trained dancers. Certainly not all those with studio training are excellent dancers by the age of 17 or 18, but it is clear that making dance education available for every child does not necessarily provide equal opportunity to become a skilled performer.

To develop the level of skill necessary for a successful performing career, one generally needs not only dance education but dance training. This includes drill and repetition to make certain actions habitual. The training must stress the muscles sufficiently to result in what is sometimes called a training effect. Dance educators are often fond of pointing out the limitations of training. Yet an experience in my own life as a mother reminds me of its appeal. My daughter, age 12 at the time of this incident,

loved to run; in particular, she loved the pleasant sensations of running, which we now know come from endorphins. Her track coach told her that she had ideal natural form and the potential to be the best runner he had ever coached. But he also shared a basic principle of athletic training: In order to increase her speed enough to be a champion, she needed to push herself beyond the point where running felt comfortable or even pleasant. While this may not sound attractive to everyone, part of me wanted her to "go for it," to know the exhilaration of pushing those physical boundaries and the satisfaction of working harder than one thinks is possible.

Dance training, like athletic training, requires effort and discipline in order to achieve results. Those who are willing to make the sacrifices, which include discomfort and even pain, may earn a big payoff. For athletes, the payoff is going faster, farther, and higher. For dancers willing to invest in this level of training, the payoff is skill levels that earn awe from admiring audience members and the satisfaction of physical power and accomplishment. Those who have been willing to make these kinds of sacrifices may be critical of dance programs that do not involve significant time spent in rigorous technical training.

There are good reasons to be critical of traditional training practices in dance, which may be harmful physically or psychologically. And yet who, other than indulgent parents, wants to watch dancers who are not really skillful? There is little place in our society for those who love the art of dance but are not highly trained. Maybe they eventually become audience members, the supporters every dance company needs. Maybe they switch to social forms, or even yoga. There are not many other choices. My community, like many others, has community musical and theater groups for amateur performers, and many churches do as well, but no comparable place for dancers. My daughter happily chose the option of being a recreational runner, and runs in periodic events, even marathons, where the emphasis is on finishing, not winning. But where does the amateur dancer go—the one beyond adolescence who loves to perform concert dance, but is not single-minded enough to achieve and maintain a high level of technique?

I go back and forth in my own thinking about dance education and dance training, wondering how much of my criticism of the latter route has been a way to justify my own taking of the former. Are my own values really self-serving? When we question our choices, we often lose the confidence that we have made the right ones.

Sometimes we may try to avoid making a choice at all. "Doing it all"—education *and* training—is the preferred position of most of my students. It is true that we can do some of everything, but not all of everything. To make this point more clearly to the young women in my class, I relate a lesson from my own life. In the early years of what we now know as women's liberation, many women of my generation thought that we could have it all. We did not want to choose between career and family, and many of us did not. What we failed to realize at the time is that there would be other things we would have to give up: sleep, for one thing, but also hobbies, keeping a journal, being with friends, and being there for every milestone in the lives of our children. Those of us who tried to do it all found that time was not an unlimited resource, and there was not time to do everything: no time for reading novels, for working in the garden, for doing all of those good-for-you activities that take "only

a few minutes a day," according to popular women's magazines. Those same magazines, just like all the self-help volumes lining aisles at the local bookstore, promise us the secret to having it all, doing it all, being it all. Busy and exhausted women have grabbed these books and articles, snatching a quick read while waiting at the dentist's office or on the telephone, desperate to find the timesaving techniques that will make it all possible. Only rarely do they tell us the real truth: It is not possible to do everything, not even everything that is really important.

This lesson is as hard to deal with in curriculum as it is in personal life. In my course, as we take up one article and author after another, each putting forth a different vision of dance education, my students say, "Yes!" They want it all in their dance curriculum. With some prodding, though, they reluctantly start to recognize that each approach has problems and limitations as well as benefits. They hold on to their optimism that they can find the perfect combination, the one way to teach dance that will allow themselves and their students to have all of the "plusses" and none of the "minuses." It is a painful moment when they realize that time is a finite resource, that the opposite side of every strength is a weakness, and a choice to do one thing is a choice not to do another. The best any of us can do is to become wide awake—conscious of our values, recognizing what we are giving up as well as what we are gaining with every choice that we make in composing a curriculum or a life.

Of course, this stance also has its limitations. Recognition that there is no perfect choice can sometimes lead to relativism ("it doesn't matter what you choose"), paralysis, or despair. We may appear indecisive, even weak, to others, and may become unable to participate effectively in advocacy. Even more important, focusing too much on limitations may keep us from recognizing possibilities that do exist. That is why understanding the possibilities is so critical.

5.2 "Moving Towards Possibility"[2]

Embracing a range of possibilities may seem quite contradictory to the above argument, that one cannot have it all. That argument is grounded in pragmatic reality, or what we like to refer to as "the real world." In some ways the world is indeed fixed. A week has 7 days, a day has 24 hours, and the human body can go only so long without sleep.

Drawing again on my heritage from the 1960s, however, I also recognize that the social world is a human construction and it can be changed. My generation was on the front lines of a number of initiatives—the women's movement, the civil rights movement, the movement against the Vietnam War—that changed the social landscape of our country. Until we examine what we consider to be fixed, we never know what might be changed, how much effort it might take, or how important it is to us. So the second theme that I introduce to my students has to do not with what is, but with what might be. Is it possible to be a professional dancer without years of technique class? I remember when Alwin Nikolais told my

[2] Greene 1980.

department that he preferred to go to clubs, not auditions, to find new members of his company. He was looking not so much for trained dancers as an affinity for the kind of movement he wanted to use. Is it possible to be a dancer without a "perfect" body? Look at the Bill T. Jones Company. Is it possible to be a professional dancer starting as a mature adult? Look at the Liz Lerman Company, "Dancers of the Third Age."

I look back at films of the early Martha Graham Company and realize that our undergraduate students today are more technically advanced than those early modern dancers. What have we lost by continually pushing the technical expectations of what it takes to be a dancer? Can we imagine something different? Can we imagine giving up some demand for technical expertise that we now know is possible, and gaining something that we might value even more in our art?

Similar imaginative visions are possible in education. I taught 20 years ago in a high school in which only narrative evaluations—no grades were given. The students still got into college, and they still do today, with no grades to demonstrate their academic potential—just a portfolio of their work and extensive comments from their teachers. In North Carolina, a college once existed that gave no grades and awarded no degrees; the faculty and students made decisions through a democratic process. Founded in the height of the Depression as an "act of faith," Black Mountain College lasted only 24 years and only 1,300 students were ever enrolled, but "the college has exerted an impact on every area of American cultural life" (Harris 1987, p. 244). Members of the faculty included Merce Cunningham and John Cage, who staged the first "happening" there. Cunningham first established his company at Black Mountain, and Paul Taylor and Ruth Currier were among the students. Doris Humphrey and Barbara Morgan spent a summer there.

Indeed, if anyone should understand this theme of possibility, it is artists, because art making requires that we be able to imagine what does not currently exist. It was a professor in education, however, who helped me recognize the connection between art making and world making. Dr. James Macdonald taught a course at the University of North Carolina at Greensboro that he called "Personal and Social Transcendence." During the first half of the course, students engaged in arts activities in a variety of media. The emphasis was on sensory awareness and imagination, at a level some would call "dabbling." This arts experience was used as a base for the second half of the course, when students were asked to imagine possibilities that went beyond paint or clay or sound or movement. They were asked to consider not just what is, but what might be, in the social world of education. I found participation in this course to be a very powerful experience. All too often, I think, arts students end up recognizing their compositional powers only in relation to artistic materials.

This connection—between art making and world making—is neither obvious nor automatic. While many of us in arts education like to claim that lessons learned in arts education will transfer to other aspects of life, there is little if any evidence to support this. If it is to happen at all, I think, teachers need to make the bridge, as Macdonald did, between what happens inside the studio and what happens outside.

5.3 Consciousness, Possibility, and Making Life Harder

In the case of my graduate curriculum course, thinking about "what might be" is not just creativity for the fun of it. My students are generally quite good at creative problem solving. When planning curriculum, it certainly is possible to imagine creative titles for technique classes, or different kinds of assignments to give for the sake of variety. But of course I want my students to go beyond this. In reflective thinking, "What might be?" raises the question "What should be?" Again, this requires that students be in touch with their values. As Macdonald advocated, we must "sound the depths of our inner selves" (1995, p. 79) to uncover them.

As a structure for identifying my students' values, I start with several basic questions:

- What is dance, meaning, what is the vision of dance that you wish to communicate to your students? Should it be the same for all students? How can this best be communicated?
- What does it mean to be educated? What is the purpose of education? Is this always its purpose? How can this best be accomplished?

These questions are challenging but not usually overwhelming. I also, however, ask students to ponder two questions posed by Macdonald, which he named as the most essential questions for all educators:

- What is the meaning of human life?
- How shall we live together? (1995, p. 146)

I encourage students to probe their answers to these two difficult queries, and to consider to what degree their curriculum should educate students to be more fully human and to be in life-enhancing relationships with others. These are clearly not the kinds of questions students thought they would have to consider in a dance curriculum course. Next to them, most other curriculum questions, such as the most effective sequence for teaching triplets, start to sound a bit trivial.

Such questions are also terrifying at times. It certainly is possible to teach dance and to plan course after course without considering them, but we are teaching something about how to be human and how we should live together even when we are doing it unintentionally, as part of the hidden curriculum. If we live an unexamined life, it is possible to live in a way that directly contradicts the values we think we hold. My students become aware of this when they try to put together their philosophy and their curriculum design, and often realize that the two are in opposition.

I press my students as I press myself, to discover what lies underneath what we say and what we do. I ask, "What are you living for? What are you willing to give up to do this? Does this practice that does not seem to fit your philosophy indicate something that you value even more?"

Some values are easily incorporated into a dance curriculum. For example, many students come to identify values related to both individualism and community. Dance can be a way to teach students to recognize and value individual differences and to recognize their connectedness with others. I push them to consider the impli-

cations: "If these are your values, how does daily ballet class fit in?" "How does cherishing individual differences affect your system of assessment?"

Sometimes students may identify values that cannot so readily be taught through dance, or values that may be taught only by skewing the curriculum to such an extent that dance seems like an afterthought. Many of us have argued for a long time that dance should not be taught as just a means to an end, a way for children to learn science and social studies. But, again, we teach more than dance whether we intend to or not. Why should we not, as Maxine Greene suggests, "live deliberately" (1978, p. 161), and make conscious choices about the hidden curriculum as well as the explicit one?

I do not think that everything can be taught through dance and many important lessons can be taught better elsewhere. But if we identify important values that just do not fit within a dance curriculum, where else might they be lived? How can we teach students that dance is not everything, that there are other important things in life too? Are we teaching this to our students by the way we live our own lives? I struggle with this issue, because I have let work and work-related activities take over such a big portion of my life, far larger than I think is warranted. With most of the faculty in our department doing the same thing, I think obsessiveness about work has become part of the hidden curriculum that we teach.

It is not that all such conflicts of values will ever be completely resolved. Like most people, I find that I live in contradiction with some of my own deep values. For example, grading students puts me in a relationship to them that is in violation of my own vision of how people ought to live together. Of course, I will lose my job if I do not turn in grades. Further, I admit that, since grades are recognized as standing for a certain level of achievement, I resist giving A's for effort alone. My awareness of the contradictions in all this, however, has led me to explore ways to give students more power over the grade they receive, by developing clear scoring rubrics so that they are not in a state of confusion about "what the teacher wants." This means that I spend more time talking about grades, which seems to give them greater importance than they warrant. I choose to live in conscious awareness of the contradiction between my beliefs and my actions, even though it means I suffer more in grading than I would otherwise. This is not because I am a masochist, but because I believe that consciousness—the ability to think about our own thinking—is one of the answers to what it is to live a human life.

I admit that it is easier not to do this kind of thinking; decision-making would be far less painful if we were not so aware of what we were giving up. It is interesting that people committing acts of atrocity seem able to turn off consciousness of pain, their own and that of others. We wonder how people who have been tried for war crimes could have gone home each day and played with their children, listened to classical music, and enjoyed a good dinner, just like the rest of us. Whether we choose to be wide awake to the consequences of our choices or anesthetized against feeling them, there is something to gain as well as something to lose.

The final part of the project that students must complete in my graduate course is to reflect on the process of developing their philosophy and curriculum design and their efforts at trying to make them compatible. Because reflecting on what

and how we teach is a project that may continue throughout one's professional life—and usually winds up like the "Unfinished Symphony"—this is the paper in which they reveal which ideas they have considered but do not know what to do with and proceed to lay out issues that are still unresolved. I tell them that everything in their philosophy and their curriculum does not have to "fit," but I want them to be aware of the pieces that do not.

A number of times since I have taught this course, this process has resulted in students questioning their choice for a career in dance. I sympathize, because I have done the same throughout my career, and still do. I remember when my doctoral advisor asked me, only somewhat facetiously, if it was not pretty trivial to spend one's days (and nights) prancing around a dance studio when people were starving and suffering all over the world. I continually seek reasons why dance is so important, why I have stayed, why I continue to stay. Among others, I find compelling an argument that has to do with freedom: If the world were suddenly changed, so that people were free from all forms of oppression, what would they then be free to do? I also note that art has persisted even in the most awful of times and places. The human impulse to create, what Martin Buber (1955) called the originative instinct, is so strong that children in a concentration camp still played and drew pictures and wrote poetry (Cunningham 1978). I suspect they also danced.

I still have days when I wonder, "Why am I doing this?" On most days, however, I end up concluding that the arts in general, and dance in particular, are important ways for me to make and find meaning in my life, and the impulse to seek meaning is another one of those qualities that define a human life. But I always must ask, am I teaching, am I living my life, in a way consistent with what I believe and value? What kind of a composition have I made, am I making?

I recognize that troubling one's work and one's life may make both more difficult. But, as Maxine Greene tells us, "To make things harder for people [means] awakening them to their freedom. It [means] communicating to them in such a way that they [will] become aware of…their responsibility as individuals in a changing and problematic world" (1978, p. 162). Through such difficulty may we move, wide-awake to our choices and possibilities, as we choreograph the curricula we wish to teach and the lives we wish to live.

Commentary

Having been a keynote speaker at the first conference of the National Dance Education Association (Stinson 1999), I was subsequently invited to submit a work for the inaugural issue of the *Journal of Dance Education*, sponsored by the organization. This work, presented as the chapter above, drew its title from an interview with a child during my research, but could also be considered a kind of reflective action research in analyzing and critiquing a particular course I had been teaching for some years. In the process, I reveal many of my own personal and professional struggles between conflicting values, and I ask a question with which I continue to

struggle post-retirement: Am I living my life in a way consistent with what I believe and value? Beginning with the citation of the Willis and Schubert book (1991), this chapter probes the interconnections between art, education, and life, and in that sense might be considered a precursor to Chap. 19 in this volume.

References

Bateson, M. C. (1989). *Composing a life*. New York: Atlantic Monthly.

Buber, M. (1955). *Between man and man* (M. Friedman, Trans.). New York: Harper.

Clark, G. A., Day, M. D., & Greer, W. D. (1987). Discipline-based art education: Becoming students of art. *Journal of Aesthetic Education, 21*(2), 130–193.

Cunningham, A. (1978). The children of Terazin. In J. Boorman (Ed.), *Dance and the child: Keynote addresses and philosophy papers of the First International Conference on Dance and the Child, July 25–27, 1978, Edmonton, Canada* (pp. 58–63). Ottawa: Canadian Association of Health, Physical Education, Recreation and Dance.

Greene, M. (1978). *Landscapes of learning*. New York: Teachers College Press.

Greene, M. (1980). *Moving towards possibility*. Paper presented as the Lawther Lecture for the School of HPERD, University of North Carolina at Greensboro, Greensboro.

Harris, M. E. (1987). *The arts at Black Mountain College*. Cambridge, MA: MIT Press.

Hutchens, J., & Pankrantz, D. B. (2000). Change in arts education: Transforming education through the arts challenge (TETAC). *Arts Education Policy Review, 101*(4), 5–10.

Lather, P. A., & Smithies, C. (1997). *Troubling the angels: Women living with HIV/AIDS*. Boulder: Westview.

Löytönen, T. (1999). *Researching one's own professional practice: Problems and possibilities*. Paper presented at the annual meeting of the Congress on Research in Dance, Claremont.

Macdonald, J. B. (1995). A transcendental developmental ideology of education. In B. J. Bradley (Ed.), *Theory as a prayerful act: The collected essays of James B. Macdonald* (pp. 69–98). New York: Peter Lang.

National Dance Association. (1994). *National standards for dance education: What every young American should know and be able to do in dance*. Reston: Music Educators National Conference.

Stinson, S. W. (1999). Leaving home. In *New horizons! 1999 conference proceedings*. Bethesda: National Dance Education Association.

Willis, G., & Schubert, W. H. (1991). *Reflections from the heart of educational inquiry: Understanding curriculum and teaching through the arts*. Albany: State University of New York Press.

Chapter 6
What We Teach Is Who We Are: The Stories of Our Lives (2002)

Susan W. Stinson

Abstract The author begins this essay with recognition that educators bring their own visions of subject matter, of children, and of the larger world, into the tasks of curriculum development and teaching. These visions come through a filter of personal values, which are often illustrated in the stories educators tell themselves and others, so examining those stories can be a way to heighten awareness of values. The author suggests, however, that awareness is insufficient if one is to go beyond the habitual to the intentional in professional practice, and that teachers need to question their beliefs, recognizing their limitations as well as their possibilities. To exemplify this process, the author shares stories that reveal some of her own visions—of dance, of young children, of the world and people in it—and how these visions have given rise to what and how she teaches. She also explores limitations to her visions and internal conflicts in the values underlying them, noting that sometimes reflection affirms one's current practice and its underlying beliefs and sometimes it challenges them; even when challenged, it may take a while before one knows how to respond. The author concludes by acknowledging the value of professional development in which educators can share and examine their own stories.

Teacher education students in methods courses learn to teach according to rules provided by other people. Once in their own classrooms, however, teachers sort through those rules, deciding which ones to keep and which to discard or replace with their own. While most teachers are still subject to guidelines and curricula provided by their employers, I find a lot of validity in the truism, "What we teach is who we are." Who we are incorporates how we see the world (including those parts of it we call the curriculum), what we know of children, what we think about teaching and learning. These visions come through a filter of our values—what we believe in, how we want to live our lives in relation to children. One way to become aware of our values is to look at the stories we tell. Just as myths and legends embody cultural understandings, and treasured family stories give evidence of what a family values, we each as teachers have stories that exemplify our beliefs. When we look at our stories, we come to recognize what we know and value.

An early version of this chapter was published in *Visual Arts Research*, 25 (2), 1999, 69–78.

But recognizing our values and visions is not enough if we are to go beyond the habitual to the intentional in teaching. We also need to question our beliefs, to recognize their limitations as well as their possibilities. In other words, I believe that we should teach who we are only if we are willing to engage in ongoing questioning, reflection, and commitment to growth. Without such questioning, teaching who we are can mean ignoring the needs of our children and the context of our communities.

To exemplify this process, in this paper I will share stories that reveal some of my own visions—of dance, of young children, of the world and people in it—and how these visions have given rise to what and how I teach. Many of the stories about children are about those I know best, my own children. (This, of course, presents its own limitation, which I shall discuss later.) I will also raise issues or questions with each piece of my vision. In this process, I am using myself only as an example; my visions are no more important than anyone else's. What is important is not my personal vision, but the reflective process that brings to consciousness our values and how they translate into what and how we do and do not teach.

6.1 Vision of Dance

One definition of dance is rhythmic movement, usually done to music. Certainly the impulse to move rhythmically is a powerful one; most of us have a strong urge to tap a foot or clap our hands when we hear rhythmic music. I remember how surprised I was when I had my first job working with day care mothers and their infant charges, to discover that babies only a few months old may bounce to music with a strong beat. I am still charmed at outdoor concerts to see toddlers get up and unselfconsciously bounce and sway. As noted in the recent guide on *Developmentally Appropriate Practice in Movement Programs for Young Children* (1995) by the Council on Physical Education for Children (COPEC), good movement programs give young children opportunities to move rhythmically, finding their own ways to do so.

6.1.1 Conscious Awareness

However, my vision of dance, now informed by many years of varied experiences, goes further than rhythmic movement. I remember my first teaching experience, when my supervisor came to observe after I had been working with a group of rather unruly youngsters for several sessions. Following the lesson, she told me as gently as possible about her mentor, renowned dance educator Virginia Tanner, who was able to get even very young children to not only move creatively, but also dance. That sent me on a journey of many years, trying to figure out what makes the difference between dancing and just moving.

One key insight I found in study with dancer and choreographer Murray Louis. I ask the reader to do the following activity, adapted from Louis, rather than just read it:

> First reach up and scratch your head; then return your arm to your lap. Next, choose a part of your arm that can initiate a reach; it could be fingertips, wrist, elbow, or shoulder. Starting with that part, begin extending your arm. Continue to a full extension, then past the point where your arm is straight, so that it is stretched, and the stretching energy comes out your fingertips. Now redirect that energy back toward your head, and condense the space between your hand and head, until your fingertips are just barely resting on your scalp.

You have just done a dance.

As this example reveals, dance is not what we do, but how we do it. It is a state of consciousness involving full engagement and awareness, attending to the inside.

When I reflect upon this definition of dance, I sometimes question whether it is appropriate for young children. Often, when I observe movement and dance activities for young children led by other teachers, they seem to be primarily about getting the children to move and to make their own movement choices. I value both of these goals, but by themselves they do not make dance. In my definition, the aesthetic experience of dancing can only come when we move with concentration and awareness; it is this which transforms everyday movement into dancing. But I sometimes question whether I may be allowing my own personal desire for aesthetic experience to take priority over the needs of children. In a later section of this paper, I will reflect further upon this issue as part of my vision of young children.

While listening to my concerns, I have worked to find ways to enhance the ability of young children and older ones to go beyond just doing the movement. This has involved "teaching to the inside," helping students become aware of what movement and stillness in different positions feel like on the inside. I can teach children by age eight or so about their kinesthetic sense, and how it works to tell them what their body is doing without their looking. With preschoolers, very simple experiences can help develop this awareness. For example, we shake our hands for about 10 seconds, then freeze them, noticing how they still tingle on the inside. A young child once told me this feeling was "magic," and I often use this description in teaching others. I teach the children that our dance magic lives in a calm, quiet place deep inside us; most seem not only to understand, but to already know this. We make a ritual of sorts at the beginning of the class, finding our "dance magic," and I try to use language and images throughout the class to help children not only move, but feel the movement. When we start to lose the concentration this takes, we take a break and intentionally do something that is "not magical," so that children will develop their awareness of when they are dancing and when they are just moving.

6.1.2 Form

One other piece of my vision of dance that I share with young children has to do with what adults call form. Just as humans have an impulse to move rhythmically, we also have an impulse to give form and order to our perceptions and experiences.

For example, adults have organized perceptions of differences throughout the age span into what we call stages of development. Similarly, we organize movement into games and dances.

Story form, with its beginning, middle, and end, is often used for organizing our experiences. I recently spent a week at the beach, all too close to where hurricane Bertha (the main character of this story) was also in residence. Bertha's presence ensured that we spent less time on the beach and more time watching the Weather Channel, and many nearby attractions were closed for part of the week. However, our vacation was not a complete loss. Bertha gave our week a sense of high drama, and offered us an opportunity to tell an exciting story upon our return. The story began as we were carefree and ignorant of Bertha's presence. Tension rose with our discovery that we were under a warning. The peak of the crisis came at 11 pm one night, when Bertha suddenly changed course and headed toward us; we packed our bags to prepare for what appeared to be an imminent mandatory evacuation. The tension resolved when Bertha shifted still again, and the story ended in relieved sunshine.

While some dances have very complex form, the most basic concept of dance form is understandable to preschoolers: A dance, like a story, has a beginning, a middle, and an end. Usually in preschool, we begin and end dances with a freeze (stillness), so that the dance is set off from movement that is not part of the dance. This reinforces John Dewey's (1934) concept of art as experience—he describes "*an* experience" as being set off in some way from the stream of the rest of the world going by.

Dewey's definition of "an experience" goes far beyond the simple perception of beginning, middle and end; his description of aesthetic form includes many aspects beyond the cognitive level of preschoolers. We do not expect a dance made by a preschooler to be complete in and of itself, with parts that flow together to make a whole; we do not expect both unity and variety, internal tension and fulfillment. But many of these conditions which make a good work of art also make a good dance class, even for preschoolers.

Just as many stories begin with "Once upon a time," a beginning class ritual focuses children's attention and prepares them for what is to follow. In my preschool classes, we do focusing activities to begin. A class gets unity from a theme; I use something from the real or imaginary world of young children, such as thunderstorms or toys, or a story, to provide the theme. Within the theme, I take different ideas, such as clouds, thunder, and lightning, or bouncing balls, floppy dolls, and mechanical toys, to provide variety. We translate each of these ideas into movement, finding, for example, which body parts can bounce, and how to "throw" oneself to a new spot by jumping.

Making parts of a class flow together is always part of my plan. For example, in a class on autumn leaves, I might ask the children to let the wind blow them back to the circle so that we can continue with what comes next. I also plan for a real ending to each class, something that brings closure and also leads into a transition to the next activity of the day.

I admit that lessons with preschoolers do not often go exactly as planned, and there are many opportunities for improvisation, another skill I learned as a dancer. But in many ways, planning and teaching my classes feels to me like a form of art-making, an idea for which Elliot Eisner (1985, 1987) is well known. He encourages us to think of evaluating teaching much as we do works of art, and encourages educational "connoisseurship" and criticism.

Sometimes when I finish teaching a class, there is that wonderful satisfaction of knowing that all the parts have come together seamlessly to create a real whole, and a shared transcendent experience has taken place. Even though such experiences occur less often for me with younger children, they are ones to cherish. As Madeline Grumet (1989) points out, it is all too easy to become seduced by a "beautiful class." We need also to maintain our critical faculties, and consider both the gains and losses of thinking about such classes as the peak experience of teaching. I have to ask myself whether the transcendent experiences mean anything in the long run, or whether they are just feel good moments that keep us engaged so we can persevere to what is really important. And what is really important is often as messy as a preschooler's play area, leaving considerable ends that are not neatly tied up into an aesthetic whole.

6.2 Vision of Young Children

Adults used to think that children were simply miniature adults. Now prospective teachers of young children are taught about distinct developmental differences. These are most often framed in terms of those things young children cannot do (and should not be expected to do), when compared with older children and adults. For example, we do not ask them to sit still for very long or to learn multiplication tables. We assume that young children will get "better," i.e., more like us, as they develop. I have reflected elsewhere (Stinson 1990) on my concerns over how a developmental model limits our thinking about important qualities that young children possess that all too often disappear as they grow up in our culture.

In this section, I will discuss three aspects of early childhood that are not always mentioned in early childhood texts but have made significant contribution to my choices of content and methodology: their capacity for engagement, their impulse toward creativity, and their drive to develop skills and become competent.

6.2.1 The Capacity for Engagement

Many of my undergraduate students have a vision of young children that I used to share: the idea that young children have a short attention span. My experiences with young children have taught me that sometimes their attention span far exceeds that of an adult. (I certainly tired of reading the classic children's story

Madeline (Bemelmans 1939) every night long before my daughter did.) While they are usually less willing than adults to stay with an activity in which they are not engaged, most young children have the capacity for significant engagement. For example, one day I was talking with a friend and colleague about her dissertation (on creativity in children) while our children, then four and five, played in a back room. When we finished we went back to the playroom, but stopped at the door. Ben and Sarah were engaged in pretend play, in fact, so engaged that they did not notice when we came to the door. My friend and I stood there for several moments before we tiptoed away. It was as though our children had created something sacred; we were not part of it, and we could hardly have walked in at that moment and said "It's time to stop now" any more than we could have walked into a religious service or any other sacred activity. This story exemplifies for me how children can engage so fully that they seem to be in another world.

I also remember my daughter at age 2½, when I took her into a partially lighted theater on my way to what was then my office; she looked around at the collection of stage sets and props, and whispered, "Does Santa Claus live here?" How many times children notice the extraordinary moments that we miss: the rainbow in the puddle, the trail of ants, the sound of grass growing. It may require great patience for us as adults to allow children to be engaged.

I think this capacity is worth cultivating. If we are always disengaging young children from what calls them, is it any wonder when they learn not to get too involved, and then we eventually berate them for their lack of concentration?

An appreciation for the capacity for engagement has had a great impact on my teaching, particularly as it has come together with my previously discussed vision of dance. COPEC's guide (1995) to developmentally appropriate practice notes that teachers of young children should serve as guides and facilitators, not dictators; this implies a child-centered curriculum, which I think facilitates engagement. We need to make sure that children have choices, and have opportunities to move and dance during free play, not just during instructional time. We need to follow as much as lead, help them discover their interests, appreciate their creations, and give them the respect of our full attention. Young children also give us very clear signals regarding when to stay with an activity and when it is time to move on; we need to attend and respond to them.

Eventually, of course, schoolchildren will be asked to concentrate on the things that interest teachers, not only the things that interest themselves. This presents many dilemmas to those of us who see how engaged young children are in their own learning and how disengaged most adolescents are. How much of this change reflects normal development, and how much comes from asking students to leave their interests behind for those things adults consider worth learning? How much should teachers prepare young children for the teacher–and subject–centered schooling that will come, and how much should they allow learning to be child-centered? If school were entirely student-centered, would this only encourage self-centeredness? I know too many adults who only want to do the chores they find interesting, leaving the boring work to partners or colleagues.

Even more troubling in regard to this part of my vision for young children is my recognition that deep engagement does not come readily to all young children. I remember my daughter's 5-year-old friend, who was so hyperactive that he entered our house by attacking it, and within minutes something was broken. Eventually I decided that this child would need to be an "outside friend," and I planned visits to a nearby park in order to allow the friendship to continue. While he was the most extreme example I have encountered, I have met many other children in my classes who had difficulty finding their "calm quiet place inside," and certainly could not remain there for very long. They are readily identifiable as "zoomers," who would spend an entire dance class running through space if that were possible. These children remind me to include vigorous, challenging movement throughout the class, with quiet moments as contrast. A freeze after sudden shape changes or shaking a body part allows us to notice ourselves in stillness. I try to start "where the children are," and gradually move with them from frenzied activity toward calm engagement. But I still question whether my cherishing of the calm center is a reflection of my own need, and my carefully developed techniques to facilitate engagement and inner sensing of the movement a way to manipulate children.

6.2.2 The Importance of Creativity: "I Made It Myself"

When children tell me, "I made it myself," or "I thought of it myself," I am reminded how important it is for young children to see themselves as creators, as makers, as inventors. My son was a sculptor; he pulled all the toilet paper tubes, cereal boxes, scraps of wood, rubber bands, string, and everything else out of the trash can for his constructions before I learned from him, and started not only saving everything but also soliciting from my friends. One year his Christmas stocking held eight rolls of masking tape, a supply which did not even last a year. When we ran out of room to store his constructions, I took pictures of them to save. I wanted him to know how much I valued his original creations.

I try to give young children many opportunities to be creators: to make their own shapes (not just imitate mine), to find new ways to travel without using their feet, to invent a surprise movement in the middle of a backwards dance. As they become more skilled, they take on greater responsibility for creation. At this point, children are not only making choices within structures I provide, but actually creating the structures.

Martin Buber called this impulse toward creativity the "originator instinct," and wrote, "Man [sic], the child of man, wants to make things....What the child desires is its own share in this becoming of things" (1965, p. 85). But Buber's questioning of the creative powers of the child as the primary focus of education led me to do the same. Buber concluded that "as an originator man is solitary....an education based only on the training of the instinct of origination would prepare a new human solitariness which would be the most painful of all" (p. 87). He reminds me that creativity alone does not lead to "the building of a true human life"; for such a goal, we must experience "sharing

in an undertaking and…entering into mutuality" (p. 87). As I will discuss shortly, I find it challenging to try to find ways to educate young children, who often have great difficulty understanding even the concept of sharing, into mutuality.

I am also aware of the current focus of arts education in areas other than creativity. The Getty Center, in a work entitled *Beyond Creating* (1985) and in many others since, has informed arts educators that too much emphasis had been placed upon creativity and production, and too little upon history, criticism, and production. Elliot Eisner (1987) emphasized that art should be thought of as a cognitive activity, rather than an emotional one, and even some early childhood arts educators are writing that young children should spend more time looking at and responding to art made by adults, which implies less time making their own. Anna Kindler (1996) criticizes any "hands off" curriculum that just allows children to create, believing that just creating is not enough stimulus for children to develop cognitive skills.

I continually question whether my vision of the young child's impulse toward creativity is some mere romantic notion that is hopelessly out of date. I also know that I gave up the idea that children needed only opportunities to dance, and no instruction, when I decided to become a dance *educator*. My career has been spent developing ways to help children go beyond where they might be "naturally," without dance education. But my vision of the young child's impulse to create is still strong.

6.2.3 The Importance of Competence: "I Did It"

A third piece of my vision has to do with the importance of competence, of being skillful, in young children's self-esteem. My son at the roller skating rink gave me one of many stories that exemplify this perception. His style of learning to skate involved leaning way forward, then going as fast as he could to get as far as possible before falling down. Etched forever in my memory is the first day he made it all the way around the skating rink without falling, and how he crowed, "I did it!!" We need to give young children many opportunities to say, "I did it," and gain the pride that comes with such achievements. To me, this means opportunities to go beyond what they can already do—not too far beyond, of course, because that generates the kind of frustration that can make children give up. But those of us who appreciate children so much *as they are* need to remember that no one shouts "I did it" when the task has not been a challenge.

It took me a fairly long time to recognize the importance of movement skill, what dancers refer to as "technique," for young children. Like many other teachers enamored of creative dance, I wanted to preserve what I saw as the "purity" of children's natural expressiveness in movement, and not spoil it by teaching them technique. Eventually I realized that children are learning from adults, and imitating us, from a very early age; this learning includes movement skills. We have to choose not whether to teach children skills, but which ones and how we will teach them. I know that children can still feel good about themselves when they learn by imitation; this is how they learn to tie their shoes, which they always seem to view as a great

accomplishment. I have also seen the pride felt by a 3-year-old in demonstrating a ballet step, no matter how poorly.

Yet I still find myself led toward exploration more than imitation, finding that a sequence of exploring/forming/performing is useful in developing movement skills as well as creative work. For dance technique, exploring possibilities (such as the differences between a bent, curved, straight, and stretched arm) is important in building the kinesthetic awareness necessary if performance of movement is to be not only correct but expressive.

I also find myself interested in basic movement skills more than codified dance steps. These skills are the kind that children will use in all dance forms and other movement activities. These include how to run or jump or fall without making a sound, how to move close to another person without touching, how to stop oneself (which is hard if one has been moving fast), how to swing oneself around in a turn, how to make points and curves with an elbow. Exploring these kinds of activities will help children become more skillful movers in any dance form they may choose when they become older, and will help them become people who say "I did it!" in the present.

Back in my reflective mode, I look through my first-born's baby book and see more dates of achievements than stories: crawling, pulling up to standing, first steps, shinnying up a flagpole, going hand-over-hand on the horizontal ladder, tying her shoes, riding a two wheeler. Sometimes I could not sort out her pride from my own, thinking that I proved I was a good mother by my child's accomplishments. I think sometimes teachers make the same error, seeing a child's accomplishments mostly as a reflection of our own competence as teachers. It is humbling to realize how many skills young children will develop without formal instruction, as long as they have opportunities that include safe and appropriate space and equipment, time to explore, and an adult who notices and encourages.

When I reflect now, I have to ask the same question my daughter asked me at age three, when I told her I was going to teach a dance class: "Why do you have to *teach* people to dance?" Another time, when someone asked her if she planned to be a dancer when she grew up, she replied, "I already am." Dance educators are fond of saying that everyone is a dancer, whether they know it or not. I wonder whether dance teachers would be needed for young children if our culture were one in which everybody danced, and knew they were dancers. In such a culture, at what level might a need for instruction be felt by a child?

As I continue to reflect upon issues raised in my previous discussion of creativity, I am aware that the only skills I have mentioned are psychomotor ones. What about the cognitive skills that the Getty Center and others are so concerned about developing? Certainly an inability to read or write is likely to be more damaging to a 7-year-old's self-esteem than an inability to ride a bicycle or to dance. I do think we should be expanding young children's vocabularies for describing dance, and I took my own children as preschoolers to every dance performance suitable for them, encouraging them to name and respond to what they saw. But there were not many of these, and there are very few dance videos that can hold the attention of most young children for very long. There seem to be far more adult created works in visual art, theater, and music that are appropriate for young children.

I am also convinced that children learn dance concepts better through movement than through looking at other people dance, especially in early childhood and in students of all ages who are kinesthetic learners. Even when I ask young children to watch me demonstrate, for example the difference between low and high levels, most of them automatically move along with me while they are watching. But I wish there were more opportunities for young children to see people other than their peers perform, and I continue to encourage those few choreographers who make performances for children to consider making videos as well. I wonder what kind of aesthetic education in dance might be possible if more suitable materials were available.

6.2.4 Reflections on My Vision of Children

For a number of years, I have taught developmental stages to my students through stories, theirs and mine. While the students have voiced appreciation for this approach, I have realized its potential limitation: Whose stories do we tell? Because my students are, like myself, primarily white middle class women, if we only collect our own stories, we are simply reinforcing what I have heard called the prison of our own experience. I continue to seek experiences for myself and my students that will allow us to expand our prisons, knowing that we can never escape them completely.

6.3 Vision of the World and People in It

I remember a Sesame Street book one of my children had, about *Grover and the Everything in the Whole Wide World Museum* (Stiles and Wilcox 1974). Each room in the museum was different: Imagine a room filled with tall things, another with small things, another with red things, or scary things. After going through room after room, one finally came to the last door, which led to "everything else in the whole wide world," and Grover left the museum. My vision of the world is filled not with things but with ideas or principles; I will share two of them.

6.3.1 Individuality

The first piece is about individuality: Each person is unique and special. I often begin teaching dance to a new group of young children by showing a collection of geodes. On the outside, they look plain and ordinary. But on the inside, each one is different and special and magical. As I tell children, so are *they*. This kind of appreciation of differences is an essential part of a preschool dance class. My belief in the importance of individuality is another reason to encourage each child to find her

own way, his own shape. Because young children often imitate each other as well as adults, we usually have to give additional encouragement to generate differences. But children in any creative dance class learn early on that the teacher values invention more than imitation.

I have already raised Martin Buber's concern about the temptation to place too much emphasis on individualism in education when we think about creativity. We also have to remember that images of individuals are constructions deeply imbedded within our own culture. (See Martin 1992, for a particularly thoughtful discussion of these images in American literature.) But there are other concerns as well about an overemphasis on individuals doing their own thing. I recall an incident when I first offered creative dance classes for preschoolers at what was primarily a ballet studio. One parent who had come to sign up her 3-year-old told me angrily that her daughter needed to develop discipline, not creativity; her child apparently climbed on the dining room table to perform, an act the mother did not appreciate.

But I think that another part of individuality that I want to cultivate in the world and in dance is the responsibility for self-management. I remember one particularly challenging second grade class that I taught. After two sessions that came close to bordering on chaos, I devoted an entire lesson to "controlling your own energy." This class was held the week after a major hurricane had occurred, and I was able to use this as an example of how destructive energy can be when it gets out of control. Bordering on desperation, I even told them that children who could not control their own energy get sent to the principal's office, while adults without control get sent to jail. Since the positive side of the message was that controlling our own energy allowed us to make things instead of destroying them, we then spent the rest of the class exploring three kinds of energy—strong and sharp, soft and sustained, and exploding—in order to make a dance about a storm. I concluded that this was probably the most important lesson I taught them.

The concept of the "inner teacher," which I absorbed from two years of teaching in a Quaker school, has also encouraged me to think of self-management as an aspect of individuality. Even with preschool children, I give opportunities to "be your own teacher, tell yourself what to do" during a class. If all children could find their inner teacher, think how different schools would be.

6.3.2 Connectedness

Another part of my vision has to do with the connectedness of all these diverse individuals, what some feminist theorists refer to as a web of relations. Our experience of connectedness begins at birth; we are born connected to another person. Beyond ties of birth, however, we usually think of connections as something we must create, with an assumption that things and people are basically separate; we have to find ways to bring them together like pieces of a child's construction set.

But my experience in dance has taught me that a great many connections exist outside our awareness of them. We do not have to create these connections, but simply

become aware of them and use them in moving and thinking. For example, I have spent many hours in dance classes lying spread-eagled on my back, finding the diagonals that exist in my body, so that movement initiated by the right hand and arm results in movement by the left leg and foot, conveyed through the center of the body.

I am convinced that, just as our bodies are held together by internal connections, we are connected to others by ties that are sometimes as difficult to see as our own ligaments buried beneath layers of skin, muscle, and fat. I have also been moved by Buber's (1958) consideration of connection: When we recognize our connectedness, we become responsible for that to which we are connected. If we recognize our connections with others, we become responsible for them; this is critical in a world in which peoples are fragmented and at war. It is also critical to recognize our relationship with, and responsibility for, the earth.

Originally spurred by Buber's call toward community, I have spent many years seeking ways to enhance community building among my students. For me, this gets far easier beyond early childhood. I find it challenging to teach relationship skills to young children; their egocentrism means that they are not ready for most partner and group work that could facilitate dance relationships. With preschoolers, I find it easier to teach lessons that deal with relationships between themselves and the environment and/or human-made objects in the world. Ideas for classes come from the imaginary and real worlds, not just from movement words like rise, turn, and sink, and abstract concepts such as high, low, fast, and slow.

For example, imagine for a moment some of the things from the everyday world that go up, turn, and come down. For the most part, when I construct dance classes with children, it is about things they care about which have shapes and/or move. My first thoughts usually go to the natural world, because I feel such a strong connection with the earth, and I want to share that with children. So autumn leaves might get picked up by the wind, turn, and fall back down. Or a bird might go into the air, circle a tree, and come back to the nest. The sun rises, shines over all the earth, sinks. The largest number of my class themes came from nature until one time I was asked following a conference presentation, "What about those urban children who do not have much opportunity to experience nature?" That question led me to expand my themes; airplanes and helicopters, as well as helium balloons, can also go up, turn, and come down.

I must note that, despite the use of themes that can easily be personified, I do not ask children to pretend to be anything other than who they are: dancers. Instead, I ask them to try on the qualities they share with whatever we are dancing about. Although some will transform themselves into leaves or birds or helicopters, I prefer to let a child's pretendings belong to them.

In my reflective mode, I still feel concerned that I do little to facilitate the development of community among preschoolers. While I do this more with primary grade children, I have little success even getting children to work successfully in partners until the third or fourth grades. At one point I smugly thought I was merely being developmentally appropriate. Now, I read of others teaching cooperative learning techniques to young children, and I wonder why I am so rarely successful in having young children sensitively mirror a partner, unless that partner is an older child or adult.

6.4 Conclusions

Taking the opportunity to think about meaningful moments in our lives, those that come to exemplify something we believe, helps us become more conscious of our visions and values. Asking ourselves questions about our values and visions gives us the opportunity for professional growth. Sometimes reflection affirms our current practice and its underlying beliefs, and sometimes it challenges them. Even when challenged, it may take a while before we know how to change what and how we teach.

Yet teachers of young children are busy people, with far fewer opportunities than college professors have to reflect on their values and visions. My hope is that professional development for early childhood educators might provide not only workshops for teachers to learn new skills (such as teaching movement and dance), but also opportunities to share and to question the stories of their lives that guide their professional practice.

Commentary

This chapter was written at the kind invitation of Liora Bresler, co-editor of the volume in which it first appeared. I am grateful to Liora for her consistent encouragement for me to write in my own voice. Most of the work I have written about young children is practical, rather than theoretical, including my 1988 book written for teachers of this age student. This chapter, in contrast, gave me more opportunity to reflect, to question my own values and visions and how I was attempting to live them, as well as becoming aware of their limitations. In preparing this volume, I notice that this chapter, grounded in my own experiences with young children, makes little use of scholarly references, even in my critical reflections on those experiences. It also contains little reference to issues of social justice, which underlie most of the other chapters in this section. I alluded to this absence when I acknowledged the limitation of examining only our own stories. My research listening to middle and high school students, referred to elsewhere in this volume, gave me stories that brought me in touch not only with joys they found in dance, but with the pain many were experiencing in other parts of their lives; it was a significant factor in expanding my consciousness. Similar stories from young children are not part of my direct experience, and indeed the inability of so many young children to speak for themselves means that it is easier to remain ignorant of their suffering, until we read occasional stories in the media. At the end of my career, I am humbled by this realization and hope others in arts education will fill in this gap in the future.

References

Bemelmans, L. (1939). *Madeline*. New York: Simon & Schuster.
Buber, M. (1958). *I and Thou* (2nd ed.) (R. G. Smith, Trans.). New York: Charles Scribner's.
Buber, M. (1965). *Between man and man* (M. Friedman, Trans.). New York: Macmillan.

Council on Physical Education for Children (COPEC). (1995). *Developmentally appropriate practice in movement programs for young children, ages 3–5*. Reston: American Alliance for Health, Physical Education, Recreation & Dance.

Dewey, J. (1934). *Art as experience*. New York: Minton Balch.

Eisner, E. W. (1985). *The educational imagination* (2nd ed.). New York: Macmillan.

Eisner, E. W. (1987). *The role of Discipline - Based Art Education in America's schools*. Los Angeles: Getty Center for Education in the Arts.

Getty Center for Education in the Arts. (1985). *Beyond creating: The place for art in America's schools*. Los Angeles: J. Paul Getty Trust.

Grumet, M. R. (1989). The beauty full curriculum. *Educational Theory, 39*(3), 225–230.

Kindler, A. M. (1996). Myths, habits, research, and policy: The four pillars of early childhood art education. *Arts Education Policy Review, 97*(4), 24–30.

Martin, J. R. (1992). *The school home: Rethinking schools for changing families*. Cambridge, MA: Harvard University Press.

Stiles, N., & Wilcox, D. (1974). *Grover and the everything in the whole wide world museum*. New York: Random House.

Stinson, S. W. (1988). *Dance for young children: Finding the magic in movement*. Reston: American Alliance for Health, Physical Education, Recreation and Dance.

Stinson, S. W. (1990). Dance and the developing child. In W. J. Stinson (Ed.), *Moving and learning for the young child* (pp. 139–150). Reston: American Alliance for Health, Physical Education, Recreation & Dance.

Chapter 7
My Body/Myself: Lessons from Dance Education (2004)

Susan W. Stinson

Abstract The author describes this essay as a "duet" between personal knowledge (her own lived experience as a dance educator) and critical social theory. As a structure, she describes three themes pervading what she has learned and taught, ones which have implications well beyond dance and teaching:

- Feeling from the inside to understand self and others (internal, somatic sensing);
- Self-direction/self-management (recognizing power to make conscious choices); and
- The body as a source for knowledge and meaning.

The author problematizes each theme using a lens of critical social theory to question the taken-for-granted, especially that within her own thinking, asking larger questions like, "In whose interest?" and "What's worth knowing?" She concludes that education of the lived body should be central in the curriculum for not only dance education, but arts education generally.

"The body" is currently a hot topic among those who claim residence in cultural foundations of education. In this home where I have lived for many years, words, ideas, theories about "the body" are produced, usually without revealing anything about the bodies of those who produced them. Following scholarly tradition, much thinking about the role of "the body" in culture and classroom is delivered in abstract, disembodied language. As Julie Sandler writes,

> For all that many poststructuralists call for a re-insertion of the body into texts, they seem to forget about this body here with the eyes burning from staring at the computer screen and the back aching from hunching over the keyboard. (1997, p. 221)

My other professional home, in which I have lived even longer, is dance education. In contrast to educational theory, most dance experiences, whether on stage or in a studio, require that the body be revealed. Dancers are usually keenly aware

Small portions of this chapter were adapted from Stinson 1995.

© Springer International Publishing Switzerland 2016

S.W. Stinson, *Embodied Curriculum Theory and Research in Arts Education*,
Landscapes: the Arts, Aesthetics, and Education 17,
DOI 10.1007/978-3-319-20786-5_7

of every bulge and sag, every twinge and tension, expending extraordinary time training, shaping, preserving, often obsessing about, their own bodies.

In recent years, we have seen the appearance of a good bit of critical theoretical work written about the dancer's body (Albright 1997; Desmond 2001; Fischer-Hornung and Goeller 2001; Foster 1995, 1996; Friedler and Glazer 1997; Fraleigh 1996; Green 1999, 2001; Ramsay 1995; Shapiro 1999; Thomas 1993). So many authors, including myself (Stinson 1995, 1998), have made the point that the low status of dance reflects its connection with women and the body, that I feel no need to go into these issues again here. Instead, I have tried in this essay to look both personally and reflectively at what I know from living as I do, with one foot grounded firmly in dance education while the other remains connected with curriculum theory.

From my life in dance education, I bring my lived body, subject of my embodied experiences. I write this essay from the perspective of a personal body, especially my own, not that abstracted virtual body which is the subject of so much postmodern discourse. I thus must acknowledge that, when I look in a mirror, I do not see the kind of a body that the general public assumes belongs to a dancer—young, svelte, perfectly toned. I look at my body with the judgmental eye that dancers—and most women—have, when it comes to their own bodies, and see far more signs of aging than just graying hair. Inside my body, I receive multiple and ongoing signals that I can no longer move as I did when I was a young adult; this has been made worse by my spending the past 9 years not in a studio, but sitting in an administrator's chair. My aging body nevertheless stores memories of past experiences, including memories of lessons learned and taught. It is three of these lessons that I will describe in this essay.

From my lived experience in cultural foundations of education, I bring another way of perceiving the world, one that often feels like I am looking not "up close and personal," but from a distance. It is from this distance that I can question the taken-for-granted, especially that within my own thinking, and ask larger questions like, "In whose interest?" and "What's worth knowing?" The critical reflections woven into this essay most reflect this way of being.

In the choreography that follows, I have tried to create a duet between these parts of myself, a dance between personal knowledge and critical social theory. In doing so, I have tried to engage in the "dual dialectic" called for by James B. Macdonald, who wrote, "Values, I believe, are articulated in the lives of people by the dual dialectic of reflecting upon the consequences of an action and sounding the depths of our inner selves" (1995, p. 79). Through remembering cherished moments and asking myself difficult questions about them, I hope to be living this call.

7.1 Feeling from the Inside to Understand Self and Others

In trying to become aware of the values I embody as a dance educator, I have been considering what I teach first and what I keep returning to, when I teach K–12 students or coach my university students who will become dance educators. This first

lesson has to do with inner sensory awareness, which is studied by those in the field of somatics. The term *somatics* is attributed to Thomas Hanna, who described it as a way of perceiving oneself from the "inside out, where one is aware of feelings, movements and intentions, rather than looking objectively from the outside in" (1988, p.20). The increasing popularity of a somatic approach in teaching dance is indicated by the 2002 issue of the *Journal of Dance Education* (Greene 2002), which was devoted entirely to it.

Long before I knew the word *somatics*, I began teaching even the youngest students to "feel from the inside," initially because I recognized that this kind of consciousness of even everyday movement transforms it into dance movement. With 3-year-olds, we begin simply—I ask them to quiver their hands for a long enough time that, when they "freeze" (stopping the movement with hands in mid-air), they can still feel the tingling inside their fingers. I tell them that this is their dance magic that lives inside their muscles, and they need to use it to dance. By third grade or so, when students love the power of knowing a big word that their parents don't know, I teach them about the *kinesthetic* sense, which allows them to know what their body is doing even when their eyes are closed.

This internal sensing has great significance not only for how one learns and performs dance but also for how we perceive the art. Without it, we certainly can see movement and patterns on stage, and hear any accompanying music, but internal sensing allows us to feel the dance and our response to it. We become participants, not just onlookers, as we breathe along with the dancers on stage, feeling the stretch that continues past the fingertips, feeling the body landing silently from a jump. Those who have never experienced a dance performance from this perspective have missed half of it.

This same sensing serves us in places other than a dance theatre. We also use it to connect with the Olympic athlete on the television screen—straining to beat the clock, bursting with exhilaration in victory, slumping in defeat. It allows us to share the weighty sadness of a friend, the tense anxiety of the unprepared student before an exam. Philosopher Kenneth Shapiro (1985) calls this kind of participation *kinesthetic empathy*. Martin Buber uses the phrase, "feeling from the other side" (1955, p. 96), which he describes as feeling within our own bodies the kind of touch we give to others, whether that is a loving caress or a painful blow.

Donald Blumenfeld-Jones (2004), who writes about bodily-kinesthetic intelligence from the lens of a dancer as well as that of a critical theorist, has drawn some conclusions similar to my own, in defining dancing as paying attention to one's own motion. He cites Merce Cunningham (Cunningham and Brockway 1977) in speaking of an "appetite for movement" experienced by some dancers:

> It does not mean the need to display oneself but rather the need to be moving and to feel the movement and to think movement. It does not mean that one always has to be moving but rather that one feels another's motion almost as if one were also moving.

So it is clear that I am not the only dancer who has learned from my life in dance to feel from the inside and to use this inner sensing to know others and myself. I think that the other two important lessons from dance which I will share are probably

grounded in this one. I cannot move on to consider them, however, without stopping to problematize my privileging of inner awareness. To begin with, sensing myself from the inside is only the beginning to knowing myself. How many times has fatigue or thirst made me think I must be hungry; how many times have I interpreted boredom as fatigue? What I feel on a body level may require critical thinking in order to interpret accurately.

Internal sensing is even more limited as a way of knowing someone else: How do I know that feelings I attribute to another are the same as those I am feeling? The senses that allow us to feel from the inside, like our other senses, provide only a private experience, and validation of private experiences is problematic. Assuming that everyone perceives an experience the same way I do is the ultimate in arrogance. While I can use my kinesthetic empathy to try to feel what someone else is feeling, there is no guarantee that it will be the same. Of course, we can *ask* others to describe what they are feeling, but words have different meanings to different individuals, and words cannot directly and completely represent our lived experiences. As Michael Polanyi (1966) has reminded us, we know more than we can tell.

Going beyond personal interaction to social concerns, one must admit that it can't be very helpful for those living in chronic poverty to become more aware of their hunger, or for those who have no choice other than hard physical labor to become more aware of their weariness and strain. I wonder if well developed internal sensing becomes a value only after basic human needs are met. How useful is it for those without sufficient food, without clean water, without the comfortable bed or easy chair or even a bit of shade from the sun, much less the climate-controlled environment in which I can rest on hot summer days? How self-indulgent is it to say that people need to be aware of what they are feeling on the inside when their basic needs can't be met? How can we bear to focus on our own bodies and ourselves when others are suffering?

As a woman who has filled and continues to fill a great many roles involving service and care-giving, I know all too well the dangers of focusing only on others and not caring for myself as well; the work of Carol Gilligan (1982) came at a time I needed to consider how to include myself as one to be cared for. Yet it is all too easy for this discovery of what I feel on the inside to become naval gazing self-centeredness. I remember a friend from some years ago, who entered a mid-life crisis to which he responded by taking one body-based class after another to develop more awareness of what he was feeling. Although it made sense at the time, especially to those of us who advocate being in touch with one's own feelings, he eventually became so focused on himself that the needs of others seemed completely unimportant. Similarly, as Martha Eddy reminds us, "Dance-making from a somatic source often gets lost in personal experience and only grows to the level of personal ritual" (2000, p. 147).

How important it is that we start with ourselves, but not end there. How important it is that we let the kinesthetic sense take us beyond our own sensations into the world, to recognize our connectedness with others—and that we go beyond sensing the pain we feel (our own or that of others) to acting upon it. I admire educators like

my colleague Jill Green, who are making the connection between the inner somatic sense and social consciousness (Green 1993, 1996a, b, c, 2002–2003).

Yet when I sound the depths of my inner self, as Macdonald (1995) called me to do, I still question my efficacy as a dance educator, teacher educator, and scholar to make a difference in a world that, as Maxine Greene so eloquently describes it, "includes homelessness, hunger, pollution, crime, censorship, arms build-ups, and threats of war, even as it includes the amassing of fortunes, consumer goods of unprecedented appeal, world travel opportunities, and the flickering faces of the 'rich and famous' on all sides" (Greene 1988, p. 12). I have long been attracted to Greene's belief that arts education should not be "linked entirely to the life of the senses or the emotions, or…subsumed under rubrics like 'literacy'" (1988, p. 13), but should emphasize moving people "to critical awareness, to a sense of moral agency, and to a conscious engagement with the world" (1978, p. 162). In my deepest questioning, however, I wonder whether this stance is just a way to justify work that I love and avoid guilt for what I am not doing. Nell Noddings' work (1984, 1992) has been meaningful in speaking to my still-unresolved dilemma of negotiating the distance between what I can do and what needs to be done in the world.

7.2 "Being Your Own Teacher"

The second most important lesson of the body that I teach in dance has to do with "being your own teacher." I first came upon this phrase while teaching many years ago in a Quaker school, but I have come to connect it closely to self control (telling oneself what not to do) as well as self direction (telling oneself what to do); this kind of self-management (or lack of it) seems to me to be intimately connected with my body. I often feel out of date when I fume over a culture that seems to constantly advocate immediate sensory gratification, regardless of the consequences, when prime time television teaches young people that sexual attraction must be acted upon before the hour's end. The morality of "If it feels good, do it" began during my adolescence in the 1960's, but its consequences have become more dangerous today. Another example of the emphasis on immediate gratification comes in the commercials. Consumerism—buying regardless of whether we need something—has even become a patriotic duty for Americans. I sought to teach my own children to recognize their own power not just to become aware of their own bodily desires but also to make conscious choices after considering the options and the consequences; this is a lesson I think all children should learn.

Much of the language that I use in teaching dance derives from this value. I direct children to "choose a spot on the floor" rather than to "spread out," to "choose a shape" rather than to "make any shape you want," seeking to enhance their consciousness of their choices. "Telling yourself" when to begin, change, or stop any movement, and then developing the skill and discipline to follow through on such inner direction, connects inner sensory awareness with conscious thought.

Such a connection seems just as important in other settings. As I continue to age, I find myself saying more often, "I can push myself to do this, but should I?" At any age, telling oneself to keep going past one's comfort level requires courage and stamina—and also critical reflection if pushing onward is to be an act of extending one's boundaries rather than ending a career or even a life.

Being in control of oneself becomes especially important for students in an activity that involves movement. When children are not nicely seated in desks that serve as containers, the possibility for chaos becomes distinctly more likely. I flash back to that third grade class I taught some years ago, as part of a series of demonstration classes I was doing before I became an administrator. I can't remember whether the children came straight to me after racing on the playground, but they were exceptionally "wild" in the first two of three dance lessons I taught. They seemed to perceive that entrance into the spacious gym came with a license to run around, accompanied by screaming when the urge came upon them. I decided that, more than anything else, they needed to learn how to control their own energy. When they came into the gym for the third lesson, I had them sit against a wall, and spoke seriously to them about the recent massive hurricane which had been so much in the news, reminding us that energy can be very destructive when it is out of control. I then told them some version of the following:

> We all need energy to *make* things, but our energy, too, can be destructive when it is out of control. If we don't know how to control our own energy, someone else does it for us. As children, you might get punished by a parent or sent to the principal's office. When people get to be grown-ups and don't know how to control themselves, they can get sent to jail. So in this class I will teach you how to control your own energy; this way you can be your own teacher and tell yourself what to do.

They each then went to a designated spot on the floor, where I directed them to lie down and feel their heart beating. Then they were to stand up, lie down, stand up, over and over again, until they could feel their heart beating really fast—and then stay lying down. I explained that, by making their muscles soft and breathing more deeply and slowly, they could actually help slow down the speed of their heart. When they felt their heart beat slowly again, I asked them to let me know by sitting up, without disturbing others. Fascinated by the experiment and the power they realized (or perhaps afraid of jail in the future—I had never used this kind of language with children and felt very odd about it), they seemed to take this lesson seriously. We then continued the class, which, I warned them, would include some activities that could get dangerous if they were not in control of themselves. The rest of the lesson involved a theme of a storm: They began in soft curved shapes travelling through space (image of clouds), which eventually got tighter and tighter until they burst into sharp pointed shapes (lightning image) and eventually "thunder jumps" (jumping high and then lowering themselves all the way down until lying on the floor). They made hard rain sounds pounding the floor, gradually getting softer and softer before stopping the sound and transforming themselves into curved shapes or pointed ones (responding to their chosen image of a rainbow or stars). There were multiple opportunities in the class to use different kinds of energy and to tell themselves what to do and when to do it, and the children were successful at it.

When their classroom teacher returned to claim her students, I told her that she would not need to tell the children to walk quietly down the hall, because they could be their own teachers and tell themselves. My own teacher education students watched this transformation in awe, and I felt quite self-satisfied when I told them that this lesson was probably more important than anything else students learn in dance.

I still think that it is essential for all of us to be able to self-manage our own energy and our own actions. When I reflect critically on my teaching of this class, however, and the messages of self-control and "being your own teacher" which I continue to teach, I can't help but find them potentially problematic. It is seductive to get children to do what we want them to do while thinking that it is their own idea. Neither the classroom teacher nor I would have been so pleased if a child had told herself to run down the hall yelling and screaming. No, I wanted the children to make choices within carefully presented options, and to tell themselves to do what they knew their teachers wanted. My manipulation was pretty effective. The children learned, performed well (using their energy constructively to create a dance about a storm), and seemed to emerge feeling proud of themselves and the dance they made. I wanted to empower them—but did I really? Or was I just using more seductive means to produce docility? I am mindful of the words of Valerie Walkerdine (1992), who has noted that this is the seduction of progressive education, a movement that established the schoolroom

> as a laboratory, where development could be watched, monitored and set along the right path. There was therefore no need for...discipline of the overt kind....The classroom became the facilitating space for each individual, under the watchful and total gaze of the teacher, who was held responsible for the development of each individual....[In such a classroom] the children are only allowed happy sentiments and happy words...There is a denial of pain, oppression...There is also a denial of power, as though the helpful teacher didn't wield any. (pp. 17–20)

Although far removed from progressive education, the goal of traditional dance pedagogy often seems to be the creation of docile bodies, mostly those of young women (Stinson 1998; Green 1999). And highly trained dancers seem to represent the epitome of bodily control, making their bodies do all sorts of things that are not "natural." Too often, dancers have learned to separate body and mind, viewing their bodies as machines or instruments to be controlled by their will. Dancers are admired for their physical feats, and often for their self-control when it comes to diet, maintaining a weight that allows their bodies to be regarded as beautiful objects in a society that places high value on slenderness in women. Yet too many dancers maintain their weight through decidedly unhealthy means, including smoking as well as weight reduction strategies that may be clinically classified as eating disorders. Such disorders are closely connected to issues of control (Bordo 1993; Woodman 1982), and they are more prominent in women, who may perceive that the amount of food they eat is the only aspect of their lives they can control. There are certainly other issues of control run amok among dancers; literature reporting related health problems among dancers (Brady 1982; Buckroyd 2000; Gordon 1983; Green 1999, 2002–2003; Innes 1988; Kirkland with Lawrence 1986; Vincent 1979) is sufficiently prevalent to make anyone realize that dancers do not have all issues of control figured out.

While individuals suffering from eating disorders deny themselves pleasure in food, and exercise excessively to maintain a particular body shape and size, I struggle with other issues related to control and pleasure. I am aware of how rarely I allow myself to choose pleasure over a never-ending to-do list (only some of which I find pleasurable).

One of the experiences that I do find pleasurable is physical work such as gardening or hiking, and on occasion I give myself permission to indulge. Perhaps for the same reason that I chose dance in my earlier days, I appreciate the pleasure of working hard, really using my muscles. How delightful it is to get hot and sweaty and tired, followed by a shower. Yet I cannot ignore the connection of my pleasure to social class and economic privilege. I have the luxury of choosing to garden because I do not have to raise my only source of food, and I have hot and cold running water available to me for showering off the dirt afterwards. Physical work was looked down upon for generations, as something the upper class should avoid, until its health benefits became known. Today, working out at a gym and recreational running are seen as more acceptable than physical work that is connected with earning an income.

Although many people work out purely for health reasons, it is likely the pleasure of such activity that keeps them going. And yet I know that such pleasure is not universal. In my current research (in progress) on young people's experiences of dance as "work," I am fascinated to realize that not all appreciate challenge (whether physical or not). Certainly one of the most important outcomes of research for me is discovering that everyone does not perceive a situation the same way I do. Yet we know too little about why perceiving that a task is hard makes it more desirable to some and less desirable to others, even though such perception has critical influence on learning, especially if we wish, as I do, for children to be self-directed in their learning.

Finally, teaching students to become their own teachers is not very useful if they will not be allowed to make their own decisions about their art or their lives. Oppression comes from outside as well as inside the self, and we must address both if we are to live in the kind of world in which freedom of expression exists for everyone. Paulo Freire (1983) and other critical pedagogues have helped us see the connection between inner and outer transformation. David Purpel, another of many theorists who see this kind of connection as essential, writes that

> the essence of education can be seen as critical, in that its purpose is to help us see, hear, and experience the world more clearly, more completely, and with more understanding… Another vital aspect of the educational process is the development of creativity and imagination, which enable us not only to understand but to build, make, create, and re-create our world. (1989, pp. 26–27)

With a similar view, Maxine Greene even titled her 1995 book *Releasing the Imagination: Essays on Education, the Arts, and Social Change*. It is my hope; too, that arts education will nourish this kind of imagination, resulting in not only art making but also world-making.

7.3 Bodily Knowledge and Meaning

The third lesson which I most value is more complex, and has to do with the body as a source for meaning making. Put more simply, I have found that my body is, in a sense, a microcosm of the world, and thus a laboratory for understanding its meaning. I concur with Kenneth Shapiro (1985), who writes that the body is "the ground of metaphor" (p. 155). Certainly it does not take long to recall a multitude of bodily-based metaphors: sticky fingers, tight ass, tight lipped, belly up, hang tight, loosen up, and so many more that give us vivid ways to express what we mean. I think of all the concepts that are grounded in body level experience, yet are often used metaphorically to describe what has nothing to do with the body: empty/full, stretched/relaxed, heavy/light, weak/strong, wide/narrow, high/low, sharp/smooth, inner/outer, holding on/holding back, balanced/falling, and more. Even beyond these obvious examples, I agree that

> the primary vehicle of experience's meaningfulness is not language or any structure that is intelligible as language. Rather, it is my body as I live it, my body as it is called to action and as it is actively situated. The ringing telephone interrupts my present activity and grips my heart well before I posit that it is that long awaited call. In a conversation I have a sense of what I want to say before I have the words. What I intend to say I find lodged bodily in me. The implicit meanings of situations and, as well, my own intended meanings are felt; they are present bodily. (Shapiro 1985, p. 40)

Despite the common perception that knowledge resides above the neck, I find that my entire body is the repository for all that I know. My memories of my educational experience, like my memories of everything else, reside in my body. I remember not pictures in my mind, but sensations—even how hot my cheeks felt that day in the third grade when my teacher, whom I adored, humiliated me in front of the class. I have felt affirmed in my memories by the words of Madeline Grumet (1988), who wrote about

> body knowledge, like the knowledge that drives the car, plays the piano, navigates around the apartment without having to sketch a floor plan and chart a route in order to get from the bedroom to the bathroom. Maurice Merleau-Ponty called it the knowledge of the body-subject, reminding us that it is through our bodies that we live in the world. (p. 3)

Unless/until I know something on this level of body knowledge—in my bones, so to speak—the knowledge is not my own, but is rather like those facts one memorizes which seem to fall out of the brain the day after an exam. Further, the knowledge that comes this way is not just about my physical body or even dance, but also about the questions that I face as a person, an educator, and a researcher. My somatic self—the self that lives experience—is necessary in my struggle to find forms which represent that experience, whether those forms are presented on stage or in a scholarly journal.

I am certainly not the only scholar who has recognized the significance of somatics in research (Stinson 1995). Jill Green (1996a, b), as a somatics practitioner, also calls for such bodily awareness as a researcher. Deidre Sklar (2000) has written powerfully about the significance of such awareness in dance ethnography. Helen Thomas (2000) makes a similar point, when she calls attention to the importance of researchers'

bringing reflexive self-awareness as experiencing, moving and dancing, culture-bearers into the research arena. The consequences of not reflecting on our taken-for granted routine bodily practices can limit or inhibit our comprehension of the bodily activities of 'others,' and this once again emphasises [sic] the need to enter the embodied field with some self-knowledge. (pp. 429–430)

One particularly vivid memory of my own thinking body comes from the time when I was working on my dissertation (Stinson 1984). I was struggling with a very abstract topic: the relationship between the ethical and the aesthetic dimensions of human existence as they relate to dance education. All of my attempts to figure out a theoretical framework felt disconnected from the concerns that had initially propelled me into the study. One day, still searching for my elusive framework, I went for one of those long walks that were a necessary part of my thinking process. When I returned, I lay down to rest and instantly became conscious of how differently I perceived the world and myself when I was standing compared to when I was lying down. Within moments I knew my framework, which was based upon a metaphor of verticality (the impulse toward achievement and mastery—being on *top*) and horizontality (the impulse toward relationship and community—being *with*). I noticed how lying horizontal felt passive and/or vulnerable while the return to vertical made me feel strong and powerful; these feelings offered important insights as to why we value achievement so much more than community. Once I had identified this dual reality in my own body, I found it in the work of others: in Eric Fromm (1941), who spoke of freedom and security; David Bakan (1966), agency and communion; and Arthur Koestler (1978), self-assertion and integration. While I had read each of these authors previously, I had to find my framework in my own body before I could recognize the connection between the concepts they had identified and the issues with which I was grappling.

Another time I remember, I chose swimming for a break in between writing sessions. But one memorable day as I swam, I became aware of the excess tension in my neck. Rather than releasing my neck to allow the water to hold up my head, I was holding on as though afraid it would sink down into the water. This awareness pointed me toward awareness of other situations in which we use unnecessary control—over our own bodies or others—and I again attended within my body to try to understand why. Climbing out of the water, I realized how much we hold on in making the transition from horizontality (the dependence of infancy) to verticality (which allowed us real mobility and independence). Embedded in our musculature, generally beyond the reach of rational thought, are this impulse toward control and the fear of letting go. I realized that, as long as holding on or letting go are perceived as the only alternatives, holding on seems far preferable, because excess tension seems less dangerous than falling down or "falling apart." Only through bodywork in dance have I found another alternative—releasing into the direction of internal body relationships that facilitate movement that is both safe and free. For example, I become aware of holding in my shoulders, a frequent accompaniment to stress and anxiety in my life. I try to "let go" of the tension, but it quickly reappears. Another choice, found through what is known as "Alexander work" (Jones 1997), is to release my shoulders out to the side, which immediately gives my neck a sense of

lightness and freedom. Considering this choice within my own body helps me consider alternatives to holding on or letting go as choices for classroom management. Releasing into relationship based on mutual trust and respect would take committed work on the part of a teacher and a classroom of children, just as it has taken work for me to learn to release into lines of movement within my own body, but it could be just as productive.

Again, this is an insight that could not have arisen without attention to embodied knowledge. These incidents, and many others, have convinced me that we can think only with what we know "in our bones," and that attending to the sensory, followed by reflection, is a valuable source of such knowledge.

Extending even further the idea of the importance of the body in thinking, Maxine Sheets-Johnstone (1990) claims that the lived body is the basis for the evolution of human thought, and she finds a bodily basis for the origins of counting and language, as well as art-making. She cites extensive paleolithic evidence, concluding, "the thesis that thinking is modelled on the body is actually supported by the same evidence that supports hominid evolution"(p. 5). When she writes about the role of the body in this process, however, she is referring to

> the *tactile kinesthetic* body…the sentiently felt body, the body that knows the world through touch and movement. It is not the body that simply *behaves* in certain observed or observable ways, but the body that resonates in the first-person, lived-through sense of any behavior. It is the experienced and experiencing body. The thesis that thinking is modeled on the body thus links thinking to spatial and sentient-kinetic life. (p. 5)

Despite the number of dance-based theorists who agree with me, I must critically examine my own thinking about my body as a source of knowledge and meaning. In doing so, I am immediately struck by what is too often a large gap between my ability to understand a situation, even on a somatic level, and my ability to do anything about it. An example experienced by aging dancers is the knowledge of how to do a movement one can no longer accomplish. On a more universal level, most of us are aware of times that our feelings about a situation are getting in the way of how we want to be, but we find ourselves unable to change them. One painful example that I recall was when my anger about something in the past got in the way of a relationship, one that I desired to be warm and caring. Knowing the source of the problem did not give me the ability to rid myself of the anger. So my thoughts about using bodily-based reflection to transform the complicated web of relationships in a classroom are offered with humility. When I go into a school classroom, even though I believe in the principle of release rather than control, fear of chaos often keeps me bound within practices I know will help prevent it. I respect that some dance educators have gone further than I have in living their beliefs about liberatory relationships with children they teach (Anttila 2003).

Beyond the dilemma of translating consciousness into action, I have more difficulty in critiquing my call to recognize the role of the body in knowing and meaning making, because I cannot imagine thinking without using my whole self. How many times as I was writing this essay (and every other one), I must get up and move, relishing every bodily need that gives me an excuse to leave the computer, not only

to relieve the knot growing beneath my shoulder blade, but to allow my confused thoughts to shake down into my feet, where I may walk in them and figure out where they are going. I cannot claim to know how widespread the experience of bodily-based thought may be, only that I do not know how to think otherwise. I know from conversations with others, and from reviews of my previous work, that all scholars do not perceive their own thought process as I do mine. This is a good reminder of the danger in knowledge that derives from the body, if we assume that what we have found is more than personal knowledge. Because our bodily experiences are constructed within a cultural context, there are no universal truths which derive from them.

7.4 Conclusions

So I have learned these lessons about my body in dance: how to "feel from the inside" and "feel from the other side," how to be my own teacher, and how to pay attention to my body as a source of knowledge and meaning. While I advocate teaching them to others, I recognize that they are not a panacea for all the ills facing humankind or all the goals of education. These and all other lessons should be accompanied by the kind of reflection that I have attempted to do in this essay, inspired by the critical social theorists who call us to attend to more than our own lived experience.

Despite these disclaimers, in sharing these lessons and suggesting that they are worth teaching others, I immediately feel the same sort of embarrassment most people feel about the naked body. This embarrassment goes beyond my recognition of the limitations that I have already addressed and the realization that others will find still more within each of my proposed lessons.

First of all, there is something so mundane and ordinary about these lessons, nothing I needed a doctoral degree to discover. Someone else has already written *All I Really Need to Know I Learned in Kindergarten* (Fulghum 1989), with much more wit than I possess. And others with much more credibility than I have suggested some version of these same lessons.

For example, ever since Dewey and other progressive educators, the idea that students learn best by doing (1938) has been popular in theory if not always in practice. Even in the twentieth century, Dewey wrote words which point toward the lessons I have suggested:

> I believe that the active side precedes the passive in the development of the child nature... that the muscular development precedes the sensory; that movements come before conscious sensations; I believe that consciousness is essentially motor or impulsive...I believe that the neglect of this principle is the cause of a large part of the waste of time and strength in school work....I believe that ideas (intellectual and rational processes) also result from action... (1998, p. 233)

Dewey continued to develop his ideas throughout his life, and it is no surprise that there is still a John Dewey Society within the American Educational Research Association, a testament to their value.

More recently, Howard Gardner (1983, 1999) has suggested that the bodily kinesthetic is one form of intelligence, and a number of schools have attempted to base the curriculum on multiple intelligences as described by Gardner (Armstrong 1994; Campbell 1999). It is not surprising that elementary classroom teachers have enthusiastically sought ideas for active learning for their active young students, based simply upon their recognition that many of their students prefer moving to sitting still. For some time, I have felt concern that many dance education advocates have seemed to uncritically claim bodily-kinesthetic intelligence as the Holy Grail for the field without having a clear sense of what Gardner means by the term. Donald Blumenfeld-Jones (2004) goes even further in his critique of Gardner's conception of bodily-kinesthetic intelligence and its implications for education in a context of democracy, with particular concern for Gardner's emphasis on examples of "genius."

Another source of embarrassment arises from the historical and current context of dance in education. The origins of dance at the K-12 level as well as higher education are in physical education. For many years, and still in many schools today, dance has been viewed as simply another form of physical activity, much like soccer or basketball except that it uses music instead of a ball. In more recent years, I have been one of those dance educators seeking to build a closer relationship to the other arts, which has involved distancing the discipline from physical education. This has become especially significant at a time when the primary goal of gym class has become physical fitness rather than educating the body.

At the same time that dance has been moving away from physical education and toward a closer tie with the other arts, arts education has been moving toward a more cognitive emphasis (Clark et al. 1987; Hutchens and Pankrantz 2000), with a corresponding de-emphasis on the body, and a focus on apprehending art rather than creating it. Certainly there are many important lessons to learn in dance education in addition to ones I have presented here, and there is more to dance than the body.

But when I affirm that dance education is about not only the body, what I really mean is that it is about not only the physical dimension of the self. And yet, as I have been describing throughout this essay, neither is the body. As the ground for lived experience, for knowing myself, others, and the world we share, my body is involved in thinking and feeling as well as doing. I agree with Donald Blumenfeld-Jones, who writes,

> Whether we desire it or not, students live bodily in school…Such lived experiences may be productive of an 'understanding' or educative outcome, but only if we can become aware of our educated bodies. Aesthetic experience, because it focuses on the senses, is particularly well-positioned to aid us in coming to this experience…an experience which joins intellect and body. (1997, p. 2)

I believe that all of the lessons we teach in dance education—about creating, performing, and responding to the art—can be taught from the perspective of the lived body. Sherry Shapiro (1999), who advocates a "Critical Pedagogy of the Body…where the body/subject as a lived medium becomes part of the curriculum" (p.142), gives one example when she describes how she creates choreography in collaboration with her students, helping them use personal memory to create movement while transforming their consciousness of who they are as women.

I would even go so far as to suggest that it is time to claim education of the lived body as appropriate terrain for not just dance education, but all of arts education. The arts begin in education of the senses; seeing, hearing, feeling from the inside, are essential if one is to be an artist or appreciate the arts. To be an artist is to be one's own teacher. To be an artist is to create forms, grounded in lived experience, which express knowledge and meaning—forms that will touch others. That is why I believe that these lessons are ones that I hope we will teach young people who will be the artists, arts educators, and audiences/arts supporters of the future, who will be creating the art we live with and the world we live in.

Commentary

This chapter, like the previous one, was written at the kind invitation of Liora Bresler, editor of the volume in which it first appeared. Structured similarly to Chap. 5, it draws much more on the works of other scholars to affirm, extend, and challenge my own interpretations, as attested to by the much lengthier list of references. Following this scholarly tradition reassures me as a scholar who is always questioning my own legitimacy when I speak in my own voice, especially since that voice is much more intimate than much scholarly writing.

As with other chapters, I made minor editorial changes for this publication, but made a more substantive revision in the last sentence. Having acknowledged my journey away from telling others what they must do, I changed the statement in the original, "I believe that these lessons are ones that we **must** teach young people…" to one instead expressing my **hope** that these lessons will be taught. In that sense, it better reflects the scholar and person that I have become.

References

Albright, A. C. (1997). *Choreographing difference: The body and identity in contemporary dance.* Hanover: University Press of New England [for Wesleyan University Press].

Anttila, E. (2003). *A dream journey to the unknown: Searching for dialogue in dance education.* Helsinki: Theatre Academy.

Armstrong, T. (1994). *Multiple intelligences in the classroom.* Alexandria: Association for Supervision and Curriculum Development.

Bakan, D. (1966). *The duality of human existence.* Boston: Beacon.

Blumenfeld-Jones, D. S. (1997). Aesthetic experience, hermeneutics, and curriculum. *Philosophy of Education.* Retrieved 8 Sept 2003, from http://www.ed.uiuc.edu/EPS/PES-yearbook/97_docs/blumenfeld-jones.html

Blumenfeld-Jones, D. S. (2004). Bodily-kinesthetic intelligence and the democratic ideal. In J. Kinchloe & A. Johnson (Eds.), *Multiple intelligences reconsidered* (pp. 119–131). New York: Peter Lang.

Bordo, S. (1993). *Unbearable weight: Feminism, Western culture, and the body.* Berkeley: University of California Press.

Brady, J. (1982). *The unmaking of a dancer: An unconventional life.* New York: Harper & Row.

Buber, M. (1955). *Between man and man* (M. Friedman, Trans.). New York: Harper.

Buckroyd, J. (2000). *The student dancer: Emotional aspects of the teaching and learning of dance.* London: Dance Books.

Campbell, L. (1999). *Teaching and learning through multiple intelligences* (2nd ed.). Boston: Allyn & Bacon.

Clark, G. A., Day, M. D., & Greer, W. D. (1987). Discipline-based art education: Becoming students of art. *Journal of Aesthetic Education, 21*(2), 130–193.

Cunningham, M. (Choreographer), & Brockway, M. (Director). (1977). Event for television [Television series episode]. In *Dance in America.* Retrieved 8 Sept 2003, from http://www.merce.org:80/filmvideo_danceforcamera.html

Desmond, J. C. (Ed.). (2001). *Dancing desire: Choreographing sexualities on and off the stage.* Madison: University of Wisconsin Press.

Dewey, J. (1938). *Experience and education.* New York: Macmillan.

Dewey, J. (1998). My pedagogic creed. In L. A. Hickman & T. M. Alexander (Eds.), *The essential Dewey, volume I: Pragmatism, education, democracy* (pp. 229–235). Bloomington: Indiana University Press.

Eddy, M. H. (2000). Access to somatic theory and applications: Socio-political concerns. *Dancing in the Millennium: An International Conference.* Proceedings of a joint conference of Congress on Research in Dance, Dance Critics Association, National Dance Association, and Society of Dance History Scholars (pp.144–148).

Fischer-Horning, D., & Goeller, A. D. (2001). *Embodying liberation: The black body in American dance.* Piscataway: Transaction Publishers.

Foster, S. L. (Ed.). (1995). *Choreographing history.* Bloomington: University of Indiana Press.

Foster, S. L. (Ed.). (1996). *Corporealities: Dancing, knowledge, culture, and power.* London: Routledge.

Fraleigh, S. H. (1996). *Dance and the lived body.* Pittsburgh: University of Pittsburgh Press.

Freire, P. (1983). *Pedagogy of the oppressed* (M. B. Ramos, Trans.). New York: Continuum.

Friedler, S. E., & Glazer, S. B. (Eds.). (1997). *Dancing female: Lives and issues of women in contemporary dance.* Amsterdam: Harwood.

Fromm, E. (1941). *Escape from freedom.* New York: Rinehart.

Fulghum, R. (1989). *All I really need to know I learned in kindergarten: Uncommon thoughts on common things.* New York: Villard Books.

Gardner, H. (1983). *Frames of mind: The theory of multiple intelligences.* New York: Basic Books.

Gardner, H. (1999). *Intelligence reframed: Multiple intelligences for the 21st century.* New York: Basic Books.

Gilligan, C. (1982). *In a different voice: Psychological theory and women's development.* Cambridge: Harvard University Press.

Gordon, S. (1983). *Off-balance: The real world of ballet.* New York: Pantheon.

Green, J. (1993). Fostering creativity through movement and body awareness practices: A post-positivist investigation into the relationship between somatics and the creative process (Doctoral dissertation, The Ohio State University). *Dissertation Abstracts International, 54*(11), 3910A.

Green, J. (1996a). Moving through and against multiple paradigms: Postpositivist research in somatics and creativity – Part I. *Journal of Interdisciplinary Research in Physical Education, 1*(1), 43–54.

Green, J. (1996b). Moving through and against multiple paradigms: Postpositivist research in somatics and creativity – Part II. *Journal of Interdisciplinary Research in Physical Education, 1*(2), 73–86.

Green, J. (1996c). Choreographing a postmodern turn: The creative process and somatics. *Impulse, 4*(4), 267–275.

Green, J. (1999). Somatic authority and the myth of the ideal body in dance education. *Dance Research Journal, 31*(2), 80–100.

Green, J. (2001). Socially constructed bodies in American dance classrooms. *Research in Dance Education, 2*(2), 155–173.

Green, J. (Ed.). (2002). Somatics in dance education (special issue). *Journal of Dance Education*, *2*(4).

Green, J. (2002–2003). Foucault and the training of docile bodies in dance education. *Arts and Learning, 19*(1), 99–126.

Greene, M. (1978). *Landscapes of learning*. New York: Teachers College Press.

Greene, M. (1988). *The dialectic of freedom*. New York: Teachers College Press.

Greene, M. (1995). *Releasing the imagination: Essays on education, the arts, and social change*. San Francisco: Jossey-Bass.

Grumet, M. R. (1988). *Bitter milk: Women and teaching*. Amherst: University of Massachusetts Press.

Hanna, T. (1988). *Somatics: Reawakening the mind's control of movement, flexibility, and health*. Reading, MA: Addison Wesley.

Hutchens, J., & Pankrantz, D. B. (2000). Change in arts education: Transforming education through the arts challenge (TETAC). *Arts Education Policy Review, 101*(4), 5–10.

Innes, S. (1988). The teaching of ballet. *Writings on Dance, 3*(Winter), 37–47.

Jones, F. P. (1997). *Freedom to change: The development and science of the Alexander technique* (3rd ed.). London: Mouritz.

Kirkland, G., with Lawrence, G. (1986). *Dancing on my grave*. New York: Doubleday.

Koestler, A. (1978). *Janus: A summing up*. New York: Random House.

Macdonald, J. B. (1995). A transcendental developmental ideology of education. In B. J. Bradley (Ed.), *Theory as a prayerful act: The collected essays of James B. Macdonald* (pp. 69–98). New York: Peter Lang.

Noddings, N. (1984). *Caring: A feminine approach to ethics and moral education*. Berkeley: University of California Press.

Noddings, N. (1992). *The challenge to care in schools: An alternative approach to education*. New York: Teachers College Press.

Polanyi, M. (1966). *The tacit dimension*. Garden City, NY: Doubleday.

Purpel, D. E. (1989). *The moral and spiritual crisis in education: A curriculum for justice and compassion in education*. Granby, MA: Bergin & Garvey.

Ramsay, B. (1995). *The male dancer: Bodies, spectacle, sexualities*. London: Routledge.

Sandler, J. (1997). Standing in awe, sitting in judgment. In S. E. Friedler & S. B. Glazer (Eds.), *Dancing female* (pp. 197–205). Amsterdam: Harwood.

Shapiro, K. J. (1985). *Bodily reflective modes: A phenomenological method for psychology*. Durham: Duke University Press.

Shapiro, S. B. (1999). *Pedagogy and the politics of the body: A critical praxis*. New York: Garland.

Sheets-Johnstone, M. (1990). *The roots of thinking*. Philadelphia: Temple University Press.

Sklar, D. (2000). Reprise: On dance and ethnography. *Dance Research Journal, 32*(1), 70–77.

Stinson, S. W. (1984). *Reflections and visions: A hermeneutic study of dangers and possibilities in dance education*. Unpublished doctoral dissertation, University of North Carolina, Greensboro.

Stinson, S. W. (1995). Body of knowledge. *Educational Theory, 45*(1), 43–54.

Stinson, S. W. (1998). Seeking a feminist pedagogy for children's dance. In S. Shapiro (Ed.), *Dance, power, and difference: Critical and feminist perspectives in dance education* (pp. 23–47). Champaign: Human Kinetics.

Thomas, H. (Ed.). (1993). *Dance, gender, and culture*. New York: St. Martin's.

Thomas, H. (2000). (Dance) ethnography strikes back. In *Dancing in the Millennium: An International Conference*. Proceedings of a joint conference of Congress on Research in Dance, Dance Critics Association, National Dance Association, and Society of Dance History Scholars (pp. 426–430).

Vincent, L. M. (1979). *Competing with the sylph: Dancers and the pursuit of the ideal body form*. Kansas City: Andrews & McMeel.

Walkerdine, V. (1992). Progressive pedagogy and political struggle. In C. Luke & J. Gore (Eds.), *Feminisms and critical pedagogy* (pp. 15–24). New York: Routledge.

Woodman, M. (1982). *Addiction to perfection: The still unravished bride*. Toronto: Inner City Books.

Chapter 8
The Hidden Curriculum of Gender in Dance Education (2005)

Susan W. Stinson

Abstract The concept of the "hidden curriculum" can reveal complex issues of gender in dance education, ones which often reinforce gender stereotypes in the larger culture. The hidden curriculum, referring to everything students are learning besides what teachers are explicitly teaching, is generated through the taken for granted structures and practices of educational institutions, including dance studios as well as schools. The author suggests that federal funding guidelines and focus on Outcomes Based Education (OBE) may be hindering the kind of research needed to more fully understand what gender lessons are being conveyed in dance classes, such as those having to do with gendered behavior and appearance. It is proposed that teaching practices embodying unwanted gender messages can be changed through a process that begins with awareness and critical reflection.

When I first began teaching professional preparation courses for dance educators about 30 years ago, much of the work of school administrators involved determining what content teachers should teach and developing the curriculum through which they should deliver it. Today, the focus has shifted from what is being taught by teachers to what is being learned by students, a direction most often called Outcomes Based Education (OBE). In this essay I will discuss a curricular concept whose value has been eclipsed by OBE, and suggest that it is worth another look, especially to help us perceive issues of gender. Before doing so, it is important to clarify how OBE is shaping current perceptions about curriculum and teaching.

In OBE, educators start thinking about teaching by determining specific, measurable learning objectives, and then tailoring the curriculum to produce them. Assessment, of course, is essential to determine whether the expected results have been achieved. Outcomes Based Education approaches, with "scientific" research to document the outcomes, are now required for federal grants in education.

While OBE appears to be the latest educational trend, it seems quite close to a popular model of curriculum planning developed by Ralph Tyler (1978) in the mid-twentieth century. Critics of the Tyler model note that its rational approach leaves out much that is significant, especially moral questions. For example, it is possible to use Tyler's approach or OBE to teach anything, regardless of whether it is good or important. There are also

© Springer International Publishing Switzerland 2016 95
S.W. Stinson, *Embodied Curriculum Theory and Research in Arts Education*,
Landscapes: the Arts, Aesthetics, and Education 17,
DOI 10.1007/978-3-319-20786-5_8

legitimate concerns that such approaches often view students as the end-products of education in the same way that standardized objects are turned out by factories.

Despite these issues, there are benefits to both the Tyler model and OBE. To the general public, most appealing is the conviction that every child can learn and it is the teacher's job to make sure that this learning occurs. In an age of accountability, when corporations can figure out how to deliver products all across the globe and create the need, or at least the desire, for them on the part of the consumer, it seems that student learning should be achieved by any teacher who sets her mind to it. Legislation such as No Child Left Behind (originally passed in 2001 as an update of the 1965 Elementary and Secondary Education Act) rests on such an assumption.

The National Dance Education Organization (NDEO), in a flyer advertising a January 2005 workshop, has recognized benefits of OBE for dance educators; these include more control over student learning and the production of data that can communicate proven benefits to those that fund education as well as the general public. Such statements can easily make it appear that everything students learn is under the firm control of teachers, a claim few educators would make. Although OBE concerns itself only with whether or not explicit learning objectives have been met, students are more than passive receivers of curricular content. They create their own meanings out of what they experience in school, in the context of their own lives within a larger culture. In other words, students are learning more than teachers are consciously teaching, including many lessons outside the subjects being taught.

8.1 Hidden Curriculum: Exposing the "Taken for Granted"

The concept of the "hidden curriculum" achieved visibility through a 1968 publication by Philip Jackson. The term basically refers to everything that students are learning besides what teachers are explicitly teaching, lessons that are often generated through the taken for granted structures and practices of educational institutions. This concept acknowledges that schools do more than transmit content knowledge; they also teach social norms and values, even though these do not often appear in a standard course of study and may not be consciously intended. Even when the overt curriculum is something as value-neutral as how to do a plié, or the setting is a private studio rather than a school, students may be learning powerful lessons, including those about gender. Because these lessons are not explicitly stated in the curriculum, they are rarely examined as I will do here.

Dance teaching and learning have a long history in relation to gender. Historically, and in many cultures today, separate dances for men and women reflect traditional gender roles, including courtship and procreation. Elsa Posey, writing about the history of dance teaching and learning in the private sector, notes that "In the late 1700s, dance masters were hired to teach social graces to young men and women, thus enabling them to enter society. Ladies and gentlemen were expected to dance, and to do so with style and grace" (2002, p. 43).

In terms of Western theatrical dance, ballet has long been considered predominantly female; Kraus and colleagues reported that "by the middle of the 1840s, so

strong was the feeling against male dancers that they were eliminated from the corps de ballet whenever a justification could be found" (1991, p. 85) and females often played male roles. Eventually, star male dancers helped to develop important roles for men, but ballet's feminine identification has remained as clear as it was when George Balanchine declared that "Ballet is woman"(quoted on the cover of *Newsweek* magazine, May 4, 1964). While the image of the Balanchine dancer still predominates in ballet, there are other images of women in different dance forms. The androgynous dancer of contact improvisation and the sexy jazz dancer are only two among them.

While acculturation into appropriate gender roles and manners was an explicit purpose for the eighteenth century dancing masters (and even for ballroom dance classes during my own adolescence), I almost never hear it mentioned today as a purpose for dance education. I doubt that many dance educators in current times would advertise that they are teaching girls how to be ladies (or boys how to be gentlemen). Yet we are teaching about gender whether or not we intend to. The hidden curriculum is hidden not because teachers are being intentionally deceptive, but rather because they, as well as students, are rarely aware of it. It is just "the way things are," to which we have become accustomed.

In making the hidden curriculum of gender in dance education more visible in this essay and in my previous work (Stinson et al. 1990; Stinson 1993, 1998a, b), it is not my intention to sit in judgment of how educators are perpetuating gender stereotypes in dance. I believe that we all, myself included, are implicated, however unwittingly. A personal example unrelated to dance may make clear how complicated all this can be.

As a socially conscious mother who had read Betty Friedan (1963) and *Ms. Magazine*, I made a conscious effort to select non-stereotypical toys for my children. I could not figure out why my daughter wanted dolls instead of the trucks I tried to interest her in, although I did not find trucks especially appealing. Only when her younger brother came along did I become fascinated with the endless variety of vehicles available, even stopping to watch whenever we passed a construction site. In other words, through interacting with my children, I found myself supporting the stereotypes I had hoped to subvert. Was this because the stereotypes are based upon "real" differences between girls and boys (see Cahill 2005)? Or because my children happened to have personal interests which mirrored the stereotypes? Or because both they and I were affected by social messages beyond our level of consciousness, so subtle that I was unable to overcome them?

8.2 Gendered Behavior in Dance: "Be a Good Girl and Do What You're Told"

I recall some years ago when I was hired to teach creative dance to 5 and 6 year olds at a local studio, and was asked to be present during an evening devoted to information and registration. One parent declared that she did not want her young child to

be in an atmosphere that encouraged independent thinking. It seemed that her daughter had a proclivity for climbing on the dining room table and other such out-of-bounds activities, and the mom was concerned that creative dance classes would encourage more of the same. I was critical of this mother at the time, although when I became a parent myself, I grew more understanding. While I wanted my children to think for themselves and be active movers (and was willing to create a home with places to climb), I also wanted them to be pleasant company so that I could feel good about taking them out in public and into other people's homes. Similarly, I understand current concerns over students who are so out-of-bounds in schools that they inhibit learning, not only for themselves but also for others.

At the same time, I feel uneasy when educators are so focused on teaching children to color within the lines and follow directions that the children lose any sense of artistic voice and capacity to find their own directions. Indeed, Jackson's work on the "daily grind" of schooling revealed that experiences that can deaden a student's desire to learn may be as strong as those which can enliven it, but they are less often recognized. For example, he reminds us that, in addition to all of the wonderful things that happen (or can happen) in school, it is also "a place in which people sit, and listen, and wait, and raise their hands, and…stand in line" (1968, p. 4). Jean Anyon's work (1994), building on Jackson's, pointed out that the hidden curriculum in schools is a way to inculcate differential work habits according to social class. For example, Anyon found that schools serving students from the working class are more likely to include a hidden curriculum of passivity and docility, preparing young people to be workers who will follow directions and not question authority, while "affluent professional" schools place more emphasis on independent work and creativity. Although Anyon was looking through the lens of social class, it is possible to use the lens of gender to look at curriculum and teaching, in studios as well as schools.

8.3 Teaching Gendered Behavior in Dance

The unwritten code of a typical dance class calls for students to maintain silence except for occasional brief questions and to recognize the teacher as sole authority. Students are expected to obediently follow directions, to stay "on task," to avoid chatting with other students or attending to any personal needs except those that are most pressing. They are cautioned to leave other concerns "outside the door" so that they may put all of their energy into doing what they are told. In such classes, teachers demonstrate, after which students attempt to imitate; then teachers "correct" the students, who again attempt accurate imitation. This is a common formula for producing standardized behavior, whether it is in the dance studio, the classroom, or the factory. It can be very successful in producing dancers who are willing to follow the directions of choreographers, in short, good girls who will do what they are told, with no talking back or questions about trying another way.

While it is easy to rail against these expectations as hindering student individuality and creativity, as well as reinforcing stereotypes, one must also recognize how important they can be when rehearsal time is limited, and how successful they may be in facilitating the physical feats we demand of outstanding dancers. Becoming strong and flexible enough to fulfill the requirements of professional dance involves spending many hours in activity that is not especially creative, following the directions of teachers who are trusted to produce the desired effects.

Considering that this aspect of training (obedience to teachers) affects both male and female dancers, one must question why it should affect them differently. I have reflected previously about this issue:

> Most women begin dance training as little girls, usually between the ages of 3 and 8. Dance training teaches them to be silent and do as they are told, reinforcing cultural expectations for both young children and women. In their landmark work, *Women's Ways of Knowing* (1986), Mary Belenky and her colleagues point out that adult women are silenced much more often than men. Their analysis reveals that "finding one's voice" is a metaphor that appears frequently when women describe their own journeys from silence to critical thinking; for women, learning to think means learning to speak with one's own voice. Traditional dance pedagogy, with its emphasis on silent conformity, does not facilitate such a journey. Dancers typically learn to reproduce what they receive, not to critique or create.
>
> In contrast, most males in our society begin dance training later, at late adolescence or even early adulthood, when they have developed some sense of individual identity and "voice." Further, limits for males seem made to be broken, and dance is likely no exception. To a young man, dance training may seem comparable to military training in that the necessary obedience is a rite of passage but not a permanent state. Once he is good enough, he will then have the power to tell others what to do, to reconceptualize what he has learned, to create art and not just reproduce it. This differential impact of dance training may contribute to the differences that are observed in leadership within the dance field. Although men are a minority among dancers, they are overrepresented in positions of power and influence and as recipients of grants (particularly the largest grants) and national awards. (Stinson 1998b)

Certainly I can see many changes in the world since my own childhood, and changing gender roles is one of them. Yet quiet, obedient little girls are still usually described as "good girls," while boys who act the same may be pitied and picked on. Rebellious, risk-taking boys are more often accepted as "all-boy." These powerful cultural messages about gender reinforce ones that children receive in dance class, and vice versa. There is still much that we do not know about how prevalent such messages may be in different dance settings, and how successful they are in impacting behavior. We need researchers who will do the kind of careful qualitative observation that Jackson and Anyon did in classrooms, research that is not so popular in these times of OBE.

Especially without research, many arguments can be made in response to my critique of traditional dance pedagogy; I have raised and continue to raise many of them. Cannot dance training be about empowering women and men, increasing their strength and competence as movers? Besides, are not the early years of modern dance closely connected with archetypes of strong women? In contrast to the pretty ballerinas of the period, early moderns purposely shed the delicate and decorative image to lead the development of modern dance. In response, I think we have to ask

what has happened to our field when today there is the kind of disparity in terms of leadership, advancement, and rewards reported by Van Dyke (1992) and Garber et al. (2007). The greater "privilege" of males in dance is accepted by most women as well as men. At my own institution, like all the others I know, males are in such demand that they are almost never rejected during auditions. Due to increasing numbers of applications, we have become more competitive for women, but not for men. One might recognize that men who aspire to become dancers in a college program have personality characteristics, including a willingness to take risks, which help contribute to their success and their capacity for leadership. One might also argue that male students in dance are not fully aware of their privilege, because it is so taken for granted by both men and women faculty and peers that they come to believe that they deserve all of the rewards that come to them, both earned and unearned. Narrative research involving in-depth interviews with men and women in dance could help illuminate some of these hidden effects, but, again, such research is not particularly valued at present.

Another reasonable argument is that not all dance teaching is about silence and obedience. What about creative dance, which teaches children to problem solve and find their "own way?" Creative dance pedagogy also exists within a larger social context, one in which girls and women are encouraged to be caretakers and nurturers, the ones who are sensitive and express their feelings; males, in contrast, are expected to be strong and "tough." Because of this, boys and girls in creative dance may learn different lessons about gender.

Even beyond creative dance for children, one may argue that not all choreographers want dancers who are capable only of reproducing movement. Many seek dancers who can be co-creators, responding to improvisational prompts with imaginative movement that the choreographer can structure. What about the improvisation and choreography classes that are taught at colleges and universities? While our students spend far fewer hours in these kinds of classes than they do in technique classes, a few of them still become gutsy and inventive choreographers breaking every feminine stereotype possible in their movement. In every age, there are individuals strong enough to break expectations, and they may seek out mentors who will help them do so. One might argue, however, that such individuals succeed in spite of traditional practices, not because of them. Too often the existence of a few positive cases may allow us to continue to ignore practices which may be detrimental to the majority of others.

8.4 Gender and Appearance: "You Look Like a Dancer"

When I visit my mother's retirement community, I hear comments that I "look like a dancer." The elderly women who live there are referring to my erect carriage and relative confidence in movement, so far removed from the embodied experience of those residents with spines curved from osteoporosis and a fear of falling which dictates caution. I smile and think how different I feel there than I do when

surrounded by people who look like the image of a dancer that still exists within my own psyche, despite years of challenging it: a body far more slender, strong, and flexible than my own.

Dance is about presenting one's body, not just one's performance, for viewing by others. Dancers look at themselves in mirrors during technique classes because appearance matters. The standards by which one's appearance as a dancer is judged are not separate from gender stereotypes. I cannot remember when I first heard the direction to "grit your teeth--it looks like you are smiling." I remember the young woman who told me that she had learned how to enhance her smile for competition dancing through the application of Vaseline to her teeth. It does not take looking at many high school yearbooks to realize that a smiling expression is more highly valued for young women than for young men.

Expectations for the dancer's body below the neck are even stronger, and traditional pedagogy in dance technique class emphasizes all the ways dance students do not measure up. Criticism of one's body is an integral component of a dance class, where the goal is an unattainable ideal and each attempt is met with corrections, while students, dressed in clothing that reveals every flaw, look in a mirror at their imperfections. The body often seems to be regarded as an enemy to be overcome or an object to be judged. However, dance training merely intensifies the values of the larger social world to which both dance and women belong. In American culture, while the body is considered an adversary by both men and women who exercise compulsively and obsessively, women's bodies are more often identified as objects to be looked at and judged.

Concerns about female body image in dance have been addressed by other researchers as well, notably Jill Green (2001, 2002–2003). Eating disorders have been so common among dancers that I am sure that mine is not the only dance department actively seeking to promote health more than thinness, banning weigh-ins and scales. Green (1999) has pointed out that simply changing the image of a dancer from the extremely thin to one with the well-developed musculature that comes from weight training does not solve all of the problems, since any dominant bodily image may become oppressive.

The quintessential "Balanchine dancer" was extremely slender and appeared delicate and graceful, but possessed incredible strength and technical skill. Certainly strength is a priority for today's dancers, and athleticism is highly valued by many modern dance choreographers. The young women in the department where I have worked for over 25 years have less desire to wear frilly tutus than to lift each other and any men who venture their way. While shaved heads are less common than they were a few years ago, in many ways these dancers remind me of the bra-burning women of my own generation. One difference is that today's young women do not perceive the oppression their mothers did. The only gender inequality I hear them speak of is that a shortage of men means that ones with less talent and training than they possess have more opportunities in dance.

Indeed, despite the best efforts of many professionals in the field, the general population still likely pictures a female body when thinking about Western theatrical dance forms, including ballet, modern, tap, and jazz. "I want to be a dancer when I

grow up" is undoubtedly heard from many more little girls than little boys, and most boys who do aspire to a dance career likely elicit concerns from parents, reflecting the endemic homophobia of our culture (Risner 2002–2003; Burt 1995; Stinson 2001b). The same cultural influences that make dance seem appropriate for girls but not boys have caused harm to both, going well beyond their participation, or lack thereof, in dance. The recent concern about schoolyard violence, more often perpetrated by boys, has brought forth a number of publications (Katz and Earp 1999; Kimmel and Messner 2004) examining the cultural and psychological effects of male stereotypes that emphasize violence, gay-bashing, excessive control, and risk-taking.

Of more concern to many dance education professionals may be the sexual images promoted by much commercial dance, supported by companies supplying studio recital costumes. Many dancewear catalogs contain pages that make me embarrassed for our field, with girls and young women in sexy poses rivaling the behind-the-counter men's magazines, although with breasts and genitals discreetly covered by sequined costumes. Dawn Clark raised concerns about the way "young girls' bodies become objects for adult consumption" (2004, p. 19). Doug Risner and associates extended this concern to look at "the complicated economic and cultural structures with which private sector dance education grapples" (2004, p. 31). They report some studio owners struggling between what their students and parents want, based on gendered images they see in the media, and their own values about what is best for young people.

The so-called "third-wave" of feminists (Baumgardner and Richards 2000) may be less critical of Barbie dolls and other sexualized icons, at least for dancers old enough to make a reasoned choice, arguing that women should be able to admire and become sexual objects if they want to. While I find some logic in such a position, I think we need to explore further why the only choices available often seem to be either repressing one's sexuality or flaunting it. It is hard for teachers to figure out how to help adolescents of both genders and multiple sexual orientations negotiate a path in between these extremes if they have not done so themselves.

There are also cross-cultural issues involving sexuality in dance, inasmuch as some traditional dances are about presenting one's sexual attractiveness to potential mates. In this case, the gender lessons are intentional and explicit. When the dances are appropriated and taught outside this cultural context, however, the hidden curriculum is clearly operating.

8.5 Conclusions

If one accepts my premise that dance education inadvertently promotes hidden lessons which perpetuate stereotypes about gendered behavior and appearance, so what? Many dance teachers may not mind such stereotypes. Some may conclude that quiet, obedient dancers are the only kind they care to work with, much like school teachers who want to spend their time teaching content instead of managing

behavior problems. Traditionalists are likely to continue to teach little girls that smiling at the audience, selling the dance and themselves, is a critical part of performance. They may also continue to dress their students in dancewear I find problematic. "This is what the customers want," I hear from such teachers; they are simply responding to the market and trying to earn a living. Besides, they may continue, the larger culture is so powerful that they could not make a difference if they tried.

But what about those dance educators who want to take a different stance, who want to use dance instruction not to reproduce the status quo, but to try to change the world? Is there any hope, when even enlightened mothers find themselves buying primarily trucks for their sons and dolls for their daughters (and maybe even sequined costumes baring the midriff for their dance recitals)? As I now face questions about what kinds of toys to buy for the next generation of children in my family, I have no quick and easy answers, but only hopeful suggestions.

As an educator, I continue to believe that it is possible to transform consciousness and thus action–perhaps not for all but for some, particularly if we help educators develop reflective skills (Stinson 2001a) along with pedagogical ones. The first step is awareness that all of us are teaching gender as we teach dance or anything else. What kinds of images are present on the walls in our dance studios and classrooms, in our brochures and web sites? Who goes on the stage and what do they wear? What kind of instructions do we give? What kinds of comments do we make to indicate approval of our students' appearance and behavior? Next, we must encourage dance educators to ask hard questions about their values, and the impact of their values on students, the dance education profession, and the larger culture. What is gained and what is lost when we teach young girls to silently and obediently follow all directions, regardless of the wisdom in those directions? What is at stake when we create choreography for young students that emphasizes their bodies as sexual objects for consumption by the gaze of the audience? What message do we send when we rush to assure concerned parents that "all men in dance are not gay," implying that being gay is the worst possible fate that could befall their sons?

I hope that such reflection will reveal some disjuncture between values and actions, and a desire to teach in a way that supports values in which educators believe. I recognize that not all teachers hold the same values, and some might be in conflict with my own. I do not think it is possible to mandate values, even in my own university where students are dependent upon me for a grade. The best we can do is to ask questions designed to disturb the taken-for-granted and support those who take up the challenge. Support is necessary because we experience discomfort when we find our values and practices in conflict, whether it comes from holding values that are themselves in opposition (easy to do if we do not think about them too much) or simply not knowing how to do things any differently.

If dance educators allow themselves to live with this discomfort, they might even share such feelings with their students, helping young dancers become aware of messages about gender within the profession, inviting them to question along with their teachers. To do so, of course, is to reveal that teachers do not have all the answers, a stance which may produce further discomfort for teachers as well as for students who think their teachers should know everything. Through such sharing,

however, we may help mute the power of unwanted gender messages, just as helping children watch television commercials critically may reduce the power of the media to convince young people that they need to possess everything that is advertised. And who knows what the next generation of dance teachers might do differently if today's students are educated to recognize that they can choose whether to accept the status quo or create new possibilities, ones that even their teachers might never have considered?

The approach I am advocating – asking ourselves difficult questions that cannot be readily answered, sharing our discomfort and uncertainty with our students – is clearly not one likely to be popular in an age when control and certainty of educational outcomes are the major concerns. Its value cannot be proven through the "science-based research" required for funding from the federal government. I admit that I hope that such funding will help find answers to some of the challenges that science-based research can answer. I also hope that we will not stop asking other important questions about what else students might be learning when we are teaching dance, questions like those raised here concerning the hidden curriculum of gender.

Commentary

This chapter was generated by an invitation from Doug Risner, a former student who had long since become a colleague, who asked me to write a piece on this topic for one of two special issues on "Dance and Sexuality" he was editing for the *Journal of Dance Education.* I was reluctant at first, having decided I was finished writing about feminism and dance education, but Doug specifically suggested that I write about the hidden curriculum of gender, and expressed the hope that I would avoid the typical stereotype that "boys like dance if it is connected to sports." This challenged my own thinking as a teacher who often began classes for preadolescents with a unit comparing and contrasting dance and sports! This is only one example of how Doug has prodded me to continue to excavate my values and how to live them; his career as a scholar and educator reminds me of how scholarly thought continues to evolve, when one generation stands on the shoulders of those who came before, and is thus able to see further.

References

Anyon, J. (1994). Social class and the hidden curriculum of work. In F. Mengert, K. Casey, D. Liston, D. Purpel, & H. V. Shapiro (Eds.), *The institution of education* (2nd ed., pp. 97–109). New York: Simon & Schuster.

Baumgardner, J., & Richards, A. (2000). *Manifesta: Young women, feminism, and the future.* New York: Farrar, Straus and Giroux.

Burt, R. (1995). *The male dancer: Bodies, spectacle, sexualities.* London: Routledge.

Cahill, L. (2005). His brain, her brain. *Scientific American, 292*(5), 40–47.

Clark, D. (2004). Considering the issue of sexploitation of young women in dance: K-12 perspectives in dance education. *Journal of Dance Education, 4*(1), 17–22.

Friedan, B. (1963). *The feminine mystique*. New York: Norton.

Garber, E., Sandell, R., Stankiewicz, M., & Risner, D. (2007). Gender equity in the visual arts and dance education. In S. Klein (Ed.), *Handbook for achieving gender equity through education* (pp. 359–380). Mahwah: Lawrence Erlbaum.

Green, J. (1999). Somatic authority and the myth of the ideal body in dance education. *Dance Research Journal, 31*(2), 80–100.

Green, J. (2001). Socially constructed bodies in American dance classrooms. *Research in Dance Education, 2*(2), 155–173.

Green, J. (2002–2003). Foucault and the training of docile bodies in dance education. *Arts and Learning, 19*(1), 99–126.

Jackson, P. W. (1968). *Life in classrooms*. New York: Holt, Rinehart & Winston.

Katz, J., & Earp, J. (1999). Tough guise. Available from http://mediaed.org/videos/MediaGenderAndDiversity/Tough-Guise/studyguide/html

Kimmel, M. S., & Messner, M. A. (2004). *Men's lives* (6th ed.). Boston: Pearson/Allyn and Bacon.

Kraus, R., Hilsendager, S. C., & Dixon, B. (1991). *History of the dance in art and education* (3rd ed.). Englewood Cliffs: Prentice-Hall.

Posey, E. (2002). Dance education in dance schools: Meeting the demands of the marketplace. *Journal of Dance Education, 2*(2), 43–49.

Risner, D. (2002–2003). Rehearsing heterosexuality: Unspoken truths in dance education. *Dance Research Journal, 34*(2), 63–81.

Risner, D., Godfrey, H., & Simmons, L. (2004). The impact of sexuality in contemporary culture: An interpretive study of perceptions and choices in private sector dance education. *Journal of Dance Education, 4*(1), 23–32.

Stinson, S. W. (1993). Journey toward a feminist pedagogy for dance. *Women in Performance, 6*(1), 131–146.

Stinson, S. W. (1998a). Places where I've been: Reflections on gender issues in dance education, research, and administration. *Choreography and Dance, 5*((Part 1)), 117–128.

Stinson, S. W. (1998b). Seeking a feminist pedagogy for children's dance. In S. Shapiro (Ed.), *Dance, power, and difference: Critical and feminist perspectives in dance education* (pp. 23–47). Champaign: Human Kinetics.

Stinson, S. W. (2001a). Choreographing a life: Reflections on curriculum design, consciousness, and possibility. *Journal of Dance Education, 1*(1), 26–33.

Stinson, S. W. (2001b). Voices from adolescent males. *daCi in Print, 2*, 4–6.

Stinson, S. W., Blumenfeld-Jones, D., & Van Dyke, J. (1990). Voices of young women dance students: An interpretive study of meaning in dance. *Dance Research Journal, 22*(2), 13–22.

Tyler, R. W. (1978). Specific approaches to curriculum development. In J. R. Gress & D. E. Purpel (Eds.), *Curriculum: An introduction to the field* (pp. 239–254). Berkeley: McCutchan.

Van Dyke, J. E. (1992). *Modern dance in a postmodern world: An analysis of federal arts funding and its impact on the field of modern dance*. Reston: National Dance Association.

Chapter 9
Dance in Schools: Valuing the Questions (2006)

Susan W. Stinson

Abstract The author notes that, after 35-plus years in dance education, she is convinced that there are no final answers to the most important questions, only temporary decisions made within specific contexts, and that she finds the questions more interesting than the answers. Her questioning in this text is organized into three interrelated issues. One focuses on the query, "Whose movement are we teaching?" The second has to do with the primacy of the lived experience of dancing and implications for teaching skills of interpretation and critical thinking, while the third centers on assessment. In each case, the author critiques the common assumptions of dance educators, such as the notion that creative dance uses children's "natural" movement, and challenges many of her own core values. Rejecting the mantle of "expert," she expresses the hope that exposing and probing her own questioning process will give others courage to engage in this process as well.

It is customary at conferences for speakers to share their expertise. We learn quite early to speak only when we have answers—the right ones. But after 35-plus years in dance education, I am convinced that there are no final answers, only temporary decisions made within specific contexts. I am also convinced that the questions are more interesting than the answers. I hope that exposing and probing my own questioning process today will give others courage to engage in this process as well.

First, I need to share some context regarding the setting in which these questions have arisen. I live in a state that has more dance educators in public schools than any other in my country—a state where, for over 15 years, there have been more positions for public school dance teachers than there have been qualified people to fill them. My institution offers graduate and undergraduate programs to prepare students for these positions. Because of my university responsibilities, I do little teaching of children and adolescents myself anymore, but I supervise many teachers in schools and participate in professional organizations where I observe what and how others are teaching, and I engage in a great deal of conversation with colleagues about issues in dance education. Despite this, I certainly don't claim to speak for all USA dance educators, some of whom will undoubtedly disagree with at least part of what I will say.

© Springer International Publishing Switzerland 2016

S.W. Stinson, *Embodied Curriculum Theory and Research in Arts Education*,
Landscapes: the Arts, Aesthetics, and Education 17,
DOI 10.1007/978-3-319-20786-5_9

I also must tell you that I have a long history as a supporter of creative dance: It got me started in my career as a dance educator, and people like Joan Russell, Ruth Murray, Virginia Tanner, and Joyce Boorman have long been my heroes. I still value kids finding their "own way" in a no-failure activity in which there are no right or wrong answers, although I have also been long aware of the limitations of this approach. For example, during a session at the 1994 daCi conference in Sydney, and later in several published pieces (Stinson 1993, 1995, 1998), I looked at creative dance from a perspective of critical and feminist pedagogy. Today, I am zooming in even further with that socio-cultural lens, to raise three interrelated issues.

The first one is, "Whose movement are we teaching?" In creative dance, the standard answer to this question is that we teach students how to find their *own* movement, their own inner dancer. Historically, the only movement skills we worked to refine were what we called "natural" or "basic" human movement: skipping and leaping, twisting and turning, starting and stopping, elevating and landing, making your own shape. In creative dance classes, whenever young people mimic too much movement they have seen in the media, we gently steer them back to the movement that we call more natural and creative: the movement that we like to see young people doing.

However, when I look through a lens of socio-cultural analysis instead of my rose-colored romantic one, I have to ask why *my* movement aesthetic is better than that of urban black kids today, why the movement of what we call contemporary dance—which might be called white contemporary concert dance—is better than that of hip hop. Is it that we don't want kids to *imitate* in creative dance, or that we want them to imitate us instead of the images in the media? Sometimes we have argued that we are teaching dance as an art form, rather than as entertainment, but that distinction also fades when we look at the history of who has made the decisions about what counts as art. (For example, we know that quilt-making was not recognized as an art form for years because only women did it, and men were the art critics.)

When we teach dance in schools in the United States, we celebrate dance from diverse cultures—but rarely black urban street culture, which happens to be the same culture feeding media images. This is the culture within which many of today's school children live. Certainly some U.S. dance educators, especially in schools that are primarily African-American, embrace hip hop in their classes, or make it a treat on Fridays to reward "good behavior" during the week. Many more are comfortable teaching traditional dances from international cultures, including African Dance: Somehow its connection to another part of the world makes it more acceptable than the dance which we find in our own communities.

I struggle with this for a couple of reasons. On the one hand, while I love the energy and vibrancy of what is called urban dance at this conference, I am a frequent critic of so-called popular culture, and think that much in it is harmful to young people; I especially despair when I see young children imitating the sexualized images in the media. At the same time, I recognize that my reaction is affected by my own culture as a white middle class American woman of "advanced middle age." Brenda Dixon Gottschild in *The Black Dancing Body* (2003) helps me to see that

In the Protestant Christian underpinnings of mainstream white culture, overt use of the separate parts of the torso reads as sexually suggestive. In black diasporan culture, using the torso is not mainly or necessarily a sexual come-on, but an aesthetic value based on whole-body dancing. This helps explain why black children are encouraged to learn the latest fad dances. They are not being trained by their elders to lead a life of promiscuity, but to carry on a tradition of polycentric, polyrhythmic body fluency. (p. 104)

This issue gets even more complicated because public schools in my country are generally very conservative institutions; what is often called the "religious right" is a very strong political voice in many school systems, as it is throughout my country. Dance educators in my state have to rigorously review music lyrics to censor language and messages that any parent or school board member might find objectionable. This kind of environment makes it easy to retreat into the "safe" movement of white concert dance, especially for white female middle class teachers, who happen to be the majority of our dance educators in public schools.

In a sense, then, this whole issue can be viewed as cultural conflict. But now that we realize there is really no "natural" movement language of childhood, and that those of us who have been in power positions in dance education have simply defined what *we* prefer as "natural," how ought we to negotiate this terrain? Which aspects of dance from a child's culture—including urban street culture—should we honor and include in public school, and which aspects should we exclude? What do we do with our own biases when they feel like important core values? When are we staying current with social changes and when are we selling out to commercialism and consumerism? I do not have the answers, and I know there is not time to teach everything, but music education scholars have been debating these questions in print for some years; I wonder why there is so little dialogue about them in dance education.

In case this issue does not seem controversial or challenging enough, I will now question another core value that I have held ever since I first fell in love with dance: the primacy of the lived experience of dancing. I wanted to become a dance educator because of the way I felt when I danced. When I ask my own students why they want to become dance educators, almost all of them say the same thing. To experience oneself dancing is to be transformed.

When Discipline-Based Arts Education was popular in the 1980s and 1990s, I was most critical of its priority of developing audiences instead of developing the inner artist within each child. I did not like the idea of arts education being more about teaching kids to be consumers, even educated ones, rather than creators. I am not alone in this preference for the centrality of the experience of dancing. In the 1990s, when I worked on the committee that developed the USA national standards for dance education, it was one of our foundational beliefs as a committee. I see this value embodied in most dance curricula in American schools, which give a nod to dance history and appreciation through occasional units of study or showing of videos; it almost always feels as though teachers have tacked it onto the "core" dance curriculum of creating and performing. In U.S. schools, most of the dances students watch and respond to are ones created by their peers.

More recently, however, I have started to ask myself questions about this. How good would kids get at writing if they did little reading other than what their friends wrote? Schools care that students develop writing skills, and know that reading and writing develop together. Leaving behind skill assessment for a moment, and just thinking about what "feels good," I do not find writing superior to reading and did not experience playing an instrument as more satisfying than listening to music. Why have I assumed that the experiences of dancing and dance making are superior to the experience of watching it? I do hear repeatedly from young people that what they most like about dance class is that they get to move around, but is this because we are not as good at teaching them about ways of looking and seeing, or because of the menu of dance videos we usually show them? We know that students today do comparatively little recreational reading, but they do listen to music and watch movies. They also seem to like to watch dance videos—at least, *some* kinds of dance videos. This takes me back to the first question I raised in this address, which is really about whose culture we should be teaching.

Today, there are certainly professional contemporary concert dance companies creating work with movement drawn from a variety of dance forms, including ones in popular culture. Rennie Harris, Bill T. Jones, and Jawole Willa Jo Zollar are three U.S. companies that come to mind. There are some dances made for film that many high school dance students could probably get excited about, but finding ones that are commercially available and acceptable for showing in the conservative environment of most public schools in my country is a challenge. Finding ones appropriate for showing to younger students is even more challenging. Even at this wonderful conference, the entire day on the theme of the child audience made no mention of video, only live performance; the goals seemed to be engagement and appreciation, not interpretation. What about watching performance as a springboard for thinking about socio-cultural issues embedded in the work? Think for a moment about what interesting discussions we might have with students regarding, for example, how women's and men's bodies appear in urban dance, contemporary dance, and other forms.

I know that I am not the only person raising this issue, and some of you are doing pioneering work in developing curricular materials that will engage young people, especially adolescents, in seeing and thinking critically about dance. I am aware of Jackie Smith-Autard's work through her company Bedford Interactive, and the Accelerated Motion project that my colleague Ann Dils will be presenting today. The Music Center of Los Angeles also has some exciting materials for younger students called Artsource that can be ordered online.[1] I hope that these kinds of work will blossom and that more instructional materials will be available and affordable on the limited budgets of public school dance programs.[2]

[1] See http://www.musiccenter.org/education/Teacher-Resources/Artsource-Curriculum/ Available-ArtSource-Units/

[2] Note from 2015: At the time this was written, I never imagined the wide availability of free resources like Youtube. However, I am also aware that many schools in my area have blocked access to such sites since they contain much more than educational content.

If they do become available, will dance educators use them? How much of our very limited instructional time are we willing to commit to helping students become critical thinkers and audience members? Although ideally one would integrate experiences watching dance works with dancing and dance-making, how much time do we want children to spend sitting and watching dance on a video screen—often just a too-small television monitor? Ironically, just as some pioneers are developing good materials, concern in my country about the epidemic of obesity in young people may deter its use. I know of one dance coordinator—in the school system in my state that has more dance educators than any other—who is asking those dance educators to complete certification as fitness professionals, because she thinks that this will be necessary in the near future to save their positions from budget cuts. As legislators in my country mandate more physical activity during the school day, competing for scarce instructional time, it may become harder to justify dance classes that do not keep students in constant motion. Or does this mean that it is more important than ever for us to frame dance in education in a way that is about *more than* "expressing yourself," so that critical thinking becomes as important to us as creativity and movement?

The third issue I will raise today has to do with assessment. When I began teaching dance, and until fairly recently, all that dance teachers in schools had to think about was what we were teaching, not whether or not students were learning it. It was so much easier! Of course, memorization of facts about dance was easy to assess through multiple choice exams. In terms of movement skills/technique, we could tell by looking at students whether or not they were learning; teachers gave "corrections" to students who weren't doing the movement properly. And if they did not become very skillful, most teachers simply accepted that those kids were lacking in "talent"—and would soon stop taking dance.

With creative work, we rarely thought about assessment—we cared about students being engaged and liking to dance, and trusted that they would get better at it if they kept doing it—or else, again, they would usually drop out. We have often viewed assessment of creative dance, at least when it involved grading, as impossible or simply wrong. Most dance educators argued for years that the arts are different, and we just cannot assess student learning the way other teachers do. For dance educators who want to stay in public schools, that time is over.

This emphasis on assessment is one of the biggest changes in public education in my country. Due to recent legislation called, admirably, "No Child Left Behind," USA schools have to demonstrate, through standardized testing, that they are successful in teaching *all* children. Test results are analyzed by subgroups—such as African American males, non-native English speaking students, students with hearing impairments. If children in any one group at a school fail to achieve the established goals for several years in a row, the school is subject to a variety of punitive measures. Those of us in dance education probably should be grateful that there is as yet no standardized test to show adequate yearly progress in dance, even though the lack of one means that it becomes easier to push dance to the periphery of the curriculum or out the door altogether, because "what gets tested, gets taught."

As do many other countries, the U.S. periodically conducts national assessment of student learning in schools; ours is called the National Assessment of Educational Progress, or NAEP. Different school subjects are assessed on a rotating basis. The last NAEP assessment of arts education was in 1997. Although Dance was scheduled to be assessed for the first time, there was not enough dance education to be able to get a random sample of students, so the dance assessment was not carried out. When I read about the results of the 1997 assessment in music education, I wonder if this might have been for the best.

In a 2004 address to a national organization of music educators, music educator and scholar Judith Jellison (2005) spoke about her disappointment in the findings of this assessment, even as she acknowledged the limitations of the procedures, which involved scoring students in three areas: creating, performing, and responding to music. Jellison noted that average scores in responding to music were 50 % or lower in all age groups, hardly a "passing grade." Scores for both Creating and Performing were even lower, averaging 34 %. Even for students who reported playing in a band or orchestra or singing in a chorus, scores were in the 40-50 % range for Performing and Creating. Further, Jellison wrote,

> For the 91 percent of the population who received music instruction, their scores on the assessment were *unrelated* [my emphasis] to the frequency of music instruction or whether a full-time music specialist was teaching music. Students' scores were also unrelated to the presence or absence of required district or state arts curricula. (p. 32).

Music education has been in schools for generations, so they have had a long time to figure out how to do it right. If there had been enough dance students to assess, would we have looked any better?

Jellison concludes that music educators are being asked to do too much, and takes a stand that music education in elementary schools—essentially up to age 11— should emphasize "competent, confident performance" (p. 35). At first glance, this emphasis seems in conflict with my concern about teaching more than studio work. However, Jellison's vision of teaching music performance is a broad one, in which

> children have frequent opportunities to learn a varied repertoire of music and have frequent opportunities to sing and play instruments expressively and with technical accuracy, alone and…in large and small ensembles…Where children develop skills of reading and interpreting music through singing and playing instruments. Where they become discriminating listeners and have frequent opportunities to make independent musical decisions and evaluations of their own performances as well as the live and recorded performances of others. Where they practice using the language of music to express preferences and describe and analyze music they perform. Where they have successful experiences leading to feelings of self-efficacy, and where children come to develop personal values and attitudes about the importance of music in their lives. (p. 34)

Jellison states that "these goals are attainable at all elementary grade levels if teachers make appropriate decisions about music literature, tasks, and contexts" (p. 34). With the amount of time typically given to elementary *dance* instruction in schools that have it (30–45 min per week is typical in my country), I wonder if comparable goals could be attained.

All of this can be quite depressing to think about. We can easily argue that the kinds of assessments we have been able to develop do not measure what is most important in learning, and undoubtedly this is true—not just in the arts, but in schools generally. It is pretty easy to measure short-term, relatively trivial knowledge in short answer tests that can be scored by a computer. Whenever I see or create rich, layered rubrics that truly reflect the complexity of the art form, I find that they are incredibly time-consuming to use. For movement work, in particular, teachers simply cannot observe 25 children moving in space at one time and be able to discriminate finely enough to assess them all on a 5-item rubric with a score of 0–5 on each. The portfolio approach advocated by Howard Gardner and his many followers (see Castiglione 1996) seems very appropriate for longer-term assessment, but what about for the dance educator who teaches 500–1000 young children? How much time do *we* want to spend in front of VCRs? And once we do the assessment, what do we do with the outcomes? How do we use the assessments to help students learn better?

Undoubtedly some of you live in countries that have this issue relatively figured out, and the rest of us could learn from you. I know that the U.K. is far ahead of the USA in developing assessments of school-based learning, and it appears that the high school dance curriculum there is more rigorous than in the tiny minority of U.S. schools that offer dance education.

But while I find assessment a very challenging issue for the field, I still find it intriguing and important. Asking myself questions about what I expect students to learn as a result of a course, and how I know that they have learned it, makes me a better teacher, even when I don't have the answers.

To conclude, what has made my career in dance education so engaging, and what keeps it that way, has been asking myself questions that don't have easy answers, questions that make myself (and sometimes other people) uncomfortable. If I could give one gift to each of my students, it would be willingness to ask those kinds of questions and to appreciate the discomfort of thinking about them, because this is what eventually helps us grow as individuals and as a profession. After all, if we are too comfortable sitting where we are, we aren't very motivated to go anywhere else.

Commentary

This chapter was written for a keynote panel at a daCi conference in The Hague. It is the most open of any of my work in revealing my unanswered questions. Perhaps I thought I had attained enough stature in the field that I could be very "out" regarding my uncertainties; as I stated, I hoped it would free those in the audience to risk revealing their own questions. I vividly recall a touch of embarrassment when others confidently claimed in the discussion following the panel how they had so easily resolved the issues I raised, and my subsequent awareness of the risk to my ego in what I had done. No wonder such openness is still not common in keynote addresses!

In reflecting now as to why I consider questions about what we *should* be teaching in arts education to be more important than answers, it is partly because assuming we have found the right answers to such questions gives us permission to stop thinking about them. I don't think there are decisions about curriculum that are always "right." We have to make decisions in order to teach, but, as I have said elsewhere, a decision to teach one thing means a decision not to teach something else, or at least to teach less of it. Staying aware of what we have given up as well as what we have gained by making a decision helps keep curriculum open to possibilities for change as we, our students, and our society continue to evolve.

References

Castiglione, L. V. (1996). Portfolio assessment in art and education. *Arts Education Policy Review,* *97*(4), 2–9.

Gottschild, B. D. (2003). *The black dancing body: From coon to cool.* New York: Palgrave Macmillan.

Jellison, J. A. (2005). It's about time. *Arts Education Policy Review, 106*(5), 29–36.

Stinson, S. W. (1993). Journey toward a feminist pedagogy for dance. *Women in Performance,* *6*(1), 131–146.

Stinson, S. W. (1995). Uma pedagogia feminista para dance da crianca (I. Marques, Trans.). *Pro-Posicoes, 5 3*(18), 79–91.

Stinson, S. W. (1998). Seeking a feminist pedagogy for children's dance. In S. Shapiro (Ed.), *Dance, power, and difference: Critical and feminist perspectives in dance education* (pp. 23–47). Champaign: Human Kinetics.

Chapter 10
Questioning Our Past and Building a Future: Teacher Education in Dance for the Twenty-First Century (2010)

Susan W. Stinson

Abstract Through description, historical autobiography, and reflection, the author charts for readers an experiential archive of postsecondary dance education during the past three decades. She begins with the state of the field before 1980, looks at how the world has changed since then, and questions the extent to which the field has changed in response. She wonders how the perceived need for constant advocacy might have kept the field from rigorous examination that is critical for continued growth. Through asking difficult questions and thinking critically about her answers, the author examines positions and practices from the past, including methodology, content, standards, and assessment, and re-evaluates them in light of twenty-first century changes and challenges. In revealing how one individual has navigated some critical issues in dance education over a long career, this piece demonstrates how change can occur on the micro-level.

I became a teacher because I wanted to make a difference in the world. Why a dance teacher? I loved the way I felt when I danced, a discovery that I had made when beginning dance study as a senior in high school. I wanted to bring that to others, to help them find a part of themselves they didn't know existed (see Stinson 1982). I started teaching dance to children in 1968, at one point holding six part-time jobs. In reflecting on my youthful idealism and early career, I can recognize more than a touch of middle class privilege: I had a family who supported me through college and a spouse who provided similar support until I finally got a full-time job with benefits.

In 1979 I began a tenure track position in dance education at the University of North Carolina at Greensboro. Below are some brief recollections from that time. I have consciously chosen to write these as *I* statements, being more willing to implicate myself than others. At the same time, I am confident that most of what I report of my own practices and ideas was widespread.

- I thought I knew how to teach. I must have been good or I wouldn't have been hired.
- It was my job to decide what needed to be taught, with no need for accountability to external agencies.

© Springer International Publishing Switzerland 2016
S.W. Stinson, *Embodied Curriculum Theory and Research in Arts Education*,
Landscapes: the Arts, Aesthetics, and Education 17,
DOI 10.1007/978-3-319-20786-5_10

- I taught my students as much as possible of all I knew about teaching dance. If students didn't learn, they must not be smart enough or talented enough or motivated enough.
- My class syllabus was a few pages long, and included no grading criteria. In class, we did various activities and discussed them. Outside of class, I expected students to read (mostly library books or ones they purchased) and to write papers and lesson plans for their field experience teaching. Primary readings were by dance education pioneers including Gladys Andrews Fleming, Margaret H'Doubler, Ruth Murray, Joan Russell, and Virginia Tanner.
- All members of the dance faculty were white women, a fact which we never discussed. Almost all of our university students becoming dance teachers were young white middle class women.
- Dance in K-12 educational settings consisted almost entirely of creative dance (often called creative movement, especially in the South or other places where there were religious objections to dance). Teaching young students to dance well was the job of private studios. There was almost no opportunity for students to see dance or to learn about dance in other times and places except by reading a dance history book. There were very few films available; there were no VCRs to record the rare dance performance on television, and no computers.
- Clear lines were drawn between dance as art and other kinds of dance (called *ethnic* or *folk*). Dance as art was mostly about the artist and his/her personal vision, and creative dance was centered on the child as creator. Although I attended the 1979 daCi conference advertised as featuring the child as Creator, Performer, and Audience member, *creating* was still primary in educational settings. Dance that celebrated being part of a community or culture was largely off my radar screen as a dance educator. I went to cultural dance events and took workshops, but knew I was an outsider and trusted that students would learn these forms as needed within their own communities.

It is embarrassing to admit this. I was naïve then, and am old enough now to realize it. The world has changed drastically since I began teaching dance educators. At that time, I held only an MA degree, so would not be hirable for my position today. Further, when I started teaching, I didn't come close to reaching the standards that today's students must meet to become licensed dance educators.

But it's not only the standards that have changed. The entire world is a different place. How much have our dance programs changed to keep pace? How much do we keep on doing what we know how to do--so we feel competent and right and avoid uncertainty? How much energy do we spend justifying our existence in the face of continuing lack of security for teachers (ones lucky enough to have positions in the first place), the lack of prestige for dance generally, the loss of dance audiences except for family and friends, and the competition with popular culture, including video games and the internet?

We often seem to spend so much of our time asserting our competence and justifying our existence that we may not take the time to reflect upon what matters most to us and whether the paths we are pursuing are in line with those values. However,

we have seen over and over again in the history of our country and the world how easy it is to start along a path and then keep blindly upon it, without ever asking, "Why are we still doing this? Is this where we want to be heading? Who is losing and who is gaining from these choices?"

Of course, all individuals in our field do not have the same values. While consensus on values is not possible, I continue to encourage us to consider our values and whether we are living them (Stinson 2001), even though questioning the fit between our values and our practices can be quite uncomfortable. After all, with each choice we make, we are giving up some possibilities in order to embrace others. Maintaining awareness of what we are giving up as well as what we are gaining means releasing the need for certainty that our choice is the only right one. Such a stance is admittedly easier to accept as an individual than as an organization striving to write a Strategic Plan and apply for funding. Further, it is more comfortable to reflect privately than to engage in discourse with others who hold different values and try to convince us we are wrong; this is especially true for many of us as women who have cultivated our politeness and dislike for conflict to such an extent that we often avoid the kind of rigorous debate that could help the field grow.

In this essay, I will engage in the kind of public reflection which I believe is essential to our field, describing how some of my own ideas have evolved through asking difficult questions and thinking critically about my answers. In doing so, I hope to encourage others to participate in this process, even if they reach different conclusions.

10.1 Constructivism and Collaboration: From Belief to Practice in Teaching Methods Courses

Believing that knowledge is actively constructed by learners rather than simply passed on from teachers, I have called myself a constructivist for many years. More recently, though, I began to realize ways in which my teaching was not very constructivist. I was spending much time in undergraduate methods classes demonstrating my favorite and most successful techniques for teaching children and adolescents, discovered and fine-tuned through multiple failures. Ones that I did not have time to demonstrate, I described through colorful stories that were very well-received. I hoped to save my students from some of my own blunders, and indeed, by graduation they were teaching better than I was after 5 years of experience. My course evaluations were strong. Some of my former students continue using those well-honed and still successful strategies. Certainly passing on the best from master to student is a time-honored technique in teaching, perhaps especially in dance.

It is always hard to question successful practices. However, although I could not have admitted it earlier, I started to realize that in some ways I was really attempting to replicate myself. Perhaps it was my sense of success that delayed the constructivist shift in my methods course that I had made earlier in other courses. I was also becoming aware of how little I fostered the kind of collaborative skills needed in

twenty-first century teaching and learning (Partnership for 21st Century Skills 2009), even though I claimed to value community as much as individualism in education. Professional workshops followed by a summer immersing myself in reading about collaborative and team-based learning in higher education (Barkley et al. 2005; Michaelson et al. 2004; Millis and Cottell 1998) helped me begin to change how I was using instructional time.

My undergraduate students now spend a significant amount of time in class working in small teams on major projects (one or two projects per semester). Following guidelines in the literature, I try to create meaningful projects that are hard to just divide up and complete individually, ones in which they can readily recognize the advantages of collaboration. To show that I take it seriously, I give substantial amounts of time in class for teams to work together, while I circulate among them to offer suggestions and challenges. In some projects, such as one described in the next section of this essay, students collaborate throughout the planning phase but then turn in an individual version of a project. In others, such as a team-created unit plan for a specific age group, the final project is a collaborative one. In both cases, I evaluate students based on their peer support as well as rigorous expectations for the final project. In almost every project, most students have helped each other stretch to accomplish far more than they could have done individually, and sometimes gone beyond what I could have created.

My job as teacher educator has transformed not just from being a "sage on the stage" to a "guide on the side"; rather, I like the phrase used by Erica McWilliam (cited in Risner 2009), of "meddler in the middle." A lot of my "meddling" comes in creation of challenging assignments that help students not just apply what they already know, but think critically about their beliefs and practices. More comes from pushing students to ask questions they may not have considered, coaching them to create and critique ways of teaching dance in a constantly changing world.

This radical change to team-based learning initially terrified me, and still leaves me with concern over those great strategies that I no longer pass on. I share with students my discomfort at trying something new and why I am doing it anyway, telling them that I hope it will give them courage to learn new ways of teaching even when they become as old as I am. I also hope I am modeling for them the ability to question their own ideas and practices in relation to their values and those of others. I discuss with them aspects of my teaching that are less successful, so that they can recognize that difficulties are part of any change. For example, I am still learning how to cope with dysfunctional groups. Occasionally a student will state that she could have done better work on her own. Even when strong students give up some of their own better ideas for the sake of compromise and inclusivity, however, they recognize what they have learned about the collaborative process, and that working collaboratively in learning communities will be part of their teaching career. The days of the solo teacher laboring individually behind classroom doors (or auditorium curtains) is coming to an end, and students are recognizing that they need to be prepared to be teachers in this new era.

10.2 From Pleasant Discussion to Engagement in Intellectual Discourse

Most students start out thinking about teaching as a purely practical endeavor, not an intellectual one. I have long taught a foundations course to undergraduate dance education students, introducing them to other people's ideas about teaching dance. Up until fairly recently, I used a time honored approach: assigning them to read articles mostly written by famous dance educators, and then discussing them in class. I used a variety of strategies to get them to do the reading, including selection of engaging material. However, I began to grow increasingly tired of reading response papers by students who knew only how to agree or disagree with ideas that jumped out upon superficial reading. Most were using the readings simply to solidify their own opinions, not to challenge them. Blaming the limitations of today's college students would not have helped; instead, I knew my teaching of this course had to change.

I asked myself *why* I wanted students to read these materials, and decided that I wanted to prepare them to participate knowledgeably in critical discourse about ideas shaping the field, and to clarify and question their values, recognizing their possibilities and limitations. I identified what I called the "Great Debates" about teaching dance that I see as ongoing among professional dance educators:

Considering that time is limited, and it is not possible to accomplish everything in any particular program…

1. What dance content should be taught? What is the relative importance of

 - Learning to dance/perform?
 - Developing dance-making skills?
 - Learning about dance and how to watch it intelligently/critically?

2. Whose dance/what kind of dance should be taught? (White Western dance forms or other global forms? Forms identified as art, entertainment, recreation, other?)
3. What is the primary purpose?

 - Developing skills and knowledge in the subject of dance?
 - Identifying and training the talented?
 - Developing creativity?
 - Developing personal and social skills? Academic skills?

4. Who should dance education be for? Who is being encouraged, and who is being left out? (Think about gender, socio-economic class, culture/ethnicity, and other differences)
5. How should it be assessed?

 - No formal assessment; emphasis on participation and enjoyment?
 - Assessment through formal auditions and placement classes, to select students for higher level classes, special opportunities for the talented, and roles in performances?
 - Formal and informal assessment as an important part of the learning process, to help students and teachers understand what students are learning and help facilitate learning for all students?

I share these questions on the first day of my undergraduate foundations class. Throughout the semester, students work in teams, analyzing readings to infer authors' positions on the great debates and compare them to their own positions and those of their peers. I model asking difficult questions and they practice challenging each other as to whether the evidence cited supports the position they claim for an author. (This kind of challenging contributes to their score for "peer support.") While some are bolder than others during their team discussion, all quickly realize that sharing their analyses in creation of a group template gives them a stronger basis for their individual final assignments: Each student envisions a dance program that would actualize her/his own positions on the great debates, then draws on the group template to compare those positions to those of different authors. Further, students are expected to use their analyses in critiquing their own positions, not just defending them.

The quality of students' analytic thinking has increased a good deal with this change. In self evaluations, students also report that they have increased their ability to participate in grounded discourse about important issues in the field. I hope that this process is developing future educators who will be able to engage in the kind of reflexivity—thinking critically about their own ideas and those of others—that I believe will help move the field forward.

10.3 The Content of Dance Education: From Creative Dance to More

As noted previously, I came into dance education when that meant, quite specifically, what was called creative dance or creative movement. Young students explored, and they made up dances which they showed to their class peers and periodically to a larger audience. This is a very constructivist process, and meaningful to children, but the final products were often not especially interesting to watch. This is not surprising. After all, could a *professional* choreographer, even with skilled dancers, create a "good dance" in 30 minutes? And good dance was not the point anyway. The point was to nurture children's creative expression. My sense today, however, is that creative expression is necessary but not sufficient for dance education.

10.3.1 Technique and Performance Skills

The experience of dancing can be transformative (see Bond and Stinson 2000/2001), and no dance education or training is necessary to have such an experience: just witness young children dancing to music in a park, or adolescents losing themselves in a crowd of gyrating bodies. To dance well, however, is not only transformative but empowering.

I did not initially recognize the significance of becoming a skillful mover. Like many of my colleagues, I romanticized the "natural movement" of the young

child and did not want to impose. As I observed my own children's pride in their developing skills and achievements, however, I started to question my previous position (Stinson, 2002). I remembered how I sought out technique classes when I needed to learn how to balance in order to create a dance with a balance in it. I noticed too, how many children eventually stop wanting to participate in dance, or other art or physical activities, because they perceive their lack of skill. And I admit I got bored watching children simply "mushing around," which is how I describe their wandering through space with arms floating around them, supposedly "exploring," but responding in almost the same way to a variety of prompts.

In contrast, our dance majors who have come through dance studios have developed their dance skills through long hours of repetitive training. I do not dispute such training as the route to becoming a master athlete or master dancer, especially in highly complex dance forms. At the same time, I know that even beginning students can develop foundational skills which will help them better implement their creative ideas. I still think Mary Joyce's 1984 book *Dance Technique for Children*, though long out of print, is unsurpassed as a source, and readily adaptable to beginners of all ages. Offering wonderful ideas for teaching conceptual skills that appear in many different dance forms, such as "moving from center," "articulation," and "opposition," it is well worth a search for a used copy.

To go beyond following a book (even a very good one) or just passing on the exercises and corrections from one's own teachers (which can sometimes be problematic if one ignores new discoveries about the body), teachers need to analyze movement on a bodily level before attempting to teach it. I am always exhorting beginning teachers to get out of their seats in order to create lesson plans: "What is going on in your body as you recover from that fall? *How* do you get yourself around in that jump? Don't just repeat what your teachers told you—what are *you* feeling in *your* body?" Their own somatic sensibility is an essential tool in teaching, helping them create images or other cues that will help their students feel the movement from the inside.

10.3.2 Skills of Dance-Making

I have often found dance educators who assume they are teaching choreography when they give students an assignment to "make up a dance," as long as it includes other requirements such as "have a beginning, middle, and end" or "use levels and pathways." I used to agree with them, and this was reflected in dance education courses I taught.

My change of heart was probably stimulated again by boredom, from watching too many dances made by students wanting to express themselves without concern about engaging an audience. While this is charming in young children, it becomes less so as children get older. So I started asking, "How can we help students develop a choreographic eye, to start to *see* the movement that is in

front of them and consider how to make it more interesting to watch?" As we do so, of course, we must acknowledge that everyone does not find the same things interesting: There are individual, cultural, and generational differences that shape our perception.

Further, if we are worthy of the label of *educator*, we do not want students to simply repeat what they already find interesting. The task of a teacher is to help students not only see, but see *more*, and to see with different lenses. In order to do this, we must expose them to more than the dances of their peers and ones they see on popular media, and we must help them think critically about what they see, how they make meaning from it, and what they value.

10.3.3 Watching Dance Thoughtfully and Critically

I observe many dance educators showing occasional videos, often preceded by a presentation of facts about the dance and/or the choreographer, and often with the expectation that students will take notes or complete a work sheet. In most cases, students appear to be far less engaged than they are when dancing.

When I began my dance education career, opportunities to observe dance were rare unless one lived in a major dance center. I loved attending live performances by professional companies, but found my own experience of dancing to be more compelling—so I would watch from close enough to feel myself moving along with the dancers. This is part of why, when Discipline-Based Arts Education (DBAE) became a powerful force in the field during the 1980s (Getty Center for Education in the Arts 1985), I heartily disagreed with its emphasis on appreciating objects of great art; to me, the kinesthetic experience was much more important that the choreography itself.

Despite my discomfort with DBAE, I have long advocated critical thinking in dance education. However, in the past decade I began to realize how little critical thinking I used as an audience member. Today, a large portion of the American population gets excited watching dancers on popular media shows, but how can we educate students, so they can get beyond "Wow" to critical thinking?

Through some collaborative teaching with my UNCG colleague, dance historian Ann Dils (Dils and Stinson 2008; Dils and Stinson with Risner 2009), I have started seeing dances as not just aesthetic objects created by individual artists, but also as cultural artifacts that both define and challenge cultures—a blind spot in my previous perception. I now perceive performances (live and on video) as a jumping off point for exciting questioning. For example, in "Circle Walker," a piece by Alan Boeding included in the curricular project *Accelerated Motion* (Wesleyan University Press 2007–2009), the buff male dancer in the circular metal sculpture raises not just questions about bodies and machines, controlling and being controlled (questions prompted in *Accelerated Motion*), but also others about bodies in our culture. Helping my students think about showing this video to middle schoolers, I encourage

questions like, "Is he dancing or just showing off his body?" "Would your perception of this piece change if it were performed by a large middle aged woman?" "Do we look at bodies in dance the same way we look at them in other settings?" I still like to sit up close and feel the dancers when I watch a live performance, and think that this kinesthetic experience can offer us many clues to understanding a dance, but now it is more of an entrance to experiencing the dance than an ending to that experience.

Further, this socio-cultural lens now seems to me appropriate for teaching all dance content. I hope that, when my students teach pliés, they will acknowledge that there are different ways to think about bending one's knees, and those ways are rooted in understanding the body in relation to the earth, not just biomechanics. When they teach dance-making, I hope they communicate that the artist does not own the meaning of a dance, and what an audience makes of a dance is as important as what it means to the creator. I hope they also teach that not all dances are created by individuals and not all viewers have the same aesthetic values. And I hope they make thinking about dance as meaningful and challenging to their students as creating and performing.

10.4 Standards and Assessment

I didn't always think Standards were important. Like many other caring educators, I was concerned that an over-emphasis on achievement was destructive to self esteem. When first asked to serve on a committee to write K-12 National Standards for Dance (Consortium of National Arts Education Association 1994), I was reluctant because I did not think that higher standards would be a source of meaningful educational reform. Nevertheless, I agreed to serve on that committee and have contributed to multiple efforts in writing state and national dance standards since then.

My sense was and still is that clear and high standards are good motivators for achievement, for those students who believe in their ability to reach them *and* see them as worthy of their time and effort. Those, however, are not the students who are underachievers in our schools. My collaborative research with Karen Bond (Bond and Stinson 2007) has helped me further understand why high standards do not work the same for all: We found some students who did not commit full effort because they perceived dance as too easy, and others who resisted because they perceived dance as too hard. Overall, the findings of this study, including experiential accounts by young people and review of scholarly literature on intrinsic motivation, revealed three triggers for commitment to the hard work necessary for reaching standards. One is emotional connection/personal interest in the subject matter, characterized by students who proclaim, "*I love to dance!*" Teachers can help students reach standards by sharing their own love for dance and helping students find a personal connection to the content; for those students who do not like dance despite our best efforts, we can offer respect and appreciation for their other interests.

A second trigger for engaging students in rigorous learning is offering challenges not too far beyond skill level, and encouraging the belief that effort matters more than "talent." A third is providing a sense of autonomy and personal control, especially in setting standards and assessing the degree to which they have been met. I am still concerned about student self esteem, but now I think that being a caring educator means not avoiding standards, but helping students to adopt their high own standards and appreciate their sense of accomplishment in meeting them.

10.4.1 Assessment

I long resisted outcomes-based assessment for good reasons, including the moral consequences of considering only how to produce effective outcomes at the lowest possible cost. In a recent paper reflecting on this dilemma, however, I also acknowledged how being forced by my University's accrediting agencies to look at data-based outcomes has generated some important insights I might not have come to on my own. As an example, I wrote,

> It was the demand for evidence of student learning that made me realize: just because we teach and students are totally involved doesn't mean they have learned what we think we are teaching. With much humility, I began to recognize that occasionally students even learned the opposite of what I thought I was teaching.
> Eventually I decided it was not a bad thing to ask, "How do we know what students are learning in dance?" …. [Indeed, it] is quite tempting to simply look for what we want to find. I now find myself just as intrigued by students who don't like dance, who don't participate fully, who don't appear to learn much even from teachers I consider top-rate. I am now fascinated by those among my university students who just want to continue doing what they already know how to do, those who don't find learning about dance education to be worth the effort, and those who don't make breakthroughs even though they seem to be trying. (Stinson 2009, p. 196)

I am fascinated with the students with whom I am less successful because they push me to go beyond what I already know about teaching. Further, the effort involved in figuring out how to assess student learning pushes me to ask how important it is that students learn what I am trying to teach. I have moved beyond resisting formal assessment to recognizing how it can not only help teachers become more effective so that students will learn better, but also help us consider what matters most in the dance curriculum.

10.5 Conclusions

The thoughts above have focused on some areas of change in my thinking over my career, but cannot be viewed as an inclusive summary of what I believe and practice now. One important area omitted here has to do with diversity among dance student and faculty populations and its relationship to social justice. In a recent publication cited extensively by Pam Musil (2010), Risner and I (2010) discussed these issues in depth.

Recognizing how my own beliefs and practices have evolved makes me hesitant to proclaim any final truths, even for myself. At the same time, I recognize the dangers of relativism. As my mentor David Purpel reminds me, "critical thinking and self expression….can be vital resources in the struggle to create a life of meaning," but without a moral compass "they are only neutral techniques capable of enabling good or evil" (Purpel 1999, p. 248). Always, we must consider the kinds of lives and the kind of a world we are helping to create.

I am certain at this juncture that, as we prepare teachers for the challenges of the twenty-first century, it is not enough for any of us to teach the kinds of dance we already know to the kinds of students we have taught in the past, in the kinds of schools we used to attend, using only the same methods with which we feel comfortable. I still think that life skills (see ACT 2010) students can learn in dance (concentration, focus, self discipline, working hard to achieve a goal, being your own teacher, being fully alive and present, problem solving, making connections, seeing relationships, collaboration) are more important than any dance content we teach. Yet I also am convinced that the best way to accomplish these goals in dance is to emphasize rigorous content at a level of appropriate challenge, sharing our love for dance as well as our caring for students and our determination to help them create meaningful lives. I am also convinced that we need to prepare dance educators to think critically about the issues they will face and their own response to them, and help them see that dance can offer intellectual as well as physical challenges. Future dance educators will need to create their own responses to new challenges, and they will need to work collaboratively with others in doing so.

We must teach our students that the world, including the world of dance education, can be better than it is, that we don't have to do things the ways they have always been done, that one person can make a difference. Change is often terrifying, especially when we are not absolutely certain we are right—but we can be courageous. As dancers, we know that each of us must start where we are, but stay flexible, taking one step and then another into the unknown.

Addendum

In reading the papers of other authors in this issue, I am struck by my own emphasis on personal transformation, as contrasted with their recommendations for organizational leadership and institutional change, recommendations with which I agree. Certainly both personal change and social change are important. As I have indicated in this essay, external developments and mandates have prompted some important shifts in my own practice. I think that NASD accreditation standards could help drive the field toward a more expansive view of dance curriculum in higher education, a curriculum more responsive to the world in which our graduates will teach. So will mandates from our local institutions, which are becoming increasingly responsive to demographic and economic shifts. At my own institution, for example, there is increasing interest in dance teacher licensure from prospective students at both graduate and undergraduate levels. While I feel concern about the university

becoming even more about job training and less about liberal education, I am conscious that the former can provide support for dance education initiatives. Further, my university's most recent strategic plan includes goals related to diversity, services to underrepresented populations, and more intercultural experiences for all students; these could prompt other curriculum changes such as those called for in this special issue of *JODE*.

Musil encourages shared conversation with those who are not already at the dance education table, while acknowledging "the challenges involved in bringing a diverse faculty, some more invested in education than others, to conversation about issues that some have previously been unwilling to consider. The path toward such discourse can be both delicate and thorny" (2010, p. 118). I too work in an environment where there is tension between the kinds of conflicting values referred to by other authors, one in which greater attention and resources go to the BFA and MFA students and programs. After 31 years, I have had little success in convincing some of my colleagues that dance education is as important as choreography and technique classes and that the pre-college age population should be of interest to *all* of us in dance. Each of us is convinced that what we do is important. For me to argue that more value be placed on dance education can readily be seen as self serving. Even when I have had opportunities for more influence, such as when I was Department Head, my own ambivalence about power and fear of abusing it kept me from privileging dance education.

I also admit to a dislike for conflict, despite my recognition that no change comes without some degree of tension. It is more pleasant to look for changes I can make on my own, in my own classes, than it is to argue with colleagues. It is also easier, and my own energies are too often drained by coping with the "onerous and rigid licensure requirements of the K-12 model" described by Risner (2010). I wonder if I have too often settled for the easy way, and not been creative enough in seeking ways to invite some of my colleagues to grapple with the same issues that I do. I wonder when the decision to debate less and just do what I can is a rational choice to conserve energy, and when it is simply a coward's choice, fueled by fear of losing the argument and being obligated to support another policy I question.

After so many years in higher education, I know that, although changes sometimes start with winning arguments and passing new mandates, these approaches are never enough. We all know plenty of policies, both helpful and harmful, that get ignored or barely followed; indeed there are a few at my own institution which I cannot morally support and look for legitimate ways to subvert. Ultimately, I think we need all dance teachers (including those of us who consider ourselves on the "right side" of these debates) to seriously consider the issues discussed here, without being locked into the standard positions to which their/our own experiences have brought them/us. I am not arguing that we should give up our commitment to justice and equity when we listen to others with different views. However, just as David Brooks (2010) has pointed out the need for political figures and the general public to be more skeptical about their own thinking, dance educators need to do this as well. We can support this skepticism by teaching metacognitive skills to our students and modeling them in our interactions with others, as well as in our publications and presentations.

Of course, questioning one's own thinking and practice, as I have done throughout this essay and many others, can sometimes leave one in a position of weakness when gathered around a table with others who are not doing the same. I have taken my stance for reflexivity not because it has helped me win debates more often, but because it has helped me be the kind of person I could live with during a long career.

As Risner and I recently wrote, "change occurs slowly, and can be demoralizing for those who start with high ambitions," yet "as dance students, we [have] learned that many skills develop slowly, over time, and injuries and other set-backs are commonplace" (2010, p. 10). I know that changing postsecondary dance education will be a slowly evolving dance. But we need to keep dancing, even when it gets difficult, and to do so with creativity, integrity, and humility.

Commentary

This chapter represents another invitation from colleague Doug Risner for a special issue he was guest editing for *Journal of Dance Education*. As a result of our dialogue during the development of this issue, we co-authored a piece (Risner and Stinson 2010) later that same year; thanks to Doug's gentle but insistent challenges, my thinking about social justice was further expanded. While that one could not be included in this volume, it is available for free in the online journal which published it. This chapter, in contrast, is more historical in nature, revisiting teacher education almost 20 years after Chap. 2, from an autobiographical perspective. (I was and am more comfortable critiquing my own positions and practices than in confronting others, even when I know many others were doing what I was doing at the time.) I see here my conviction, also expressed in the Chap. 4, that every choice involves giving up some possibilities in order to embrace others, so that it becomes critical to maintain awareness of what we are giving up as well as what we are gaining, and that there are always other paths that might have been taken.

The addendum at the end deserves some explanation: All authors were asked to respond to the articles by others in the same issue, which is a wonderful stimulus for dialogue (and humility!)

References

ACT. (2010). Work keys assessment. Retrieved 27 July 2010, from http://www.act.org/workkeys/assess/talent

Barkley, E. J., Cross, K. P., & Major, C. H. (2005). *Collaborative learning techniques: A handbook for college faculty*. San Francisco: Jossey Bass.

Bond, K., & Stinson, S. W. (2000/2001). "I feel like I'm going to take off!": Young people's experiences of the superordinary in dance. *Dance Research Journal, 32*(2), 52–87.

Bond, K., & Stinson, S. W. (2007). "It's work, work, work, work": Young people's experiences of effort and engagement in dance. *Research in Dance Education, 8*(2), 155–183.

Brooks, D. (2010). A case of mental courage. Retrieved 31 Aug 2010, from http://www.nytimes.com/2010/08/24/opinion/24brooks.html?_r=1&ref=davidbrooks

Consortium of National Arts Education Associations. (1994). *Dance, music, theatre, visual arts: What every young American should know and be able to do in the arts*. Reston: Music Educators National Conference.

Dils, A. H., & Stinson, S. W. (2008). Toward passionate thought: Peer mentoring as learning from and with a colleague. In T. Hagood (Ed.), *Legacy in dance education: Essays and interviews on values, practices, and people* (pp. 153–168). Youngstown: Cambria.

Dils, A. H., & Stinson, S. W., with Risner, D. (2009). Teaching research and writing to dance artists and educators. In T. Randall (Ed.), *Global perspectives on dance pedagogy: Research and practice. Proceedings of the Congress on Research in Dance 2009 Special Conference* (pp. 151–165). Leicester: DeMontfort University.

Getty Center for Education in the Arts. (1985). *Beyond creating: The place for art in America's schools*. Los Angeles: J. Paul Getty Trust.

Joyce, M. (1984). *Dance technique for children*. Palo Alto: Mayfield.

Michaelson, L. K., Knight, A. B., & Fink, L. D. (Eds.). (2004). *Team-based learning: A transformative use of small groups in college teaching*. Sterling, VA: Stylus.

Millis, B. J., & Cottell, P. G., Jr. (1998). *Cooperative learning for higher education faculty*. Phoenix: American Council on Education Oryx Press.

Musil, P. (2010). Perspectives on an expansive postsecondary dance. *Journal of Dance Education, 10*(4), 111–121.

Partnership for 21st Century Skills. (2009). Framework for 21st century learning. Retrieved 19 Nov 2013, from http://www.p21.org/

Purpel, D. E. (1999). *Moral outrage in education*. New York: Peter Lang.

Risner, D. (2009). Challenges and opportunities for dance pedagogy: Critical social issues and "unlearning" how to teach. In T. Randall (Ed.), *Global perspectives on dance pedagogy: Research and practice. Proceedings of the Congress on Research in Dance 2009 Special Conference* (pp. 204–209). Leicester: DeMontfort University.

Risner, D. (2010). Dance education matters: Rebuilding postsecondary dance education for twenty-first century relevance and resonance. *Arts Education Policy Review, 111*(4), 125–135. Reprinted in *Journal of Dance Education 10*(4), 95–110.

Risner, D., & Stinson, S. W. (2010). Moving social justice: Challenges, fears and possibilities in dance education. *International Journal of Education and the Arts, 11*(6). Retrieved 15 Jun 2014, from http://www.ijea.org/v11n6/

Stinson, S. W. (1982). Aesthetic experience in children's dance. *Journal of Physical Education, Recreation, and Dance, 53*(4), 53–54.

Stinson, S. W. (2001). Choreographing a life: Reflections on curriculum design, consciousness, and possibility. *Journal of Dance Education, 1*(1), 26–33.

Stinson, S. W. (2002). What we teach is who we are: The stories of our lives. In L. Bresler & C. Thompson (Eds.), *The arts in children's lives* (pp. 157–168). Dordrecht: Kluwer.

Stinson, S. W. (2009). Music and theory: Reflecting on outcomes-based assessment. In T. Randall (Ed.), *Global perspectives on dance pedagogy: Research and practice. Proceedings of the Congress on Research in Dance 2009 Special Conference* (pp. 194–198). Leicester: DeMontfort University.

Wesleyan University Press. (2007–2009). *Accelerated motion: Towards a new dance literacy*. Wesleyan University Press and the Academic Media Studio. Retrieved 25 Jul 2010, from http://acceleratedmotion.wesleyan.edu

Chapter 11
Rethinking Standards and Assessment in Dance Education (2015)

Susan W. Stinson

Abstract This chapter addresses the need to consider ethical issues, not just practical ones, in thinking about standards and assessment in primary and secondary dance education. The author asks what's worth assessing and how assessment might facilitate learning and empower students and teachers, rather than judging and ranking them. Suggesting a number of dance standards that support significant life skills, the author compares her proposal to that from a consortium of business and educational leaders identifying skills needed by twenty-first century graduates, then excavates and critiques underlying values in both.

When I was enrolled in doctoral work in curriculum studies in the 1980s, one of the most compelling questions was "What's worth knowing?" (Postman and Weingartner 1994). This question, whether explicit or not, still underlies all decisions about what to teach. In dance, sometimes we simply teach what we know. Sometimes we teach whatever the students want. Sometimes external accrediting groups determine content.

Emphasis on what students should learn led to the development of the first USA voluntary National Standards in all subject areas, including dance, during the mid-1990s. Today, however, the concern at all levels of education is not just what standards students should meet, but how we know whether they have done so. Even dance educators are now being required to provide quantifiable data as evidence for whether their students have met given standards. In my state, North Carolina, university students who wish to become licensed for public school teaching must demonstrate that all of their pupils have met selected standards taught within a 3–4 week unit, or the would-be teachers cannot be recommended for licensure. When teachers must have hard evidence that all their students have met a standard within a short instructional period, there is great motivation to focus on the 'small stuff': skills and knowledge that the students do not usually start with but which can be learned within limited time.

Struggling with this reality as a teacher educator in dance led me to write two papers presented at conferences and published in their Proceedings. The first (Stinson 2009) charted my journey in coming to terms with the value of formal assessment, while the second (Stinson 2013) suggested possible practical solutions

© Springer International Publishing Switzerland 2016 129
S.W. Stinson, *Embodied Curriculum Theory and Research in Arts Education*,
Landscapes: the Arts, Aesthetics, and Education 17,
DOI 10.1007/978-3-319-20786-5_11

to the challenges raised. In revisiting these papers from a bit more distance, I have more clearly identified two primary issues in need of rigorous dialogue:

> What's worth assessing in dance education?
> How might assessment better facilitate learning and empower students and teachers, rather than judging and ranking them?

These questions reveal a perspective that goes beyond pragmatic issues of developing and implementing an assessment plan. They suggest that, when deciding what to assess, it is necessary to consider our deepest values while remaining conscious of contemporary educational realities.

11.1 Ethical Issues

My ethical concerns regarding a strong focus on outcomes-based assessment deserve to be made visible at the outset. They begin with historical knowledge of how often efficiency and effectiveness in accomplishing outcomes have been used as criteria for evaluating far more than educational practices. A most compelling example is the development of the 'Final Solution' in 1942, when 15 men in Nazi Germany determined the most cost-effective way to extinguish the lives of millions of people. Those men sitting around the table were highly educated, with over half holding a doctoral degree (Aktion Reinhard Camps 2005). Clearly education alone is insufficient as a moral compass; we all are subject to seduction when requested by those in authority to use our rationality and creativity to develop policies, even ones that are harmful. Corporate culture and many legislative decisions throughout the world offer more examples.

While one can reasonably argue that educational assessment does not lead to mass murder, thinking only about outcomes, and not the value of the goals themselves and what is required to reach them, is still problematic. Certainly artists know that the best creative work usually comes from being open to possibilities that emerge, rather than maintaining a single-minded focus on an outcome. What do we miss on any journey when we care only about the destination? What is overlooked that might be equally important when we attend only to accomplishing the objectives we defined when we began? When teachers are judging students as better or worse according to pre-determined criteria, are they overlooking what may be unique to an individual? When young people become completely focused on the goals set by their teachers, are we guiding them away from intrinsic motivation and the capacity to discover what gives their own lives meaning? I suggest that these are ethical questions as well.

Among professionals in arts education, conflicts about assessment go back decades; Malcolm Ross argued in his chapter "Against Assessment" that

> Many—perhaps most—arts educators feel an innate abhorrence towards many of the traditional forms of assessment practiced in schools. Rank-ordering children in terms of their paintings, their acting or musical performances seems to strike at the heart of the relationship

that nurtured them. Constraining and curtailing personal creativity in the interests of meeting the requirements of external examinations…forces a compromise over fundamental principles. (Ross 1986, p. 87)

Yet it is clear that dance can remain at the table of public education in those places where it has obtained a presence only if it adheres to the demands of those in power. Is this just another table that someone should have the courage to upset? In going along, when are we participating in a corrupt enterprise, and when are we swallowing unreasonable concerns in order that all children might have access to dance education in schools?

Despite these worries, I began to examine my own resistance to formal, data-based assessment, recording my change of consciousness in a 2009 paper:

> I have a lot of qualitative data from my own research and that of others, revealing perceptions from [many] young people…[of] powerful experiences in dance classes, making new discoveries about themselves, and finding pleasure in working with others to accomplish common goals (Bond & Stinson, 2000/01, 2007; Stinson, 1993a, 1993b, 1993c, 1997, 2001; Stinson, Blumenfeld-Jones & Van Dyke, 1990). But it is quite tempting to simply look for what we want to find. I now find myself just as intrigued by students who *don't* like dance, who don't participate fully, who don't appear to learn much even from teachers I consider top-rate. I am now fascinated by those among my university students who just want to continue doing what they already know how to do, those who don't find learning about dance education to be worth the effort, and those who don't make breakthroughs even though they seem to be trying. What am I going to do about *those* students? How uncomfortable do I allow myself to be when a demographic analysis of student learning reveals that students of color are disproportionately represented among the low achievers in my courses and in all courses in the Department? What are my own students (the ones who are successful and go on to become teachers) going to do about *their* students who don't dance much better at the end of the semester than at the beginning, or those whose ideas about dance aren't changing from ones they entered with? Is it okay to just dismiss those students as not bright enough, not talented enough, or not interested enough to learn? To what extent does that dehumanize them, just as those with power have so often dehumanized those without it? (Stinson 2009, p. 196)

Despite continuing concerns about how assessment may be used and what can be lost in the process, I concluded that formal and informal assessment should be an important part of the learning process, for the purpose of helping students and teachers understand what young people are learning and facilitating learning for all students.

11.2 What's Worth Assessing?

Obtaining good assessment evidence and analysing it well, however, are challenging and time consuming. Before I left my long-time role as a teacher educator in 2012, I was spending a large portion of instructional time helping prospective dance teachers develop check sheets and rubrics to assess whether or not their students had met the standards-based learning outcomes, and to analyse the pre-assessment,

formative, and summative data they collected. This meant far less time dealing with child and adolescent development, philosophical issues, and all the other important topics necessary to educate teachers. Of course, as standardised assessments are developed, dance educators will spend less time designing rubrics but will have even more pressure to focus on what the rubrics are assessing; as in other subject areas, administrators will be able to evaluate dance educators based on their students' examination scores and dismiss those whose students do not score well. While I still object to this use of assessment, it becomes critical to re-examine what we think is most important for students to learn in dance.

With recognition of my own complicity in the development of previous national and state standards for dance, and with respect for colleagues who continue to work on such documents, I admit that I find most of the skills and knowledge included in those standards to be relatively trivial within the whole of human existence. Are there new ways to think about standards if we consider more than just modest changes in what-has-been? For the 2013 paper, I asked myself, 'What is important for every student—not just those who hope for a dance career—to learn?' In other words, within the context of contemporary schools in the United States, what is truly worth learning by every single student who experiences dance in education?

I propose that, if we are going to spend so much time figuring out how to assess students and then assessing them, we ought to focus on *what really matters*. While it is relatively easy to assess whether students can make shapes on different levels, identify three characteristics of Graham choreography, or demonstrate a correct tendu, focusing on this level of skill and knowledge takes us away from what seems more important. More radically, especially considering my own participation in standards development, I now think that what matters most in dance education for young people is *not* learning to dance in any specific style or genre, make dances, or respond to dance; these skills by themselves do not matter much (after all, many people in the world live very satisfying lives without them), although they can be entrances to learning what *does* matter.

For me, what matters most are important life skills that can be learned specifically in dance education, especially when there is a focus on critical thinking and somatic experience. These skills cannot be accomplished in one lesson or one unit of 3–4 weeks, but rather require extended periods of time to develop. When trying to articulate such skills, I initially came up with three areas, what I called *Self-Management*, *Performing and Attending*, and *Creating and Communicating* (Stinson 2013). I noted that many people assume that such skills are not valued in an era when standardised test scores are so significant. However, I also found many commonalities between my list and a recent one developed by a consortium of educational and business leaders (Partnership for 21st Century Skills 2009). This group, the Partnership for 21st Century Skills (P21),[1] was formed in 2002 through the efforts of entities that included the U.S. Department of Education and a number of large corporations, including AOL Time Warner, Apple Computer, Cisco Systems,

[1] Although not cited on the P21 site, one of UNESCO's themes is Education for the Twenty-first Century (see http://en.unesco.org/themes/education-21st-century).

Dell Computer, Microsoft, and SAP (a German software company). Many state school systems in the USA are now members of this organization (http://www.p21. org/about-us/strategic-council-members). In words taken from their website,

> P21...advocates for 21st century readiness for every student. As the United States continues to compete in a global economy that demands innovation, P21 and its members provide tools and resources to help the U.S. education system keep up by fusing the 3Rs[2] and 4Cs (critical thinking and problem solving, communication, collaboration, and creativity and innovation). (Partnership for 21st Century Skills 2009)

In their publications, P21 further elaborates upon these "4Cs" as well as other basic skills, including Information and Technology Literacy and Media Literacy, and the personal attributes (Life and Career Skills) necessary to achieve them:

- Flexibility and adaptability
- Initiative and self-direction
- Social and cross cultural skills
- Productivity and accountability
- Leadership and responsibility.

Looking for commonalities between my goals and those of the P21 group, I value the self- discipline that comes with dance, and the corporate world wants self-directed workers. Creativity and Communication appear on both lists, while other C's and many of the skills the Partnership articulated were embedded under my larger categories. Re-reading the P21 list for this chapter has caused me to reorganize and add to my own list (See Fig. 11.1 below for a comparison between some of the Partnership's proposals and my own, listing skills that are important for students to develop by the time they complete high school).

On the one hand, it was affirming to realize that, not only can dance education deliver many of the skills that corporate and business leaders want but, in fact, these skills are inherently part of dance. There was a difference in language (between corporate wording and my own, written from the first person perspective of the learner), but dance educators have always needed to communicate across boundaries. Although the P21 goals seemed to lack any sense of the significance of somatic awareness as a foundation for other skills, my list short-changes some P21 goals that can be addressed in dance education, including writing and use of media and digital information. Certainly different perspectives are valuable and can help us recognise what we might be missing. Yet I still heed Ross' warning from 1986: "Everywhere we are exhorted to follow the lead and adopt the practices of the successful businessman" (p. 85). Had my own thinking been so corrupted by years of enculturation by the military-industrial complex (Eisenhower 1961) that I could no longer think outside of such values?

In re-examining the P21 goals, I find the unstated but implied value for efficient and effective production one would expect of the business and corporate world. There is mention of ethical behaviour and responsibility to the larger

[2] The term "3Rs" is commonly used in the US to refer to Reading, wRiting, and aRithmetic.

My proposal	P21
A. Self-awareness and Self-management	*Initiative and Self-Direction,* *Flexibility and Adaptability,* *Productivity and Accountability,* *Critical Thinking and Problem Solving,* *Creativity and Innovation*
1. Be my own teacher, telling myself what to do and when. Bodily: Both calm and energize myself when appropriate, so I am not a victim of my impulses. Intellectually: Ask and pursue my own questions, ones that don't have easy answers.	*Initiative and Self-Direction:* Monitor, define, prioritize, and complete tasks without direct oversight. *Critical Thinking and Problem Solving:* Identify and ask significant questions that clarify various points of view and lead to better solutions.
2. Push myself beyond what I already know and like to do—to be willing to experience ambiguity and strangeness. Remain engaged even when it gets hard and frustrating.	*Flexibility and Adaptability:* Work effectively in a climate of ambiguity and changing priorities. *Initiative and Self-Direction:* *Go beyond basic mastery of skills and/or curriculum to explore and expand one's own learning and opportunities to gain expertise. *Demonstrate commitment to learning as a lifelong process. *Productivity and Accountability:* Set and meet goals, even in the face of obstacles.
3. Be as critical of my own ideas as I am of other people's ideas.	*Initiative and Self -Direction:* Reflect critically on learning experiences in order to inform future progress. *Creativity and Innovation:* View failure as an opportunity to learn; understand that creativity and innovation is a long-term, cyclical process of small successes and frequent mistakes.
B. Connecting self and others	*Leadership and Responsibility*
1. Recognise the connectedness of the body and movement to the physical world and to ideas.	*Critical Thinking and Problem solving:* Analyse how parts of a whole interact with each other to produce outcomes in complex systems.
2. Pay attention—to what is subtle as well as what is obvious, to what I see and what I feel on a somatic (bodily) level, and to the words and movement of others.	*Communication and Collaboration:* Listen effectively to decipher meaning, including knowledge, values, attitudes and intentions.
3. Be conscious of the impact of my choices on my work and on others.	*Leadership and Responsibility:* Act responsibly with the interests of the larger community in mind.
4. Be willing to make decisions and take responsibility for myself while also making conscious decisions regarding when to work collaboratively with others.	*Communication and Collaboration:* *Exercise flexibility and willingness to be helpful in making necessary compromises to accomplish a common goal. *Assume shared responsibility for collaborative work, and value the individual contributions made by each team member.

Fig. 11.1 Comparison of proposed Stinson principles to select P-21 principles

C. Creating and Communicating	Creativity and Innovation, Critical Thinking and Problem Solving, Communication and Collaboration
1. Imagine something that doesn't exist and work to create it. Recognise that something can be different than it is and contribute ideas for making it better.	*Creativity and Innovation:* *Use a wide range of idea creation techniques (such as brainstorming). *Create new and worthwhile ideas (both incremental and radical concepts). *Elaborate, refine, analyse and evaluate their own ideas in order to improve and maximize creative efforts. *Develop, implement, and communicate ideas to others. *Act on creative ideas to make a tangible and useful contribution to the domain in which innovation occurs. *Demonstrate originality and inventiveness in work. *Be open and responsive to new and diverse perspectives.
2. Look at the same thing (a piece of choreography, a movement) from multiple perspectives and articulate them.	*Critical Thinking and Problem Solving:* Analyse and evaluate major alternative points of view.
3. Be fully present in my body, moving with clear intention and focus, not just going through the motions.	*Communication and Collaboration:* Articulate thoughts and ideas effectively using [oral, written, and] nonverbal communication skills in a variety of forms and contexts.
4. Have an impact upon others through communicating verbally and nonverbally.	*Leadership and Responsibility:* Use interpersonal and problem solving skills to influence and guide others toward a goal. *Communication and Collaboration:* Communicate effectively in diverse environments.
5. Attend respectfully to other people's dances and ideas about dance.	*Media Literacy:* Understand and effectively utilize the most appropriate expressions and interpretations in diverse, multi-cultural environments. *Media Literacy:* Examine how individuals interpret messages differently, how values and points of view are included or excluded, and how media can influence beliefs and behaviours.

Fig. 11.1 (continued)

community, but this is quite modest. Recognising implicit values in the P21 standards emphasized the need for me to further probe the values underlying the standards I had proposed.

In many cases, I recognised that my goals simply reflect some of my most cherished experiences in dance. These include feeling so fully alive while dancing, which is why Maxine Greene's work, such as her chapter "Towards Wide-Awakeness: An Argument for the Arts and Humanities in Education" (1978) has moved me for so many years. Wide-awakeness, or paying attention to what is around us and within us, is also a means for expanding understanding of self, others, and the world, a necessary step towards caring for each. In addition, I love the sense of accomplishment that comes when meeting a challenge in dance, although I know that one can experience such pride even when an accomplishment is relatively trivial. I also value the courage to go 'off balance' both literally and figuratively, as a way to avoid stasis.

Other values implicit in my proposed standards include connection and community. At the same time, I maintain the importance of independent thought and action, while knowing that I am under the influence of many forces not immediately apparent to my consciousness. It is so tempting to justify our own positions as *the* right ones. The only defence against self-righteousness is to be as critical of our own thinking as we are that of others.

Further, I recognise the existence of multiple realities and the uncertainty this brings. And I cherish a sense of possibility: Humans have created the systems and structures under which we live, and can recreate them to make a more beautiful, more just, and healthier world for all of us.

11.3 From Standards to Assessment

Despite the challenges of determining what is truly important enough for all students to learn in dance, merely having standards which we continue to problematise does not satisfy the current demand for rigorous assessment to determine whether students have met them. As hard and as long as dance educators have laboured to gain a place in public education, few would advocate that the field abandon this effort. But pondering how to assess, especially the kinds of complex life skills I envision, and how to do it in ways that support learning rather than take time away from it, raises even more questions.

In the USA, there is continued emphasis on high stakes standardised tests, evaluating the least sophisticated skills and the lowest levels of knowledge. This is not appropriate for assessing the complex life skills both P21 and I propose. But as schools continue the twenty-first century reformation, there is hope. In fact, there is an interesting document on the P21 website, mapping 21st Century Skills onto rich content from all arts education disciplines. This 'map' (http://www.p21.org/documents/P21_arts_map_final.pdf) creates sample activities that could facilitate devel-

opment of the skills and knowledge needed to meet each goal. Here is an example of Critical Thinking and Problem Solving suggested for the 8th grade:

> Dance students investigate, identify, and discuss the key components of a successful dance composition and how that composition might be affected by the technical expertise of the dancers performing it. Students then view dance videos of varying styles and time periods and, working first individually and then together as a class, determine criteria for excellence in performance and composition. Students apply these criteria to future viewings of dance and their own compositions. (p. 3)

This arts map makes clear that rich projects to be carried out over time are the only way to accomplish the kind of learning necessary for the twenty-first century, and most of the examples, including this one, could provide exciting educational experiences. Although the map does not offer tools for actually determining the degree to which the goals have been met, it should not be too difficult to develop rubrics or check sheets for assessing how well students accomplished the tasks called for in the example above. But the more I thought about what a rubric for assessing student work might look like, the more questions I had:

> If the dancers were very skilled, what else might an educated 8th grader say besides 'If they were not such good dancers, it wouldn't look so good'? How much nuance should they be expected to notice?

> Should a class of 13–14 year-olds be expected to agree on criteria for excellence in performance and composition? Most critics would argue that such criteria are context-specific, so what is regarded as excellent for a classical Asian dance work would not be the same for a hip-hop piece, and in fact critics do not always agree on the quality of a work even when looking at it in its cultural context.

> How many videos of dances that students do not like or find 'just weird' would they need to see to recognise how the lenses they bring affect their viewing and their judgments? Such recognition is not accomplished in one semester even by many students in university-level dance appreciation classes.

> Would having a rubric get in the way of continued cognitive development? It could if this task were regarded as something that could be completed, rather than always in progress.

While still holding these questions, I also see that the particular example of an educational activity cited above could facilitate development of quite a few of the skills I proposed (in Fig. 11.1):

> A2: Push myself beyond what I already know and like to do—to be willing to experience ambiguity and strangeness.

> A3: Be as critical of my own ideas as I am of those of others.

> B2: Pay attention—to what is subtle as well as what is obvious, to what I see and what I feel on a somatic level, and to the words and movement of others.

> C2: Look at the same thing (a piece of choreography, a movement) from multiple perspectives and articulate them.

> C5: Attend respectfully to other people's dances and ideas about dance.

To determine student progress in reaching these goals, I would want to assess over a period of years:

> How willing are students to continue watching something that does not initially look very interesting to them? (One might measure how long students remain engaged).

> How successfully can students describe the feeling of discomfort or strangeness? Is the feeling any different if they try to imagine doing the movement, what it would feel like somatically? (One might assess the depth of description and the inclusion of somatic language).

> How willing are students to ask themselves why this dance looks weird or stupid, and why it might not look that way to others, and to imagine themselves as someone for whom this dance matters? (One might assess the degree to which different perspectives are included).

Yet in keeping with my values, I need to be as critical in examining my own ideas as I am in examining the P21 goals, and I find similar challenges with trying to assess them, raising both practical and theoretical questions:

> For how long should young people (or anyone) be expected to engage in an activity they find boring or unpleasant? Where is the line between these states and educationally provocative strangeness?

> While we can invite children to engage in experiencing other perspectives as an adventure rather than using authority to require their participation, what about students who resist our best 'invitations'?

> How open are we to aesthetic perspectives of young people that are opposed to those in the arts education canon? Who decides which 'other' perspectives are educationally valid? Are we as educators equally open to all perspectives? Whose dances are we showing? Should we be open to all kinds of dance, including examples which we find offensive? Are all ideas equally worthy of respect?

Such challenges can seem paralysing if we think we must have all issues resolved before proceeding with teaching and assessing. But in reality, similar questions might be part of classroom discussion with adolescents. It might be helpful to assess student work even in relation to problematic standards, as long as the assessment is used as a way of understanding student learning rather than simply as a judgment of the worth of students and teachers.[3] In other words, teachers could note student responses to dances of others, including resistance, as a point of information rather than as a judgment indicating a student has failed. Surely it is educationally valid to explore and understand one's resistance.

Teachers could even use check sheets and rubrics (completed by students as well as themselves) to facilitate ease of data gathering in a large class, and likely get fairly honest responses, as long as the data were used to help understand student learning and to raise further guiding questions. Teachers might also invite students to identify what else they thought they were learning through the activity, and how they could demonstrate such learning, perhaps through portfolios of their work collected over time and assessed annually. Such an approach to assessment, as a

[3] As of October 2013, 38 of 50 states in the USA require that teacher evaluations be based on student achievement (Lu 2013).

way to understand and enhance learning rather than to sum it up and give prizes to those who are most successful in meeting only pre-determined standards, differs radically from most contemporary educational assessment in the United States.

I note my failure to end this chapter with ready solutions to the assessment challenge. It indeed is tempting to simply supply effective and efficient solutions for dance educators when so much is being demanded of them. I do not begrudge ready-made rubrics and check-sheets for assessing student progress in meeting mandated standards, as long as they are not regarded as the 'final solution' to the assessment conundrum. My hope is that this chapter will contribute to continued problematising of solutions and exploring the ethical issues underlying practice in dance education.

Commentary

It is not uncommon for writers to revisit some of their previous work, and realize how it no longer represents their current thinking about a topic. Since earlier work, once published, does not go away, the only solution is to write another piece. I took advantage of this opportunity for this chapter. I had not, however, realized until beginning the proposal for this book that I had been struggling with and writing about assessment almost since the beginning of my career. Now that my formal teaching career has ended, I expect this piece is my own last word on the topic, but it is clear that others continue to address it as the field continues to evolve. My hope is that, for at least some period of time, this work may contribute to the dialogue.

References

Aktion Reinhard Camps (2005). The Wannsee Conference attendees. Retrieved 19 Nov 2013, from http://www.deathcamps.org/reinhard/wannsee/att.html

Eisenhower, D. D. (1961). President Dwight D. Eisenhower's farewell address. Retrieved 25 July 2013, from http://www.ourdocuments.gov/doc.php?flash=true&doc=90

Greene, M. (1978). *Landscapes of learning*. New York: Teachers College Press.

Lu, A. (2013). How states evaluate teachers varies widely. *Stateline: The daily news service of the Pew Charitable Trusts*. Retrieved Feb 2014, from www.pewstates.org/projects/stateline/headlines/how-states-evaluate-teachers-varies-widely-85899511032

Partnership for 21st Century Skills (2009). Framework for 21st century learning. Retrieved 19 Nov 2013, from http://www.p21.org/

Postman, N., & Weingartner, C. (1994). What's worth knowing? In F. Mengert, K. Casey, D. Liston, D. Purpel, & S. Shapiro (Eds.), *The institution of education* (2nd ed., pp. 231–244). New York: Simon & Schuster.

Ross, M. (Ed.). (1986). *Assessment in arts education: A necessary discipline or loss of happiness?* Oxford: Pergamon.

Stinson, S. W. (2009). Music and theory: Reflecting on outcomes-based assessment. In T. Randall (Ed.), *Global perspectives on dance pedagogy: Research and practice. Proceedings of the Congress on Research in Dance 2009 Special Conference* (pp. 194–198). Leicester: DeMontfort University.

Stinson, S. W. (2013). What's worth assessing in K-12 dance education? [8 pp.]. In S. W. Stinson, C. Svendler Nielsen & S. -Y. Liu (Eds.), *Dance, young people and change: Proceedings of the daCi and WDA Global Dance Summit.* Taiwan: Taipei National University of the Arts, July 14th–20th 2012. Retrieved 19 Nov 2013, from http://www.ausdance.org

Part II
Research Methodology and Voices of Young People

Prelude to Part II

While curriculum theorists like myself would consider the first ten chapters of this volume to be research, this section includes work the general public would more easily recognize as being *about* research (Chaps. 12–15) or examples *of* research (Chaps. 16–19). After I completed my doctorate, I soon began teaching a graduate research course which I had helped design, as well as speaking about research methodology. I am amazed at this point by assumptions that I possessed the expertise to do either. The reality is that, in dance education, such expertise at that time was hard to find, especially in what was often referred to as "interpretive research." I am struck by the sense of authority I conveyed in Chap. 12, presented only a year after completion of my dissertation; I have much more humility now than then.

I have always found writing and teaching to be important modes of learning, and indeed I was learning about research by doing both. Reading about methodology helped give me language for communication with others, but I always had to "translate" the literature for my audience, if not myself. Because I was mostly teaching masters students in dance with little if any research experience, and my audience at conferences was usually educators and artists with the same, I sought language that would be meaningful for them. I am deeply grateful for my students (at my home university as well as international ones where I was an occasional guest), whose questions helped me to clarify not only their understanding, but also my own.

In addition, I learned from collaborations with colleagues in both teaching and research, and this section includes three examples of such work. I longed to have included more, realizing how much working with others, even when it was challenging, has expanded my own perspectives. While collaborative teaching is a rarity in most institutions, it is fortunate that collaborative research is becoming not only more accepted, but even encouraged in higher education.

Chapters 16–19 focus on a particular genre of qualitative research; these studies involved collecting data from dance students and listening deeply to what they were communicating about their artistic and educational experiences. I have labeled these

chapters collectively as "Voices of Young People," but am struck now by my emphasis on listening only to the young. Such an emphasis is not surprising, since so much of my career was spent teaching children and adolescents and those who would become teachers of this age group. Now in my retirement years, I am equally fascinated by the stories of those who have lived far longer, many of whom share warm memories of their lives spent with children.

I have briefly documented in the commentary on Chap. 16 the epiphany that prompted my research focus on listening to the voices of young people in dance, essentially absent from the literature at that time. It is affirming to see how popular such work has become since my co-authors and I first presented the content of that chapter in 1988. Later, I began to recognize the significance of action research for the artists and arts educators I was teaching, and shifted much of my focus in that direction. I needed to learn how to do this kind of research in order to teach it, and I again proceeded to learn by doing. However, having spent so much of my career in critically reflecting on my own professional work, as documented in Part One, my more formal action research studies never captured my imagination as much, and none are included in this volume. I wonder what new methodological trends and approaches will evolve in the future, as my former students and theirs continue the journey.

Chapter 12
Research as Art: New Directions for Dance Educators (1985)

Susan W. Stinson

Abstract This chapter documents the lack of research in dance education in 1985, when it was originally delivered at a conference of Dance and the Child: International (daCi). While acknowledging that some of the dearth of publication in dance education might be credited to lack of a journal dedicated to dance education, the author suggests that the low interest in research among dance educators might be partially due to the incompatibility of traditional research models with the most significant questions in the field. Beginning with a careful discussion of traditional empirical research methodology, the author describes its limitations in terms of research into the nature and meaning of children's dance. At the same time, she cites a number of theorists who find commonalities between the quest of the scientist and that of the artist, recognizing that both face the task of making meaning out of a multitude of forms and experiences which may at first seem unrelated. Proposing some alternative ways of thinking about research which may prove more fruitful for the dance educator, the author briefly presents several different approaches to research regarding the nature and meaning of children's dance, specifically phenomenological research, hermeneutics, autobiography, ethnography, and criticism.

As a University faculty member, I am aware that persons in many disciplines choose teaching careers as a way to support their real love: research. From discussions with my students and colleagues, I judge it unlikely that a love of research is a motivating factor for most dance educators. In fact, it seems that those of us in dance who do find research in a written mode to be of major intellectual and creative significance are considered anomalies by others in dance professions. As Rose Hill reminded us at the first Dance and the Child: International (daCi) conference, the disinclination of most children's dance educators to do research is evident in the literature: "All dance educators should be aware of the dearth of research in the area of dance for young children, whether in dance development, the values we attribute to it and/or the suitability of different teaching methods" (1978, p. 65).

While Hill's remarks perhaps prompted an emphasis on research in the call for papers for the second (1982) daCi conference, there still is hardly an overabundance of research being carried out in our field. Examination of *Research in Dance III* (Brennan 1982) confirms this limitation: While there are not many listings under

© Springer International Publishing Switzerland 2016 143
S.W. Stinson, *Embodied Curriculum Theory and Research in Arts Education*,
Landscapes: the Arts, Aesthetics, and Education 17,
DOI 10.1007/978-3-319-20786-5_12

"children's dance" to start with, the majority consists of master's theses in dance therapy. Further, as Brennan (1985) points out, hardly any theses and dissertations in dance find publication. In contrast to other arts education disciplines, there is no journal for dance education research, and there have been hardly any articles on children and dance in *Dance Research Journal*. While a lack of suitable publication outlets may hinder the productivity of budding researchers, it seems likely that there has not been sufficient demand to warrant such a publication.

The British journal *Drama/Dance* includes some articles on dance, but these are primarily reports on programs. To date, the *Arts and Learning* proceedings from the American Educational Research Association annual meeting include no papers in dance education. While some of the dearth of publication in our field may be credited to the fact that there are not very many of us, we must also conclude that research is hardly a favorite pastime among dance educators, particularly once the master's thesis or doctoral dissertation has been completed. In this paper I will suggest that this is at least partially due to the incompatibility of traditional research models with the most significant questions in our field, and I will propose some alternative ways of thinking about research which may prove more fruitful for the dance educator.

My own interest in research originated in my social science background. As an undergraduate major in sociology, I had become aware that the key to respectability for researchers in sociology was the use of scientific methodology. When I entered the field of children's dance, it seemed to me that dance educators also needed to adopt scientific methodology in order to prove the value and validity of our work. For example, if we could prove that children who studied dance developed in ways valued by administrators—increasing self-esteem, creativity, social skills, aesthetic perception, critical thinking—then surely those administrators would support dance in education.

The scientific methodology I was revering was a product of the Enlightenment, man's attempt to break out of a history that had been limited by the boundaries of myth and magic. With the advent of science, we no longer had to depend on such untrustworthy sources to find out what the world was like and why things happened. We could look for ourselves and find out the truth: seeing is believing. Further, finding out the way things really were and what made them that way would allow us to predict and control what might be.

The methodology that developed to help humankind gain this new knowledge reflected not only what it was seeking, but what it was reacting against. In order to prevent the new world of truth from being contaminated by the old one of mysticism and tradition, the two were firmly separated. There was a real world of things which was the domain of science, one which could be examined and analyzed by those seeking truth. There was also an inner world of imagination, feelings, and intuition. Scientists recognized that this inner fantasy world might color what we see of the real world, but it could be conveniently contained as the subject of art. Scientific methodology was designed to keep the inner world as removed as possible from the "real world," and scientific instruments were designed to help us get closer and closer to the real world itself.

With this understanding, it is important to note that recent findings in science (Zukav 1979) make us seriously question whether there is a "real world out there" which we can know objectively. Quantum mechanics, a field of physics concerned with subatomic particles, finds that the only way we can know the world is to participate in it and thereby, of course, we affect it. There are many instances in which the nature of subatomic particles seems to depend totally on what we are looking for, i.e., what experiment is done. This leads to the distinct possibility that we actually create a particular reality by looking for it (just as an undercover agent may create criminal behavior by "testing" a person's honesty). These findings help remind us that all perception comes through persons. We cannot see anything in the world unless we first know what to look for; thus *believing*, or at least imagining, always precedes *seeing* and colors it.

Meanwhile, however, social scientists, including educational researchers, have been attempting to study the inner world of persons using the same methods as physical and natural scientists. To briefly review, with admitted oversimplification, the basic points of this methodology, one first selects a piece of the world that is of interest, based upon one's questions about the nature of things. The next step is to develop a proposition, or proposed answer to one question, in the form of an if/then proposition.

The third step is more complex, since it involves setting up procedures to test the proposition. Vague or general terms must be defined operationally so that only one variable will be manipulated at a time, and to ensure that one is dealing with empirical realities. In addition, possible sources of error and bias must be controlled as much as possible. Further, the researcher must select a sample population from which results can be generalized to the larger population of interest.

Finally, the study or test is carried out, the results analyzed, and the proposition is either accepted or rejected. In the jigsaw puzzle of reality, a proposition which is accepted becomes another small piece that fits—at least until someone comes along who can show that it really does not fit, that we only thought it fit because of our inadequate human perception, or because we were trying to make the wrong picture.

Let us see what happens when we apply this methodology to questions about the relationship between children's dance and creativity. We might propose, for example, that if children study dance, they will become more creative. In order to verify this proposition, we need to define the terms in a way that can be tested. For example, we may define creativity according to a commonly accepted paper and pencil creativity test. Or we may use a motor creativity test, seeking either those responses which appear infrequently within a group (defined as originality) or those persons who produce the largest numbers of responses to given problems (known as fluency). Such tests, of course, do not verify the existence of creative process or what goes on inside the child. In order to study the process, one might administer a questionnaire asking such questions as, "Is this an idea you have seen before?" or "What kind of process did you go through?" We are limited, however, in the kinds of answers we can request of students not only by their ability to write (especially in the case of younger students) but by our ability to analyze the data; fairly brief

answers which can be readily tabulated are the most appropriate when dealing with the large numbers of people necessary in order to have a valid sample. Further, such a questionnaire leaves us open to bias, since children may respond with the answers they think we want to hear.

Another term which must be operationally defined is the study of dance. How many hours of dance instruction will be included and over what period of time will it occur? What length of dance study is necessary to allow significant results to appear and/or to be maintained over a period of time? Researchers in any area of education always seem limited by the time available for the study, often designed to meet a deadline for degree completion, or by funds, or by an institution that does not want its regular program disrupted for too long, even in the interest of science.

Even beyond such questions of time, there are others of content and methodology. What out of all the possibilities will be taught and how will it be taught? Even if both are specified by clearly written lesson plans, the individual teacher still influences the lesson: his or her personality, warmth, encouragement, as well as degree of comfort and experience with the material and the children. One can never control all of the variables, including the setting, the particular combination of children, and factors existing outside of the dance class itself, many of which may be beyond our awareness. Furthermore, the more such variables are limited in the study, the less generalizable the results will be in the real world of children's dance.

When I first began to do research in children's dance, these obstacles seemed to be challenges which any energetic and clever researcher could conquer to an acceptable degree. And of course, there was always the researcher's caveat: the section of a paper called "Limitations of the study" in which one makes all the disclaimers and explains why this study on which so much time has been spent is really only a very small, very tentative piece of the puzzle.

Having carried out several studies of this kind, and read a number of others, I was struck by how insignificant and even dull most of them seemed, nowhere nearly as interesting as the reality of dance and children. By the time we summarize results on neatly typed tables, we have lost not only the richness but the lived reality of children's dance. It was this dissatisfaction that caused me to cease my early research activities and devote myself to simply trying to be the best teacher I could, not by consulting results of formal research, but by responding to each particular child and group of children. I decided that my only "methodology" would consist of listening to each of the children—their words and their movement—and trying to be *with* them, trying to be aware of both my own actions and the children's responses to them. I was less interested in predicting and controlling their learning than I was in respecting them and entering into the adventure of learning with them. I learned later that I was not really too far off base in terms of an alternative research methodology.

But before I conclude my discussion of traditional empirical methodology for research in dance, I must admit that I do recognize its value in certain areas, particularly those related to the structure and function of the body and, to some degree, in child development. I am grateful for researchers in the biomechanics of dance who have revealed the potential harm of many traditional practices in dance.

I also think that studies that help us recognize "normal" behavior at different stages of development can give us necessary perspective in teaching. However, I find these areas for research to be "support fields" for children's dance, capable of providing important and helpful information, but not the core of our work, and not capable of answering the most essential questions.

The most essential questions in children's dance, I think, are not related to how we can get children to learn, more effectively and efficiently, what we want them to know and do. When such questions become primary, we are trainers of children, not educators. Training a child—or a laboratory animal—means that we know just what behavior we are seeking; training is a way of manipulating individuals to get them to do what we desire and/or think will be good for them. It leaves out the capacity of the child to make her own decisions, to become his own person.

Educating a child, by contrast, implies that we as educators do not have all the answers, or even all of the questions. Our goal is not to shape behavior, but to ignite the children's capacity to create their own knowledge, their own dances, their own lives, in the context of the knowledge of others. For this kind of teaching, no research can give us clear directions as to how we should proceed. Research can only help us understand and point us toward some things to look for as we tenderly make our way. Research in children's dance, then, becomes concerned with larger questions: What is the experience like, for children, teachers, parents, administrators? What does it mean to them, to us? What is the significance of these meanings in the context of our lives as persons and professionals?

Before discussing research methodologies appropriate for dealing with questions related to the nature and meaning of the children's dance experience, it is important to indicate what I mean by meaning. As I use this term, it has to do with connections and relationships: those within and between persons, things, and events outside of us and, more importantly, between those things and ourselves. This understanding of meaning is applicable to science, art, and our everyday lives. For example, the size of a mountain in a photograph has meaning only in relation to the size of a person standing at its base. Other people are meaningful to us because we recognize our relatedness with them, such as a shared interest in children's dance, or shared membership in the human family. Ideas, stories, and works of art have meaning for us when they have an internal cohesiveness and when they touch us. And our lives become meaningful when we recognize the coherence of seemingly unrelated events and circumstances and find a wholeness of purpose.

As scientist and poet Bronowski (1972) notes, this definition of meaning describes the goal of science, for all science is the search for hidden likenesses, to discover unity in the variety of our experiences. However, Brownowski also points out that art involves the same search: "What is a poetic image but the seeing and exploration of a hidden likeness, in holding together two parts of a comparison which are to give depth to each other" (p. 16).

Indeed, recognizing connections is at the center of the process of doing art. Even in the most abstract work, there is still the relatedness of line, color, sound, or dynamics that makes the work of art a whole. In traditional art, the artist was assumed to *create* these relationships. However, the avant-garde artists especially in

the late 1960s and 1970s helped shatter this assumption. These artists recognized and demonstrated that relationships exist in the universe whether or not we choose to see them. Music exists in everyday relationships of sounds, dance exists in the relationships found in everyday movement, whether or not we chose to hear and see. The task of the artist becomes not creating the relationships, but becoming aware of them and revealing them in a form. The task of the observer, in looking at the form, is to look as an artist, rediscovering relationships.

Both scientists and artists, then, as well as all persons who contemplate their own lives, have to face the task of making meaning out of a multitude of forms and experiences which may at first seem unrelated. While this is one among several important similarities between science and art, there also are differences in how scientists and artists approach forming and meaning-making. Elliot Eisner (1981), art educator and curriculum theorist, points out that both approaches are relevant as research, but he notes ten areas of difference. For example, scientific methodology seeks a standardization of style, while artistic methods find standardization to be counterproductive. While scientific methodologies focus on manifest behavior, artistic ones focus more on the experience individuals are having and the meaning their actions have for others. Scientific research seeks trends and generalizations of statistical significance; artistic approaches to research emphasize the unique and idiosyncratic which nevertheless have significance beyond the particular situation in which they emerge.

It is such an artistic approach that I see as most fruitful for allowing us to deal with the most significant research concerns related to dance and children. It is relevant to note that there are increasing numbers of researchers from social science and education reaching similar conclusions in regard to their disciplines. Historian Kariel (1972) finds that every human act may emerge as a work of art. He encourages us (1977) to look first at the familiar experiences which make up our daily lives. When we look at seemingly trivial incidents in the same context in which we would look at a painting or poem, they take on new meaning. We may see that a child having a temper tantrum, for example, is literally "making a scene," creating a form for gaining recognition. When we look at our own lives in this way, we may become more capable of looking similarly at the world. Political action becomes a form of art as we create increasingly penetrating images of prevailing institutions. Through such images, we may recognize the missing parts of our lives and bring them into balance, making our lives whole.

Sociologists Nisbet and Brown also see the significance of thinking of their discipline as an art form. Nisbet (1976) finds similar landscapes (such as problems of urban life) occurring in sociological studies and in literature and paintings. Yet not only are the sources the same, but so are the themes by which sociologists and artists alike make sense of the events of their lives—such themes as community, conflict, power, and alienation. Brown (1977) notes that the logic of discovery in sociology depends upon metaphoric thinking, and aesthetic properties (such as originality, economy, cogency, etc.) are fundamentals of sociological theory.

James Macdonald (1981) also justifies art as a valid process in research. He has noted three kinds of methodologies which may generate understanding of reality: science, critical theory (a reinterpretation of history, based on a general analytical

theory, in order to free us from the domination of misunderstandings), and poetics. Macdonald points out that poetics is often overlooked as methodology, and as a result we overlook a large portion of reality: "Science…cannot deal with ultimate meaning and critical theory…leaves open the questions of infinity and eternity. For this and a host of more mundane aesthetic aspects of reality we need poetic participation in meaning" (p. 135).

Macdonald observes that all three kinds of methodologies operate in a circular relationship with respect to theory and practice: Action is grounded in how we see our reality, but our reality changes as we engage in action and reflect upon it. Thus theory and practice are not separate from each other. Macdonald refers to this relationship as a hermeneutic circle, finding that it is a search for meaning which sets the circle in motion and continues to fuel it. When the methods of poetics are utilized in this circle, the process is more personalized and biographical: Insights, images, and imaginative symbols are created as possible meaning structures. However, these meaning structures are examined not just in terms of their own coherence, but even more by the concrete, practical experience of the participant in relation to them.

In the next section of this paper I will briefly present several different approaches to research regarding the nature and meaning of children's dance. One can make a good case that each of these approaches is as much or more like art as like science. I must note, however, that not all researchers using these methodologies would be pleased to be removed from the scientific camp and placed in an artistic one. Many would prefer a designation that is between art and science, which Giorgi (1970) refers to as a human science. What these approaches have in common is their descriptive and interpretive nature and their embracing of the knower, as well as the known, as part of research. Further, these methodologies are compatible with a view that what is most important about children's dance is not what we can readily observe and measure. All art, including dance, comes from inside persons; if we look only at what is outside, and not at the relationship between inner and outer, we will not really be looking at children's dance. This is not to say that we can ever truly "get inside" another person, but that the stance of a researcher must be *with* a person, not objectively distant from him/her.

The approaches I will discuss include phenomenological research, hermeneutics, autobiography, ethnography, and criticism. I will not go into detail with any of them, not only because of limitations of time and space, but because there are already important resources for each which should be consulted by the prospective researcher. More importantly, I do not wish to set up any of these methods as a rigid determinant of and guide to research, a simple substitution for traditional scientific methodology. They are offered to indicate a range of possibilities. The researcher of artistic orientation need not start with the predetermined guidelines of a particular methodology, but may let the form arise from the content, perhaps drawing from several approaches to create one that is uniquely suitable.

I wish that there were examples of research in children's dance available to cite for each approach. In their absence, I have chosen research from related areas which I hope will be of similar value.

Phenomenological research is grounded in an approach to philosophical inquiry emphasizing the nature of experience. On the simplest level (and there are much more complex levels), it asks, "What is it like to have this particular experience, from the perspective of the person living it? The researcher attempts to suspend his or her own prejudices and assumptions in order to understand, as clearly and as richly as possible, the perspective of the other. The researcher does not begin with a proposition to prove or disprove, but rather with an openness to another person and his/her experience. Questions that are asked are open-ended, and responses are recorded in a way that allows each person's unique voice to be heard, rather than simply categorized in a table. Themes arise through the listening process and the subsequent stages of interpretation.

Kollen's recent study (1981) on the experience of movement in physical education is an excellent example of a rigorous phenomenological study. Kollen notes that little research in physical education has dealt with "the essence and meaning of man as a moving being" (p. 13), despite the fact that this is most central in the profession. Kollen conducted intensive interviews with ten high school students which focused upon how their perceptions of themselves as moving beings were influenced throughout their public school physical education experiences. Kollen's concentrated listening to students reveals a powerful picture: Students experienced primarily a dualism between thought and action, a sense of meaninglessness, and self-consciousness in their physical education experiences, despite the fact that each of the students personally sought and valued the experience of being "into movement."

Another relevant study is Valerie Polakow's investigation (1985) of young children's experience of reading. When I heard this paper presented at a recent meeting of the American Educational Research Association, there was a shocked response to the realization of how rarely educators, in their quest to find better methods of teaching reading, consult children. I think we should similarly be concerned at the absence of research in children's dance that attempts to tell the child's story. Polakow notes that nowhere in the reading literature "did I hear the child's voice, articulating his perspective on the question…and so I began with four 5-year old children—four friends who became my informants" (p. 2). Much of what she learned from the children contradicts how schools teach reading, and Polakow concludes that, at this point in their lives, reading still remains an experience of living stories, to be distinguished from the school experience of, in the children's words, "dopey readers and dumb workbooks" (p. 12).

The work of Kenneth Beittel (1973) is helpful in providing both justification and examples of alternative research methodologies in art education, methods which "emphasize the subjective, bound-to-this-one-life, situational aspects of making art" (p. 2). Beittel's own research, as reported in this volume, is primarily phenomenological in nature, as he set up special procedures to access the artist's active stream of consciousness in making art. Specially trained research assistants were selected to be *with* the student artists who were subjects in the research; the goal of the participant-observers was not to analyze or critique the artists' work, but to understand it in the most respectful, nurturant, subjective way possible. Beittel

notes that such an approach allows us to "become immersed in psychic realities, potential and shared insights which we more or less construct and present, rather than merely categorize and describe" (p. 22). He also notes that such work is akin to biography, because it tells the individual story of each artist.

Biography and autobiography are significant dimensions of research that is subjective by intention. The nature of our experiences and the meaning we make of them become our life story; our experiences with dance and children are part of our story as dance educators. The writing of biography can help us become conscious of what dance is for children and other teachers. Writing autobiography helps us understand what it is for ourselves as educators, researchers, and persons. Autobiography is considerably more useful in generating understanding when it not only relates a chronology of events and details of places, names, and times, but when it becomes a conduit to the inner connection between dance, children, and ourselves. Ann Truitt's *Daybook: The Journal of an Artist* (1982), while not related to children's dance, exemplifies such a search for connections. In this work the author, a visual artist, reflects upon her own life as an artist and person, seeking meaning and a sense of wholeness. Both her search and the insights she develops are significant in understanding creative process in the context of a person's life.

Autobiography is an important aspect of hermeneutic research, and hermeneutics may also be used in combination with phenomenology. The term *hermeneutics* originally referred to a form of Biblical or literary interpretation concerned with the meaning of a text. When applied to educational research, the idea of "text" becomes more broadly interpreted, and the researcher may focus upon the meaning of his or her own experience. Interpretation occurs in a spiraling process which is initiated by a search for meaning. The basis for the search is one's individual biography and values; the search is carried out through a process of reflection and personal dialogue with theory. This process adds new meanings which result in a reinterpretation of one's view of the world, one's own personal history, and the relationships between them. I will cite here my own work (Stinson 1984) as an example of a hermeneutic study. In this study I sought to understand connections between my professional concerns (including but not limited to children's dance), personal concerns, and larger social concerns. The conceptual framework of the study focuses around a metaphor of verticality/horizontality to represent two dimensions of existence. The vertical dimension represents the impulse toward autonomy, self-assertion, and mastery; the horizontal represents the impulse toward communion, intimacy, and understanding. Through autobiographical reflection and dialogue with theoretical voices, the original meanings of these dimensions are reinterpreted, revealing a renewed vision for dance education.

Ethnographic methodology has been borrowed from anthropology by a number of educational researchers. Ethnographic study is probably viewed as closer to science than any of the forms I have discussed so far. It includes several levels: gathering concrete, usually measurable information which details the structure of a given culture; noting details of daily behavior; and collecting personal statements or anecdotes which reveal the spirit of a people. Such an approach when applied to children's dance would include gathering of both "objective" and "subjective" data

from a variety of sources—parents, teachers, and children—by a person who was a participant-observer in the situation, in order to make as vivid and rich a description as possible of the life of a classroom in children's dance. Wanda May's study (1985), "Four Kids Cried in Art Class Friday: A Case Study of an Elementary Art Curriculum," is an example of such an approach in art education. May studied the written curriculum, surveyed parents and teachers, and observed as a classroom participant over a prolonged period of time in order for patterns to emerge. She found that the educational process in art was routinized, fragmented, and detached from the lives of children, emphasizing realistic representation and following the teacher's directions. She also noted that teachers had neither time nor opportunity to critically reflect about knowledge, curriculum goals, or instructional strategies in art, especially with professional colleagues; and she concluded with the importance of reflection upon the nature of children's experiences in art class.

The final approach to research which I will discuss uses as its model art criticism. Elliot Eisner (1979) is best known for his work in this area. Eisner points out that both teaching and curriculum development are not only practical undertakings but artistic ones, and traditional, quantitative measurement does not and cannot reveal the artistic aspects: taste, design, wholeness, creativity, sensitivity. Eisner proposes that the same criteria and processes that we use in art criticism are also appropriate in studying education. Effective criticism, whether in the arts or education, demands first of all knowledgeable perception of what is subtle, complex, and important; the critic then discloses the qualities or events perceived. Of course, literal translation is impossible for many of the meanings the critic perceives. Thus poetic language— metaphor—is appropriate for revealing the qualities of life found in the classroom or studio as well as in a work of art. Eisner sees three functions of educational criticism: to describe, to interpret, and to evaluate. His work and that of his students included in his book exemplify these functions and make clear that the goal of the researcher, just as the goal of the art critic, is to look for qualities, forms, and meanings, and to communicate these with a sense of clarity, imagination, and expressiveness.

There are other approaches as well which researchers have used to try to understand, from the inside, the nature and meaning of educational experience. Again, the purpose of this paper is not to be a quick course in research methods but to point out that there are alternatives to help us study those questions which are of greatest significance to us, and that whatever form of research we choose must arise from ourselves as persons and from the persons and ideas with which we are concerned, just as the form for a dance arises from the choreographer, the movement material, and the dancers.

However, I do not wish to support an "anything goes" approach, or that anything is legitimate as research. There is a difference between research and reporting. It often seems to me that a majority of dance articles in journals consist of project descriptions: here is what we did and how we did it. If we are to have credibility as researchers, we need not follow procedures which are better suited to other disciplines, but we must search beneath the taken-for-granted and be willing to question, not just defend and justify, what we do. What I hope emerges from this discussion is not a sense that research is a snap, but that there are legitimate,

rigorous ways to pursue research that will allow us to function in both an artistic and scholarly manner as we attempt to understand and live in a world that includes both dance and children.

In conclusion, I wish to support some important future tasks for research in children's dance. One is to study ourselves as dance educators, to try to understand what about dance and children is important to us, what we are really doing and not doing as we teach, why we are making these choices, and whether or not we wish to continue to do so. We need to try to uncover fears and discomforts which may be affecting our teaching. And we need to discover the ways in which our work with dance and children is related to the larger world in which we all exist.

Secondly, we need to listen to the voices of children: to find out what dancing feels like and what it means to them, how they see us as teachers and how they experience the learning process in dance. We need to find out what they are learning besides the things we think we are teaching. And we need to reflect upon their words, asking what they mean for us as teachers and persons, so that all we come to know becomes a link in a continuing spiraling dialogue between theory and practice.

It is this dialogue, then, that is most important. Research cannot give us final answers, but it should keep the questioning process open, and keep us from hardening knowledge into lifeless forms. Research, just as dance, can become a way for us to better understand our students and ourselves and the life we share, to keep growing and moving together.

Commentary

As clearly described in this chapter, research in dance education was at its infancy when it was first presented at the 1985 conference of Dance and the Child: International in Auckland, New Zealand. I am still amazed at the impact this piece had at the time, launching me into the limelight as a leader in the field when I was really quite a junior researcher, having just completed my doctoral dissertation the year before. Clearly, the time was right for dance educators to hear about alternative possibilities for research. The ongoing significance of the piece was reflected in its selection for inclusion in a 2012 collection of 12 papers representing the first 30 years of daCi.

Of greater historical significance is that, due to the shortage of research studies in dance education in 1985, I needed to draw from related areas of arts education to exemplify most of the specific research approaches I identified; the single exception was my own dissertation. I went on to do research using most of the approaches mentioned in the chapter. Today, of course, this list of approaches to research in dance/arts education seems very limited. Development of dance education research since that time can be documented by the existence of a major research journal for dance education (*Research in Dance Education*, published in the U.K.), research papers in the field published in a number of other journals, and a large number of

theses and dissertation in dance education (many documented in the Dance Education Literature and Research descriptive index (DELRdi), maintained by the USA National Dance Education Organization (www.NDEO.org). Further, the 2012 daCi conference held in Taipei, included multiple research papers in each of five categories: Curriculum, Dance Learning, Education of Dance Teachers and Artists, Dance as Social Justice, and Teaching Dance. The Proceedings from this conference, including work by researchers from multiple countries, may be found at http://ausdance.org.au/publications/details/dance-young-people-and-change. Future conferences of daCi, held once every 3 years, will continue to document the emergence of new scholars and forms of scholarship.

References

Beittel, K. R. (1973). *Alternatives for art education research*. Dubuque: William C. Brown.
Brennan, M. A. (1982). *Research in dance III*. Reston: American Alliance for Health, Physical Education, Recreation and Dance.
Brennan, M. A. (1985). Where have all the scholars gone…long time passing. ERIC# ED 263 045.
Bronowski, J. (1972). *Science and human values* (First Perennial library). New York: First Perennial Library. (Originally published: Harper & Row, 1965).
Brown, R. H. (1977). *A poetic for sociology*. Cambridge: Cambridge University Press.
Eisner, E. W. (1979). *The educational imagination*. New York: Macmillan.
Eisner, E. W. (1981). On the differences between scientific and artistic approaches to qualitative research. *Educational Researcher, 10*(4), 5–9.
Giorgi, A. (1970). *Psychology as a human science*. New York: Harper & Row.
Hill, R. (1978, July). The importance of dance experiences and concepts in the aesthetic development of children. In *Dance and the Child* (pp. 64–79). Conference sponsored by Canadian Association of Health, Physical Education and Recreation, Edmonton, AB.
Kariel, H. S. (1972). *Saving appearances*. Belmont, CA: Duxbury.
Kariel, H. S. (1977). *Beyond liberalism, where relations grow*. San Francisco: Chandler & Sharp.
Kollen, P. S. (1981). *The experience of movement in physical education: A phenomenology*. Dissertation abstracts international, 42, 526A.
Macdonald, J. B. (1981). Theory-practice and the hermeneutic circle. *Journal of Curriculum Theorizing, 3*(2), 130–139.
May, W. T. (1985). *Four kids cried in art class Friday: A case study of an elementary art curriculum*. Paper presented at annual meeting of the American Educational Research Association, Chicago, IL, Mar 31–Apr 4.
Nisbet, R. (1976). *Sociology as an art form*. London: Oxford University Press.
Polakow, V. (1985, April). *On being a meaning-maker: Young children's experiences of reading*. Paper presented at the annual meeting of the American Educational Research Association, Chicago, IL.
Stinson, S. W. (1984). *Reflections and visions: A hermeneutic study of dangers and possibilities in dance education*. Unpublished doctoral dissertation, University of North Carolina, Greensboro.
Truitt, A. (1982). *Daybook: The journal of an artist*. New York: Penguin Books.
Zukav, G. (1979). *The dancing wu-li master*. New York: Bantam.

Chapter 13
Body of Knowledge (1995)

Susan W. Stinson

Abstract Recognizing dilemmas posed by the body-mind duality in schools and the prioritizing of the cognitive over the physical even by other theorists in arts education, the author makes a case for how one's somatic self (the self which lives experience) is deeply connected to thought, including that in educational research. The paper explores how choreography can be both a metaphor and model for academic research, using examples drawn from the author's teaching of an introductory research course to MFA students in dance. Academic researchers and choreographers engage in similar tasks, including selection of an idea they find compelling, generating or collecting material relevant to it, paying attention to the material and selecting that which seems most significant, finding relationships among the different pieces, pondering what they mean, and making something which can communicate with others. Even theory building and editing are shown to have a bodily component. Using sensory language throughout, the author concludes with a hope that such language might make scholarly work more accessible and move readers beyond theory toward action.

As a scholar in a dance department, I am expected to produce words, not movement, scholarly research instead of choreography. While I have experimented with some forms that mix media, combining spoken scholarly text with choreographed or improvised movement, and presented these at several conferences, I do not think that research must be sung, painted, or danced in order to represent the influence of the arts. In this paper I will explore how my experience in dance is represented in my educational research. That experience includes more than 30 years of being in the audience as well as in the studio. Yet it is the lived experience of dancing that I have found to be most influential in my thinking and writing, and which has provided the metaphors that have helped me to understand my life and my work as a scholar.

I believe that when most people think about the arts as forms of representation they think about form as something external, the product that results from artistic process. For example, choreographic works have a beginning, middle, and end; a cohesive work has a sense of wholeness along with variety or contrast. Choreography students in universities, like students in all the arts, take multiple semesters of courses designed to help them to understand the complexities of crafting their form.

© Springer International Publishing Switzerland 2016 155
S.W. Stinson, *Embodied Curriculum Theory and Research in Arts Education*,
Landscapes: the Arts, Aesthetics, and Education 17,
DOI 10.1007/978-3-319-20786-5_13

However, artistic form is not only external but also internal. For example, when I teach children the concept of shape in dance, I tell them that most people think about shape as what something looks like on the outside, like a square or a circle. Dancers, however, know that shape is not only about what something looks like on the outside, but what it feels like on the inside. We make shapes on the outside by what we do with our bones and muscles on the inside; internal forming creates the external form. It is this internal sensing of oneself in stillness and in motion that turns what would otherwise be standing or sitting, walking or running, into dancing.

This internal sensing has great significance not only for how one performs dance but for how we perceive the art. If we think about dance as an artistic object only to be looked at, it becomes little more than a moving picture. Certainly an audience does look at dance (and, if there is music, listen to it), but the visual and auditory senses return only a surface view. In order to understand dance, one must also use the kinesthetic sense.[1] The kinesthetic sense allows us to go inside the dance, to feel ourselves as participants in it, not just as onlookers.

The more familiar five senses take us out into the world, to see, hear, touch, taste, smell something out there. The kinesthetic sense, combined with the visual, can also take us out into the world. We use it as we connect with the dancer on stage: stretching so that energy extends beyond the fingertips, leaving the floor and returning silently. We also use it to connect with the Olympic athlete—straining to beat the clock, bursting with exhilaration in victory, or slumping in defeat. It allows us to share the weighty sadness of a friend, the tense anxiety of the unprepared student before an exam. The kinesthetic sense thus contributes to our understanding of what another person is feeling on a sensory-motor level.

The kinesthetic sense, however, not only heightens our awareness of the other who is outside us, but also what is inside ourselves. It allows us to notice what we are feeling in our own interior, letting us know when we are stiff or fatigued or upside down, whether our fingers are stretched apart or close together. The kinesthetic sense thus both tells us about ourselves and connects us with others as embodied selves.

Yet the kinesthetic sense, like our other senses, provides only a private experience, and validation of private experiences is problematic. For example, we do not know if what we see when we look at an object or an event is what is there, since the only way we can perceive anything is through our own senses. While we can ask others to describe what they see, words have different meanings to different individuals, and words cannot directly and completely represent our lived experiences.

External validity becomes even more difficult when referring to the knowledge of internal bodily experience, such as what I see when I close my eyes, or whether I

[1] Physical therapists typically use the term kinesthetic to refer to the sense arising from nerve endings embedded in the joints and muscles. They contrast the kinesthetic with the proprioceptive sense, which is related to balance. Specialists in the study of somatics ordinarily use proprioception to refer to all internal sensing. Dancers most often use kinesthetic to refer to the inner sensation of movement and tension; I am using it that way in this paper.

feel relaxed or hungry. While technology does exist to measure degrees of muscular contraction, how I experience myself cannot be proven true or false; neither can how I experience the world.

Elliot Eisner (1993) notes that it is only by means of external forms of representation that we can communicate private experience. Words are the most common means of communicating private experience, and I will suggest shortly that verbal language should include kinesthetic imagery if it is to represent fully lived experience. However, symbols other than words often are closer to the immediate experience. In the case of dance, we represent internal kinesthetic experience through movement symbols, using human bodies. As long as the bodies stay at a distance, on a stage or a television screen, we may look at them as aesthetic objects and appreciate them. Up close, bodies become more problematic. Most of us, particularly women, do not have much appreciation for our own bodies; even well trained dancers are highly critical of their bodies in appearance if not performance. Our bodies are the source of deep pleasure but also pain and embarrassment. Our responses to other people's bodies are also mixed. We may appreciate their beauty or skill, but also find them worrisome, unsanitary, or threatening. Bodies carry germs and emit odors. They sweat and produce other fluids which are not highly regarded in an age when a pair of rubber gloves must be regarded as part of every teacher's essential gear. I found it interesting that a high school participant in my recent research (Stinson 1993), an academically gifted student enrolled in several Advanced Placement classes, described her academic courses as "antiseptic" in comparison to her dance class. While dancing is not a mindless activity, the lived experience is highly physical, and this is indeed what attracts many individuals to the field and repels others.

Some forms of physical expression are viewed less ambiguously. Fighting and adolescent sex are dangerous to the futures of our students. The young child's wiggling around is not dangerous, but often seems to get in the way of learning. Most educators appear to want to suppress student physicality, not enhance it; even in the early grades, teachers attempt to train students to sit still and delay bodily inclinations, even ones so basic as going to the bathroom. Most often, physicality is recognized as something that must be managed in order to obtain the best academic performance. Physical education may be regarded as helpful in allowing children to release "excess energy" so that they are better able to use their minds in the important work of school.

This body-mind duality in schools has been recognized by a number of theorists (Brodkey and Fine 1988; Grumet 1988; Johnson 1983; McDade 1987; McLaren 1991; Noddings 1992; Shapiro 1999). However, even those of us who struggle to get beyond it find ourselves hindered not only by language (how do we write about body and mind without implying that they are two different things which must be joined by a hyphen or slash mark?) but by our own experiences when our bodies seem to hinder our thinking. For example, the body's need for sleep may keep us from staying up all night at our scholarly pursuits; other times we may feel too "edgy" to sit and read. I became aware, at one point when writing this paper, of a knot that had formed inside my shoulder blade, forcing me to leave my computer

even sooner than my more usual eyestrain would have done. It is easy to notice those times when our physical selves seem to stand in the way of mental activities, and harder to recognize how essential our embodied selves are in thinking.

Eisner has persuasively argued for the significance of the senses in cognition as well the use of the arts in creating forms of representation. However, I find it interesting to examine some of his excellent work on this topic (1982) and notice that he does not mention the word "body." It is no surprise that Eisner, coming from a background as a visual artist, should make frequent reference to the eye and use language that calls forth visual images in the reader. It is also understandable, considering the discomfort so many educators seem to feel with the body, that a scholar would choose to leave out words that might stimulate kinesthetic sensation. Perhaps my student informant would say that leaving out the body sanitizes discourse about the senses.

Eisner (1988) and Howard Gardner (1989, 1990) are probably the most influential theorists who speak of art as primarily a cognitive activity, noting that it is not the art work itself, but how we perceive it, that makes it art. I have long been a proponent of recognizing the cognitive dimension in dance education. The dance world is filled by too many teachers who say, "Don't think about it, just do it." The legendary George Balanchine is often credited with stating that he wanted his dancers to be beautiful, like flowers, but not to think. I have felt a responsibility to let the public know that dancing is not mindless work, and to suggest that dance educators encourage student reflection, as well as their own. But there has been a loss to accompany the greater recognition of the importance of cognition in dance. As dance educators have joined other arts organizations in advocating for the arts in schools, and have disconnected from their historical ties with physical education (trends which I have supported), they have also disconnected from the body. The body is reduced to serving as an unfortunate necessity: a tool, an instrument, or a medium like paint on paper. Dance educators often seem embarrassed to speak too much about the body, thinking that to note the physical labor of dance demeans it in the eyes of intellectuals, and to call attention to the sensory, bodily pleasure of dancing makes us seem mere hedonists.[2]

But as a person whose professional home has been dance for many years and whose personal home has been my body, I experience thought as something that occurs throughout my body, not just above my neck. Until I know something on this level—in my bones, so to speak—the knowledge is not my own, but is rather like those facts one memorizes which seem to fall out of the brain the day after an exam. Further, the knowledge that comes this way is not just about my physical body or even dance, but about the questions that drive educational researchers as well. My somatic self, the self which lives experience, is necessary in my struggle to find forms that represent my lived experience, whether those forms are presented on stage or in a scholarly journal.[3]

[2] Leslie Gotfrit (1991) discusses the "politics of pleasure" in regard to dancing in a social (club) setting. While the setting for theatrical dancing is different, many of the issues she discusses are the same.

[3] For additional discussion of the significance of somatics in educational research, see Jill Green (1993) and Lous Heshius (1994).

Of course, just like the choreographer must use other senses in addition to the kinesthetic to create a work, the researcher must draw on other dimensions of the self. I find choreography to be a useful metaphor for research, because choreographers and academic researchers engage in quite similar tasks: They select an idea they find compelling, generate or collect material about the idea, pay attention to it, select from their observations those that appear to be significant, perceive relationships among them, ponder what these might mean, and make something out of the whole process.[4] Along the way, both use sensing and reflecting, internal and external consciousness.

13.1 Process and Product: Research as Choreography

One of my teaching assignments for the past nine years has been an introductory research course, largely for MFA students in dance. These students, while fairly experienced choreographers, are novices at research. They know that their choreography is about "saying," metaphorically, what they want to say. Their initial idea of research, however, usually involves going to the library to learn what other people have to say, then putting these various comments all together (the academic equivalent of a "routine" in dance), perhaps with a few comments of their own.

While certainly time in the library is an important dimension of scholarly research, increasingly I have found myself drawing parallels between what my students know—choreography, and what they do not—research. In looking for ways to make research meaningful to them, I have become even more aware of the importance of my body in the research process and the importance of conveying more of that awareness in the final product.

My first task is to help my students recognize that scholarly research, like choreography, is their work. Their research comes from them just as much as their choreography, even though both choreography and scholarship have additional sources as well.

13.2 Selecting a Topic: A Matter of Passion

The initial point at which research arises from researchers occurs in the selection of a topic. Researchers must choose something in which they are passionately enough interested to be willing to invest the labor required. We recognize that an idea has engaged us the same way we recognize an attachment to anything (or anyone) else: We are drawn to it, it occupies our attention, and everything else seems to remind us of it. In fact, we often feel as though an idea has chosen us, and we elect to return the embrace. An idea for research is my companion as I walk to work, do the

[4]These tasks do not occur in the linear way in which I present them in the next sections of this paper, but overlap and reappear in often unpredictable ways.

laundry, sort the mail. The idea for this piece has been interwoven with reaching up to hug my suddenly taller son goodnight, with watching the Winter Olympics, with dancing alongside adolescents. Each of these experiences, and more, has contributed to the development of my ideas.

13.3 Data Gathering[5]: Kinesthetic Perception

Once the idea has been chosen, there follows a process of gathering or generating the raw materials of the work. In choreography, this may happen in private studio time or, if one draws movement material from dancers, during rehearsals. In scholarly research, one may similarly generate material in private, at one's desk, or gather it from others.

Early in my research career I engaged in a good deal of what William Pinar (1978) refers to as *currere*, writing reflections on my lived experience of education. My memories of my educational experience, like my memories of everything else, reside in my body. I remember not pictures in my mind, but sensations—even how hot my cheeks felt that day in the third grade when my teacher, whom I adored, humiliated me in front of the class. I felt affirmed in my memories by the words of Madeleine Grumet, who spoke to me when she wrote about

> body knowledge, like the knowledge that drives the car, plays the piano, navigates around the apartment without having to sketch a floor plan and chart a route in order to get from the bedroom to the bathroom. Maurice Merleau-Ponty called it the knowledge of the body-subject, reminding us that it is through our bodies that we live in the world. (1988, p. 3)

So the reflections I wrote were filled with kinesthetic images: of dancing, of rocking babies, of pressing my hands into clay. By reflecting on my own images, I was able to generate a number of important insights, just as Pinar had suggested.

But my use of kinesthesia goes well beyond my own autobiography, to help me connect with others in my work as an interpretive researcher interested in how students make meaning of their educational experience. It helps me to answer that first question I ask myself when I enter an educational setting: "What's going on here?" Currently, my "data gathering" involves spending time in classrooms and conducting rather open interviews with students. Because the classrooms I enter are usually dance classrooms, it is easy to see how the kinesthetic sense might be involved. I am a participant observer, and I do the same movement activities that the students are asked to do, so I know what it is like to engage with them in isolations and grounded weight (part of a unit on African dance at one school), or to work with a group to make a movement sequence and then vary it by using half time and double time.

Yet the most important of my fully lived experiences are those that can be encountered in any classroom, such as when I use my kinesthetic sense to connect with the seventh grade kids on the back row who are leaning against the wall, not engaged, going through the motions only when the teacher is looking (if then). Sometimes the

[5]Admittedly, this term is not preferred in interpretive research, but no suitable substitute has yet been put into practice.

teacher assigns groups for a compositional activity ("make a dance sequence which has the following things in it...."). I stand around with other members of my group, holding back, waiting for someone to say or do something, experiencing awkwardness and boredom when no one does. I compare these sensations to what I know about full engagement and resulting accomplishment, which offer so much more in both momentary pleasure and long-lasting satisfaction. Only then do I recognize how powerful is the culture that keeps kids from becoming involved, and the fear of looking stupid that keeps kids from trying. It is apparent in coming to this last conclusion that I have moved beyond sensing to reflecting. However, I would miss what was most important if I were not fully living the experience.

In my current research involving middle-schoolers, I also experience what it is to feel left out when no one chooses me as a partner, and what it is to feel included when some kids come to talk to me before class, without my initiating the conversation. These experiences connect me to the adolescents in my study as well as to the adolescent in myself.

I have no guarantees that my experiences are the same as theirs, just as I cannot assume that the relief I felt when Olympic speed skater Dan Jansen didn't fall was the same as his relief.[6] Yet it is my kinesthetic sense that I must use if I am to know my relatedness with my embodied fellow participants in my research. The same is true when I conduct interviews with my participants. In the interview, we are two persons, two bodies together in a room. When interviewing middle-schoolers, I am often larger than they are, and I am in charge: I set the time, bring the tape recorder, ask the questions. How do I encourage the students to take ownership, to frame their own experiences, to know I truly want to listen? In the good interviews, I experience a connection between us that is much like that I feel when engaged in deep conversation with a close friend, using all of my senses, feeling *with* (see Oakley 1981).

These conversations are another way of gathering material for my work. I speak of gathering as though these words existed, just waiting to be plucked by a researcher, whereas actually they are joint constructions between myself and my participants. Nevertheless, these are my raw materials, just as movement themes are the raw material for the choreographer.

This gathering is actually the easiest part of my research, even though it may take quite a long time. Like the choreographer, I generate much more material than I will eventually use in a particular work. The more difficult tasks are selecting out what is worthwhile, by which I mean what has the possibility to generate insights, figuring out what it means, and then coming up with a way to construct a cohesive paper that can communicate my process and my insights to others. These, too, are activities that involve my embodied self, in my effort to find the form and content of the work I am constructing.

What makes this process especially intimidating for new researchers, and difficult for all of us, is that we do not even know what it is we are making until we are well into making it. It is like facing a large number of puzzle pieces, trying to figure out how the puzzle goes together even before we know what picture we are making.

[6] See Morrison (2007).

As choreographers, my students know this process well, and the courage it takes. They initially go into the studio with some ideas, but without a clear sense of either form or content. (If either is initially clear, it often changes before the work is complete.) They pay attention to the movement they have generated, and make decisions about what does and does not fit. This is a time of trying out, false starts, unfinished phrases. Eventually both form and content become clear, but there is a good bit of messiness along the way, a good bit of trial and error. One hopes for patient dancers and for a muse that will speak as quickly and as clearly as possible. But it is indeed an act of faith to go into the studio, trusting that a dance will result from one's labors.

For me, starting to write a scholarly paper is just as much an act of faith, and the process is just as messy. Initial drafts are like improvisation with words: a time of trying out, false starts, unfinished sentences. I experience the frustrations of trying to get ideas down before they disappear, of crafting paragraphs that lead only to a dead end. For me, this part, this most creative part, of writing must be done in pencil, a symbol of its impermanence. It is important not to fall too much in love with my own words or those of my respondents, because large amounts of this material may get thrown away, or at least thrown away from this project when it turns out to be heading in a different direction than originally expected.

My graduate students, who would quickly reject the idea of following a choreographic formula, assume that there is one for writing a scholarly paper, and eagerly ask for it. Indeed, there are some kinds of choreography and some kinds of writing that do use formulas. I remember being taught a formula for expository writing in high school, and it successfully got me through all those essay exams in college. But while an expository formula is effective in conveying information, it is not so useful in conveying interpretive scholarship. Similarly, choreographic formulas, which might create precision drill team routines, do not usually produce very interesting art.

But the lack of a formula for choreography does not mean that there is no structure. One muddles through, not for the sake of making a mess, but in order to find the right structure for this particular work. Similarly, in research one must look for the right structure. In the kind of research I do, there are two kinds of structure with which I am concerned. One is the theoretical framework, and the second is the structure for the final research paper.

13.4 Theory Building: Knowing in My Bones

A theoretical framework is about relationships: the relationship between ideas and concepts, between the parts of a whole. And a theory is not likely to arise in the form it will ultimately take. Albert Einstein said that, for him, visual and kinesthetic images came first; the words of a theory came later.[7] I often tell my students, in relation to theory, "If you can't draw it or make a three-dimensional model of it or dance it, you probably don't understand it."

[7] This idea (in the form of a letter) was published as an appendix, "A Testimonial from Professor Einstein," in Hadamard (1949), pp. 142–143.

For me as well as Einstein, there is a definite connection between theory and the sensory/kinesthetic; thinking is an active verb. One particular example that stands out for me occurred when I was working on my dissertation (Stinson 1984). I was struggling with a very abstract topic: the relationship between the ethical and the aesthetic dimensions of human existence as they related to dance education. All of my attempts to figure out my theoretical framework felt disconnected from the concerns that had initially propelled me into the study. One day, still searching for my elusive framework, I went for one of those long walks that were a necessary part of my thinking process. When I returned, I lay down to rest and instantly became conscious of how differently I perceived myself and the world when I was standing compared to when I was lying down. Within moments I knew my framework, which was based upon a metaphor of verticality (the impulse toward achievement and mastery: being *on top*) and horizontality (the impulse toward relationship and community: being *with*). I noticed how lying horizontal felt passive and vulnerable while the return to vertical made me feel strong and powerful; these feelings offered important insights as to why we value achievement so much more than community. Once I had identified this dual reality in my own body, I found it in the work of others: in Eric Fromm (1941), who spoke of freedom and security; David Bakan (1966), who spoke of agency and communion; and Arthur Koestler (1978), who spoke of self-assertion and integration. While I had read each of these authors previously, I had to find my framework in my own body before I could recognize the connection between the concepts they had identified and the issues with which I was grappling.

Another time, I remember, I chose swimming for a break in between writing sessions. But one memorable day as I swam, I became aware of the excess tension in my neck. Rather than releasing my neck to allow the water to hold up my head, I was holding on as though afraid it would fall down otherwise. This awareness pointed me toward awareness of other situations in which we use unnecessary control—in internal relations within our bodies as well as relations with others—and I again attended within my body to try to understand why. I realized how much we hold on in making the transition from horizontality (the dependence of infancy) to verticality (which allowed us real mobility and independence). Embedded in our musculature, generally beyond the reach of rational thought, is this impulse toward control and the fear of letting go. Again, this is an insight that could not have arisen without attention to embodied knowledge. These incidents, and many others, have convinced me that we can think only with what we know "in our bones," and that attending to the sensory, followed by reflection, is essential in research.

13.5 Crafting the Choreography of Research

The second kind of structure I must deal with in my research is the structure for the final product: the form that will ultimately communicate the content of the research, telling the story of where I started, where I ended up, and how I got there. Traditional

scientific research has a formula for this; if one does a dissertation in science, there is little question about what Chapter 2 will be.

But, as I tell my students, in other kinds of research this is not all that clear. The "Review of the Literature" does not necessarily go in Chapter 2; it may even be woven throughout the paper, so that voices already in the literature speak in response to newer voices. "How do you know where to put anything? How do you decide? ", my students ask. I tell them everything goes where it fits best; the choices are usually aesthetic ones, not unlike those they make in choreography. For myself, I even find that seeing ideas in space helps during this process; my living room floor becomes the stage, as I spread out the parts of a paper and rearrange them, seeing what looks right, sensing what feels right.

Unlike traditional choreography, of course, the building material for this structure is words. Since I am trying to tell a story of lived experience, I look for words that do more than communicate abstract ideas. I want to use sensory-rich images in hopes that a reader can feel the words and not just see them on the page.

The final stage of research is, for me, the least enjoyable, because by this point all the important discoveries have been made. This is the time for editing. In choreography, editing requires standing away from one's work in order to look with the most objective eye possible, or listen with the most objective ear, as though it were not one's own offspring. In my writing, I have to get similar distance: I do it by typing the penciled words I have birthed into the computer; the hard square lines of the typed letters make them look as though they could have been written by anyone, and allow me to be more critical. I remember the advice of my dissertation advisor—"Kill the little darlings"—by which he meant that sometimes we have to cut those parts with which we are most in love. Editing is difficult whether I am cutting words or movement; I must sever my intimate relationship to what I have written, freeing it to go into the world without me, like an almost-grown-up child who needs to be made ready to leave home.

13.6 Conclusions

It is no surprise that those whose past included extensive dance experience should draw on that experience in whatever work they go on to do. If I were a mechanic or a beautician, I would probably also find connections to dance. But what does the experience of dancers have to do with those who do not know themselves as dancers and choreographers? Is it like an exotic culture, an interesting oddity but of no particular value to others except as something to gawk at in a journal article? I expect it is only dialogue that can let us know if our own experiences, whether expressed in art or in a scholarly paper, are idiosyncratic or if they resonate with others.

My conclusion at this point is that, while not all of us are trained dancers, we all have the capacity to attend to what we are experiencing on a body level. We can allow ourselves to use all of our senses as we live in the world with others and try to understand them and be present with them. In our research as well as in our teaching,

perhaps we can follow the guidance of Martin Buber, who described what it is to "feel from the other side" in words that I can understand within my body:

> A man belabours another, who remains quite still. Then let us assume that the striker suddenly receives in his soul the blow which he strikes: the same blow; that he receives it as the other who remains quite still....A man caresses a woman, who lets herself be caressed. Then let us assume that he feels the contact from two sides—with the palm of his hand still, and also with the woman's skin. (1955, p. 96)

Beyond feeling from the other side, we can also attempt to communicate beyond our own boundaries: not only "antiseptic" abstract ideas, but lived experience, by means of a language rich in sensory images, including kinesthetic ones.

While all of us can do this to some extent, we can do it better if we develop our senses as well as the capacity to form a variety of symbols to represent our experiences. This, of course, is one argument for including all the arts in education.

However, it does not answer the question of *why* we should do this, particularly why we should attempt to cultivate the kinesthetic sense and use kinesthetically rich images when other senses may seem more "respectable" in scholarly discourse. One answer is that it will allow us to perceive more clearly, understand more deeply, the embodied others who are subjects if not participants in educational research. Further, it will allow our readers to understand us better. Much educational research, free from examples or sensory images, is unintelligible to teachers and the general public, as well as to our students.

One might ask, of course, why it should be intelligible to those outside academe. Certainly much scientific research is not understood by the general public. There may be some ideas for which a rich sensory language is not appropriate: ideas which cannot be pointed toward by means of an image or clarified by means of a concrete example. If there are, I would guess that there are not many. Far more often, I fear that we limit ourselves to purely abstract, disembodied language as a way to exclude those who have not yet undergone the rigors of graduate school. In this regard, I was moved by the statement by Patricia Hill Collins in the Preface to her work *Black Feminist Thought*. Collins wrote,

> I was committed to making this book intellectually rigorous, well researched, and accessible to more than the select few fortunate enough to receive elite educations. I could not write a book about Black women's ideas that the vast majority of African-American women could not read and understand. Theory of all types is often represented as being so abstract that it can be appreciated only by a select few. Though often highly satisfying to academics, this definition excludes those who do not speak the language of elites and thus reinforces social relations of domination. Educated elites typically claim that only they are qualified to produce theory and believe that only they can interpret not only their own but everyone else's experiences. Moreover, educated elites often use this belief to uphold their own privilege. (1991, p. xii)

In moving beyond abstract language to use language that touches readers on a sensory level, I hope to make my work accessible. In making reference to the kinesthetic sense, I hope that readers will not only be moved but move, to take action instead of hiding in the safe confines of theory. Such movement may ultimately be the most significant reason to embrace the sentient body in educational research.

Commentary

This chapter extends Chap. 12, going beyond theory to include practical examples from my teaching, since I had begun teaching a graduate research methods course in the interim. An earlier version of this chapter, titled "Research as Choreography," was presented upon my selection as National Dance Association (NDA) Scholar in 1994, and subsequently distributed by NDA. Still in use in dance research methods courses decades later, it was revised and reprinted (Stinson 2006) in an international dance education research journal in a section called "Perspectives," which is designed to make significant historical work available to a wider readership.

Encouraged by the reception of my work at conferences outside of the arts, such as The Bergamo Conference and the American Educational Research Association, I responded to suggestions from colleagues to create a version of this piece for the journal *Educational Theory*, in which this chapter was published in 1995. Since that time, other scholars inside and outside of the arts, most notably Liora Bresler (2005, 2006, 2008), have written about the significance of the arts in educational research. An upcoming book on the topic, edited by Bresler with chapters by international authors, is in process, with publication by Lund University Press expected in late 2015.

References

Bakan, D. (1966). *The duality of human existence*. Boston: Beacon.

Bresler, L. (2005). What musicianship can teach educational research. *Music Education Research, 7*(2), 169–183.

Bresler, L. (2006). Embodied narrative inquiry: A methodology of connection. *Research Studies in Music Education, 27*, 21–43.

Bresler, L. (2008). Research as experience and the experience of research: Mutual shaping in the arts and in qualitative inquiry. *LEARNing Landscapes, 2*(1), 267–279.

Brodkey, L., & Fine, M. (1988). Presence of mind in the absence of body. *Journal of Education, 170*(3), 84–99.

Buber, M. (1955). *Between man and man* (M. Friedman, Trans.). New York: Harper.

Collins, P. H. (1991). *Black feminist thought: Knowledge, consciousness, and the politics of empowerment*. New York: Routledge.

Eisner, E. (1982). *Cognition and curriculum: A basis for deciding what to teach*. New York: Longman.

Eisner, E. (1988). *The role of Discipline-Based Art Education in America's schools*. Los Angeles: Getty Center for Education in the Arts.

Eisner, E. (1993). Forms of understanding and the future of educational research. *Educational Researcher, 22*(7), 5–11.

Fromm, E. (1941). *Escape from freedom*. New York: Rinehart.

Gardner, H. E. (1989). Zero-based art education: An introduction to ARTS PROPEL. *Studies in Art Education: A Journal of Issues and Research, 30*(2), 71–83.

Gardner, H. E. (1990). *Art education and human development*. Los Angeles: Getty Center for Education in the Arts.

Gotfrit, L. (1991). Women dancing back: Disruption and the politics of pleasure. In H. Giroux (Ed.), *Postmodernism, feminism and cultural politics: Redrawing educational boundaries* (pp. 174–195). Albany: State University of New York Press.

Green, J. (1993). Fostering creativity through movement and body awareness practices: A postpositivist investigation into the relationship between somatics and the creative process (Doctoral dissertation, The Ohio State University). *Dissertation Abstracts International, 54*(11), 3910A.

Grumet, M. R. (1988). *Bitter milk: Women and teaching.* Amherst: University of Massachusetts Press.

Hadamard, J. (1949). *An essay on the psychology of invention in the mathematical field.* Princeton: Princeton University Press.

Heshius, L. (1994). Freeing ourselves from objectivity: Managing subjectivity or turning toward a participatory mode of consciousness? *Educational Researcher, 23*(3), 15–22.

Johnson, D. (1983). *Body.* Boston: Beacon.

Koestler, A. (1978). *Janus: A summing up.* New York: Random House.

McDade, L. A. (1987). Sex, pregnancy and schooling: Obstacles to a critical teaching of the body. *Journal of Education, 69*(3), 58–79.

McLaren, P. (1991). Schooling of the postmodern body: Critical pedagogy and the politics of enfleshment. In H. A. Giroux (Ed.), *Postmodernism, feminism, and cultural politics* (pp. 144–173). Albany: State University of New York Press.

Morrison, M. (2007). Jansen saves his best for last: A gold medal and a world record in 1994. Retrieved 13 Apr 2015, from http://www.infoplease.com/spot/winter-olympics-jansen. html#ixzz3KqY1YDFX

Noddings, N. (1992). *The challenge to care in schools: An alternative approach to education.* New York: Teachers College Press.

Oakley, A. (1981). Interviewing women: A contradiction in terms. In H. Roberts (Ed.), *Doing feminist research* (pp. 30–62). New York: Routledge.

Pinar, W. (1978). *Currere:* Toward reconceptualization. In J. R. Gress & D. E. Purpel (Eds.), *Curriculum: An introduction to the field* (pp. 526–545). Berkeley: McCutchan.

Shapiro, S. B. (1999). *Pedagogy and the politics of the body: A critical praxis.* New York: Garland.

Stinson, S. W. (1984). *Reflections and visions: A hermeneutic study of dangers and possibilities in dance education.* Unpublished doctoral dissertation, University of North Carolina, Greensboro.

Stinson, S. W. (1993). Meaning and value: Reflecting on what students say about school. *Journal of Curriculum and Supervision, 8*(3), 216–238.

Stinson, S. W. (1994). *Research as choreography* (National Dance Association scholar lecture). Reston: National Dance Association.

Stinson, S. W. (2006). Research as choreography. *Research in dance education, 7*(2), 201–209. (revised and reprinted from 1994 publication).

Chapter 14
Teaching Research and Writing to Dance Artists and Educators (2009)

Ann H. Dils, Susan W. Stinson, with Doug Risner

Abstract According to results of a national survey on graduate dance programs in the USA, questions about research and how best to incorporate it into graduate education are timely. The co-authors describe a model for teaching research and writing to graduate students in dance which they began implementing and refining over a 5-year period beginning in 2004. The model entwines scholarship, teaching, and artistry. Dils and Stinson reflect on two issues that arise from their teaching: embodiment as it relates to dance research and to online learning, and maintaining high expectations for critical and reflective thinking in light of the developmental levels of students.

Should master's degree students in dance take research courses? If so, what approaches to research are of value, and for which students? Should students preparing for careers as choreographers know something about academic research? Or should their focus be exclusively creative research? How about graduate students preparing to be educators?

Our planned exploration of these questions took two forms. For the purposes of this presentation, as well as for research being conducted for the United States-based National Dance Education Organization (NDEO), Doug Risner conducted an online survey of graduate student research programs and coursework in dance in the USA (2009). We are sorry Doug couldn't be here today as planned. He invited 45 post-secondary institutions to participate in the survey, which was filled out by graduate program directors, department heads, or graduate faculty. The survey included questions about current programs as well as qualitative responses concerning the unit's research-related goals for graduate study. A little under half of those invited completed the survey. Doug's results are available at www.dougrisner.com. We include excerpts from the qualitative responses in our conclusions.

We (Dils and Stinson) have explored these questions by reflecting on our own teaching. In our presentation, we will describe a model for teaching research and writing to graduate students in dance which we have been implementing and refining for the past five years. Our two-semester course sequence, officially Dance 610 and 611, Dance: The Phenomenon I and II, arose, in part, from a desire to engage students who see themselves as artists and/or teachers, in research and writing.

© Springer International Publishing Switzerland 2016 169
S.W. Stinson, *Embodied Curriculum Theory and Research in Arts Education,*
Landscapes: the Arts, Aesthetics, and Education 17,
DOI 10.1007/978-3-319-20786-5_14

We have developed a syllabus that includes thorough descriptions of the assignments, grading rubrics, hints from past students, and sample assignments. The course involves a great deal of independent work as well as peer mentoring. Most of our time is spent developing and revising assignments and serving as research and writing tutors. Syllabi for both courses are available by request.

In this presentation, we will describe our students, then introduce the course sequence before discussing what we have learned about embodiment as an aspect of the research process and of online learning, and then what we have learned about reflective thinking. We will both be talking about challenging issues that have emerged along the way.

14.1 About Our Students

Our two-semester course is designed to meet the needs of diverse graduate students. Most of our students are in programs that emphasize choreography or dance education, with a few in a more scholarly "theories and practices" track. Some are in resident programs and some in online programs. In combining the MFA and MA[1] populations, we have learned that *all* of our students are interested in teaching and see teaching in their futures. Most of our MFA students aspire to teach in higher education, and teaching assistantships are highly coveted as ways to develop their skills. Some of our MFA students also make careers teaching in public schools or in dance studios.

When both populations are enrolled, the courses are taught entirely online. We try to create virtual connections among students to supplement those already established. MFA students bond while sharing a TA office and technique classes. The online MA students in dance education come to campus to take classes during the summer. This requirement is an important part of establishing a tight community whose members mentor each other throughout their programs and after they graduate.

Students come to our graduate programs and to our courses with very different backgrounds. Some enroll directly from undergraduate school. Others are well into university teaching careers or are making career transitions. These students might have advanced degrees in dance or other subjects. Although we require the Graduate Record Exam, we have no hard and fast rule that students must make a certain score for admission. Instead, it is used, along with video and writing samples, to establish the student's promise for graduate study.

Students leave our courses with very different accomplishments. For some, even their first assignments reveal outstanding scholarship and articulate writing. These are the students in whose work we see the potential for a very fine publication.

[1] The MFA (Masters of Fine Arts) degree is a 3-year residential program with emphasis in choreography. Our MA students may choose a concentration in Dance Education (available only for part-time students, delivered mostly online), Choreography, or Theories and Practices.

Two (Stark 2009; Ward-Hutchinson 2009) have just been published. Other students make good progress or even major breakthroughs. Still other students have breakthroughs that they can't sustain, doing very well on one or two assignments but falling into old habits or losing focus on others.

14.2 About Our Course

14.2.1 Dance 610 (Dils)[2]

In the first semester, DANCE 610: Dance the Phenomenon I, students read exemplary writing in dance studies as well as pursue their own research project, including analysis, research, and commentary about an existing dance work. I emphasize the understanding of dance as a social/cultural entity that can tell us about our social values, ways of understanding and valuing the body and movement, and aesthetic priorities.

We have multiple, often conflicting concerns in selecting choreography. We want students to experience work that is challenging and resistant of social mores or expectations within the dance community or academia. These works are often not useful for those teaching elementary and secondary students, so we offer an alternate selection. The works must be cheaply available in electronic format. Among those previously used are works by Efva Lilja (2006), Victoria Marks (1994), Alvin Ailey (1960), Yvonne Ranier (1978), and Jawole Willa Jo Zollar (2006).

Students watch the choreography many times, learn a portion of it, and read applicable scholarly and critical work including writing by the choreographer, if available. Along the way, they write a series of descriptive and reflective responses based on analysis of the work's structure and movement content and on their own somatic and autobiographical experience of the work, as well as a review of literature. At the end of the semester, they pull all of these assignments together in three ways:

- Incorporating the written work they've already compiled, they write a 15–20 page essay emphasizing the work's social and cultural meaning.
- They create and teach a unit, approximately 1 week long, exploring the work with their *own* students. In their teaching, they are expected to engage students through movement, oral discussion, reading, and writing, echoing the ways in which they have investigated the work themselves. Dance education students work with their own young pupils, while others are assigned to a university Dance Appreciation class. They carefully document their teaching on video and by collecting the students' written work.

[2] In our presentation, we alternated in presenting our remarks. We have indicated the speaker here only when necessary for understanding. Throughout our presentation, we included Powerpoint slides that helped organize and reinforce our remarks. Where appropriate, these have been integrated into our text.

- As a coda to their study, students re-state their findings within the paper in another form. They might make solo movement studies or poems, or combine visual images and text.

14.2.2 **Dance 611** *(Stinson)*

During the second semester, I mentor students through an action research project based on the teaching assignment the previous semester. I begin with an introduction to action research, during which students read some examples in order to identify the parts of a research report as well as what we call its "performance" aspects. Prompts for this assignment include: "How did the writer facilitate your reading as a pleasurable activity? How did the writer enhance your understanding? What aspects of the writing gave you the most struggle?"

At the same time, students are transcribing the data for their own research: describing their students' movement responses as well as the words spoken and written. I expect them to become as intimate with their data as they have been with the dance, initially asking big questions: "What is going on here? What can I learn from what my students are telling me: about dance, about *this* dance, about teaching, about myself and my teaching?" As themes and issues emerge from their analysis, I help them locate literature that can enlarge their understanding. Throughout, I use a model of research as a form of embodied artistic practice (Stinson 2006). And eventually, their final paper for the semester takes shape and is refined.

14.3 **Embodiment and the Research Process/Embodiment and Learning** (*Dils*)

Before joining forces with Sue, I taught a version of DANCE 610 that was mostly an introduction to dance studies research and to investigating established choreography through movement analysis and critical commentary. In creating our two-semester course, embodiment was an important concern. Mindful of the online environment, we wanted to promote student engagement through assignments that employ the body and that foster student-to-student interaction. In pursuing our own research, Sue and I had found differing ways to meaningfully employ and reflect upon bodily experience and we wanted students to similarly experience the body as a connection among artistry, teaching, and scholarship.

We addressed these concerns in several ways. First, we added a writing assignment that requires the students to learn part of the dance they are studying in order

to respond to the work somatically and autobiographically. In writing their response, students are asked to consider the following prompts:

- Describe the movement and your experience of it.
- Does the work have an inside and an outside, a core and a shell? How do inner and outer perspectives mesh? Inform each other?
- What are the emotional and physical joys and challenges of the movement? What emotions or insights are evoked while moving?
- What is the relationship between your life experience and the work as performed and watched?

After receiving too many responses that focused on the writer's experience without illuminating the dance in question, we added this prompt:

- The object of the exercise is to illuminate the work being studied, and to use your somatic and autobiographic experiences to better understand the work and your relationship to it. Keep the focus on the work, not on yourself.

To support student work, we selected literature that models how the body, movement, and artistic practice can be used in academic research, including Albright (1997), Cancienne and Snowber (2003), Chatterjea (2004), Sklar (2001), and Stinson (1995). Finally, we added the teaching assignments described earlier.

The work students have done in bridging the activities and literatures of artistry, pedagogy, and scholarship has helped us towards a more complex understanding of embodiment. Liora Bresler employs a good definition of embodiment in the introduction to her 2004 *Knowing Bodies, Moving Minds: Towards Embodied Teaching and Learning*. She is quoting Varela, Thompson, and Roasch: Embodiment is the "integration of the physical or biological body and the phenomenal or experienced body," suggesting a "seamless though often-elusive matrix of body/mind worlds" (viii). I also like this excerpt from Meridel Le Sueur's (1976) poem "Growing Up in Minnesota," as she animates the more academic definition Bresler supplies:

> The body repeats the landscape. They are the source of each other and create each other. We were marked by the seasonal body of earth, by the terrible migrations of people, by the swift turn of a century, verging on change never before experienced on this greening planet. (p. 17)

I find Le Sueur's description helpful in foregrounding embodiment as it figures into our teaching. She makes clear that all of our activities—dancing, research and writing, computing—are embodied. Our question should not be if an activity is embodied or not, but what the activity requires of our bodily complex, how it organizes us, and how we can reorganize ourselves and the activity in question to best advantage. Again, "The body repeats the landscape. They are the source of each other and create each other."

14.3.1 Embodiment and the Research Process

Students have found learning parts of existing dance work helpful in gathering and analyzing data about the work, in theorizing, and in finding evocative language. I have two examples from the data gathering and analysis stage of writing: In one project, a student learned the opening section of Ailey's *Revelations*. I'm sure we can all conjure up that well-known image of the wedge of performers, staring upwards, as they stand in a warm island of light. What I hadn't realized, and he discovered, is that the individual bodies in that wedge move between being pressed, flattened as if between two panes of glass, and breaking out of that flatness as they circle their arms and then bend forward. This sense of being pressed, of oppression, became very important to his analysis of the work, as he began to ask what *Revelations* might suggest about the repression of sexual difference.

In another project, a student who began thinking that *Trio A* was a rather simple dance, realized how difficult Yvonne Rainer's long sentence of uninflected movement is to memorize and how full of subtle details and tricky co-ordinations that pose performance challenges. In learning the movement, the student began to see a relationship between *Trio A* and release technique. Especially interesting was a shared concern with quirky, specific, movement articulations. This led her to rethink conceptual boundaries between postmodern and contemporary dance.

Students have also been successful in looking to their own bodily experience in theorizing, guided in part by Sue Stinson's remarks (1995) on the body and theorizing. This passage, slightly paraphrased below, has been especially useful to students:

> A theoretical framework is about relationships between ideas and concepts, between the parts of a whole. And a theory is not likely to arise in the form it will ultimately take. Albert Einstein said that, for him, visual and kinesthetic images came first; the words of a theory came later.
>
> For me as well as Einstein, there is a definite connection between theory and the sensory/kinesthetic; *thinking* is an active verb. One example that stands out for me occurred when I was working on my dissertation. I was struggling with a very abstract topic: the relationship between the ethical and the aesthetic dimensions of human existence as they related to dance education. All of my attempts to figure out my theoretical framework felt disconnected from the concerns that had initially propelled me into the study. One day, still searching for my elusive framework, I went for one of those long walks that were a necessary part of my thinking process. When I returned, I lay down to rest and instantly became conscious of how differently I perceived myself and the world when I was standing compared to when I was lying down. Within moments I knew my framework, which was based upon a metaphor of verticality (the impulse toward achievement) and horizontality (the impulse toward relationship). I noticed how lying horizontal felt passive and vulnerable while the return to vertical made me feel strong and powerful; these feelings offered important insights as to why we value achievement so much more than community. Once I had identified this dual reality in my own body, I found it in the work of other scholars who spoke of freedom and security, agency and communion, and self-assertion and integration. While I had read these authors previously, I had to find my framework in my own body before I could recognize the connection between the concepts they had identified and the issues with which I was grappling. (pp. 50–51)

Next I offer a sample quote from a student, who theorizes about dance watching as an intersubjective process. While the example I will use here comes most obviously from observation, and indeed is a theorizing of the relationship between observer and observed, it also stems from her experience of learning the work she explores, Efva Lilja's (2006) *Movement as the Memory of the Body*, a creative research project involving performances by mature dancers:

> Abramson's performance … absorbs me. I am fascinated by his intense connection to the material, by the subtext of his movements, by what he may be thinking. As the performer, he is aware of my gaze, as an aging dancer (he/I), I become acutely aware of our commonalities. His defiant removal of his clothing amidst the jeering laughter that seems to surround him, and his ensuing nakedness affect me in a personal way and lead me to become aware of my discomfort with my own body; the jeering I hear in my own mind at the idea of exposing it, clothed or unclothed. Yet, I rejoice in his defiance of that humiliation as he removes each piece of clothing, methodically, and moves unabashedly through the space. I rejoice not with the dance, but with the dancer (he/I). My gaze is firmly fixed throughout on the object of the dance (his/mine) rather than the dance itself. (Lilja has made the gazer the object of her gaze.) When he crouches on the floor in fear, clutching his clothes in front of his naked body – not unlike a frightened child – I become aware again of my intense fear of physical exposure. As an older person, his vulnerability does not disgust or sadden me. It simply reminds me. (I become the object of my own gaze.)[3]

This quote is also a good example of compelling word choice. The author does not look at the observed dance, but is "absorbed" by it; she does not regard the dancer, but is "firmly fixed" on him. At the end, she situates her reaction to the dancer within her own bodily complex of emotion and thought: "his vulnerability does not disgust or sadden me. It simply reminds me."

14.3.2 Embodiment: The Researcher as Learner

Throughout the course, we've noticed how complex and varied people are in ways of meeting and negotiating the world and in organizing themselves to learn. The somatic and autobiographic assignment that we hoped would draw movers into the research process and help them adapt to online learning is one place we notice interesting differences. While learning parts of an existing dance has been productive for most students, others have a great deal of trouble finding their way into this assignment. Several students have complained that watching a dance on DVD just doesn't connect to them as dancers, indeed that they watch dance, even in a theatre, as a visual experience and not as a kinesthetic one. While they can mimic shape and speed, other movement information isn't available to them and nothing is evoked— emotionally, somatically, in terms of individual history—by imitating others moving. Looking for a way to help these students, we suggested that they think about how they would teach this movement. Verbalizing how the movement should feel to someone else has helped these students make more connections.

[3] Student work is used with permission but authors are intentionally not identified.

Another way in which students have shown a preference for linking verbalizing and moving is in reading. A student wrote these words of advice to her colleagues:

> Trying to make a more palpable connection to the articles and stay fully engaged, I found myself reading aloud. This brought my attention to my own kinesthetic learning needs. It helps me to involve my body through forming the words with my mouth, engaging my breath, and feeling the rhythmic flow of the sentences. At times, it even helps to walk around while reading, though this makes highlighting precarious. People crave feeling, even if it isn't embedded in their learning style. Is this not why adolescents embark on "dangerous" physical endeavors—to FEEL something inside their physical beings?

Too, we have had many experiences that suggest that students organize themselves in writing and in choreography or teaching in similar ways. Students often remark that the prompts we make concerning writing parallel the suggestions they receive in choreography classes. Our understanding of student strengths and challenges is affirmed during portfolio review, an important transitional step that allows faculty to assess student progress across their work in choreography or pedagogy, and academic writing. A lack of attention to evocative language shows up in choreography as a lack of attention to movement invention. Writers who have trouble creating clear structures for their essays, also have trouble creating choreographic structures and developing coherent teaching plans. A lack of investment in critical or reflective thinking is noticeable across all work.

Working with our students has also helped us rethink our feelings about the magic of the classroom, and of immediate experience as the preferred mode in learning. We agree that we have had greater success with student writing in this course, than we have had working with students in traditional settings. Part of this success may have to do with the performative sense that writing accrues online. In the traditional classroom, students can absent themselves by not speaking and because their work is seen only by the instructor. In our online course, everyone sees their writing, making digital space into public space, with an exposure that might be compared to the dance studio or stage. This exposure encourages investment in writing. Some older students complain that the online environment seems sterile to them, devoid of opportunities to hear others talk about important issues that can improve their comprehension. For these students, we have built in peer mentoring assignments. Younger students are used to learning and forming friendships on line. These adept online learners have helped us by suggesting casual chat areas for ongoing discussion of issues and for questions and answers about the course.

14.4 From Critical to Critical/Reflective Thinking (*Stinson*)

One of the important criteria we have for evaluating assignments in these courses is that students demonstrate critical and reflective thinking. During the past five years, we have continued to develop our understanding of what we mean by this expectation, our ability to encourage it in students, and its significance to artists and educators as well as scholars. We are still on this journey, but will share a few discoveries up to this point, as well as some continuing struggles.

We used to just state that our goal was "critical thinking," often regarded as the "holy grail" in higher education. A work by Patricia King and Karen Strohm Kitchener (1994) is helping us understand what else we are looking for. King and Kitchener point out that traditional ways of understanding "critical thinking" involve use of rational, logical arguments to support a point, and often rely on what they call "authority-based thinking." Many students come to graduate school with academic skills that rely on both the recognition of authority *and* the ability to state an opinion. Almost all of our students have these strengths:

- Reading scholarly material (not necessarily the most difficult material) and deciding whether they agree or disagree with the author;
- Watching a dance and expressing an opinion about its meaning; and
- Using the library and/or the internet to find quotes from "authorities" who confirm their opinions or interpretations. Among these authorities are the choreographer, dance critics, and scholars in dance or related fields.

Typically, if the authority's interpretation differs from their own, many students yield to the authority (who *must* have it right—after all, doesn't the choreographer know what the dance means?). Alternatively, they simply claim that everyone has a right to their own opinion—and no opinions are necessarily better than others.

Our students' beginning level of understanding about what it means to "teach" a dance rests on the skills they possess:

- Giving their students factual information about the work, as well as the "artist's intent";
- Showing the video; and then
- Asking students for their opinions: how they liked it, what they think it means.

Certainly, we want our students to recognize and make use of good authorities and to have their own opinions. But what else do we want them to do when they look at choreography and when they teach their students how to do so? Here is where King and Kitchener (1994) provide more help, when they discriminate between *critical* thinking and *reflective* thinking. They note that, while *critical* thinking is very important in solving problems where a correct answer can be found, *reflective* thinking is needed for ones where a single correct answer doesn't exist. Today's world-wide recession is an excellent example. Such problems can't be resolved with a high degree of certainty, and multiple authorities often disagree about the best solutions. This doesn't mean that all arguments are equally valid or all solutions are equally useful, but authorities can't provide certainty.

We see questions of meaning or interpretation in dance and dance education as being in this category. Searching for the "right" answer is fruitless. Yet there *is* more than personal opinion involved. Some interpretations are better grounded than others—in the dance or, in the case of qualitative research, in the data. Further, an interpretation requires an interpreter. It is important to understand oneself—the lenses that we each bring to watching dance or anything else. What do these lenses reveal, and what do they conceal? To what extent are lenses based on purely personal or idiosyncratic experiences, and to what extent do they arise from a shared culture? How do we put together these ways of perceiving the world to construct, deconstruct, and reconstruct meanings?

To summarize this in student friendly language: What something means is more than what the authorities say, and more than just personal opinion. To be a good meaning-maker, you have to develop your own sense of authority, not through blind belief that you are right, but by rigorously questioning those authorities and your own opinions. What is influencing their thinking—and yours? What are you leaving out? What are the strengths and what are the limitations of these ideas and opinions? What are some other important ways to look at this?

Some students respond readily to such prompting, especially if accompanied by an example or two. Perhaps these students are "ready" to make the shift to reflective thinking, like the child just ready to walk who can do so if a loved one holds out their arms a step or two away. Some of our graduate students, like those whose work has been presented or published, are ready not just to walk but to run.

14.4.1 A Developmental Progression in Reflective Thinking

But such success doesn't come so quickly to all. King and Kitchener's proposal for a developmental progression in reflective thinking has illuminated some of our observations about differences among our graduate students. These authors identify seven stages in the development of reflective judgment in adolescents and young adults, identified through years of interviews; their book is liberally laced with qualitative examples of each stage. Like other developmental progressions in abstract thinking, their Stage 1 begins with a belief that all questions have certain answers and that authorities are the ones with those answers.

King and Kitchener state that most students reach Stage 4 by the end of their undergraduate degree program. Individuals in Stages 4 and 5, which they group together as the "Quasi-reflective" stages, recognize that *Knowledge* is contextual and specific, so always involves some ambiguity. Here are sample quotes from their interviews demonstrating Quasi-reflective thinking:

> Stage 4: *I'd be more inclined to believe evolution if they had proof. It's just like the pyramids: I don't think we'll ever know. Who are you going to ask? No one was there.* (p. 15)
> Stage 5: *People think differently so they attack the problem differently. Other theories could be as true as my own, based on different evidence.* (p. 15)

Here is an example of Quasi-reflective thinking from a first draft of student work in DANCE 611, after finding an author who "strives to 'invite students to draw their own conclusions' ":

> This is what I now am going to encourage my students to do. An example of this … came up recently in my personal life. My boyfriend came to a dance concert with me over the past weekend. The show…used a lot of apples as props. When the show was over I asked my boyfriend what he thought and the first thing he said was "I didn't get the apple." Without even thinking I said "Well you don't necessarily need to 'get' the apple. You just have to take it as what it means to you." … I realized … that this is a great way to express to my students what I am looking for them to do when they interpret works of art, use their own experiences to draw their own conclusions.

While this student had gone beyond authority-based thinking, at this point in her development, an apple or anything else in a dance meant whatever any interpreter thought it might mean. I tried to help her go further, by asking how much of an interpretation comes, or should come, from an individual observer and how much from the dance itself. Further, I gently tried to help her think about cultural meanings of apples, ranging from the Garden of Eden story to metaphors such as "the apple of my eye," and what these meanings might have to do with interpretation of the dance. I might have gone further still and prompted her to speculate about how the audience might have perceived the exclusively male/female partnering in the dance, when paired with those Garden of Eden images. As a teacher, did she want to leave students with simply their own interpretations? To help them, she had to go "further" herself.

What is "*further*" in development of reflective judgment? According to King and Kitchener, real reflective thinking is found in Stages 6 and 7. By this level of development, *Knowledge* is recognized as the outcome of a process of constructing solutions to problems that cannot be resolved with certainty. That construction occurs through comparing and evaluating evidence and opinion from different perspectives on an issue. Here are some sample quotes from their interviews:

> Stage 6: *There are degrees of sureness. You come to a point at which you are sure enough for a personal stance on the issue.* (p. 15)
> Stage 7: *One can judge an argument by how well thought-out the positions are, what kinds of reasoning and evidence are used to support it...* (p. 16)

The length of this presentation doesn't allow me to present a quote from a student paper to illustrate this stage of thinking, but the works by students Stark (2009) and Ward-Hutchinson (2009) exemplify it. We don't expect publishable work for the highest grade in our course, but we have realized that we expect what King and Kitchener define as stage 6 or 7. I will problematize this shortly, but first will share some strategies we have discovered to help students develop their reflective thinking skills beyond where they start. The first two, I acknowledge, draw heavily on "authorities" about teaching writing and thinking

14.4.1.1 The "Moves That Matter" in Academic Writing

The first resource is a modest little paperback suggested by a wise colleague, which I initially rejected as a recipe book for writing. But I quickly realized I was wrong about Gerald Graff and Cathy Birkenstein's book *They Say/I Say: The Moves that Matter in Academic Writing* (2005). I started thinking about how much "taken for granted" knowledge we forget about in teaching dance and in teaching writing. For example, novice dance students don't know they should start at the end of "5,6,7,8" on the next count in the same tempo, or what it means to "go across the floor." There are many similar conventions in academic writing, ones that we as dance scholars know in our bones just as much as we know what "*first position, plie*" means. But many of our students don't know scholarly conventions. This book demystifies academic reading and writing by letting our students in on secrets we had forgotten we knew.

What I like most about Graff and Birkenstein is their idea that all academic writing is a kind of conversation, one in which students can participate once they understand the conventions. The titles of the chapters reveal their step-by-step instruction—how to start with what others are saying, respond to the voices of others and distinguish one's own view, saying why it all matters, and tying it all together:

Part 1: They Say

- "They Say": *Starting with what others are saying*
- "Her Point Is": *The art of summarizing*
- "As He Himself Puts It": *The art of quoting*

Part 2: I Say

- "Yes/No/Okay, But": *Three ways to respond*
- "And Yet": *Distinguishing what* you say *from what* they say
- "Skeptics May Object": *Planting a naysayer in your text*
- "So What? Who Cares?": *Saying why it matters*

Part 3: Tying it all together

- "As a Result": *Connecting the parts*
- "Ain't So/Is Not": *Academic writing doesn't mean setting aside your own voice*
- "In Other Words": *The art of metacommentary*

Their chapter on "planting a naysayer in your text" is especially useful for those students who initially claim that they don't want to reveal the limitations in their arguments, since it might make them look "weak." Graff and Birkenstein, however, describe ways to question one's position in order to strengthen it.

14.4.1.2 Self Evaluation According to Established Criteria

Second, we encourage students to evaluate their own work using criteria for the course. We started doing this routinely after one student told us her breakthrough in writing occurred after she taped the criteria to her computer and referred to them daily.

However, this particular student had a "relapse" in her writing after completing the course. She had attended to "what the teachers want" but couldn't (or didn't) adapt and apply our criteria to her further scholarly work. We were thus pleased to find Susan Wolcott's more generic online forms (2003) to help students evaluate their own thinking. Grounded in King and Kitchener's progression, Wolcott's rubric has five levels for evaluating student work according to each criterion. For example, in Wolcott's rubric for evaluating one's "Own Biases and Overall

Approach to Problem," a beginning level student will proceed as if the goal were to find the single "correct" solution. One slightly more advanced will stack up evidence and information to support her own conclusion. At the highest level, a student will proceed as if the goal were to construct knowledge, to move toward better conclusions over time.

Similarly, in "Identifying Pros and Cons of Arguments," at the lowest level a student will cite some arguments directly from readings, but without using her own words. At a midway point, a student will objectively present pros and cons, including multiple arguments in favor of each alternative; the next step adds to this, by organizing the discussion to clarify the most important issues. The highest level of work incorporates even more: possible future information that might influence evaluation of alternatives.

It is insightful, and humbling, to use this rubric in evaluating my own work. It is not a perfect fit with all assignments, but this past year I referred a couple of students to it when they were "stuck"; next year I plan to try out more direct use, even asking students to turn in a self-evaluation along with the first draft of their essay. We are hoping to help students become good critics of their own thinking, using the work of authorities as part of the process. We also need to help students consider other criteria for good writing, including criteria they generate themselves and ideas from their peers. Indeed, the last two strategies I will share have to do with using the work of peers to stretch students' thinking.

14.4.1.3 Using Examples of Scholarly Work Written by Peers

Since the second year of co-teaching, we have provided multiple good examples (from students who took the course previously) for most assignments. As someone who finds examples really helpful, I like offering them to students.

Another use of student work is in the assignment in which students "map" a research report to identify its parts; prompts include these:

Analysis of data: What has the author determined is important about this data? Did the writer convince you that the categories for organizing data are a meaningful way to think about it?

Interpretations and theorizing: Do you see the author as largely reporting data? Or does the author use the data to make some larger point about practices in their field or about how we see, think, or teach? Are there other interpretations *you* might make?

While we started out having students map work by established scholars, for the past two years I have had them analyze strong work by previous students—and this has generated much greater success. Perhaps this is because there is a clearer "match" between their assignment and the example they "map"? Perhaps because this reading is less intimidating, not so far beyond them?

14.4.1.4 Assignments Requiring "Peer Support"

In addition to this use of student *work* as exemplars, Ann and I are getting better at using peer *support* to help students think more reflectively. Here is an example of a comment (made in a formal assignment in which students write a letter responding to their peers' first phase of data analysis):

> I am unsure about what you had expected from the lessons. True, you may not have gotten what you wanted, BUT you did get a great deal of valuable information from your kids. I kindly (and with a gentle voice) ask you to try to think about (and be flexible about) the way you are analyzing your data. Perhaps the lens that you are using is not quite right for your action research. [Could you allow this] thought: "My students have made some honest connections and even if not every student had a lot to offer, some of them truly said so much."

The recipient quoted this letter in her final essay, and responded as follows:

> Instantly, my new ideas of critical thinking along with my question for this paper began evolving. … I trusted that [my peer] would not lead me astray. With a new lens for looking at my students' work, I revisited my data [and] noticed that my students *were* indeed answering the questions, …just not to the depth that I had expected or desired. As I sat with the same data as before, I realized another question for this paper. Why do students react … toward the reflective process as they do?

Sometimes, students can receive an insight from a peer that they are not ready to hear from a teacher. We'd like them to be developing the kinds of peer mentoring relationships that Ann and I described in a recent chapter on the subject (Dils and Stinson 2008). Even more important, we are trying to help students experience what it means to be part of a community of scholars. In such a model, academic scholarship becomes, as Graff and Birkenstein wrote, a dialogue among people, rather than a collection of words from authorities found only in disembodied books and articles.

So we are slowly figuring out better ways to help more students move further along in the development of what I am now calling critical/reflective reading and writing, the path to becoming scholar/artists or scholar/teachers. I am quite sure that we now have more students doing reflective thinking at higher levels than we did 5 years ago.

14.4.2 No Graduate Student Left Behind?

And yet, despite these strategies which have been successful with many students, we are not equally successful with all. King and Kitchener give a number of suggestions that can help students make progress in their development, especially if practiced by faculty in multiple courses, but they also make clear that there are no magic bullets, no quick tricks. They say that students take a couple of *years* at each level before being ready to move on to the next. This has particular implications for a one-year course like ours.

This issue takes on more significance due to the context of grading at our institution. The Graduate School requires that all students earn an overall average of a B, in order to complete the graduate degree. No more than six credits (essentially two courses) evaluated as a C+ or C will count toward a master's degree, and anything below a C is recorded as failure. This very slight range means that students (and many faculty) interpret a grade of B as meaning "almost failing," and most students earn grades of A or A- in most graduate courses.

Our expectation that students demonstrate what King and Kitchener describe as reflective thinking—stage 6 or 7—in order to earn a grade of A, comes into conflict with our students' expectation that everyone should have an equal opportunity to reach the highest level. The reality is that they don't. In a developmental construct, individuals can't skip a stage, and just wanting to develop won't make it happen faster. In addition to having opportunities and encouragement to develop, students have to be at a level of readiness to move to the next stage, just like a child has to be *ready* to run and to skip. This implies that some students, no matter how much effort they (and we) invest, are not going to be able to demonstrate high levels of reflective thinking by the end of two semesters with us. They might move from early Stage 4 to Stage 5, but not all the way to what we have described as reflective thinking.

An alternative interpretation is that developmentalism is just a convenient explanation for why all of our students don't make it to the top, and I am just not good enough as a teacher to help them get there. As I continue to reflect on this, I try to walk a precarious path: grading based on high standards of achievement, while valuing students wherever they are. To say it differently, I try to challenge students *intellectually* while supporting them *personally*. I often point out to students that they are far more advanced in other areas, such as performance, choreography, and film-making, than I am—and reassure them that development is a journey they can continue as long as they wish. And as I travel with them, I am learning how to become a better teacher, to help them start running as soon as possible, even if it is not as soon as they might wish.

14.5 Further Areas of Exploration

Our experiences with these courses, and our students' experiences, provide many possible further areas of exploration. We have already written an article about peer mentoring (Dils and Stinson 2008). Another area of exploration is the dilemma of students who can't write clearly about the work they read: Is the problem their writing or not understanding the reading? Third, some of our students are deeply invested in the "truth" of their own bodily experiences and think of their bodies as the homes of their best and true selves. We have had tearful conversations with a few students in the course of encouraging them to problematize their feelings, if not their academic understanding, of embodiment. We sometimes wonder if the somatic and autobiographic reflections assignment encourages these feelings. Finally, the relationship between this course and ongoing student and professional work is also

of interest. Our sense is that in-depth exploration of existing choreography inspires MFA students, giving them new research tools and the sense that choreography is an important means of social dialog. We also wonder about the long term impact on our students: Do they continue to employ research methods in their teaching and dance-making? Do they continue to read academic literature? How does it impact their relationships with colleagues whose work is in academic research?

Answers to Doug's survey suggest that, like us, faculties around the USA are concerned about research, including definitions of research, its worth for students, importance to teaching and to artistry, and implications for dance as a field, or perhaps inter-discipline. Doug weighed in with some observations about the data in regards to teaching. One survey question asked, "In terms of graduate student learning, what is the purpose of research requirements in your graduate program?" Doug commented, "I counted 10 participants who talked about teaching and pedagogy. It seems that many make the leap from learning about research and research requirements to applications in/to teaching. I don't necessarily see how that leap happens or would happen."

A second survey question asked respondents to rank various aspects of the curriculum in terms of importance to the overall [MFA] program. Doug reflected,

> I was surprised at how low participants scored "Teaching and Pedagogy" as Important or Highly Important. When combined, it was ranked 5th after Improv/Choreography (#1); Artistic Practice (#2); Scholarly Research (#3); and Performance (#4). Do you have ideas why Teaching scores so low, especially with the MFA being a terminal degree for higher education? Might it be the assumption that MFA graduates will somehow by osmosis come out as highly prepared teachers?
>
> In the same question, and based on their later comments, I was surprised that Scholarly Research scored in the top three, given the emphasis on artistry and artistic practice.

Still another survey question asked, "Which of the following experiences had the most profound influence on your research education/ training?" Doug noted,

> Participants overwhelmingly said "teaching their classes" (75 %). Again, the significance of teaching surprises me in terms of the strongest influence. Might it be that in order for us to be able to teach something we have to really work on it? And that people assume this must happen after [they've] graduated?

We conclude in agreement with this anecdote from one of the respondents to the survey: "A larger conversation is needed. What is the MFA? The EdD? The PhD? What is the role of practice versus scholarly discourse? Who will teach the next generation of scholars/artists? Where is dance heading?" We hope that our presentation will contribute to this conversation.

Commentary

This chapter is the most "applied" of any included in this volume. It indicates the evolution of the course I referred to in Chap. 12, from one I had developed individually to a two-semester sequence that was initially team-taught. It also reveals more specific details as well as some of the unresolved problems. There were a large

number of requests for the syllabi following this conference presentation to an international audience of dance researchers. Sadly, by the time we made the presentation, the course as described here no longer existed: In a curricular overhaul of our MFA program, a faculty committee decided that scholarly research was not important enough for MFA students to warrant two courses, so DCE 610 was moved to the second year of their program and DCE 611 was no longer required. Since both Ann Dils and I have since left UNCG, the course as described in this chapter thus represents what I consider a "Camelot moment" in my teaching: brief but memorable.

Yet while this particular course no longer exists, much of this chapter still seems relevant in thinking about teaching scholarly research to arts students. Our search for how to make online learning a more embodied process generated assignments which are transferable to other courses, even ones outside of dance. The issues involved in teaching critical and reflective thinking in research courses, including ethical concerns, are ones with which faculty in many fields struggle. I was grateful to our colleague Dr. Jane Harris for alerting us to helpful references referred to in this section. Finally, in rereading this chapter, I became aware of how much writing about our teaching of this course sequence not only clarified what we were trying to do but also pushed our own thinking further. In that sense it can be considered a kind of action research project as well as an affirmation of the value of the writing process itself: We do not just write what we know, but we write in order to figure things out.

References

Albright, A. C. (1997). *Choreographing difference: The body and identity in contemporary dance*. Middletown: Wesleyan University Press.

Bresler, L.(Ed.) (2004). Prelude. In *Knowing bodies, moving minds: Towards embodied teaching and learning* (pp. 7–10). Dordrecht: Kluwer.

Cancienne, M. B., & Snowber, C. N. (2003). Writing rhythm: Movement as method. *Qualitative Inquiry, 9*(2), 237–253.

Chatterjea, A. (2004). *Butting out: Reading resistive choreographies through works by Jawole Willa Jo Zollar and Chandralekha*. Middletown: Wesleyan University Press.

Dils, A. H., & Stinson, S. W. (2008). Toward passionate thought: Peer mentoring as learning from and with a colleague. In T. Hagood (Ed.), *Legacy in dance education: Essays and interviews on values, practices, and people* (pp. 153–168). Youngstown, NY: Cambria.

Graff, G., & Birkenstein, C. (2005). *They say/I say: The moves that matter in academic writing*. New York: W. W. Norton.

King, P., & Kitchener, K. S. (1994). *Developing reflective judgment: Understanding and promoting intellectual growth and critical thinking in adolescents and adults*. San Francisco: Jossey-Bass.

Le Sueur, M. (1976). The ancient people and the newly come. In C. G. Anderson (Ed.), *Growing up in Minnesota: Ten writers remember their childhoods* (pp. 17–48). Minneapolis: University of Minnesota Press.

Sklar, D. (2001). *Dancing with the virgin: Body and faith in the fiesta of Tortugas, New Mexico*. Berkeley: University of California Press.

Stark, K. K. (2009). Connecting to dance: Merging theory with practice. *Journal of Dance Education, 9*(2), 61–68.

Stinson, S. W. (1995). Body of knowledge. *Educational Theory, 45*(1), 43–54.

Stinson, S. W. (2006). Research as choreography. *Research in Dance Education, 7*(2), 201–209.

Survey of Graduate Research Programs and Coursework in Dance in the U.S. (2009). Retrieved 13 Apr 2015, from www.dougrisner.com. Under CORD/CEPA Panel 2009.

Ward-Hutchinson, B. (2009). Teaching from the outside in. *Journal of Dance Education, 9*(2), 52–60.

Wolcott, S. K. (2003, February). Steps for better thinking: Self-evaluation form. Retrieved 6 Jan 2009, from http://www.wolcottlynch.com/Downloadable_Files/SelfEval_Alternate_0302.pdf.

Dance Works Referenced

Ailey, A. (1960). Revelations. In *An evening with Alvin Ailey American Dance Theatre.* DVD, directed by T. Grimm, 1986. Chatsworth: Image Entertainment.

Lilja, E. (2006). *Movement as the memory of the body* (Book and DVD). Stockholm: Danshögskolan.

Marks, V. (1994). Outside/in. In *Accelerated motion: Towards a new dance literacy*. Retrieved 6 Jan 2009, from http://acceleratedmotion.wesleyan.edu/bodiesandsociety/bodiesandmachines/index.php.

Rainer, Y. (1978). *Trio A* (VHS). Columbus: The Ohio State University Dance Film Archive.

Zollar, J. W. J. (2006). *Walking with pearl: Southern diaries.* In *Accelerated motion: Towards a new dance literacy*. Retrieved 6 Jan 2009, from http://acceleratedmotion.wesleyan.edu/dance-history/identities/index.php.

Chapter 15
Searching for Evidence: Continuing Issues in Dance Education Research (2015)

Susan W. Stinson

Abstract This paper reviews, analyzes, and reflects upon two important reports released in 2013, both discussing research evidence for the value of dance education or arts education more generally, among school-aged students. One report was created by a large dance education advocacy and support group in the USA, the National Dance Education Organization; the other came from the European-based Centre for Educational Research and Innovation, affiliated with the international Organisation for Economic Co-operation and Development. Studying the two reports next to each other brings into focus important issues facing the field, especially distinctions between advocacy and research, and between values and facts, along with the impact of such distinctions on research questions and methodologies selected to pursue them. The author examines and challenges not only ideas in the reports, but also her own professional choices during a long career as dance educator and researcher.

Should dance education be accessible to all young people? Does it belong in schools? Most dance educators would answer in the affirmative without hesitation. But fewer would be able to follow up with a convincing response as to *why* this should be the case. What is the value of dance education? What makes it important enough to deserve a place in an already-crowded school day and a share of limited public or foundation funding?

In June and July of 2013, two important and extensive reports were published, discussing research evidence for the value of dance education or arts education more generally, among school-aged students. One report was created by a large dance education advocacy group in the USA, the National Dance Education Organization (NDEO); the other came from the European-based Centre for Educational Research and Innovation (CERI), affiliated with the international Organisation for Economic Co-operation and Development (OECD). In this paper, I will review, analyze, and reflect upon these reports and the issues that came into focus as I read them next to each other.

© Springer International Publishing Switzerland 2016 187
S.W. Stinson, *Embodied Curriculum Theory and Research in Arts Education*,
Landscapes: the Arts, Aesthetics, and Education 17,
DOI 10.1007/978-3-319-20786-5_15

15.1 Report Analysis: Advocacy and Research

While there are some similarities between the two reports, the differences between them highlight the distinction between advocacy and research. This should be expected, given the different profiles of the two organizations. NDEO's purpose is clearly to advocate for dance education and support its practitioners; according to its home page (www.ndeo.org), it is

> dedicated to the advancement and promotion of high quality education in the art of dance. NDEO provides the dance artist, educator and administrator a network of resources and support, a base for advocacy, and access to programs that focus on the importance of dance in the human experience. (About NDEO/Overview)

NDEO publishes a quarterly journal (*Journal of Dance Education*) and annual conference proceedings; both include papers of interest to researchers as well as practitioners.

In contrast, CERI is primarily about research. Its online brochure (http://www.oecd.org/edu/ceri/brochure_CERI-final-all–web%20Aug%202,013-size.pdf) lists over 30 member countries (including the USA) and notes its 'international reputation for pioneering educational research. It has opened up new fields for exploration and combining rigorous analysis with conceptual innovation.' Its stated goals are to generate forward-looking research analyses and syntheses, identify and stimulate educational innovation, and promote international exchange of knowledge and experience; the publications listed on its website appear to fulfill these goals.

With these distinctive profiles, one should not be surprised that, while authors of both reports sought evidence for the value of arts education for young people (and, in the case of NDEO, dance education in particular), they use different lenses for interpreting their findings. I regard their differences as an issue for the field only because advocacy and research are too often conflated to become what Gee (2007) has called 'advo-search.'

The analysis that follows reflects my own views as a dance educator and researcher who has struggled with this dichotomy for many years, often feeling torn between the need to advocate as a dance educator and the need to be skeptical of advocacy claims as a researcher. If it appears that I am more critical of the advocacy position, it is because, I, like Gee (2007), notice that enthusiastic advocates sometimes ignore the distinction between the two, and view research as simply a means for 'selling' dance education. I believe this weakens the research enterprise and ultimately, the credibility of the field. In the interest of transparency, I acknowledge that, as a founding member of NDEO, I am personally connected with the organization and am deeply grateful for its contributions to the field and its acceptance of my work over the years. Nonetheless, I have attempted to look dispassionately at the issues, both problematizing possible positions and also questioning myself and my own choices.

I will begin with the USA report published by the NDEO in July 2013, titled *Evidence: A Report on the Impact of Dance in the K-12* Setting[1] (Bonbright et al. 2013). Since its inception, NDEO has been an advocate for dance for all people, especially

[1] In the USA, *K-12* refers to kindergarten through high school, or 5–18-year olds.

school aged children, and for well over a decade NDEO has been searching for research evidence to further this goal. To that end, they have invested significant resources (mostly obtained from a federal grant) to develop what is now known as the Dance Education Literature and Research descriptive index (DELRdi). That the title includes the word *literature* as well as *research* reflects a debate as to what kinds of scholarly writing in dance can be considered research. As indicated in this section of the NDEO website,

> the index includes writing from 1926 to the present that informs teaching, learning, and future directions of research in the field of dance education for all ages. It contains extensive descriptions of over 4500 literary works including theses, dissertations, journal articles, conference proceedings and other reports from over 200 different publications and organizations and 147 university dance programs in the United States.

The index provides detailed descriptive information on the methodology, techniques, and characteristics of each work documented in the index. Although there are no judgments about the quality of the research listed, and much of the older work, in particular, is difficult to obtain, the index is a valuable source for any dance education researcher doing a literature review or studying research in the field.

The *Evidence* publication draws on the index as well as a couple of other sources, especially a newly discovered collection of reports (many of which are unpublished) from the U.S. Department of Education's Arts-in-Education programs. The NDEO writers prepared evaluations and summaries of 82 of these studies since the beginning of the twenty-first century, ones they thought provided insight and evidence of how dance education impacts teaching and learning. In other words, they were looking for positive benefits of dance education within the school-aged population, such as transfer of learning from dance to other subject areas and correlation with student achievement in general, school climate, and student attendance. They found a few studies supporting what they were looking for; these are featured in the related brochure 'Stand Up for Dance in America's K-12 Schools: A Quick Guide for Legislators, Administrators, Teachers, Parents, and Students,' which is available through the NDEO website.

Many of the benefits cited in the report are ones I have observed during my career in dance education. I have seen dance classes challenge students of all ages, increase their self-confidence, and build vocabulary as well as community. I have seen young people deeply engaged in learning during their dance classes, and have known those who stayed in school only because of dance. As a believer in the value of dance education, I appreciate reading about programs that achieve such positive results.

But I also have seen dance classes that reinforced separation and divisiveness within a school, have seen students who were bored in dance or developed a negative body image, and have known young people who loved their dance classes but still dropped out of school. I have observed plenty of students who excelled in dance but not in other subject areas, revealing no apparent transfer of learning. One will not find any indication in the NDEO report, however, of such outcomes.

My skeptical self really questions any report that presents only the evidence supporting positive benefits of dance education, just as I would question one reporting only negative cases. I note, however, that the NDEO authors get a bit more skeptical

near the end of the report, in recognizing not only how few studies they found (thus stating that 'further research is still needed'), but also the methodological limitations of ones they did find. They noted that, in many of the studies reviewed for this report, it was difficult for them

> to determine what kind of dance/movement was used, how it was incorporated into the classroom activities, how the lessons were conducted, and what qualifications … the person leading the dance/movement activities held. Including details about the type of movement and how it was incorporated into the curriculum, the specific dance teaching methods and lesson plans used, and the theoretical grounding for those choices would be most advantageous in *proving the benefits of dance in and as academic learning* [my emphasis]. (Bonbright et al. 2013, p. 51)

It appears that NDEO sees more and better quality studies as a way to prove that dance education does indeed cause the extrinsic benefits they are already certain it provides, and also to reveal what kind of dance education best causes them. In another section of the report, the authors try to encourage researchers to engage in the kinds of research necessary to provide this proof, particularly quantitative, experimental studies. For suggestions regarding the kinds of research needed, they refer readers to NDEO's 2004 publication, *Research Priorities for Dance Education* (Bonbright and Faber 2004), since there has been little change in the priorities they identified at that time. In other words, relatively few dance researchers are doing the kind of research that NDEO sees as necessary to prove the value of dance or determine the kinds of dance classes which can best accomplish the goals they think are most valuable. My observation based on reading the literature and attending conference presentations in dance education has been that researchers generally seem to choose topics they find interesting and projects that can be accomplished fairly quickly and inexpensively, rather than ones deemed necessary by a professional organization. I will return to this point later.

In contrast, the CERI report titled *Art for Art's Sake? The Impact of Arts Education*, takes a more skeptical perspective from the beginning: One may note that they even place a question mark in the title. The authors acknowledge that 'Most people, including policy makers, *believe* [my emphasis] that arts education fosters creativity and possibly other skills conducive to innovation' (p. 3). But they clearly maintain some uncertainty, asking,

> Does arts education really have positive effects on non-arts skills? Does it enhance performance in academic subjects such as mathematics, science or reading, which are also seen as crucial in our knowledge-based societies? Does it strengthen students' academic motivation, self-confidence, and ability to communicate and cooperate effectively? Does it develop the habits of minds [*sic*], attitudes and social skills that are seen as critical to innovation societies? (Winner et al. 2013, p. 3)

To produce this report, published in June 2013, the authors investigated research databases in education and psychology in Dutch, English, Finnish, French, German, Italian, Japanese, Korean, Portuguese, Spanish, and Swedish. As contrasted with the NDEO primary source (DELRdi), which went back to 1926, their examination attempted to cover all empirical studies published since the 1980s, and made new use of studies unearthed in former meta-analyses (from 1950 on). They examined verbal, mathematical, and spatial skills; creativity; academic motivation; and social

skills including self-confidence, empathy, and emotion regulation. They further examined neuroscientific literature related to arts education, which was also included in the NDEO report.

In terms of transfer of learning between arts education and academic skills in non-arts areas, the CERI reviewers found little to no solid evidence that arts education impacts these other skills in positive ways, and in fact found some studies with evidence to the contrary (Winner et al. 2013, p. 6). They also found

> no more than tentative evidence regarding the impact of arts education in its various forms on other behavioural and social skills, such as self-confidence, self-concept, skills in communication and cooperation, empathy, perspective taking and the ability to regulate one's emotions by expressing rather than suppressing them. (p. 8)

The little evidence of positive results they did find seemed to be in arts other than dance, but they acknowledged finding less research overall in dance education. In other words, their report provides very little research evidence for the advocates in our field.

Like NDEO's study, this one calls for more empirical research related to the impact of arts education on the development of a variety of skills. The CERI authors also raise the very important distinction between correlation and causality. For example, even if a researcher finds out that dance students in Swedish high schools are more likely to attend college (a correlation), one cannot assume that the college attendance rate is *caused* by the dance instruction; there could be many other factors affecting this outcome. In order to discover causality, CERI recommends longitudinal studies with an experimental or quasi-experimental design, even while noting the enormous hurdles involved in carrying out such studies, only one of which is cost.

Further, the CERI publication states that the development of *artistic* skills, rather than other academic skills, is currently the priority objective of arts education in the curricula of OECD member countries. The report, however, expands the definition of artistic skills to include not only the technical ones developed in different art forms (such as playing an instrument, composing a piece of music, dancing, choreographing, painting and drawing, acting, and so forth) but also the habits of mind and behavior that are developed in the arts. The authors would like to see more research on these broader habits of mind, such as creativity and critical thinking. And, like NDEO, they also propose that future research should focus on the quality and effectiveness of different types of teaching in arts education, or what kinds of instruction best facilitate these skills.

The CERI study might be speaking about NDEO when noting that

> Much of the research findings showing positive impacts of arts education on all sorts of achievements and competences [*sic*] in other subjects and activities have been used for advocacy purposes. Claims about the impact of arts education on academic achievement and motivation tend to reflect the view that the arts are important not in themselves, but only for how they can support other aspects of the curriculum. These kinds of claims may well have developed pragmatically—as a way to save the arts because the arts are perceived as endangered. (Winner et al. 2013, p. 15)

This is certainly true in the USA, where the arts are indeed endangered in public education. Yet the authors of this report, based on convincing data, do not see arts education as endangered, at least in most OECD countries. They thus conclude that 'the primary justification of arts education should remain the intrinsic importance of the arts and the related skills that they develop' (p. 15).

15.2 Discussion

These two reports, released practically on top of each other, emphasize the international prevalence of questions about the value of arts education in general and dance education in particular. At least some readers who take the time to peruse both reports may find the similarities between the two more striking than the differences. But my own analysis of them, admittedly shaped by years of struggle between my role as an advocate and believer in dance education and my role as a researcher, finds the contrast illuminating and worthy of consideration by current and future professionals.

Good advocacy requires that we be passionate believers in our cause: Trying to present a balanced perspective, with both pros and cons, will not likely win a debate, much less big dollars from funders or favorable decisions from politicians. Advocates are normally certain they are right in their positions, and seek evidence which supports them. No one in dance would argue that advocacy is unimportant for the future health of the field. Most of us have been in a situation in which we had to lobby for the importance of dance, whether to students, parents, or an institution, and research supporting its value would appear to be a useful kind of evidence. Good research, on the other hand, needs skeptics: people who problematize, ask questions, and attempt to uncover flaws in their own thinking as well as that of others. Researchers are ethically bound to look dispassionately, regardless of their own beliefs.

Both of these reports call for more research based on a science model (quantitative, empirical research seeking cause and effect), so it is relevant to consider the nature of science as one particular kind of research. Reputable scientists are always skeptics: They usually begin their research with a hypothesis, and look for evidence that supports it as well as evidence that does not. They may have a hunch and even a hope, but are open to uncertainty. Any truth claims they make are based on the best possible evidence at the time, but scientists know that better evidence may become available in the future that can turn upside down what they thought was true. As an example, let us think about nutritional research.[2] From one month to the next, we may read drastically different reports about what is good for us or bad for us. And of course this is often confusing to consumers wanting to know whether we should drink green tea or coffee, red wine or white, and whether cherries are any better for

[2] The April 2014 issue of *Nutrition Action Newsletter,* published by the US Center for Science in the Public Interest, presents an easy to understand description of the complexity of such research.

us than blueberries or raisins. But such uncertainty is the nature of science. And increasingly, science is discovering that all people do not react the same way to the same food, medical treatment, or instructional approach. In cancer research, scientists are looking at genetic markers which they think some day may reveal how much of which medication is the best choice for each individual. If such markers were known in dance education, teachers would know the best approach to produce the desired outcomes in each student. Scientists have every reason to expect that, over time, they will get closer to the truth, but in most areas of study, the absolute, complete, and final scientific truth will never be known.

Yet we want truth. We want to know what we can do to keep from getting breast cancer or developing Alzheimer's, and we want it to work–all of the time. The NDEO report reflects this hope for dance education: irrefutable proof that dance education is good for some purpose already valued by the public that will justify public and private support to make it available to all. Beyond public education, artists and educators in the private sector may hope for something that will convince people to take dance classes and attend performances instead of staying home to watch streaming movies or play computer games. And, of course, finding the results we desire from such research also helps secure our future livelihoods as dance professionals. One may remember that brief time when we thought that all we needed in dance education was to find something comparable to the 'Mozart effect,' initially hailed by music educators as the proof of the value of music education for young children's brain development. But good scientific research must be replicable, and further studies were not able to replicate the very modest effects shown in the initial research (Carroll 2006; Mehr et al. 2013). The myth of the Mozart effect, however, is perpetuated by many who have a profit to make from Mozart.

It is hard for those of us who believe so strongly in dance education and its value to have the skepticism required for good research. This is partly because we love dance, and partly because our livelihoods depend on convincing others it is important. It is interesting but not surprising that almost all research funded by product manufacturers (including pharmaceutical companies, food manufacturers, even cell phone manufacturers) shows positive effects of the product (Center for Science in the Public Interest 2007). If it shows negative results, it usually does not get published. And often the research is not just funded but also carried out by those who manufactured that product. How believable is research designed to prove the value of dance, or a particular teaching method, when conducted by those who have a vested interest in the outcomes? Yet who else besides dance educators has sufficient passion and personal interest to do research on dance education? Clearly, this presents a conundrum.

Most of us are believers in some parts of our lives and skeptics in others, but as researchers, it is important that we be skeptics. I must say that I do not think it is completely impossible for those who love dance to rigorously investigate the claims made for dance education. But to do so, we have to be willing to look even harder for evidence that the dance 'treatment' does not accomplish what we hope for. In other words, to be a good researcher of any kind, we have to suspend any certainty that we already know the truth.

On the other hand, as indicated previously, an acceptance of uncertainty may not produce the most passionate advocates. I suspect that, like me, many dance educators who also have a deep understanding of research may feel uncomfortable using the limited and tentative evidence cited in the NDEO advocacy materials to try to persuade others that dance education is as important for everyone as it has been for us, and that arts education is the right of all children. Other kinds of research may be necessary to make these arguments.

15.3 Facts or Values: Research Questions and Methodologies

Back to the two reports, my 'believer vs. skeptic' distinction between them is not as dramatic as I have implied thus far. Both groups are certain of the educational value of the arts, but they seem to find the arts important for somewhat different reasons. What is it that makes dance valuable? Both the NDEO authors and those for CERI looked for evidence of extrinsic benefits for arts education, and neither found much solid evidence (although the NDEO report highlights the positive outcomes and, despite their tentative nature, supports using them for advocacy). But while both called for more and better quality research, the NDEO report still implies that the greatest need for the field is evidence of the value of dance in accomplishing non-dance goals, and that all we need is more and better research to provide more and better proof. Here are the concluding paragraphs from their report:

> The evidence has been growing for the ways in which dance impacts learning, as a part of the arts, and as a separate and unique discipline. Much of the evidence is tantalizing and promising, and should be further developed. Indications exist that the instrumental use of dance is powerful and long-lasting, despite the fact that the mode used is nonverbal … In fact, it would appear that the evidence of the efficacy of embodied learning is significant and worthy of further investigation. The impact of the programs reviewed on schools and teachers is also significant. In schools where dance programs flourish, students' attendance rises, teachers are more satisfied, and the overall sense of community grows.
>
> However, as promising as the research is, it can and must get better: more rigorous methods, more clearly defined variables, and more references to existing research are necessary. For better research to be developed, funding is required. It is the hope of the authors of this report that the promising evidence herein will encourage such funding to be developed. The National Dance Education Organization stands ready to lead this effort. (Bonbright et al. 2013, p. 56)

The CERI report, while more skeptical in looking at the research and less hopeful regarding the possibility for generating the kind of evidence necessary to prove extrinsic benefits, concludes with a believing, or advocacy, stance as well. The authors argue that the intrinsic value of the arts is the greatest reason they should be included in education:

> The main contribution of arts education to innovation societies lies in its development of broad and important habits of mind … [but] *the value of the arts for human experience is a sufficient reason to justify its presence in school curricula whether or not transfer results from arts education* [to achievement in other areas] [my emphasis]. (3)

... Ultimately ... the arts are an essential part of human heritage and of what makes us human, and it is difficult to imagine an education for better lives without arts education. (Winner et al. 2013, p. 15)

This assumption—that the arts are an essential part of what makes us human—is a value judgment, more than a fact that can be proved by researchers. While I share that value, a skeptic would ask, 'Are those who dance more human than those who don't?' We could find out whether people who dance rate their lives as more meaningful or satisfying than those who do not dance, but does that make them more human? I cannot imagine any way to either prove or disprove a claim that the arts make us human. That is because this is ultimately a question of values, not facts, and values guide as much or more behavior than facts, even in times like the present when data-driven decisions seem like the only ones that matter. Values, however, cannot be proved as right or wrong. All researchers can do is attempt to better understand how values come to be and how they work in people's lives. For exploring such questions, different methodologies are necessary.

If we want to prove or disprove a statement of fact, then a quantitative empirical methodology is necessary. This is especially the case if we want to apply research findings to a larger population. On the other hand, if we want to better understand how people experience their lives and construct meaning and value from their experiences, then a variety of qualitative methodologies are best equipped for this task. I have oversimplified this dichotomy between quantitative and qualitative methods, and recognize that mixed-method approaches are often useful, but it is important to be sure that we choose the right methodologies for the kinds of questions we are asking. This is one reason why graduate programs typically offer research courses, so that students will understand which methodology is best suited to their projects. An issue for the field is that people too often do small-scale qualitative research projects (which is what most research in dance education is at this point) and then they or others take what they find out as a broad statement of fact.

So what kinds of questions dance education researchers ask, how they choose the appropriate methodologies to pursue them, and how they frame their findings also become important for the field. These issues are revealed as well in the two reports, both of which support long-term, quantitative, empirical studies to determine any evidence of causality in relation to a variety of benefits of dance/arts education. NDEO further proposes that researchers follow research priorities that they identified in 2004 (Bonbright and Faber 2004). As I read the reports, I experienced discomfort in realizing that neither suggests the kinds of studies to which I devoted my research career prior to my 2013 retirement.

What degree of responsibility do researchers have to select research topics deemed of particular significance to the field, rather than just ones of compelling personal and professional interest? How much difference should these reports make in shaping the kind of research that is done in our field? This is another values question, one important to ask, although not one that is appropriate for scientific investigation. But it can be, and should be, reflected upon. To do so with the kind of rigor it deserves leads me to question my own research choices.

I have believed for as long as I can remember that, unless there is powerful extrinsic motivation (like getting or keeping one's job or grant funding, or earning a degree), research is simply too much work without a burning interest in what one might learn from it. While I was required to do research as a part of my job as a faculty member in a research institution, I always selected topics based on what I found most interesting and relevant, usually generated by my teaching of young people and university students, and often related to how they were understanding their experiences in dance education. And I made a pretty successful career out of it, with many invitations to present and publish and many people telling me that my work inspired them to ask their own questions. But in reading these two reports, I have to ask myself to what degree my choices have been ego-centric and self-serving. Have I chosen my own interests over needs in the field? Should I have been following NDEO's priorities for research in dance education, at least since they were published in 2004? Why have I focused my research not on extrinsic goals or on other knowledge claims which require proof, but on trying to understand ways young people make meaning out of their experiences in dance education and what that might mean for how we teach?

I confess that the initial reason I gave up attempting to prove anything through my research (which I actually did try to do at the beginning of my career, Stinson 1975) was based not on a philosophical position, but on my recognition of the enormous challenges to doing it well. I very much appreciate science, but also know its limits. Even if I had been able to get the kind of funding necessary to do good science, I realized early on that the questions I thought most essential to the field as well as the ones which most excited me, were not about facts or truths that could be proved or disproved. Yet as someone who is not only a skeptical researcher but also a believer that dance education should be available to everyone regardless of their ability to pay for it, I am obligated to question my own path. Reflection helps me understand my decisions, but can provide no certainty that they are the only right ones, especially for anyone else.

Beyond my own choices, should contemporary dance education researchers select their questions based on what a national professional organization thinks are most important? Should faculty members mentoring student researchers be encouraging them to contribute to what the field needs? I am inclined to think that this should be part of the conversation, along with a discussion of the limits of science in proving educational outcomes.

15.4 Conclusions

This paper, combining analysis of two reports and personal reflection generated by the emergent issues, is difficult to summarize. I have set up what appear to be conflicting positions: advocacy versus research, and research designed to reveal facts (especially cause/effect relationships) versus research designed to enhance understanding of meaning and values. Yet, in the twilight of a professional career in which I have valued rigorous critical reflection, I am loath to tell others which positions

they should hold, and I recognize that 'both/and' is often preferable to 'either/or.' All I can do is raise the kinds of questions with which I hope the next generation of dance educators will struggle.

To do so, I will make the comparison again with nutritional research: I am someone who tries to make healthy choices. But do we, should we, choose what we eat based primarily on what scientists discover will help us have a better chance of avoiding this disease or that one, knowing that advice based on scientific findings changes rapidly, or because eating tasty and wholesome food, especially in good company, can contribute to living a happy and satisfying life? Similarly, would more people dance if research found it was really good for them? What is more important: that dance can help boost student scores and make schools better, or that it can help make life richer and more meaningful, for at least some participants? Even if we acknowledge that both extrinsic and intrinsic purposes are important, our time and resources as researchers are limited, so how shall we best invest them?

Eventually, well past our lifetimes, perhaps researchers will be able to determine which kind of arts education 'treatment' will be most effective for each individual, but what kinds of effects are most important? What if we found that one approach to dance education produced more professional performers, while another was most effective in reducing obesity or crime rates, and still another improved math scores or helped children learn to read better? I ask myself, what if it was my own child or grandchild suffering from obesity or learning disabilities, or who wanted to become a professional dancer? What if the approach to dance education that would cause one of these effects I valued was not the one that made my child or grandchild say, 'I love dance class—when can I do it again?' What kind of evidence would be most effective in convincing other parents, grandparents, or taxpayers to want dance education—this particular kind of dance education—for those children they love and other people's children? Further, how should education agencies best use limited funds? Should they support more science-based research in hopes of providing evidence for a variety of important outcomes external to dance? Or would it be better to spend the same amount of money providing dance education for young people, especially classes taught by reflective teachers who are asking themselves important questions and even engaged in small scale action research projects to better understand their particular students and what helps them find dance meaningful? In raising these questions, am I just defending my own values and choices?

Ultimately, I think decisions about how we advocate for dance and what kinds of research we conduct pertain not only to what might be the most 'effective,' but to how we choose to live our lives. Science is not very useful in considering such decisions. As a new retiree attempting to create the next chapter of my own life, I found a personally helpful answer in wisdom from theologian Frederick Buechner (2007), who reminds us that we find our vocation—our 'calling'—in the place where our deep gladness meets the world's deep need. Perhaps this wisdom is equally helpful for dance education practitioners and researchers at the beginning or in the midst of their careers. May each of us make appropriate use of both passion and skepticism, pursue questions that matter to ourselves and others, and find the place where our deep gladness meets the world's deep need.

Commentary

This chapter began its life as one of three invited presentations on research, to masters students and faculty in Contemporary Dance Didactics at DOCH (Dans-och cirkush-ögskolan) in Stockholm in late 2013. As I told the audience at the time, this was not the paper I had expected to deliver when I first received the invitation. However, the appearance of these two reports, released so close together just as I was starting to think about the lecture, made me reconsider other possible ideas. My sense was that these reports were important reading for all those expecting to be researchers in dance education. Although the reports themselves present data that will be out of date within a matter of years, I think the issues they raise will persist long into the future. It is the significance of these issues that made me decide to include this work as a chapter in the present volume.

References

Bonbright, J., & Faber, R. (Eds.). (2004). *Research priorities for dance education: A report to the nation*. Bethesda: National Dance Education Organization.

Bonbright, J., Bradley, K., & Dooling, S. (2013). *Evidence: A report on the impact of dance in the K-12 setting*. Silver Spring: National Dance Education Organization. Retrieved 9 Apr 2015, from http://www.ndeo.org/content.aspx?page_id=22&club_id=893257&module_id=153248

Buechner, F. (2007). Listen to your life. In B. Abernethy & W. Bole (Eds.), *The life of meaning* (pp. 415–419). New York: Seven Stories Press.

Carroll, R. T. (2006). Mozart effect. Retrieved 27 Sept 2013, from http://skepdic.com/mozart.html

CSPI (Center for Science in the Public Interest). (2007). Integrity in science watch week of 01/08/2007. Retrieved 27 Sept 2013, from http://www.cspinet.org/integrity/watch/200701082.html

Gee, C. B. (2007). Valuing the arts on their own terms? [Ceci n'est pas une pipe]. *Arts Education Policy Review, 108*(3), 3–12.

Mehr, S. A., Schachner, A., Katz, R. C., & Spelke, E. S. (2013). Two randomized trials provide no consistent evidence for nonmusical cognitive benefits of brief preschool music. *PLoS One*. Retrieved 22 Apr 2014, from http://www.plosone.org/article/info%3Adoi%2F10.1371%2Fjournal.pone.0082007

Stinson, S. W. (1975). Creative movement in the public school: Project analysis. *Dance Research Journal, 7*(2), 44–50.

Winner, E. T., Goldstein, T. R., & Vincent-Lancrin, S. (2013). *Art for art's sake? Overview*. Paris: OECD. Retrieved 27 Sept 2013, from http://www.oecd.org/edu/ceri/ART%20FOR%20ART%E2%80%99S%20SAKE%20OVERVIEW_EN_R3.pdf. The complete version of the report can be accessed at http://dx.doi.org/10.1787/9789264180789-en

Chapter 16
Voices of Young Women Dance Students: An Interpretive Study of Meaning in Dance (1990)

Susan W. Stinson, Donald Blumenfield-Jones, and Jan Van Dyke

Abstract This frequently cited work was one of the earliest examples of research in dance education that draws on qualitative data from dance students. The researchers observed seven 16–18-year-old participants in their dance technique classes and conducted extensive interviews following the classes, seeking to understand how these young women were making sense of their experiences in dance; the analysis drew from procedures in participant hermeneutics and phenomenological inquiry. They found that, for these participants, the meaning of dance was intertwined with the identity of the students; the students perceived dance as either discipline and structure, with a goal of "getting it right," or else as a transcendence of structure, a release and/or an escape from the everyday world. At the same time, the students saw themselves as outsiders in terms of the professional dance world, perceiving it as consisting of fixed values with little chance for change. The researchers discuss their findings in the context of socio-cultural structures and draw implications for teaching young women dancers.

What is dance and what is the experience of dancing? What does dancing mean for those who do it?

Dance scholars and critics have written many words in response to these questions. Choreographers give their answers to "what is dance?" in the work they create and, often, in commentary about it. Professional dancers have also spoken, primarily in biographies and autobiographies, of what dance and dancing mean to them. Not all voices are heard in dance literature, however. In particular, the voices of children and adolescents, especially those not enrolled in professional schools, are silent. What is the dance experience like, and what does it mean, for them? What do their experiences—and the meanings they make of them—say to us, who work with young people in dance?

The research presented in this chapter was supported, in part, by a grant from the Research Council at the University of North Carolina at Greensboro. It was initially presented at several conferences; earlier versions appeared in the 1988 CORD conference proceedings and in the proceedings of the 1988 Conference on Dance and the Child: International.

© Springer International Publishing Switzerland 2016 199
S.W. Stinson, *Embodied Curriculum Theory and Research in Arts Education*,
Landscapes: the Arts, Aesthetics, and Education 17,
DOI 10.1007/978-3-319-20786-5_16

These were the questions that propelled three researchers into this study focusing on a group of 16–18-year-old young women. In particular we were interested in finding out what young women dancers thought of their place within dance and dancing. This research focused initially on adolescents and, as such, represents only a beginning of what we view as an important area of investigation.

As in any study, our questions were not divorced from who we are and what we value. The voices of students heard in this study come through our own. We thus find it relevant to make ourselves visible before we begin.

We share a concern for the relationships between what goes on in the dance classroom and the rest of a student's life, as well as a desire to look critically at dance education in its social context. By "dance education" we mean the general notion that people are educated in the ways of dance in a variety of dance classrooms: professional schools, private studios, public schools, recreation programs, and university and college dance programs.

Our perspective on the relation of dance education and social context was shaped by our common experience as doctoral students in Curriculum and Teaching, with an emphasis in Cultural Studies, at the University of North Carolina at Greensboro. At the time of the study, we were also teaching at UNCG, where our students were, generally, only slightly older than our subjects. Beyond these commonalities, we each brought our own individual experiences, our own lenses, to this work.

Jan Van Dyke grew up with the desire to become a dancer. She began studying dance as a child at both modern dance and ballet studios in the Washington, D.C. area. She majored in dance at the University of Wisconsin, earned an M.A. in dance education at George Washington University, studied in New York City with Martha Graham and Merce Cunningham, and then ran her own school and performing space in Washington, D.C. in the 1970s and a company from 1972 to 1985.

Donald Blumenfeld-Jones began to dance at the age of 21. Prior to his graduate school experience, he danced professionally in New York City for seven years and studied in professional studios there. Subsequently he taught dance at Duke University and Columbia College in South Carolina.

Both Jan and Donald, having come to their doctoral work from backgrounds in professional dance performance, started with a focus limited to technical aspects of dance: how to do it, how to teach it, how to get funding. In their doctoral study they began to encounter ways of thinking which enabled them to seek answers to long submerged questions about dance education, questions which had arisen during their professional experience. Because their professional experiences had differed, they developed different areas of exploration. Specifically, Donald began to question whether or not many of his negative educational experiences had been necessary for learning to dance, and whether or not there could be ways of teaching which would be more attendant to humane values while still enabling quality dancing. Jan began to examine artistic funding as a cultural force in the development of dance knowledge.

Sue Stinson began to study dance as a 17 year-old, but her study was limited and definitely avocational until completing her undergraduate work in sociology. When her career interest shifted from social work to education, she settled on dance as

"something to teach" and pursued a graduate degree in dance education. Following several years' engagement in choreography and performing, she began an intensive focus on teaching children, especially in public school settings. She was named a Master Teacher by the National Endowment for the Arts' Artists-In-Schools program, and then joined the UNCG faculty in dance education. Her doctoral work in curriculum allowed her to recognize not only the possibilities but also the problematic aspects of learning to dance.

As the three of us shared our stories with each other—when and how we had started in dance, why we continued—and as we pursued our work together, we found increasing appreciation for our differences in helping us expose our biases and find their roots. We became particularly aware that the language we used legitimated some experiences over others. For example, we realized that the phrase "professional dance background" conventionally refers to only those professionals who are connected with the stage. Other kinds of professionals in the field—the educator, the historian, the critic—despite their skill and years of preparation, are often regarded as less significant than the performer and choreographer. Even though we found such a hierarchy problematic, it was difficult to avoid using language that perpetuated it. As the study developed, our subjects made clear to us how deeply embedded hierarchy was within our dance culture. However, our interaction made us, in effect, additional subjects in the study; we wish to acknowledge the impact of our own consciousness(es) on this research.

16.1 Methodology

16.1.1 Assumptions

Two assumptions guided our choice of methodology. First, meaning in dance is, ultimately, personal meaning. Despite commonalities among people, each individual's point of view is, by definition, uniquely his or hers. We sought a methodology that would retain the uniqueness of each person, and at the same time reveal larger issues.

Second, personal meaning as we saw it is not always immediately available to consciousness, ready to be expressed briefly and quickly. This implied a methodology that would allow us to pursue each individual's emerging thought in whatever way it unfolded, and to follow up on issues raised. It was important that we participate in a dialogue with our subjects rather than administer a questionnaire. The length of time needed with each individual and the amount of data that would be generated posed a limitation to the number of subjects we could include.

In keeping with our focus on personal meaning, emerging thought, and our assumptions about the lack of immediate availability of meaning, we chose an interpretive methodology drawn from both phenomenological and hermeneutic inquiry. These methods allowed us to seek meaning through the twin processes of attending to the words given (a phenomenological approach) and of interpreting meanings of the words (a hermeneutic approach).

It should be understood that form and content are related in interpretive research similarly to the way they are related in choreography. In both situations, form and content evolve together. There are no pre-existing rules which determine this relationship. As Howe and Eisenhart (1990) state,

> [A] methodology must be judged by how well it informs research purposes...methodology must respond to the different purposes and contexts of research. (pp. 4–5)

They go on to say that a methodology proceeds by what they call "logic in use," by which they mean that the logic for the method evolves during the process of research. In the case of this research, what we found and the subsequent discussion at each step of the process guided subsequent decisions about how to proceed. This procedure will become clearer as we describe the interview material and our processes of interpretation (For further information on this methodology see Beittel 1973; Braxton 1984; Kollen 1981; van Manen 1990).

16.1.2 Subjects

In order to allow us to focus on more personal, individual differences we attempted to select a group that was relatively homogeneous in terms of a number of fairly obvious characteristics. We agreed to limit our subjects to young women between the ages of 16 and 18 who had studied dance for at least five years, and who lived in a geographic area that would be accessible to us. Further, we decided to focus on serious, well trained, and verbally articulate dancers. Four studios and schools known by us were contacted and asked for referrals of individuals who met the criteria for the target group. They included one jazz studio, one ballet studio, one modern dance studio, and one with an equal reputation in both ballet and modern. Only one of the studio/school directors indicated both interest and support for the project; both referrals from this studio indicated their willingness to participate. Two of the other three directors referred students, but only one of these students was willing to participate; this student was reached only through a personal contact known to one of the researchers. We were very aware that these were busy young women who considered dancing a more valuable use of their time than talking to university researchers. The difficulty of finding participants for a study such as this is a methodological problem that needs to be addressed in future studies.

Ultimately, other participants for the study were selected from among entering freshman dance students at a single university, ones who were placed, through audition, at the upper intermediate level or higher in ballet and/or modern dance. All of these students were sent letters inviting them to participate in the study; the four who responded were selected. This gave us a total of seven subjects.

It would be most appropriate, in terms of our intentions to present each of our subjects in depth, allowing them to speak in this paper as they did with us, one by one. Limitations of time and space, and the anonymity we promised, prevent that. We will give only a brief introduction; all names have been changed.

Two students were from the same studio, a modern dance school which includes improvisation and choreography within the curriculum. These students had also studied other dance forms at their studio, and while they were still in high school had attended a summer dance program for college students. They had been friends and had danced together since they were four years old.

Our general observation about all of the young women with whom we spoke was that they were mature, bright, and verbally articulate, as well as skilled dancers. They had started dancing as young as age 2 1/2 and as old as 11; all except Jane had been studying almost continually since that time. Jane had taken a 2 1/2 year hiatus from class, during which she continued dancing and choreographing for high school musicals. By their final year in high school, the other six students were dancing, in class and rehearsals, almost every day of the week.

Despite these similarities, the students were all unique individuals. When asked to describe herself, Rachel chose the words "intelligent athlete"; she noted that she did not fit the stereotype of an "artsy" person. Ellen spoke of having "a best friend who doesn't dance," with whom she did "normal" things like shopping and going to movies. Lily was classified as "academically gifted," and had just received a valuable scholarship based on her academic excellence. As she described herself for us she said, "I'm a good girl," and observed that sometimes others saw her as "Little Miss Perfect." Peggy talked about her desire to be involved in activities other than dance; she was particularly interested in running track, but found that it conflicted with her dance schedule. She also indicated that she was very conscientious about grades. Amber described herself as having been the "average high school student on appearance," and, in addition, noted that she was intelligent and generally cheerful. Jane described herself as changeable and open-minded. In thinking about her future she said she wanted "to help people, not just relate with them." Elizabeth told us about her aunt, a very independent woman who was a role model for her. In the future, Elizabeth said, she would like to be very assertive and intelligent, and to be in control of her actions and her life.

16.1.3 Procedures

Each student was interviewed twice by one of the researchers. The first interview, lasting in most cases 60–90 min, focused on questions that allowed the student to speak about dance and about herself as a person and as a young woman. Later, the interviewer observed the student in a dance class. The observation class was followed by a second, shorter interview focusing on the student's feelings during that class and issues that arose in relation to it.

During the interviews we used some pre-determined questions that were intended to serve as a framework for conversation rather than to guide the dialogue in a particular way (see sample interview questions in the Appendix). Instead of obtaining answers to specific questions, our interest was in hearing the young women speak about dance and about themselves, selecting aspects they (the students) considered significant. Because of this, different issues came up in each interview.

Tape recordings of the interviews were transcribed, resulting in 28–92 pages of data per student. Analysis of the data occurred in three stages. The first was a summary of the transcripts using the students' words but eliminating what we considered to be extraneous material: such things as hesitations (except where we interpreted them to be significant markers of shifting thought patterns) and redundancies within a particular interview.

There were two checks on the accuracy and completeness of these summaries. First, the summary prepared by each researcher was checked by another researcher against the original transcript and against the tape recording, when necessary, for clarification of intent. Second, each student was consulted regarding whether or not the summary basically reflected what she felt at the time of the interview; the few changes requested by the students were made.

The summaries were the primary source used in further stages of interpretation. However, we did find it necessary to return at times to the full transcripts and even the tape recordings for confirmation of interpretations.

The second stage of the analysis was a reduction of the summaries in which each researcher identified each interviewee's point of view about dancing. With three researchers, the result was three versions for each student. There were many similarities among our versions, but each was also distinct. Since the distinctiveness of individual voices is considered an asset rather than a liability in this kind of methodology, we decided not to attempt to reduce our unique perspectives to a single version of what each interviewee was saying.

The third stage of the analysis involved using our three perspectives in regard to each individual to seek common themes across subjects. Again we discussed the similarities and differences of our interpretations. We recognized that our differing views of the meanings of these young women's words stemmed from our differing life experiences and attitudes toward those experiences. Through a series of drafts and negotiations about meanings we eventually came to an agreed upon understanding of the young women's words. This understanding will be discussed in Sect. 16.2.

16.1.4 Clarification of Purposes and Limitations

It is important to recognize the intent of the interpretive methodology we chose and what it can and cannot tell us. The work of Robert Donmoyer (1985) presents a helpful way of thinking about research methodology in relation to its purpose. He points out that questions of meaning are appropriately answered by methods of what he refers to as "humanities-based" research. This kind of research is not concerned with testing whether a proposition is true or false, but with developing a language, which provides a way of illuminating the lived experience of the persons in question. In all cases the language which emerges out of the investigation becomes a way of narrating a number of different and specific stories.

Languages are neither true nor false. However, each has considerable capacity to be useful to us, because different languages allow us to "both see different things and see things differently" (Donmoyer 1985, p. 4). To alter our language is to bring into view new perspectives on a situation, thing, or experience. Thus, different investigations will develop different languages, all of which can account for differing experiences in the world and enhance the possibility of understanding the stories and experiences of others.

Interpretive research, then, cannot tell us whether a proposition is true or false. Further, it does not give us findings that are generalizable in a statistical sense. Donmoyer (1990) argues that statistical generalization is important when thinking about aggregates and cause-effect relationships, but not when we wish to think about individuals, who construct their own meanings from their lived experiences. Vicarious experiences, whether they come from reading a novel or listening to the voices of others in interpretive research, can also contribute to this construction of meaning. Donmoyer suggests that this kind of generalization is particularly important in helping us expand the cognitive structures that serve to filter our perceptions of the world. In other words, when we see the world through someone else's eyes, we may be able to see a different world.

These comments are important in understanding the purposes and limitations of this research. Our desire was not to develop a statement of fact about what dance means to all young people, or even to the seven young women with whom we spoke. Rather, we sought to expand our own language for thinking about what dance can be for those who do it, how it comes to have meaning, and what all of that means to us as persons involved in the teaching and doing of dance with young people. Such language is grounded in what people actually say about their experience in dance, and our own language was enriched by the words of the young women with whom we spoke.

In the spirit of participant hermeneutics, we invited our subjects to engage in the meaning making process with us. By this we mean that we did not act as neutral or mechanical observers of their discourse but, rather, engaged in interested conversation with them. We did not so much lead as allow them to direct the conversation by encouraging them, during the conversation, to reflect on what they were saying. We expected our respondents to not just tell us what they already knew about their experience of dancing and what it meant to them, but to become more aware of its meaning in the process of trying to find words to talk about it. One of the premises of hermeneutic inquiry is that the meaning of a phenomenon becomes richer and/or more clear in the process of reflecting on it.

In the spirit of phenomenological inquiry we attempted to describe the lived experience of our respondents and the structures of consciousness underlying it. Holding to the guidelines for this methodology, we attempted to attend to only that which presented itself. During the interview process this meant allowing the students' interests to guide the development of the interview. During the analysis phase we required that our interpretations be substantiated by the words of our respondents, and we as researchers frequently challenged each other in this regard.

Our attempt to attend to only that which presented itself made us quite aware of two premises underlying phenomenological research. The first is that the researcher cannot remove subjectivity from a relationship, even a research relationship. In the interviews, our own personal interests inevitably influenced the way we each followed up on initial statements with further probing questions, and the way each of us came to understand the interview content. We recognize the current debate over objectivity and subjectivity in research methodology (for examples see Bernstein 1983; Peshkin 1988; and Phillips 1987). While we will not discuss this issue further here, we must note that subjectivity was intentional for our method, allowing us to interact with our subjects as subjects ourselves.

A second premise of phenomenological research is that the nature of the data is always fragmentary. We recognized that the words spoken by our respondents were not in themselves the complete and accurate representation of what these students actually thought and felt, and that much of the reality out of which each of us acts does not exist in our conscious awareness.

16.2 Analysis

In our analysis we identified two general structures which helped us organize the words of the interviewees and begin to understand the way dance became meaningful for the students with whom we spoke. The first structure focuses on the relationship between the student dancer and her own experience of dancing. The second focuses on the relationship between the student dancer and the dance world as she makes the transition from childhood.

16.2.1 The Dancer and Dancing

In the first structure the meaning of dance is intertwined with the identity of the students. Their own words help clarify this point:

> It is who I am.... If I couldn't dance I think I would feel like there was a part of me that was just totally dead. (Lily)
> I just can't imagine life without it. (Peggy)
> I can't imagine not doing it. If something would happen and I couldn't do it I'd be a very bitter person probably. (Amber)

It became clear that how students perceive, describe, and experience dance reflects in general what they value. We do not know to what extent these values are instilled by dance training and to what extent students bring the values with them and thus shape their own experience of dance. We do, however, see their relationship with dancing as a satisfying one.

One particularly vivid example lies in the area of hard work and discipline. Jane noted, "Dance is...discipline that I need." Rachel referred to structure and hard work when she discussed her preference for technique class over improvisation:

> You work harder and things are set, so you know what you're supposed to do....And you get a hard sweat, heavy sweat and get tired. I guess I like it 'cause it feels like you're really dancing...working hard.

Amber echoed the words of other students when she spoke about discipline, saying,

> ... if I'm in any class I'm there to take class and not to goof around. I don't particularly like to be in class with somebody who's all the time laughing and talking and not paying attention.

The focus in technique class is on doing the movement and getting it right. When asked what she was thinking about during class, Lily responded, "I'm basically thinking about the step and how you do it....I think about what I would look like to someone if they were watching me right now." Ellen stated her thoughts as "I gotta get it. Oh God I did that wrong. I gotta do this right. I'm too fast here, I'm too slow here." Jane said, "There's so much pressure to get everything right. I want them [teachers] to think that I can do things. I want to impress them, for them to see my progress."

Dance class offers challenges and thus gives students a forum for proving themselves. Peggy described one teacher as "throwing" the material at the class, and "then we have to do it. I really enjoy that because it's a challenge for me." Satisfaction comes from meeting challenges (keeping up when the teacher "pushes you," keeping up with older and more experienced dancers, being able to do things which are physically demanding), doing specific movements correctly, improving (seeing the results of one's hard work), and getting recognition from the teacher or choreographer. The recognition need not be in the form of approval; just being recognized validates their existence and effort. As Amber said, "I'd much rather be told that I'm doing it wrong than not to be noticed at all." Elizabeth recalled one setting where "I got yelled at a lot, but that felt just as good, getting yelled at or told you did something wrong."

Performing offers another arena for proving oneself. Lily described a special moment on stage that illustrates this: "I did a triple [pirouette] on stage....I just threw it in...like, well why not? Show what I got—that was a really neat moment, just being able to say I can do it and doing it." The consequences of failure are greater in a performing situation, but the resulting sense of risk can be a bonus when one is successful. As Elizabeth stated, "It's the excitement...thinking about whether something will go wrong and if it doesn't it's such a triumph." They recognize their own mistakes even when the audience does not. However, audience response is a major contributor to their sense of satisfaction. Amber noted, "I like to perform better when the audience is good...you give them back so much more. Your satisfaction is greater when you know without a doubt they enjoyed it." Lily said, "It's nice to have someone say that was really wonderful...when you get the nice reviews and the compliments or maybe someone's admiration...these are like bonuses."

While these young women desire the acknowledgment of others, and are most satisfied when they exceed the expectations of others, they also need to feel connected with themselves. A number described needing time alone. Class allows them to get in touch with their bodies; Elizabeth described it as being like "each little part is talking to me." They said that performing gives them a chance to express their feelings; most find this easier through dance than through the written or spoken word. As well as helping them get in touch with the body and express feelings, dancing gives them a chance to enter a transcendent state. Elizabeth told us, "When I dance I'm more of a soul." Sometimes the transcendence of the here and now happens in class. Ellen indicated this when she said, "I come to dance a lot because it's a way to forget everything else." Several spoke of transcendence when they dance all alone, without anyone watching. As Peggy noted, "…when I…get frustrated with life in general…it's a real release…I can come out so at peace with the world and ready to take everything on." Performing offers another major opportunity for transcendence, going beyond the steps. It was described as "the ultimate high" (Lily) and "above the normal plane of living" (Elizabeth).

Whether dancing alone, in class, or in performance, there is a total absorption in what one is doing; the rest of the world is blocked out. As Peggy stated, "Sometimes I really get in touch with something…in which case I'm so caught up with it that the whole world could crash around me." There is a sense of power and well-being that comes from feeling in control of one's body, as long as one is able to do what is called for and do it well. Elizabeth referred to this when she said, "It's such utter control and all that's important is that pirouette that you've done."

The real limitation to this sense of power, however, is that, no matter how well one dances, one's body and technique are never good enough. These young women have high standards for themselves. Lily and Jane each claimed to be "a perfectionist"; Peggy said she "likes perfection." Yet perfection is never possible in dance technique and satisfaction is elusive. As Amber noted, "I always feel I have so much room for improvement." Rachel said, "Technique is hard because you're always striving for more." Elizabeth described a teacher who often tells students they are doing well, but says, "A lot of times I just don't believe him…my standards are higher than his." Further, dance students believe that only certain kinds of bodies are desirable in dance. Rachel alluded to this when she said, "Lots of times I think I'm too much of a brute to be a dancer. Dancers in companies always seem either long and lean, tall dancers, or they're petite and small." Amber told her interviewer, "If my legs matched my body then I'd be perfectly happy." To her friends who asked why she dieted, she responded, "You don't go in a studio with the little stick girls and see yourselves looking at the leotards with the blobby legs." Lily said, "I can see myself as practically a hunchback." Elizabeth summed it up this way:

> I don't look at myself in the mirror very often, except when I have to. Or if I do, then I look at my face or my feet, or my hips to make sure they're right. But I don't like my body, the way it looks. I guess everyone's critical on themselves.

In regard to the theme of dance as identity, then, we see a number of dualisms. The students perceive dance as either discipline and structure, in which the goal is to "get it right," or else as a transcendence of structure, a release and/or an escape

from the everyday world. Lily expressed the dualism she experiences when she stated, "You either dance it or you don't. There's no in between. You're either performing or you're working." Similarly, the students experience themselves as alternately body or soul, working hard and sweating or existing "above the normal plane of living." They feel alternately full of deficiencies and limitations, trying to improve themselves; or strong and full of power, as they meet challenges and exceed the expectations of others.

16.2.2 Making the Transition from Childhood

In addition to what they know of their own experience of dancing, the students' words reflected an implicit awareness of a world of dance that exists beyond their own experiences in the studio and theater. Their ideas about the larger dance world emerged for us as they told the stories of how they had gotten started in dance, as they recounted the effects of studying dance intensively while growing up, and as they told us what they saw as their future.

In terms of starting to dance, a common theme for these young women was the influence of their mothers. As Rachel told us, "I don't know how my mom got me into it. When I was four I didn't have much to say about it." Several of them said they hated dance at first, but it is clear they are all glad it is now a part of their lives. As Jane said, "Even though I might not have wanted it or I might have missed a lot when I was younger, I'm glad that my mom put me in those classes." However, they are not sure how dance came to be so meaningful to them. Rachel simply stated, "It's really important or I wouldn't be doing it." There is a sense of finding themselves on a path without being clear how they got there. As Jane observed, "It just depends on what you are put into when you're young."

At this point a number of factors keep them dancing. One is personal satisfaction; as Amber told us, "I dance because I want to dance." Another is fear; Ellen said, "If you give it up you'll regret it later." Several noted they can never let up or they will "lose it." There is also a sense of need or dependency, not only because dance is such an important part of their lives, but also because they have done it for so long and cannot imagine not doing it. Rachel said, "I'd have to find something else to do every day." Being a dancer means living a disciplined life, having control over oneself. Jane described her self-disgust when she stopped and "got out of shape."

Despite this sense of almost being driven to dance, our respondents clearly valued the idea of free choice in regard to whether or not one dances; several said that being forced to dance would ruin the experience of dancing. They had no regrets about their choices thus far, but recognized that a choice to dance was also a choice not to do other things. They noted that it was hard to have a "normal" life and also be a dancer. Non dancers usually did not understand them. Rachel's words echoed those of several others in our study when she said, "Most of my friends don't even know what I do. Every day you go to dance and you want to get away from that sometimes and do other things…" The most extreme statement of this came from Elizabeth, who said,

> I didn't have any friends. Dance was all I talked about, cared about. I wanted to get through school so bad so I could go take my ballet class. I didn't care about anyone there and I thought no one understood.

Ellen, however, felt differently, saying, "It's hard to have a normal life but I do…. I don't want to feel like I'm missing out on something."

Several students noted a sense of community or of understanding with other dancers, at least among those at their own studio, as indicated in this comment by Jane: "Artsy people are a lot more caring…. Everybody in a class becomes friends and you have something in common. The people you meet and the friends you make are real, not superficial."

However, the sense of community is equaled or even exceeded by the competitiveness fostered among dancers. Most competition is regarded as constructive; as Rachel said, feeling competitive "is good in a way because it makes you strive for more."

There also is a sense of feeling special in being set apart. While dancers may not be particularly understood or appreciated by the larger culture, these students appreciate themselves: the discipline that characterizes their lives and the knowledge they have that others do not. Elizabeth indicated this when she shared, "I think that dancers are above angels—God [at the top], dancers, angels, humans."

The young women with whom we spoke perceived their future options in dance as very limited. Performing was the only dance career any of them had seemed to consider. They had all weighed whether they had what it takes to become a professional performer: ability (talent and the right body) and great effort/will/desire. Elizabeth told us,

> Technique has to come first. People who have soul aren't allowed on stage unless they have strong technique. I see where that's important, 'cause everybody probably thinks they have a special something inside of them when they dance; if you really do it will probably come through in your work…Maybe there wasn't anything inside of me that did make me work hard enough or do what they wanted me to do. If you really love it, it'll show in your technique.

All of the students seemed to feel it was important to be "realistic" in evaluating their own abilities in relation to the expectations they perceived. None of them thought they could make it to the top echelon in dance. Lily was the only one who clearly intended a performing career, but felt there were limitations in how far she could get:

> I think I could make it in the corps level in New York, but I think I started too late to get any further—not that I couldn't do it but that I'm too old by their standards….I'd like to be a principal dancer in a regional company.

Other students were still in the process of choice-making. Elizabeth was typical in her confusion over what she wants to do, mixed with a general optimism about deciding not to pursue dance as a career:

> …if you're going to be a dancer when you're young that's all you can be. But once you're not going to, you can be anything. Now I'm confused because I don't know what I want to do. If I were going to be a dancer maybe it would be safe 'cause I'd know, but if I failed it would be too late and now I can do anything. I can be an anthropologist, a dentist, whatever.

Rachel expressed the conflict involved in trying to make a choice between what she saw as mutually exclusive opportunities:

> I'm really concerned 'cause I don't know if I want to do dance, or all my education that I've learned at school, I don't want to throw that away. I'm thinking about maybe minoring in dance or something, 'cause I'm going to hate spending this much time working hard and coming to this point and then just throwing it away.

All of these young women seemed to have considered a career as a dancer, and with most there was at least some sense of sadness in giving up a dream. Elizabeth spoke poignantly to us when she said,

> Every six year-old girl wants to be a dancer. It's like every six year-old girl has a pink tutu in their closet. I just thought mine was special and apparently it's not 'cause I would have [been successful] already and I haven't.

It seemed to us that these students were giving up the dream not because they preferred to do something else but because they did not think they would "make it" as a major performer. Several of them noted that it was easier for men to be successful in dance, because there is less competition.

Even if they were to succeed in professional performance, however, they recognize that there is little monetary reward for such a career. Further, they realize that they would have to continue to make the sort of sacrifices that currently characterize their lives. As Jane said,

> To be a dancer means going through a lot. You have to really love it, really care about that a lot and not about a lot of other things. Everybody knows that being a dancer does not give you money. It does not give you a lot of time to go out and do things. It's hard to have a family. It's got to be something you love.

Despite the risks and sacrifices of a performing career, teaching dance was not seen as an attractive alternative. Even though dance teachers clearly had been important in their lives, the students perceived teaching as having considerably less status than performing, and offering much less gratification. As Amber said, "I don't particularly want to teach people to do what I should be doing myself." None of the students with whom we spoke mentioned any other career possibilities in dance.

Elizabeth summed up her very strong feelings about herself in relation to the dance world when she said,

> I feel good when I do a combination myself but if start thinking about myself in relation to anyone else who might have done that, it's not important 'cause it's not the professional world which is what I wanted. I can't settle for teaching. It's like stepping down from what I wanted. If I can't have exactly what I wanted, I don't want to settle for something else. I want to just remove myself from it completely, and do something else that I can succeed in. If I stay in dance I'll feel like a failure. I can't live with myself if I only do it halfway.

As these young women spoke to us about trying to decide what they would do with their lives, a picture of the Dance World emerged for us as a separate and fixed world, a hierarchy that is created and controlled by others. They perceive themselves as being at the bottom of it, and at times outside of it altogether. At the top of the hierarchy are Real Dancers—professional performers—and at the very top are those in the best known companies. The hierarchy functions as a series of levels to

which individuals must gain admittance; teachers and choreographers serve as gatekeepers, deciding who may enter. Such decisions are based on fixed requirements in two basic areas: ability and desire. There is no way of knowing if one has an adequate amount of either without attempting to gain admittance; those who "make it" are the ones who have what it takes. What it takes gets greater and greater as one moves up the hierarchy. Failure is inevitable for the majority of those who attempt to enter; the number of those who wish to be Real Dancers, even the ones who are talented, is much greater than the number of places open to them.

16.3 Discussion

As we discussed the relationships that emerged through the words of the students, we were particularly struck by what seemed initially paradoxical. On the one hand, the students feel a sense of identity between self and dance. On the other hand, they feel themselves on the fringes of dance and likely to remain so. They seem to conceive of those who dance for a living as existing in a Dance World composed of a set of givens and fixed values. These students, themselves, are powerless to do anything about affecting or changing the values which delineate the Dance World. Instead, they focus not on their lack of power over the field of professional dance but on their power to make "realistic" choices about whether or not they wish to try to enter the field as it is.

The more we discussed this paradox, however, the more it made sense to us, and a metaphor—of mother and daughter—began to emerge. Because the child is connected with the mother prior to a consciousness of self as separate creature, both child and parent are aware of the ways in which the parent influences the child, shaping and molding her, but both are hardly aware at all of the child's corresponding influence on the parent's development.

Similarly, we see a picture of students beginning dance at an early age, and finding themselves embedded in it before developing a separate consciousness. As Amber said, "I've always done it." Our students recognize that dance has made them who they are. Their teachers, in some cases, have acted very much like surrogate nurturing parents and in others like distant, authoritarian parents. In either case, the young women do not question the correctness of the teachers' behaviors but see them as necessary for their dance development, and not only in terms of physical development. Responsibility and discipline are particularly credited to dance. As Ellen stated, "I usually finish what I start. I think that's because I dance….I've got everything together and I'm real responsible and I think that's because of dance." They do not seem to conceive of themselves as being able to influence the development of the art (either as dance performer or choreographer); nor do they see that they might contribute to the art, or even change it, in the future. They remain unable to perceive any choice other than whether or not to participate in it.

We do not see this as particularly surprising in the context of current society. The vast amount of education for most children is directed toward helping them fit into

society and adjust to things as they are. This is particularly true for oppressed peoples (Freire 1983) and women. Recent dance literature (see, for example, Brady 1982; Gordon 1983; Kirkland with Lawrence 1986; Vincent 1979) points out the degree to which dancers in professional ballet companies are encouraged to remain both physically and emotionally at a prepubescent stage of development, children who will obediently do what they are told and fit into structures created by others. The young women with whom we spoke are not as passive as the picture presented of professional level ballet students; they seem to be strong young women who wish to be in control of their own lives. However, they still perceive the world as fixed and do not see that the dance field is a human creation which they have the capacity to expand and/or change. It might be argued that young people, in general, are not interested in changing their world but only in fitting into it; we are attempting to point out how the particular experience of dancing reinforces this mode of thinking. In addition, we remain convinced that both young people and the field would be better served if the students were able to see themselves as active contributors to dance as an art and a profession, rather than only as passive recipients of someone else's knowledge.

16.4 Conclusions and Implications

At first glance, the results of this study seem decidedly unremarkable. It appears natural and inevitable in a glamorous and competitive field that only a few will "make it." "Many are called; few are chosen" applies to many other fields as well as dance. It also appears natural that young students in the midst of their dance study reject career possibilities other than performing even if they hear about them. Some degree of disappointment and confusion is normal during adolescence; these students have gotten many good things from their dance study and now, whatever their choices, will go on to live the rest of their lives.

Our conclusions address two areas: (1) the questions we stated at the beginning and (2) the significance of this research methodology for analyzing and understanding the experience of dance students. A number of issues emerge for us.

We find evidence that the choice to dance is not necessarily as freely made as one might assume. To some extent dance has chosen these students and will not let them go, while at the same time expelling them from the ranks of the chosen. By "dance will not let them go" we mean to indicate that their dancer identities dominate the other aspects of their self-definition. It is as if their ability to exist is strongly bound up with their ability to dance. In addition, their feelings of self-worth are strongly tied in with their ability to succeed in dance. Dance, seeming to exist outside of themselves, appears to measure their success and failure against external standards. These young women find themselves in the sway of values and judgments over which they exercise no influence. Simultaneously, they are at a point in their lives when they are concluding that they do not possess the qualities necessary to "make it" in the field of dance. They recognize that they possess many admirable dance qualities but not the right ones. Failures are due either to their own weakness or

inability, or to physical factors over which they have no control. Coupling their strong self-identity as dancers with their lack of exposure to alternative possibilities both inside and outside the dance field makes more problematic their belief that they will not be able to continue being dancers in the terms they have known.

We also note that these young women can see performance as the only possible way of being involved with dance and it appears that their dance study has been focused almost entirely on learning technique. They have not had a full education in the art, which would include exploration of its career possibilities and their satisfactions, as well as ongoing dialogue regarding how they perceive dance and their place in it. As we look beyond the students to the current world of professional ballet and much of modern dance, we see extraordinary technical demands which dictate the requirement of almost total dedication to training from middle childhood through adolescence, especially for girls. This is not so for boys, because the competition for men is not as great; therefore, they do not have to start as early to do it. In other words, girls have to start dance training at an early age without sufficient understanding of their options. Influenced by parents and teachers, they become embedded in a system before they can concretely think of what is best for themselves.

What are the costs of this state of affairs? In terms of human costs, we see that they may include a great deal of personal destruction, as revealed by recent literature on the professional ballet world (see, for example, Brady 1982; Gordon 1983; Kirkland with Lawrence 1986; and Vincent 1979). However, only one of our respondents, Elizabeth, indicated that her experience in dance had been personally destructive.

Whatever the human costs, readers may feel that they are an inevitable consequence of having great art. But we see that there are consequences as well for the art. What is lost when a great many bright, articulate young women decide that there is no place in dance for them, because they do not have the "right body," or do not otherwise meet the requirements for the art as it now exists? To what extent does this restrict the development of the art, by allowing entrance only to those who will maintain the art as it is?

Another issue which may reflect the costs of the current system is the disproportionate representation of men in positions of leadership and power in dance. We wonder how this relates to the emphasis on passivity and obedience in dance training, and the earlier age at which girls begin to study.

We also question whether it is natural and inevitable that the system operate in this way, in which human lives are seen primarily as means to make great art, and the art itself is diminished by the loss of so many who might well have important contributions to make. Is it inevitable that art determine artists, rather than artists determining the art? Who is being served by maintaining the extraordinary technical demands which dictate an obsessive dedication to dance study that has time only for technical training? What kind of art form might result if dance training consisted of less time learning to reproduce movement, and more time studying dance more broadly, learning to think about it as well as do it? What might result if teachers spent more time in dialogue with students? Teachers are the major points of access through which students develop their relationship with dance; teachers serve as

interpreters of the dance world and gatekeepers to opportunity and self-esteem. When we asked the students about dance, all spoke at some point about dance teachers. Some of their relationships with teachers had been close, nurturing, supportive; others were characterized mainly by distance, pressure, inequality, power plays, and fear. Regardless, the authority of teachers was rarely questioned. We find this problematic as we reflect on the way in which these strong young women seem to give up so much personal power when they make the choice to participate in the dance world. The responsibility is on us as teachers to reflect on what we do, what of dance—and the rest of the world—we present to our students, and how we encourage students to use their own power.

In considering the significance of the methodology used in this research, we note that listening to students gives us input which may help guide the choices we make in our studios and classrooms. We continue to reflect on the words of our respondents. However, speaking is also important for the students themselves, giving them a chance to develop their voices as well as their bodies. Many of these young women indicated what we would describe as delight in having someone listen to them with clear interest as they spoke of dance and of themselves. Several noted that they had never had an opportunity to speak in this way with someone who understood, and that all dancers should have a chance to do this.

We looked for verbally articulate young women dancers and we found them. We also recognize that many others have not developed their verbal skills as much as our respondents. Belenky et al. (1986) point out that development of one's voice is part of the development of one's mind, and one's whole self. They carried out an extensive study regarding how women come to see themselves as knowers, concluding that finding one's own voice is essential if individuals are to become able to recognize their ability to create their own knowledge and not just receive the knowledge of others. They observed that, in our society, women are effectively silenced much more often than men. Since most young dance students are girls, we cannot help but question any pedagogy which takes these girls at a young age, before they have found their own voices, and trains them to be silent. It seems critical that teachers build in opportunities for dialogue with students and between students about what dance means in their lives, and what they perceive as possibilities for their futures.

It also seems essential for the voices of dancers to become a part of the literature in dance research. Theories of how to teach dance, what to teach in dance, and what the importance of teaching dancing in particular ways might be, are all grounded in our own experience. The voices and stories of dance students surely need to be part of the realm to which we attend as we deliberate over dance curriculum and pedagogy.

Lastly, we believe that the themes we derived from these young women's stories may be useful in interpreting further research. These structures will become modified as we hear more voices which provide new kinds of language for our understanding. The framework becomes, therefore, open-ended and available to constant change, functioning not only for purposes of analysis and research but also for developing ways of thinking about teaching dance.

If we have a disappointment with this research it is that we have lost much of the distinctiveness of each individual because of constraints on space. We heard each voice individually, but we are unable to allow each to truly speak as an individual in our presentation. In many ways we feel that this sort of work is better presented in a book rather than an article, in which our voices would go alongside theirs without dominating them.

We began this paper with a number of questions. It is clear that they do not have easy answers. However, the value of interpretive research lies not in its capacity to give answers, but in its capacity to reveal complex issues. We hope to continue exploring these issues in the future in our work as educators and researchers. As we do so, we take with us a clear affirmation of the significance of hearing the voices of dancers.

Appendix: Sample Interview Questions

Initial Interview

1. Background information:

Years of instruction
Age when started instruction
Frequency of class
Time away from dancing
Forms of dance studied
Age now
Why did you start to dance?

2. Try to describe for me what it is like when you take a dance class? How do you feel when you dance in class? (Is it different when you dance different styles?)

What is it like when you perform dance?
Is it different for you when you dance in a group situation and when you dance alone? If so, how? Is it different when you dance with or without a teacher present? If so, how?
Are you different when you're dancing compared to when you're not dancing? If so, How?

3. How important is dance to you? Why is it important/not important? What does your dancing mean to you?
4. Tell me about the kind of adult you want to be and/or think you will be (including career plans, if any). Tell me about your family.
5. What things do you like to do when you are not dancing? Can you tell me some words that describe you as a person? How would others (parents, teachers, friends) describe you?
6. Can you describe yourself as a woman? (Do you think women are or ought to be different from men? If so, how?) Has the fact that you are a woman and/or your

feelings about it made a difference in your choice to dance? If you had a daughter/
son, would you like her/him to dance? Why/why not?[1]
7. Can you describe a very favorite experience you have had in dance?
8. Is there anything you do not like about dancing? Have you ever wanted to stop
 dancing? If so, why—and what made you continue?
9. Is there anything else you would like to tell me about yourself and dance?

Second Interview (Following a Class Observed by the Interviewer)

1. Is this class like most you have taken? What characteristics make it similar to or
 different from other classes?
2. How were you feeling (or were you thinking about anything) during specific
 parts of the class)?
3. Is there anything you have thought of since our first interview that you would
 like to tell me about yourself and/or your dancing?
4. Do you have any comments to make about the interview process in which you
 have participated?

Commentary

Soon after completing my doctoral defense in spring 1984, with the tenure clock
starting up again, I was anxious to implement a study using more of the range of
methodologies about which I had spoken at the 1985 daCi conference (see
Chap. 11). I had gotten excited by a paper I had heard at the 1985 AERA conference
by Valerie Polakow, in which she remarked that the voices of children were absent
from the literature about how children learn reading. It was a transformative moment
for me as a budding researcher. Recognizing that the voices of dance students were
similarly missing from the literature, I was launched on a path which continued
throughout my career. I invited two dance colleagues, who were still enrolled in the
same doctoral program I had just completed, to join me in this initial venture; it was
the first experience for us as novices in collaborative research. Writing the extra
lengthy section on methodology and procedures in this chapter helped us better
understand what it was we were trying to do, in the way that writing so often creates
understanding.

Some years later, another colleague challenged me on our stated assumption
herein, that "all meaning in dance is, ultimately, personal meaning." Of course,

[1] We asked questions which gave each student an opportunity to speak about being a woman because
of our expectations that gender issues are involved in the complex relationships between dance,
dancers, and the society of which both are a part. However, awareness of relationship between gender
and dance seemed minimal in their consciousness, and we elected not to pursue it at this time.

personal meanings cannot be constructed outside of a cultural context, something I wish we had stated at the time.

This work seemed to resonate deeply with the dance audiences to whom we/I presented it prior to its publication. Although most of the presentations were juried, I also was invited to present it at the Tenth Annual Dance Ethnology Forum, UCLA Graduate Dance Ethnology Association, in Los Angeles (1989) by Allegra Fuller Snyder, then chair of the program. I was amazed and deeply honored when this renowned dance ethnographer mentioned in her introduction that this was one of the best pieces of dance ethnography she had ever heard. At this event as well as the others, hearing the stories of the young women dance students brought forth the stories of many in the audience, affirming for me the power of this kind of work. It was cited extensively for a number of years and stimulated other studies by dance education scholars.

References

Beittel, K. R. (1973). *Alternatives for art education research*. Dubuque: William C. Brown.

Belenky, M. F., Clinchy, B. M., Goldberg, N. R., & Tarule, J. M. (1986). *Women's ways of knowing: The development of self, voice, and mind*. New York: Basic Books.

Bernstein, R. (1983). *Beyond objectivism and relativism*. Philadelphia: University of Pennsylvania Press.

Brady, J. (1982). *The unmaking of a dancer: An unconventional life*. New York: Harper and Row.

Braxton, J. B. (1984). *Movement experience in modern dance: A phenomenological inquiry* (Doctoral dissertation, University of North Carolina at Greensboro, 1984). *Dissertation Abstracts International, 45*, 1332. (University Microfilms. No. DEQ 84–17879).

Donmoyer, R. (1985, April). *Distinguishing between scientific and humanities-based approaches to qualitative research: A matter of purpose*. Paper presented at annual meeting of the American Educational Research Association, Chicago.

Donmoyer, R. (1990). Generalizability and the single case study. In E. Eisner & A. Peshkin (Eds.), *Qualitative inquiry in education: The continuing debate* (pp. 175–200). New York: Teachers College Press.

Freire, P. (1983). *Pedagogy of the oppressed* (M.B. Ramos, Trans.). New York: Continuum.

Gordon, S. (1983). *Off balance: The real world of ballet*. New York: Pantheon.

Howe, K., & Eisenhart, M. (1990). Standards for qualitative (and quantitative) research: A prolegomenon. *Educational Researcher, 19*(4), 2–9.

Kirkland, G., with Lawrence, G. (1986). *Dancing on my grave*. New York: Doubleday.

Kollen, P. S. (1981). The experience of movement in physical education: A phenomenology. *Dissertation Abstracts International, 42*, 526A.

Peshkin, A. (1988). In search of subjectivity—One's own. *Educational Researcher, 17*(7), 17–21.

Phillips, D. (1987). Validity in qualitative research: Why the worry with warrant will not wane. *Education and Urban Society, 20*(1), 9–24.

Polakow, V. (1985, April). *On being a meaning-maker: Young children's experiences of reading*. Paper presented at the annual meeting of the American Educational Research Association, Chicago.

van Manen, M. (1990). *Researching lived experience: Human science for an action sensitive pedagogy*. Albany: State University of New York Press.

Vincent, L. M. (1979). *Competing with the sylph: Dancers and pursuit of the ideal body form*. Kansas City: Andrews & McNeel.

Chapter 17
Meaning and Value: Reflections on What Students Say About School (1993)

Susan W. Stinson

Abstract This study examines how high school students in dance make sense of their experiences, using a methodology of interpretive inquiry. Based on field work in five different dance classes, taught by three teachers at two high schools, most of the data comes from extensive interviews conducted with the 36 students who chose to participate and returned consent forms. The researcher identifies two major themes, one having to do with relationships (with dance classes often described as a safe and idealized home and/or family, providing supportive teacher and peer relationships), the second with how students construct meaning and value from their school experiences. Through the data emerges what students say they desire from school:

- To be stimulated, to learn;
- To have a sense of meaning in what they are being taught;
- To be treated with understanding, to be cared for; and
- To be able to be themselves. This involves conditions of both security (being accepted as they ought to be in their own family) and freedom (to express themselves).

While students indicated that these desires are largely met in their dance classes and not in required courses, this did not translate into their perceiving greater value for dance. With their clear belief, strongly supported by the culture, that school is a means to important ends (graduation, admission to college, career preparation), electives like dance, no matter how personally meaningful, are not viewed as very important. Dance class and other personally meaningful activities become a temporary escape, allowing students to tolerate the rest of their hours in school.

My neighbor, who returned to college when her youngest child started school, just finished her first year of teaching. She told me she is looking for a different job and will undoubtedly become one of the many teachers who leave the profession shortly after entering it. She describes the vast majority of her students – in high school math – as not caring about learning, despite her best efforts to make math interesting and even exciting. Her comments mirror my own observations of students: that most of them, by high school, have "turned off" the zest for learning found so often among young children. My neighbor has a hard time understanding such

© Springer International Publishing Switzerland 2016
S.W. Stinson, *Embodied Curriculum Theory and Research in Arts Education*,
Landscapes: the Arts, Aesthetics, and Education 17,
DOI 10.1007/978-3-319-20786-5_17

individuals; she was a different kind of high school student. If my teacher education students are any indication, so are most individuals who plan to be teachers; teaching is a fairly natural occupational choice for those who love school.

As blame is being placed for the current crisis in education, students who do not care about school are receiving their share. Increasing standards, homework, and time spent in the classroom seem to have had minimal impact on student attitudes. Educators blame students for their lack of engagement but have appeared to have little interest in understanding how students perceive school and how they assign (or fail to assign) meaning and value to their experiences there. As Max van Manen notes, most education books fail "to consider how particular situations appear from the child's point of view, how the child experiences his or her world at home, at school, and in the community" (1991, p. 11). I find myself agreeing with van Manen when he suggests that "from a pedagogical perspective the most important question is always, 'How does the child experience this particular situation, relationship, or event?'" (p. 11).

This study focuses on how students in one high school subject make sense of their experiences. Because that subject is dance, some may dismiss my findings as irrelevant to other academic areas. However, although more students may like dance and other elective courses, what they told me of their lives in and out of the dance studio/classroom has significance far beyond any one subject.

17.1 Methodology and Procedures

I felt it was important to hear students in their own language, rather than receive superficial answers to survey questions; I wanted to be able to follow up on brief expressions and thoughts that might not be fully formed. I knew I needed to establish a relationship of trust with students if I wanted them to really share their thoughts and feelings about school. I selected a methodology of interpretive inquiry, what Robert Donmoyer (1985) refers to as "humanities-based research." Unlike science-based research, it is not trying to prove or disprove a hypothesis; *meaning* rather than *truth* is the goal. The intent of such research is to develop a language, or way of talking about a subject. Different languages are neither true nor false, but each has the capacity to reveal different realities.

The results of humanities-based research cannot be generalized in a statistical sense, but in the way that we generalize when we read a novel or see a film (Donmoyer 1990). When we look at the world through someone else's eyes, we may be able to see a different world.

The initial work for this study took place over one and a half years. During the 1989–1990 school year, I spent two periods per week each semester in a total of four Dance I classes taught by two different teachers at a single high school. Dance I is

the designation in my state for the first year of high school dance, an elective course; in the system where I did my research, this is a semester-long course that meets 55 minutes daily. I functioned as a participant observer, taking class with the students, hanging out in the dressing room with them, attending their performances. I interviewed a majority of them at the end of each semester. In fall 1990, I extended my study to a fifth class, under a third teacher, at a second high school. Due to the different format of these classes, I was most often an observer; I also interviewed a majority of the students at the end of the semester. All classes were small, with 8–14 students in each.

I also spent a good deal of time talking to the three teachers and formally interviewed them as well. Two of the teachers were white, and one was black. Abigail (all names for teachers and students are pseudonyms) was an experienced teacher, one of the most gifted teachers I have ever observed. Marlene had been teaching for several years, mentored by Abigail. In Abigail's and Marlene's classes, students were almost always fully engaged; if a student "sat out," which was rare, illness was apparent. Katherine was in her second year of teaching, a "lateral entry" teacher who had not yet completed her certification. Sitting out was much more frequent in her classes, often because students forgot their dance clothes; students who sat out were given an alternative written assignment.

I took notes following my weekly visits to the classes and interviewed 36 students, all of those who chose to participate and got their forms signed and returned to me. The demographic makeup of the 36 high-school-aged students included three white males (out of a total of five in the classes), 18 white females, 12 black females (one recently arrived in this country), two Asian American females (one a recent immigrant), and one Hispanic female. The interviews lasted one school period, taking the form of a conversation loosely based on a series of questions (see Appendix). Because of this open structure, I was free to follow up on what students told me, and I tried to let their perceptions, rather than my questions, shape the conversation. I tape-recorded and transcribed all interviews. Following several months of listening and rereading, I identified a total of 14 topics, some of them overlapping, in the words of the students. Examples are Learning, School, Value of Dance, Body, Gender, Fun/Pleasure, Easy/Hard, Teachers, Family, Relationships, Creativity/Self-expression. I sorted all material according to the topics. I then attempted to determine the essence of what the students were saying on each topic. Eventually, the essences of several topics coalesced into a few broad areas, related both to issues of arts in education and to schooling more broadly. Discussion of these areas follows, illustrated by excerpts from student transcripts. I have not included each student comment that supports the points I have made. The students are speaking here primarily through me, in that I have made selections from among the 4–19 single-spaced pages in each student transcript. I have even, at the request of some of the students, edited their comments into standard English (changes noted in parentheses). Finally, I identified two themes that emerged, giving me the basis for further reflection.

17.2 How Students Experience School

I consciously looked for students who saw school as a positive experience. Dionne, a bright senior in several classes for the academically gifted, was one of them. She commented about school:

> It's pretty good. It's challenging…we have to work really hard to keep up. It's fun, too, because I have some interesting teachers….I get bored with it every year at this time…I never get so tired out that I wish I could just stay home…Some days you have to get up and make yourself come to school. But still, I think it's worthwhile.

Afrika,[1] who called herself "a pretty good student," commented, "I've always liked high school…I like learning…I always try to learn something new, something different…that I didn't know every day." Sky, who described herself as a "fair" student, told me, "I like school because I see everybody, and you get to express yourself in some classes and tell your opinions."

A few other students, while not so positive about school in general, nevertheless had positive comments about the teachers they had during the year I interviewed them. Lynnette, on the opposite end of the academic scale from Dionne and Afrika, also had behavioral problems leading to frequent suspensions. I was surprised to hear her say that dance is like other courses because of her teachers: "They push hard. They show they care…all my teachers want to see me do well in school and achieve a lot of goals." However, Lynnette was frequently absent and was not doing well in school.

Several other students gave school a more mixed review. When I asked Kristen if she looked forward to going to school, she said, "Well, going to school – having a boyfriend doesn't hurt – but going to school is like – what else would I do? Just sit there."

Kyteler stated, "I like some parts of school. I like learning things." However, all the rest of her comments related to what she did not like about school, including the following:

> I don't like being forced to take classes that I have no interest in or can envision no use for…I don't like the high school atmosphere, like the competitiveness for grades, the stress on sports over academics; I don't like a lot of the people I've met here, because I find many of them very shallow or…close-minded.

For Bea, school was a positive experience mainly in comparison with home, where she became primary caregiver of a severely handicapped sibling. She told me she loved going to school, "because I don't want to stay home too much."

Other students had much less positive comments about school. Annika was clear about this: "I'm not really into school. I actually hate it pretty much." When I asked what she hated about it, she said, "The work, and being bored all day…Right now I'm not doing good at all – I'm failing three of my academic subjects." However, Annika had grades of A and B in her three arts classes.

[1] All student names are pseudonyms chosen by the students.

Francesca was another bright student who expressed strong dislike for school – at least, this particular school:

> I just don't like it…'cause I'm really just not learning anything…I used to skip school a lot…when I…do come to school, I get A's in all my classes. But…I don't think I should be here not learning anything when I could be out getting a tan or something.

Francesca had decided not to skip school that year to prove a point to her parents: "that I can get good grades and I'm not dumb."

The things students told me about school life in general seemed to fall into four categories. First of all, they said, school is boring, and they have a hard time staying awake. Francesca told me about boring classes:

> If you have a class where you just go in, you talk in a monotone voice, you don't do anything, you let students leave the room whenever they want to, no one's going to learn anything…It's boring.

Sky was even more vivid, telling me that in her classes other than dance, "I feel like I'm dead." Madeline, one of the gifted students, said, "I'm just used to coasting through school…in the limbo zone." Bridget's description of her history class was typical:

> We go in there, we have to spend 55 minutes. This man (doesn't) do (anything) but talk for 55 minutes. What (are) you getting out of that?…And if you go to sleep, you get written up.

There are few opportunities, other than arts and physical education classes, to move around and do things, to talk in a class discussion or plan a project with a partner or group. These are the kinds of activities that my respondents told me keep them awake. Stephanie, who was in a number of classes for the academically gifted, added that "hands-on stuff, the more things you do" help her learn better.

When I asked Janet to respond to a proposal to have only required subjects in school, with electives meeting after school, she responded in a way similar to many others:

> If it's math, English, and social studies…you don't want to go to school. It's boring, boring. So I don't think they should take those [electives] out. There'd be more dropouts and stuff.

The second point these students made is that many students in other (required) classes do not wish to be there and disrupt the class for their fellow students. Michelle echoed several other respondents when she said dance should not be a required subject

> because some people would get in there and they'd just…hate it…And they'd probably mess around the whole time, and they might make it bad for people that were trying to learn something. [Does that happen in other courses?] Yeah, most of them.

The third point made had to do with the rigidity and pettiness of school. Annika asked, "If people are a little late, why make them be in trouble?" Students pointed out that general school rules had to be followed in dance class. However, in most other classes they were not allowed to express their feelings and felt unable to be themselves. Janet described one class in which

> you can't even look down 'cause she thinks you're asleep – she'll write you up. She's real strict. Like, if you have your foot on the chair, "Get that foot down." If you yawn and forget to cover your mouth, she'll tell you to cover your mouth.

The fourth general point, which was often connected to the third, is what students perceived as a general lack of caring from teachers. Denise stated, "Most classes, they just tell you to DO THE WORK. Well, what if I don't understand it? They go, 'Just do it.'" Amanda told me that

> Some teachers are real nice and real creative and let you be yourself. But some teachers, like, you're just a class and not a real person...And then self-expression. They don't even want to listen to you. Some of 'em do...those are the good teachers. The rest of them, I don't consider them teachers. They're people's babysitters, just there to watch us.

Brittany, when asked what she wished her teachers would do differently, told me, "like Mr. __, I wish he'd start caring a lot, 'cause he (doesn't) care, and he should care if his students know it or understand it...and he (doesn't)." Mercedes added, "If a teacher doesn't care, why should I care?"

Ameria described

> This teacher I had last year, she wouldn't go over stuff with you, she, like, "here's what you do, and I'll give you a grade," and there's no feeling about, "Are you OK?"...I know they shouldn't baby you, but...you should still consider how that person is feeling that day... maybe it's just because she had so many troublemaker students that she thought everybody was the same.

It was clear that, for most of these students, feelings about a subject were closely connected to feelings about the teachers. If they liked the teachers they usually liked the subject; and as Denise stated bluntly, "If I don't like 'em...I'm not gonna do anything for 'em." This was confirmed by Bridget, the one student who did not like dance, who said, "It could be fun, if you had the right kind of teacher to teach it." I must point out, of course, that liking the teacher did not always mean students were successful academically, as indicated by Lynnette's and Denise's stories I cited earlier; they liked all their teachers that year, but were not doing well for other reasons. Clearly there are other factors involved in student success.

17.3 Contrast Between Dance and School

It is not surprising to hear teenagers express dislike for school. What is more surprising, perhaps, is that all but one of the students I interviewed had such positive comments about their dance class in school. Only Bridget had a negative response to dance as well as school:

> I don't like school, period. I dropped out two times...I know I need my education to get somewhere in life – that's why I'm back. The only reason I...do what she [the dance teacher] tells me to do is 'cause I'm going to have to pass her class in order to graduate in January next year.

The students told me in a variety of ways that, despite the fact that dance existed in the larger school structure and had the same general rules, it did not seem like school. K. G. spoke clearly about this when he described dance as

a good way to get away from school…once you step into the auditorium, everything is kind of shattered…you can make it what you want, when you first walk in…it's almost like time has stood still outside of those doors.

Kylie added to this when she said, "As soon as I go through that…door, here's my other world…If it wasn't for that, I don't know what I'd do—just enter it when I went home." Sky spoke of freedom: "In this class…you just learn some freedom… You're freer to express yourself and stuff like that…So it's real different than any of my other classes." Afrika agreed: "It's like an escape place, a place where I can just relax and be normal and be me and just express myself. I can be free again." When I asked if she had other places like this, she said, "There's always my home…my family. I don't have to act or anything around them…I'm just me." Other students in Abigail's and Marlene's classes also spoke of home, such as this comment from Britain: "(I'm) sort of myself at home in dance class."

Although in these statements, the comparison of dance with home is a positive one, other things the students told me made it clear that home was not a very happy place for a large number of them. Only a few were from intact, two-parent families. I have already described Bea as caretaker for a younger handicapped sibling; two students were caretakers for alcoholic parents. Another was in her third foster home when I interviewed her; she moved to her fourth a month later. Several had a history of suicide attempts; several had recently moved out or been kicked out of their homes. One student had been abandoned by his mother. Most students did not have fathers at home, and several spoke of particularly painful problems with fathers or stepfathers. Certainly adolescence, including family life, is often a time of stress. However, the situations faced by many of these students went beyond the range one would hope would be normal. A large number were classified as "at risk."

17.3.1 The Caring Teacher

Perhaps this is one reason that students found particular significance in a caring teacher. When I asked how their dance teacher was like and different from other teachers, many students spoke of the difference in caring and understanding. Mercedes said, "She cares, and you can tell by the way she does things." Many students told particular stories or gave descriptions to illustrate that caring. One way teachers demonstrate caring is by giving additional help during or after class when the students do not understand material or have difficulty learning.

Mercedes mentioned that the willingness to give extra help in the learning process differentiated her dance teacher from others: "If there's something in the warmup that someone doesn't understand how to do or doesn't understand why we're doing it, she explains it. I mean, she just doesn't say, 'Do it.'"

Kristen told me that her dance teacher at school was different even from studio dance teachers she had had, but acknowledged the significance of class size, a point mentioned by several other students:

She's willing to work with you more on a one-to-one basis…'cause the class is so small that she has time to do that…she wants it to be right. But she's also willing to take you off to the side and help you.

Monique added, "She's real understanding, she's real patient…There's a lot of teachers here that don't care. And [my dance teacher] cares." Britanny was not a strong student academically, but she spoke eloquently when she said,

I'm not a slow person, but I'm, like, you have to explain or show me to understand, and when we started doing something and I didn't understand…and [my dance teacher] knows that I can't understand stuff that good, so she talked to me and she said, "If you have any problems just come let me know." …She knows that look, like I don't understand…and then she explains it to me and I understand. What's different about [my dance teacher] is I say I don't understand and she helps me.

Students said that their dance teachers not only helped them with problems in the class, but with personal problems as well. As Ameria commented, "She's so young, it's like she really understands us…if you have a rough day or something, she'll go out of her way to make you feel better." Similarly, Janet noted,

She's different 'cause she's young. She knows the things we go through…so if we come in with an attitude, she'll say, "What's wrong?" She understands, not like other teachers… well…some teachers really care. But she asks us what's wrong with us. If we don't want to talk about it, OK, we don't talk about it, but – she's a good teacher.

Onan said, "I think she's one of my youngest teachers…she likes to talk with us… and listen to what we have to say." Students of all three teachers commented about the youth of their teachers, whose ages ranged from mid-20s to near 40.

Several students at one school told me that their dance teacher called if they were absent to see if anything was wrong. For example, Elizabeth said,

She's different because she's…friendlier…If you're absent and there's something we have to do that day…she'll call to make sure you're all right. And she'll talk to you…about anything…She's there for you if you need help.

Annika said, "I feel like I can talk to her a lot more about anything, not just dance." Annika also felt the weekly journal assignments gave her a chance to "talk" to her dance teacher: "She really reads it and takes time to try to understand what you're going through."

The students described a caring teacher not only in terms of helping them with problems. Having high expectations for students was also valued. Students of two of the teachers described their dance instructor in these terms. Said Francesca,

None of my other teachers really care. They're just like, "If you don't want to learn, then you don't…But I can't do anything about it." But she makes you learn, she pushes you to… 'cause she knows you can do it.

Afrika told me that her teacher is "always…commending you, so it makes you want to do it better."

Dionne, one student who spoke positively about school, said that her dance teacher was like others because "she expects you…to get it done, expects you to work your best at it." But Madeline clarified differences between teachers in this

way: "[my dance teacher] expects us to do it, where other teachers expect certain students not to."

Both Janet and Michelle described their dance teachers as "more of a friend than a teacher." Nevertheless, Michelle said, "She's still strict and that's good…she takes charge of a class, she doesn't let them get out of hand." In other words, one way a teacher shows caring is by preventing students from disrupting the learning process. However, the strictness of the dance teacher seemed different from the strictness of the other teachers. Kim said, "She (doesn't) like to get upset with you, like other teachers, and they'll just go off and write you up or whatever; but she's not like that."

17.3.2 Peer Relationships

Relationships with fellow students also differed in dance class compared with the rest of school. Kristen told me:

> You don't have to worry about other people in other classes. In geometry, who cares what the guy next to you is doing?…but in dance you want to make sure that what they're doing is good-help them out, if you can.

Lynette said it this way:

> It's a lot different. The people in my dance class, they care a lot. In other classes, most other students…they're not that much caring. You can't just sit and talk to them and be serious. Most like to joke around, and when it's time to be serious they don't want to.

K. G. added, "In other classes I just kind of sit back and do my work. In dance, your work is to cooperate with other people, to work together in a group and to talk." Brittany had this to say:

> It felt like everybody was close 'cause…our group is so little, and we all shared different things and all have something in common with each other and it was different…from the other…classes.

One reason for the difference, Brittany felt, is that there were not any "trouble-makers" in the class. Certainly more of these students chose to be in dance class than is true in a required course. However, there were some students who indicated that the choice had been minimal. This was particularly true second semester, when a number of students told me they were in dance because they had failed a yearlong course, and dance was one of only two or three semester-long courses offered that period. Either they had already taken the other alternative(s), or dance seemed to them the "least bad" of the choices.

Madeline, who was gifted academically as well as in dance, told me, "Another thing I love about my [dance] class is the combination of people in it. 'Cause they would never know each other." Since the arts classes are not tracked like most academic courses, they have a mixture of students who do not share other classes. Madeline indicated, too, how her appreciation for other students as dancers had increased:

> I didn't know that the girls in my class would be able to do as much as they can…a lot of times you think about a dancer having to get their leg up to *here*, or having a real strong center, or a perfect body, and you don't have to. And you see that when you see all these different-shaped people who, some of them, can't lift their leg off the ground, but they still look the same doing the dances, because it fits different (skill) levels.

Madeline's appreciation for her peers had increased so much that she requested their input and critique on a solo she was preparing for competition at her dance studio.

Mercedes brought the metaphor of family to her description of peer relationships:

> When you start to know everybody you're in an atmosphere where you feel safe – and secure. It's kind of like…when you have a security blanket when you're little…after a couple of years the blanket is part of you. And dance – that's what it was like…you get to feel like part of each other. So you feel like, when you dance in front of them, it's like dancing in front of your grandma or something.

The theme of relationship with other students was very strong in Abigail's classes and was clearly present in the two classes taught by Marlene. Katherine's students, at another school, presented a somewhat different picture. A few of her students described closeness with others, as in these comments by Monique: "I've made a lot of connections with (other people in the class). Like most of the people in the class, if we were just in the hallway they wouldn't say anything to me." More of the students, however, described discomfort with separations along racial lines and wished the teacher would do something about it. This was one of two classes I observed in which partners and groupings were usually self-selected, and black and white students almost never chose to work together. Perhaps this point did not come up in interviews with students in the other class because I did not follow up as well on clues offered to me. In addition to racial separations, several white students described personality conflicts with other students, primarily white. But the activity of dance seemed to offer some opportunities to transcend boundaries between students. For example, Kara told me about her favorite experience in the class:

> The second day, everybody was very uncomfortable, and people were kind of fidgeting, and nobody really knew anybody else, and there were all sorts of prejudices there. And [the teacher] got out the drum, and she started playing…we did a human knot – and for a little while, all of those prejudices kind of went away, and we were just *people*, having fun together…to the rhythm of the drum…and it didn't matter what kind of classes you were taking, it just mattered that you were here, now.

17.3.3 Dance as a Positive Experience

The teacher, then, and, in many cases, the students, helped provide a caring, supportive group, even a "family" to some. In addition, dance itself helped some students accommodate to the painful or difficult aspects of their lives. As Sandy told me, "Dance is just an ease to your problems." Others said that dance class offered a kind of release from tensions of home and school. Ameria put it this way:

When you're upset you can express it in dance, where if you're upset in one of the other classes, you'll be fussing at everybody…and getting up out of your seat, and that'll get you in trouble in a regular class…but in dance you don't have to say (any)thing to express how upset you (are) or how happy you (are) 'cause it just show(s) in your dance.

Amanda had similar comments:

If you have totally academic courses, you need some kind of release for expression, or pressures, or whatever. Like when I was upset about my boyfriend, I did a really dramatic dance. It's a good way to express yourself and release energy. I mean, if you're going to sit there all day, you're going to…tap your feet and click your pen.

Kara, who was in mostly honors and AP classes, told me,

One of the things that I really like about dance is it's not really academic. There's not so much pressure on it. There's something kind of – I don't know how to say it – antiseptic? – about academic subjects, and there's something very pure, very simple, very basic, about dance.

Kristen pointed out:

It's a break from classes. You can just pour yourself into it. It's not like, you know, geometry – you just sit there and can't do anything. Then by third period [dance], I'm ready to get up and do something.

Annika spoke of transcendence and self-expression:

I get into my dances and I can feel it. You just become one with it. You can express your ideas or your feelings with it in a different way other than talking or acting…You feel like you have control over yourself and what's happening.

Students said that dance gives them not only a chance to express themselves, but to be themselves. The smaller class size contributed to this. Amanda commented, "You…get to be a person there, more than anywhere else. Like, some classes you get to be yourself, but there are so many other people there you don't get much of a chance." Monique added, "It allows me to search for different parts of Monique that I didn't know I had."

As I indicated earlier, most students told me they had a hard time staying awake in school. Shantell said dance is

not like other classes I take, 'cause…you really like to dance, it wakes your body up, like I have it first period, you just (are) tired from the morning, it gets your body going for the day. And other classes, you like want to fall asleep in there, but in dance you can't fall asleep 'cause you're always moving.

Although many students felt that it was the active format of the class that made a difference, a few acknowledged that they found the content of the class more compelling. As Rochelle said, "I like learning about dancers and dancing more than I want to hear about history and war…it's just more interesting to me because I'm interested in dance." Annika added, "Physical work is more interesting to me."

It was not only the content and format but also the teacher who helped the students wake up in class. As Kristen said, "She's so energetic, she's like one of us." Kylie said, "She's very physical." And Monique commented: "I can see how her love for dance comes out…Dance is…like her lifeline." Elizabeth put it this way:

"She's so perky, so alive, that you can see it everywhere…You can feel it when she gets near you." In other words, the teacher's energy and enthusiasm and love for the subject matter were contagious.

For almost every student with whom I spoke, then, dance was a positive experience, and dance class was a place they liked to go. To a certain extent, the act of dancing itself provided the pleasure. As Onan said, "When I picture myself dancing, just picture me with a big smile…. That's how I just picture dancing – just makes you feel real good, and being happy." Students in all five classes described a warm relationship with their teachers; they largely felt cared for and supported. All three teachers actively tried to cultivate such relationships. Students indicated that relationships with other students also contributed to the pleasurable ambiance of dance class; this was particularly true in classes of two of the teachers.

17.4 Learning

The issue of student learning in dance is a major one as administrators seek to determine the value of arts courses. I found that the greatest differences among teachers appeared when students spoke about what they had learned. Katherine's students spoke more than others of learning about dance – about different styles, about historical figures. She divided the semester into units on modern dance, ballet, jazz, and so forth; and these seemed to give students a structure to recall. Stephanie said,

> Last year we had to learn about Isadora Duncan…and I learned it, but it didn't stay in my head. And this year…We're learning it over again. Plus we're going over some dances like they did…So it's finally getting into my head and staying there.

There were also many opportunities to "make up a dance" in Katherine's classes. Although I observed little instruction on choreographic craft or process, Katherine's students did speak of learning to develop their "own ways of dancing." When Sky told me what the teacher wanted students to learn, she thought it was "to be able to open up to the world, to different things that you haven't learned, and be able to… express yourself." "Expressing yourself" was easier for some students than others. Sky said she learned by watching others: "You can learn other things, like when you watch people…. How people can think of the neatest things, how to do it, and it's not hard at all." Alex gave a contrasting view: "The hardest part is constantly coming up with your own dances…I really have a problem with that. I'm more used to being taught a dance and doing it."

Kara, too, mentioned difficulty with creating dances; she felt the teacher could contribute more to this process:

> If I was learning anything, it would have to be how to manage a group of people in dance, because a lot of the people are too shy to speak up…I sort of wish [the teacher] would step in and do something with individual interpretations, so that those people could learn.

Onan thought she had learned a great deal in the class, although she had difficulty articulating the content: "I didn't know we were going to learn all this other stuff. I thought she was just going to throw something at us and tell us to do it."

A number of Katherine's students were unclear about the agenda for learning and told me they really did not know what they were learning. Kara said she thought it had to do with "the basics...of dance. The two-meter and three-meter things that we did last week. And – I don't know really...I wish I was more clear." Alex thought she primarily learned coping skills for dealing with others:

> I don't think I've really learned anything about dancing in there...I've learned I have to get along with certain people in a group.... I guess it maybe teaches you how to cope with certain situations a little bit maybe.

The students in Marlene's and Abigail's classes did not speak much of learning about history and styles of dance; the curriculum these teachers had developed for Dance I focused on the elements of dance and the process of dance making; Dance II included a unit on dance history. One student indicated a desire to learn more about "famous choreographers and dancers...their names come up a lot, but nobody really knows who they are." Others, with the exception of Bridget, indicated a sense of satisfaction with their learning and an ability to articulate that learning more clearly than did Katherine's students.

As teachers, Abigail and Marlene followed a similar format. They began their classes with a warmup that emphasized technical skills and usually included some improvisation as well. They picked out certain aspects of the warmup each time, elaborating on the concepts underlying the skills and allowing time for work on them. The warmup was often connected to the concepts in the rest of the class, which emphasized movement elements and the crafts of improvisation and choreography.

Their students spoke in some detail of learning about the material of movement. Michelle said she learned "the basic parts of dance...about phrases, about making up different combinations, about words that have to do with dancing, things that make you feel a certain way...the structure of dance." Kylie added that she had learned "different movements, like impulse movements...different ways of warming up, using all parts of your body, and...using sound...you get to make a sound and move your body the way a sound is moving."

Francesca echoed others when she told me, "I've learned how to keep...a good focus – that's the best thing." Kristen added, "I'm learning that there's other things in dance besides, you know, just steps...she's talking about taking abstract ideas and making it into a dance." Madeline told me,

> Before, I knew how to make up a dance, but I didn't know what I was doing...I can choreograph a lot better because now we've learned about breath phrases and types of movement...especially sustained movement and percussive.... When I first started dancing I'd get out of breath...and now it's easier to breathe 'cause you can set yourself up how to do it, and I sort of learned how to do that in Dance I. And I also learned how to be more aware of my body all the time.

Amanda described how her teacher, Abigail, individualized learning:

> She wants us to learn what we don't know...she goes to each one of us individually... she'll pick out what we're not good at and help us with that. (She is also teaching) the feeling, and she's trying to get us to understand the motivation for dance, like, it doesn't come from the music, and it doesn't come from this neat move you saw, but it comes from what you feel.

Britain indicated aspects of learning that might be referred to as "dance appreciation" or "dance criticism":

I used to think, you go see ballet, it's all boring and everything – [but] I liked it. I wanted to go again. I've been learning…about the different things in movement…when we had our performance, if I had looked at it, maybe last year sometime, I wouldn't have known anything about focus, or…extension or that kind of stuff. When I was watching, I was sort of criticizing in my head: "They're not holding that focus." I was thinking about all of those things I could see…. We're learning to appreciate dance…we always watch videotapes…I would never have sat down and watched…that kind of show.

Kyteler spoke of learning dance theory. She had a much longer list, however, of what she was learning:

I've learned technique. And I've learned that I can do a lot more things than I give myself credit for. I've learned that I'm a lot more flexible than I thought I was. I've learned that I can take the lead in making things. I've learned that I like doing things like this. I've learned that I can take what I've learned in dance and apply it to other things – say, psychology. I've learned that I can work well with people that I don't know very well. I've learned that sweat won't kill you…I've learned that I do live inside these bones and skin and I can make them work for me, and I can use them in various ways, and I'd like to explore these ways more thoroughly.

It was clear from observing the classes that the students had developed skills in dance technique and choreography. But they also spoke of aspects of their learning that went far beyond this:

Afrika: You're learning a lot about your body and a lot about your inner self, how you feel…you're learning to observe things more clearly, like maybe the pages of a book waving when the air is blowing on it…. It gives you a whole 'nother way of mind, a whole 'nother way of thinking.

K. G.: Before Dance I, you kind of look at everything…the same…But dance kind of puts in, like a skip and a heartbeat.

Kristen: She's teaching us how to be ourselves, how to…let go sometimes, and just – give everything you've got, instead of keeping it all within yourself…how to work with others…and have patience…and understanding, cooperation–things you can't get in world history.

Dionne: It kind of helps in everything 'cause I learn how to concentrate and focus – even like focusing more in class when the teacher tells you…I probably learn how to work with others, too…. [Dance] kind of helps you find yourself.

Michelle: It makes you aware of different things, and it opens up your mind.

Denise: I'm learning to be more myself.

Annika: (We're learning) self-control, understanding of (our) bodies, understanding (our)selves, trying to figure out what (we) think. She's teaching us structure – we have to dress out, we have to memorize the sequence of events in dancing and warmups.

Damien indicated that he felt responsible for his own learning in the class: "What I've learned has not been from the teacher, but from what I've got out of it myself, I mean from dancing…it's discipline, it's not just go crazy." He added, "I think it's more educational than any class you could ever take."

17.5 Assigning Value and Significance

The students seemed to be telling me that some things had happened for them in dance class that were for the most part not happening elsewhere at school – things that sounded pretty important, even life changing, to me. But I was surprised to hear that the students did not seem to value these things as highly as I would have expected. As they spoke to me of school, of their lives, and of their thoughts about the future, I began to realize how school fit into their lives; with few exceptions, dance in school was assimilated into this view. Although students experienced school as boring and largely meaningless to their present lives except for contact with friends, they believed it was essential to their future. As Kristen told me, "You have to go to school 'cause you want to be somebody." Bridget said she returned to school because she did not want to be flipping hamburgers for the rest of her life.

There seemed to be three basic ways school prepared students for the future. The first had to do with the most basic, functional life needs, which could probably be fulfilled by math and English classes below the high school level. As John said,

English…you need to know how to talk and read and stuff. Math, when you get older you have to pay bills and stuff. You need to know how to add and subtract and divide and all that stuff. And when you start paying taxes, you have to know how to add up things and subtract stuff.

To college-bound students, courses required for college also held value, even if they were not appreciated or enjoyed. Janet said math is "like, in your future. Dance is not really in your future…it's not like you're going to have to take it in college." Courses were also valued if they were connected to a student's career plans. Toba, for example, commented that the arts are "not essential…you're just taking them for your spare time…unless you really want to be a dancer or a musician."

Students take most courses because they are required either for graduation or college admission, although they do not think that all of these should be required; they had difficulty seeing why they "needed" many of the courses they took in high school. Britain told me that many students "feel their time is wasted…like taking math, when you don't want to have anything to do with it in your own profession… going through all those different classes of what they really don't need."

Electives seemed to fill one of three roles: career exploration/preparation, personal interest, or fun and relaxation. When I asked Annika if taking dance would make any difference in her life, she said, "Who knows? I could grow up to be a famous actor or a dancer." To a similar question, Stephanie replied, "I'm not sure – can you get a dance degree or can we graduate from dance?"

Personal interest was mentioned frequently as the major reason one should take dance and lack of it cited as a reason not to require dance. A typical comment was heard from Sunshine: "Some students just aren't into dancing…Some people never

dance a day of their lives and might not care about it." Afrika said that the arts "are important to me. But then again, to others, they may not think so. [Other courses] are more basic." And Michelle concluded, "I think it just depends on what you're into...I'm sure there's somebody interested in it in every school."

Some students indicated that they took dance not only for personal interest, but because it gave them a chance to have fun and relax. As Sandy said, "You've got to have fun sometime." John gave a traditional explanation of fun in dance: "I talk more. And just act sillier than in a regular class." For most students, however, when I probed what they meant by "fun," I received responses of more depth than one would ordinarily expect. Several connected fun with learning. Many students told me that dance was fun because it was "new and different." Stephanie commented, "I've never done a chair dance, and it's fun. But it's hard.... It was fun. It was different." K. G. said that what makes dance fun is

the people, I guess...just to be able to be there and to be able to do the work together, as a group, and to be able to produce something from nothing, is, you know, really a lot of fun. To be able to choreograph your own thing and feel it, take...nothing and turn it into a performance. That's really fun.

Relaxation was mentioned particularly by students in higher-track academic classes. Afrika spoke of relaxation, but learning was not excluded: "Dance is a way for me to relax...forget chemistry for a while, forget algebra – you know, it's a learning process for me. I get to do something new, something different." Stephanie said that dance is "just a way for me to relax and calm down from the day...get all your tension off." Without electives, she felt "people would be so tensed up that they wouldn't be able to do really good in academic subjects."

I had expected to find that students might not value dance as highly as courses they saw as more difficult. Most students told me they worked as hard in dance as they did in other courses. Some, like Francesca, indicated they worked harder in dance: "If you go into world geography and you come out, you can get an A, but you have to work in dance." Only a few made an admission like Britain's: "Other subjects are a little harder...'cause if you study, maybe it (doesn't) stick." They also did not seem to particularly value other courses that were harder, and most indicated that dance would be less appealing if it required more reading and writing. John revealed this clearly when he noted, "I don't think anybody would take it if they knew they were going to have to write a lot of papers and study a lot. They'd probably take an easier subject."

Several students noted that dance contributed to their fitness and a positive sense of their bodies. Kylie commented, "It's better than...being a couch potato." Francesca added, "It makes me feel better about myself...I feel more – exercised, and healthier." According to Alex, "It teaches you coordination, and you're more at ease with your body." And Madeline elaborated, "How are you going to be well-rounded if you don't know what your body is?...You have to live in your body, but you don't have to live in your English book or your math book...or whatever."

Only a few students indicated that they valued education in the broader sense of the liberal arts. Afrika thought that dance classes would "broaden people's minds."

Alex noted that "just to learn anything cultural like that is going to make a difference." But a number of students indicated that dance would make or had made a difference in their lives in other ways. Amanda said, "I don't tend to get as embarrassed about things as I used to." Mercedes added, "I've learned to accept people for who they are and not what grade they're in. And I'm easier to work with now. I used to be…real stubborn…taking dance, I think I grew up." Francesca thought dance would help her in her goal of being a lawyer: "It's shown me how to…really get along with other people and it takes more than one person to achieve a goal." She also stated that working hard in dance was good preparation: "I'm going to have to work the hardest that I can to defend them." Britain thought dance would help her be a better psychiatrist: "It may make me more sensitive, I think. You know, it just does that. It makes you more aware of feelings and emotions." Lynette also saw a broader application: "You know more about yourself and the things that you can do…The things you thought you could do, you can do if you put your mind to it." And Brittany added that dance had made a difference in

> caring and how you feel about people…my mom and my boyfriend…have seen a difference in me since I was in dance, 'cause I'm more caring; I cared, but now I see how their feelings are, and I try to help them and stuff.

17.6 Discussion

The words of the students raise many interconnected issues for me as an arts educator and a teacher educator. For purposes of discussion, I will address them in two sections: issues having to do with the theme of relationship and broader issues having to do with how students construct meaning and value from their educational experiences.

17.6.1 Relationship

Clearly students expect caring in their relationships with peers and faculty at school, even though their expectations are frequently not met, especially with regard to teacher-student relationships. It is not surprising to hear young people, particularly young women, speak of the importance of caring relationships; this is consistent with literature on how women view the world and how they learn (Belenky et al. 1986; Gilligan et al. 1990). However, the students' perception of uncaring teachers (many of whom are also women) is worth further reflection. I do not think that teachers are, as a group, less caring than others; an empirical study might even find the opposite to be true. But, as a few of the students seemed to recognize, the structure of teaching in public schools can keep teachers from being able to show they care. Grumet (1988) has pointed out how women teachers become socialized into a

patriarchal institution that expects them to respond to children in a detached way, rather than as parents would to their own children. Further, large classes, alienated and disruptive students, and bureaucratic pressures can keep teachers from being able to respond to the many needs – both personal and academic – of students. Gilligan (1982), in her study of moral development among women, described the ethic of care as "helping someone when you can"; the highest level of ethical development occurred not when women sacrificed themselves to care for others, but when they included themselves in the ones to be cared for. However, a teacher with 150 or more students a day cannot provide active caring for very many of them, especially if that teacher is also caring for his or her own needs. Freedman's 1990 account of the life of a gifted and compassionate teacher who ends up leaving the profession makes this dilemma particularly apparent.

Nel Noddings, in her 1984 book *Caring*, also affirms the importance of caring for self. For Noddings, caring involves engrossment in the other – feeling as nearly as possible what the other feels – and then acting as though in one's own behalf, but on behalf of the other. She points out that caring involves receptivity, relatedness, and responsiveness, and that there is an important difference between caring-for and caring-about. The latter is an abstract feeling that does not require a response to an individual. She notes that, in an increasingly complex world, thoughtful persons may reduce their contacts so that caring-for does not deteriorate to caring-about. Noddings advocates a reorganization of schools to make them smaller, with more long term student-teacher relationships, to facilitate caring. Noddings believes that ethical caring is rooted in natural caring and states that caring derives from the "language of the mother" (p. 1), a feeling-level responsiveness of mother to infant. While Noddings's work has been criticized for its reliance on the traditional nuclear family, as exemplified by the (white) mother, father, and child on the cover of the book, I found that my students, too, seemed to associate caring with a sense of family when they referred to their dance classes as feeling like a family. The small size of the dance classes facilitated this. Such small classes will likely be increasingly rare as budget pressures continue to escalate. One could more easily accept their loss as a simple financial reality if students received the care they needed elsewhere; the stories of my respondents made it abundantly clear that they did not.

I find it noteworthy that the recent efforts at school reform have largely left out the relational aspects of schooling. Teachers are criticized for not knowing their content well enough or for not being smart enough to earn high test scores; remedies include requirements for second academic majors and higher scores. I wonder if any teacher education programs require a course in how to care. Perhaps we assume that caring, like enthusiasm, cannot be taught. Yet the words of my respondents, speaking over and over of the importance of caring in helping them learn, indicate that it is too important to be left to chance. One might also consider the importance of caring even if it did not lead to higher levels of academic learning; surely it has something to do with teaching students how to live in a shared world.

17.6.2 The Construction of Meaning and Value

As I read the words of the students again and again, I am struck by the reasonableness of what they are asking for:

- To be stimulated, to learn;
- To have a sense of meaning in what they are being taught;
- To be treated with understanding – to be cared for; and
- To be able to be themselves. This involves both security (being accepted as they ought to be in their own family) and freedom (to express themselves).

It certainly is easy to be critical of adolescents who seem to want rewards without working for them, or freedom without responsibility. It is also easy to be critical of young people who were raised on "Sesame Street" and seek to be constantly entertained. But in dance class, at least, most students found pleasure in working hard and being fully engaged in active learning because the conditions listed above were largely met. And they claimed to be bored only by the sort of teaching techniques that most of us would find soporific, or by not learning anything, or by not seeing any purpose in what they are being asked to learn. The students' expectations seem reasonable unless, as some theorists (for example, Shapiro 1990) point out, schooling is designed to prepare them for a future world of work in which they will have to passively accept boring tasks and trivial rules for no purpose other than a paycheck. Although students did not indicate that they expect this kind of future, they did reveal a paradox when they said the experiences they found personally meaningful and valuable were not necessarily what they saw as important in terms of their future. John Goodlad noted in a 1984 study that students seemed to have accepted the overwhelming passivity of their school experience. Similarly, my respondents implied a belief that school is a means to an end, something to be wearily tolerated for 13 years in order to get a payoff. Although they would like it to be more pleasant, they are, for the most part, not questioning their underlying belief about the purpose of schooling. When they have drastically different experiences, such as in dance class, they seem to separate the experience from the rest of school. Dance class and other personally meaningful activities become a temporary escape, allowing them to tolerate the rest of their hours in school. Several said that cutting out electives like dance would lead to more dropouts.

Much of the current reform in arts education is directed at helping the arts become part of the core curriculum. Some arts education leaders (Eisner 1988; Getty Center 1985; National Endowment for the Arts 1988) have suggested that the arts still remain on the periphery of education because they are viewed as mostly affective, and that one solution is to focus more on the disciplines of art history, criticism, and aesthetics, and less on production or creating. However, the students in my study spoke most powerfully and passionately when they spoke of learning

which, while it took place in the context of dance education, went far beyond these disciplines. They spoke of enhanced understanding of self, perception of the world, and ability to respond to others – things that largely were not happening in more "academic" or discipline-based courses.

Making the arts more like other academic subjects will not make them appear more valuable to students, and probably not to parents or teachers either. This is not only because of the way other subjects are taught, but because of the prevailing view that the major purpose for high school is career training or preparation for college-level career training. Students found little long-term value in other academic classes if they did not fit these purposes; for example, few saw the value of science courses unless one intended a career in science. Even if dance educators make sure that students learn about dance-related careers, few students will find the pragmatic value they think school is about; there are not that many jobs in dance.

17.7 Conclusions

It is tempting to close without offering any practical suggestions for school reform; it would also be appropriate. After all, interpretive research offers us insights into problems, not answers to them. However, the students in my study spoke to me too strongly for me to retreat back into academia without noting the implications of the study for school reform, however partial and incomplete they might be.

It is clear that caring teachers, small classes with a sense of family, and active, hands-on learning are necessary, though not necessarily sufficient, for students to care enough to learn. These factors ought to be relatively easy to accomplish; in fact, they characterize a number of experimental and alternative schools around the country. One cannot help wonder why they are not more highly cultivated if schools really do seek to increase student engagement.

Other implications of the research are more complex, arising from the indication that students do not always see as important those courses that they find personally satisfying. Students seem to believe the pervasive societal message that high school is about job preparation. However, this effectively leaves out of their value system those courses that they do not see as related to this end; it also creates problems for those students who do not know what kind of job they want, or who cannot find in their school the job preparation they seek. I see several possible responses for educators:

- Keep trying to convince students that their career might require all those courses we want them to take (for example, lawyers also need calculus because…). So far this approach has not been very successful.
- Allow students to take only those courses they want to take, ones they see as valuable or interesting or fun, and assume they will take others in the future when they see the point. While this seems to be what students want and would eliminate most of the disruptive students, it would require a significant degree of trust in students; most educators and others with a stake in schools would probably not be willing to take the risk.

- Change the way students think about the purpose of school – which means changing the way all of us, including educators, administrators, politicians, business people – think about school and its value in the life of an individual and a community. For example, we might also think about schools as experimental communities of people engaged in learning, working, playing and relaxing, exploring what it means to live a human life and how we should live together. These issues were first suggested to me by curriculum theorist James B. Macdonald (1977), who said two questions ought to be central in education: What does it mean to be human? How shall we live together?

It is clear to me that one aspect of being human is the capacity to examine our lives and seek meaning. How long should people postpone their desire for a life of meaning? Until high school graduation? Until college graduation? Until retirement? Or should education be linked to living a meaningful and satisfying life, of which meaningful and satisfying work is one, but not the only, part? How can both school and work be made more meaningful and satisfying for people, with intrinsic as well as extrinsic value?

The voices of my respondents have not only given me new insights but raised significant questions for me in my roles as an educator, teacher educator, mother, and citizen. I come away not with definitive answers, but with appreciation for the students who raised them for me, and affirmation of the value of bringing the voices of young people into public and professional discourse on education.

Appendix

Sample Questions Used to Structure Student Interviews

Why did you sign up for Dance I?

What did you expect it would be like? Has it been what you expected?

Can you remember back to the first day or week of dance and what thoughts/feelings you had about it then? How do you feel about it now?

How is it like and different from other classes you have at school? Are you learning anything? What are you learning?

Is there anything about the class you'd like to be different?

Talk to me about how [your dance teacher] is like and different from other teachers at school.

If the principal came down and said to [your teacher], "What are you teaching these kids, anyway?" how do you think she might respond?

What do your friends have to say about your taking dance?

What was the response of your parents to your taking Dance I? Tell me about your family.

What are your plans for after high school? Do you plan to take more dance?

Will it make/has it made any difference in your life, that you've taken this course?

Do you have a favorite experience from Dance I? A least favorite? What has been hardest about Dance I? What has been easiest?

I'm sure you're aware of the concern in our state about low SAT scores. Lots of
people have been making suggestions about how to help. One of them is that
school should consist only of courses like English and math and science, and
electives like dance should meet after school; what do you think of that idea?
Another suggestion is that arts courses should be more like other courses, with
more reading and writing in them; what do you think?
Is there anything else you could tell me that would help me understand what Dance
I means to you?

Commentary

In beginning this work as a newly-tenured faculty member, I could afford to tackle
a project that would take longer for completion. It was logical that I focus on stu-
dents studying dance in schools, since teacher education was the focus of my teach-
ing. Having received some modest funding for the previous study, I again applied
for University funding to cover the cost of interview transcription. When I met with
the Provost who rejected the committee recommendation (thus denying funding),
his disdainful comment was, "How can you learn anything from a bunch of high
school students?" My efforts to educate him about methods considered appropriate
for educational research were not successful. This denial, however, turned out to be
a blessing in disguise. I found that typing my own transcripts provided an opportu-
nity for repeated deep listening to the voices of my informants.

Another interesting side-story related to this chapter happened when I presented
a portion of this research on a panel at AERA. Because time was limited, I decided
to focus on the data analysis and discussion dealing with the theme of relationship.
The renowned scholar who served as discussant for this session was similarly dis-
dainful of my work, not due to its methodology but because it focused on the affec-
tive dimensions of learning. This was an attitude I had met elsewhere, and it
emphasized the perspective that efforts to achieve status for arts education in schools
needed to focus on the cognitive.

These two incidents helped me realize that I was, in some ways, at least, operating
from the margins as a researcher.

References

Belenky, M. F., Clinchy, B. M., Goldberg, N. R., & Tarule, J. M. (1986). *Women's ways of knowing:
The development of self, voice, and mind*. New York: Basic Books.
Donmoyer, R. (1985, April). *Distinguishing between scientific and humanities-based approaches
to qualitative research: A matter of purpose*. Paper presented at annual meeting of the American
Educational Research Association, Chicago.
Donmoyer, R. (1990). Generalizability and the single case study. In E. Eisner & A. Peshkin (Eds.),
Qualitative inquiry in education: The continuing debate (pp. 175–200). New York: Teachers
College Press.

Eisner, E. (1988). *The role of Discipline-Based Art Education in America's schools*. Los Angeles: Getty Center for Education in the Arts.

Freedman, S. G. (1990). *Small victories: The real world of a teacher, her students, and their high school*. New York: Harper & Row.

Getty Center for Education in the Arts. (1985). *Beyond creating: The place for art in America's schools*. Los Angeles: J. Paul Getty Trust.

Gilligan, C. (1982). *In a different voice: Psychological theory and women's development*. Cambridge, MA: Harvard University Press.

Gilligan, C., Lyons, N. P., & Hanmer, T. J. (Eds.). (1990). *Making connections: The relational worlds of adolescent girls at Emma Willard School*. Cambridge, MA: Harvard University Press.

Goodlad, J. I. (1984). *A place called school: Prospects for the future*. New York: McGraw-Hill.

Grumet, M. R. (1988). *Bitter milk: Women and teaching*. Amherst: University of Massachusetts Press.

Macdonald, J. B. (1977). Value bases and issues for curriculum. In A. Molnar & J. Zahorik (Eds.), *Curriculum theory* (pp. 10–21). Washington, DC: Association for Supervision and Curriculum Development.

National Endowment for the Arts. (1988). *Toward civilization: A report on arts education*. Washington, DC: National Endowment for the Arts.

Noddings, N. (1984). *Caring: A feminine approach to ethics and moral education*. Berkeley: University of California Press.

Shapiro, S. (1990). *Between capitalism and democracy: Educational policy and the crisis of the welfare state*. Westport: Bergin & Garvey.

van Manen, M. (1991). *The tact of teaching: Meaning of pedagogical thoughtfulness*. Albany: State University of New York Press.

Chapter 18
A Question of Fun: Adolescent Engagement in Dance Education (1997)

Susan W. Stinson

Abstract This interpretive inquiry explores questions of engagement in dance among middle school dance students. The researcher conducted field research at three different schools in classes taught by three teachers. Primary analysis for this paper has focused on data from interviews with the 52 students who close to partici- pate and returned signed consent forms. The words most frequently used by the students to describe their dance classes as well as particular experiences within them was *fun*, although they used the term to refer to very different kinds of experi- ences. In addition to the conventional meaning ("playing around" with no goals), students specifically referred to the social, creative, novel, and physical aspects of dance as fun; many also referred to learning as fun, and noted the role of the teacher in making it so. Not all students found dance fun; almost all who did not were located at the only one of the three schools where there were many students, almost all of them African–American, not participating on a regular basis. Students who did not participate fully sometimes blamed the (white) teacher, or the choice of activity or music, but often the reason came from within themselves: Either they were tired or not feeling well, or "just [didn't] feel like it." Other values some students found in dance included stress release, focus and concentration, self- expression, self-esteem, freedom, and transcendence.

In interpreting the findings, the researcher draws from a triangular model pro- posed by Hirschman (1983) to better understand the different kinds of experiences reported by the students. She also probes and problematizes her own contradictory feelings about fun and draws implications for teaching dance to young people.

Ever since the publication of *A Nation at Risk* (National Commission on Excellence in Education 1983), educational literature and the popular press have been filled with concern over low achievement levels among students in this country. One of the more recent responses has been the development of rigorous national standards, including standards in all the arts (*National Standards for Arts Education* 1994). At the same time, there is recognition that far too many students are not motivated to meet even existing standards. The September 1995 issue of *Educational Leadership*, a publication whose themes reflect issues of current significance to public school administrators, was devoted to strengthening student engagement. Editor Ron Brandt

© Springer International Publishing Switzerland 2016 243
S.W. Stinson, *Embodied Curriculum Theory and Research in Arts Education*,
Landscapes: the Arts, Aesthetics, and Education 17,
DOI 10.1007/978-3-319-20786-5_18

opened the issue with a description that is familiar to almost anyone who walks into a typical high school class in any community:

> Some [students] see no connection whatever between their priorities and what teachers expect of them, so they refuse lessons and even refuse to try. Others realize they must play the game, but go through the motions with minimal attachment to what they are supposedly learning. Teachers, thwarted by resistance or passivity, complain that students are unmotivated, and either search valiantly for novel approaches or resign themselves to routines they no longer expect to be productive. (1995, p. 7)

Certainly this dismal picture does not apply to young children, who arrive so eager to learn in kindergarten. It is reasonable to ask what happens to children, especially as they move through adolescence, to leave so many so unmotivated and disengaged.

Howard Gardner's response to educational reform in the 1980s speaks to the importance of engagement:

> Almost everybody realizes that the American schools have been disappointing in recent years. But I think most of the reactions to this concern will not be very productive in the long term. Getting higher scores on standardized tests is not the real need.... What we need in America is for students to get more deeply interested in things, more involved in them, more engaged in wanting to know; to have projects they can get excited about and work on over longer periods of time; to be stimulated; to find things out on their own. (in Brandt 1987/1988, p. 33)

Gardner further suggests that "the arts are a good testing ground for such activities because many members of the educational establishment don't care about them so much, so teachers can afford to take chances" (in Brandt 1987/1988, p. 33).

This study examines engagement in one particular art form, dance. The study looks at middle school students, in those critical years between the time when most are eager-to-learn elementary students and the time when many become passive or resistant high school students. It seeks to understand what, from the perspective of the students themselves, draws them into dance, i.e., why some students are so engaged, and others not.

18.1 Procedures and Methodology

I began this study with some of the classic questions for interpretive researchers:

> What's going on here?
> What does the experience of the participants mean to them?
> What do their meanings mean to me as researcher?

18.1.1 Procedures

I selected three middle schools as the site for the study, all on the outskirts of a medium-sized southeastern city. I knew all three teachers well prior to the study. All three were Euro-American, and their ages ranged from mid-20s to near 40. Following

procedures used in my earlier study of meaning in dance among high school dance students (Stinson 1993), I functioned as a participant observer in one class each week throughout the term (Classes were held 4–5 days per week). I participated in all class activities on the days I was present; while I was clearly not a peer age-wise, I worked both individually and in small groups along with the students. At the end of the term, I interviewed all students who were willing and who were able to obtain a parental signature and return the form. The participant observation time was not only to allow me to observe interaction in the class, but to gain sufficient trust from the students so they would be more likely to talk with me in the interviews. I interviewed 52 students in 48 individual interviews and one group interview. At the beginning of each interview, I guaranteed student anonymity and asked each to select a name by which I could refer to them in the research; all names used in this paper are pseudonyms. The data consist of extensive field notes, documents such as examinations and class handouts, and transcripts of the interviews. Primary analysis for this paper has focused on the interview data.

In spring 1993 I began my study in one private school and one public school. The public school, which I shall call Johnston, served sixth- to eighth-grade students, with a socio economic range from middle class to welfare. I worked with one relatively large and crowded sixth-grade class (8-week course) and one small eighth-grade class (full semester course). The private school, Greenway, served pre-school through grade 12. It was known as an alternative school within the community, partly because of its informality, thematic courses, and opportunities for student choices and decision making. The clientele was largely white, and most students were from professional families. The middle school at Greenway incorporated fifth to eighth grades. The first course in which I participated included all these grades, while the second course included only fifth-and sixth-grade students; each lasted eight weeks. Student engagement (or lack of it) did not catch my attention as I observed during this semester. At Johnston, almost all students participated fully. At Greenway, all students participated fully in every class; this was an expectation if they were to be allowed to take the course. The following year, I participated in one seventh- and one eighth-grade class (each a full semester) at a third school, which I shall call Lewisburg. Both of these classes, approximately 17–18 students each, filled their space in a portable building to capacity. The school drew from a more rural and somewhat less affluent population than Johnston, and had a higher proportion of minority students. In the classes at Lewisburg, a large number of students were to be found sitting out during all or part of each class, and there were many instances of students appearing to go through the motions (or some of the motions) without much investment. This seemed the case not just in dance, but in other classes as well. It was at this point that I began to focus on the issue of student engagement. In the interviews with these students, I added queries about what, in the students' views, affected their participation and that of their peers.

At all three schools, dance was officially an elective course, although at the public schools a number of the students (especially males) were placed in the class because their other choices were full. The public school teachers followed a relatively standard program specified by the state. The majority of classes revealed a

typical format with a warmup, then an introduction to one or more conceptual elements of dance, followed by some guided and open exploration, and group composition projects. During the semesters I observed, there were also units ranging from dance history to African dance. Students did some note taking, took some written tests, and watched some videos.

At Greenway, the first course involved developing a lecture-demonstration performance for younger students at the school, while the second was the introductory dance course for middle school students. The first course was open to all who had had the introductory course a previous year. The introductory course included more work on basic movement skills (developmentally appropriate technique) than at the other schools; it also focused more on the process of dance making than on specific elements of movement, although basic elements were infused into the assignments given. Students spent extended time creating "air mail dances" and "radio dances" in the fashion of choreographer Remy Charlip[1]; they interpreted Charlip's symbols to create their own dances and created their own symbols to be interpreted by others.

18.1.2 Methodology

One might hypothesize that the differences in engagement that I observed were related to different demographics at the schools or within the classes I observed, or to the different styles of the teachers, or to different lesson content. One might attempt an experimental study in order to prove what causes different levels of student engagement in dance. Such a study might generate information that would facilitate prediction or control of student outcomes, allowing teachers to, for example, select strategies and activities that would have the best chance of promoting student engagement among the demographic population they were teaching. However, there are many complex factors involved in the teaching/learning process. In such a dynamic situation as a real dance classroom, it is not possible to accurately identify all the variables affecting student engagement and then control all but one or two, even for the sake of an empirical study. Further, standardizing class instruction to the degree necessary for control of a single variable would not allow for the responsiveness to students and the environment that is an essential aspect of good teaching.

Certainly I, as an educator of dance teachers, often engage in attempts to predict or control student outcomes. In this study, however, I was more interested in how diverse students describe their dance experiences, and what that might tell me as an educator about student engagement in dance. Such responses are best facilitated by an interpretive methodology. Interpretive research is concerned with questions of meaning rather than truth, with developing a language rather than proving or disproving a hypothesis (Donmoyer 1985). I was interested in understanding and finding a

[1] See http://www.remycharlip.org/mobi/index.php?p=39

way to talk about student engagement, grounded in the perceptions of the students themselves, rather than what I already knew and told student teachers about how to get students engaged.

For those readers more familiar with traditional scientific research, questions about objectivity, reliability, validity, and generalization may arise. The interpretive researcher recognizes that the presence of a researcher does change the research setting, despite attempts to be as unobtrusive as possible. However, the interpretive researcher has a responsibility to reflect upon how his/her own perspective might be affecting what is sought and what is found. Throughout the stages of observation, interview, and analysis, I have intentionally questioned my own assumptions and looked for discrepant cases that would counter my initial interpretations.

However, subjectivity is not regarded as just an unfortunate necessity in interpretive research. There is also appreciation for the perspective that each participant brings to the research process. Thus I did not attempt to standardize the interviews for the sake of objectivity by asking the exact same questions the exact same way in each interview, but tried to be an actively engaged listener (Oakley 1981), allowing each student to place her/his own frame around the experience (sample questions are in Appendix 1).

In interpretive research, it is recognized that meaning is not a fixed entity which is only waiting to be uncovered by the diligent researcher; rather, it is constantly in the process of being created. Since it is never complete, one can never have it all, regardless of how many classes one observes or how many interviews one conducts with how many individuals. While I tried to interview as many different kinds of students as possible, there are students whose voices I did not hear. For example, in the sixth-grade class at Johnston, none of the African American students wanted to be interviewed, despite my greater interaction with them during the class. In contrast, African American students were overrepresented, compared to the class makeup, in the seventh-grade interviews at Lewisburg (demographic composition of those interviewed at each school may be found in Appendix 2). Further, the students I did interview might well have had very different stories to tell if I had spoken with them a day, a week, or a month later. My understanding of the "whole picture" of student engagement in dance is only partial, and could never be otherwise. It is only one possible interpretation, based on not only what I observed and heard but also what I as researcher brought to the research. It is my hope that the reader will find my interpretation to be a reasonable one, supported by the statements of participants, and that it will be useful, i.e., generate thoughtful questioning and reflection on the part of the reader.

Despite the fairly large number of students I interviewed, I have not attempted to quantify any of the data. While I have indicated at times that "many" or "several" students had a particular response, I was as interested in a comment made by only one student as I was in a view shared by many. As Mihaly Csikszentmihalyi and Reed Larson noted in their study of adolescents,

> If one boy out of a hundred finds a way to get along splendidly with his parents, this is something that hardly warrants mention in a statistical description of what teenagers are like. But this one-in-one-hundred finding can be the most important fact if we wish to

understand what adolescence *could* [my emphasis] be like. So…we are not only concerned with proportions and averages; perhaps the most telling insight on this age of transition comes from persons and events that show how, despite widespread confusion or boredom, it is possible to create enjoyment and meaning. (1984, p. xv)

In the next section of this paper I shall discuss the primary themes I identified related to the issue of student engagement. In support of each, I will present a few quotes from the students. In most cases, I had a very large number from which to choose – so many, in fact, that I was at times tempted to look more quantitatively at the interviews, and record how many students spoke about the topic. However, in keeping with my methodological orientation and ultimate purpose, I selected those statements from students that I found the "juiciest," i.e., those most colorful, complex, and well stated.

18.2 Analysis of Findings

It is noteworthy that the word most often used by the students to describe their dance classes as well as particular experiences within them was *fun*. While I did not specifically ask them if dance was fun or even if they liked dance, I followed up when they mentioned fun, trying to understand what it meant to them. It became clear that the word is used in many different ways. Some could not say what it meant: "It's just real fun to do stuff like that and I'm not real sure how to explain it" (Nike); "It's hard to put it in words" (Charlotte). But others gave me a clearer sense of what fun means to them when they told me why dance was (or was not) fun.

18.2.1 The Meaning of Fun

A few students spoke of fun in the way I think most adults think about the word, using it to describe activities that do not really matter, that are "just for fun." I heard only a few comments from students that reinforced this view of fun. Rebecca, for example, told me that her parents wanted her to take dance so she "could like just have fun and…not do a whole lot of work but just dance and everything." Nicole described herself as "a wild kid…I like to have fun a lot." Shelby, who did not appear wild in class, said dance is "fun, sometimes boring, I mean you can act crazy."

Other students had a more serious notion about what happens and should happen in dance. Bobby noted that dance is "funner but it's not that you go in there and just play around." Bill concurred, stating that "some people just want to play in dance, but for me and the rest of them that want to participate we really get into the movements." Lavena expressed the more common adult values when she noted her lack of respect for her peers who "joke around too much…and sometimes they just want to have fun, fun, fun and never want to be serious about anything. Sometimes you

have to grow up…all that fooling around is not going to get you anywhere." Fun in general, however, was not a negative descriptor to most middle school students with whom I spoke, and they were able to tell me a variety of reasons that dance was fun. The order in which I report these reasons does not reflect any priorities or the frequency with which they were mentioned, and the categories in which I have placed their comments are my creation.

18.2.2 Fun as Social Interaction

To some students, activities are fun when they get to interact with their friends; these responses were especially prevalent among the seventh and eighth graders. Sweet R, who said she did not find dance fun, told me, "Fun is like when you happy that you're doing something, like when you happy to be around that person." Rene said that dance is "just funner than my other classes 'cause I get to socialize with my friends." Lana explained that if her peers "get to work with at least one of their friends I think they'll have fun or something." Alyssa told me that she and her good friends in the class get together and "try to remember the dances together and we'll look over our notes and stuff together – it's fun. We talk about how fun it is and how fun it is to be with your friends." Cody, a sixth-grade boy, went a bit deeper: "You can really get more friends and you can also strengthen your friendship with people, because in dance…you have to have a lot of trust sometimes."

Not all students, however, found the social aspect of dance class to be a positive factor. Desiree related that "sometimes I have problems working with people, certain people that I don't get along with and you know I think I don't do my best when I'm with these people, makes me feel like I don't really want to be over here so I'm not going to do anything." Bill told me that his misbehavior in class the previous year came from wanting to impress his peers. He said that students did not participate fully "cause their friends laugh at them…'cause they might look funny, just because they're focused in on it and they're not, and they might be jealous of them is why they're laughing." In addition, some students pointed out that working in groups is sometimes problematic. Nike, from a class with many nonparticipants, noted that "when not everybody puts forth effort it's just real hard…and a lot of people don't care, they just sit there." Lavena, from the same school, explained that groups work only when "there's one person that doesn't fool around and everything so she like brings everybody together…. So if you have like one strong person you can make like anything happen."

Still, for many students, working with peers was an important part of fun in dance. Getting in groups, working together "to make up things," was mentioned as fun by a number of my respondents. As Rebecca noted, "I really like doing that – when you get in your groups and you just make up different things and go along with it and it's real fun." Joseph replied that what made dance fun was "getting to work with other people and…making up your own dances." "It's just fun working together trying to figure it out," said Jennifer. Lavena said she would tell other students that "they

should take dance because it's fun and you get to know a lot of people there and you can make up your own thing and you work with a lot of people there."

18.2.3 The Fun of "Making Up Stuff"

For a great many students, "Getting to make up stuff for yourself instead of what the teacher says to do" (Lana) is what makes something fun. Crystal added, "You just have to do what you want to do and have fun with the dances and I think the best part is getting to create your own dances." Tim concurred: "Just being able to practice and make up your own movements – that's a lot of fun." Jessica said her favorite experience was "making up the dances 'cause…I got to make up these moves and it was really fun…. because we could experiment with different ways of doing things and [the teacher] wasn't telling us exactly what we should do."

18.2.4 The Fun of Moving Around

In addition to the social and creative experiences, getting to "move around" also made dance fun for most students. Rebecca's statement about what makes dance fun combines these themes: "when you get to move around a lot and you don't have to sit there and you get to make up things and…you get to like be with other people and like have fun and make up things together and that's fun." Crystal said that dance is "more fun than anything else because you have to get in groups and work on things and you don't always have to sit in your seat and work on paperwork and stuff." Similarly, to Kim what makes something fun is "a lot of movement, not sitting around writing all the time." Agatha echoed that dance is "a fun class, 'cause you don't have to sit in desks and stuff, you just move around."

The importance of moving around was particularly mentioned by a number of boys in the study. Ravon expected dance to be fun " 'cause you get to move around in there instead of just sitting down and doing work all the time." Bobby spoke of dance as "just funner…'cause I like doing stuff, moving around." Similarly, Joseph said, "It's been a lot of fun and you could *do* a lot of things…I like to get up and *do* something once in a while." Sam added, "It's a really good break from sitting… you're just sitting in a desk all day, you want to get out and move around."

The movement in dance can also create a sense of aliveness that draws students out of the lethargy some described experiencing in school. Jennifer said dance is "just lots of movement and it gets you hyper and it's fun," and Nike replied, "It gets me worked up for the day and I just think it's fun." Lance described getting "pumped up" when really dancing, while Cody spoke of "getting out energy." Dare elaborated, "I'll be so hyper leaving, I'm just so jumpy, it's really wild, it's fun." Shelby noted that, in her other classes, "you get so tired sitting there, and once you go to dance, you're happy, hyper, stand up, do what you want."

Only Mike indicated that he preferred classes in which he got to sit and not move around. Even so, a number of students, mostly at one school, made the choice to "sit out" on a regular basis. I wondered why, if students like to move around, some preferred to just sit there. "Not feeling good" or being sick or tired were sometimes mentioned. After one teacher remarked that a number of her students did not get enough sleep, I asked Mike how late he usually stayed up. He admitted to staying up until "about 11:30 or something" and getting up "about 5:30 or 6." If his situation is as common as his teacher indicated, perhaps lethargy in class is no surprise.

In summary thus far, fun to most of these students meant to move around and do new things, to make up stuff and work with other people, even though there were some limitations to these factors. It does not seem remarkable that many students might like school better, i.e., find it more fun, if they could do these things in all classes. Certainly these aspects of dance education are the most obvious, and no surprise. Further factors, however, added complexity to my quest to understand student engagement in dance.

18.2.5 The Dance Teacher in Relation to Fun

Most of the students liked their dance teachers, and several said that the teacher "makes it fun" or "really wants us to have fun." My file on comments about the teachers was thick with statements about how their dance teachers were nicer than other teachers. There were, how ever, a few students who claimed that dance would have been fun if they had had a different teacher. With one exception, the few students who claimed to not like the teacher were all found in one class at the school where there was a good deal of non-participation.

18.2.6 Learning as Fun

A number of students mentioned fun in relationship to learning. Alyssa "thought it'd be pretty fun to learn how [to dance]." Bobby, while he had expected to "learn different dances so…if I went to a dance I could use it," thought there was status value in what he learned: "It's fun…you learn all this stuff…you can brag and say 'look what I learned' and your friends get all jealous and they want to take it too." Yelnik took responsibility for his learning:

> In dance I usually come to get out and learn a lot, but sometimes I just seem to get in one of those giggly moods, and that's harder to concentrate…but I don't learn as much from dance…it's not quite as much fun when I come out of dance class and I say, "Gee, I didn't learn too much today."

Agatha, a very committed and engaged eighth grader, gave a long list of what she had learned in dance that was fun, making clear that students sometimes mislearn as well:

> Right now we're doing dance history and so far we've done Isadora Duncan, and we're
> doing her dances right now, we're doing oh gosh, what was that person's name.... and we're
> just learning about how dance history really got started, how, you know, Agatha Christie
> came over to America, you know, to show them what she'd thought of – all the stuff she'd
> done. All the people thought that she was weird, and that they didn't like her or anything,
> you know they didn't understand her, but she was the real reason why modern dance got
> started in America.

This student was so attached to her misunderstanding that she chose the name
Agatha as her pseudonym.

18.2.7 Not Fun

It became clear to me that learning is fun to students only when they consider that
learning to be relevant. Some students, again all from the school where there were
many nonparticipants, revealed that they did not value what the teacher was teach-
ing. Rene was disappointed in her dance class because she had expected it would
include "dance contests and stuff." Kadijah complained that "you do stupid exer-
cises and stupid movements that don't make much sense." Kadijah indicated that, in
all her classes, she valued learning "stuff that you use in life." She also noted that in
her dance class, "we learn stuff about choreographing, but since I'm not a real cho-
reographer or dancer that doesn't really help me in any way." Kadijah and several of
her peers claimed that they did like to dance, the social dances or "street dancing"
that they did at parties with their African American friends. Audrey explained that
"street dancing is when you get wild and dancing [in class] is not the same.... not
like the same dances that we do."

To these students, the class was often "boring." Kadijah said she did not like
dance because "we do stuff that doesn't interest me." Audrey noted that "Some days
it be boring, some days it be fun...stuff the teachers do, some people don't want to
do it...if it's boring, we don't do nothing." The music choices contributed to this; to
this group of disaffected students, "It would be okay if she put on music that people
like," "the music that *we* [emphasis added] listen to all the time." Sweet R said,
"Some of her music is good, some of it is not, some of it is like old. I don't listen to
that kind of music and listen to rap, R and B and stuff like that."

I found it relevant that almost all of the students who complained about not liking
the class activities and the music were African American. During the semester I was
present at the school with the disaffected students, the curriculum included a unit on
African dance and a week's residency with an African American guest artist accom-
panied by African drummers, and the teacher made a conscious attempt to use jazz
and music by African American artists. This situation made clear the complexity of
multicultural issues faced even by well-meaning teachers.

It is interesting to look at the other reasons students gave for lack of participation
(other than not feeling well, not liking the teacher, and not liking the music and/or
the activities). Again, I brought up this topic explicitly only at Lewisburg, where
there were many students sitting out. One student spent most of her interview time

telling me about a fight with her best friend, which so upset her that she could not even consider participating at that point. As she went into a lengthy and emotional description of the incident, I was reminded that anything at school may seem irrelevant in comparison to personal crises in adolescence. Ravon said some times he was mad about events totally unrelated to class, and he used the time to sit and think about it. He described one time that the guest artist had come over and talked to him: "She…said I should get up and dance and said maybe it'll take my anger out by dancing." While he found that this approach was successful, he did not indicate that he tried it again.

One of the most prevalent views about why students did not participate placed responsibility on the students themselves. One category of students consisted of those who just were not interested in dance. Alyssa said class is "really fun if you like to dance." Mike thought his sister had liked her dance class and he and his brother did not like it because "She like to dance and we don't." Charlotte noted that, "If it's fun for me, it doesn't mean it's fun for you." Dance was an elective course at all three schools, which seemed to imply that only some students were expected to find it worth liking, worth choosing.

Another perspective on this issue came from those who placed blame on students for not participating. Nike said about such students,

> I don't think they care. I mean, some people just don't even like doing stuff…that makes them work…they'd rather sit around all day…I don't think it's fair towards [the teacher] or any of the other people that try to work I just don't think that they want to…put out all that energy…and would just rather sit there and talk, socialize with each other. People that do care I think they are working for something and they do want something out of life and the other ones just really don't care.

Nike noted that the teacher "doesn't give up…. she still makes them get up and do it, and even if they don't she still goes on…she just keeps working harder and harder."

Ravon, like most students at Lewisburg, said that he had no classes where everyone was involved: "Not even gym. They'll sit around and talk all day." When I asked if he thought teachers should do anything about it, he replied, "Let that be the choice of the students if they want to fail…they should just do what they want to do. They don't want to come to school to learn, just sit around all day." Interestingly, Ravon was one of the students who mostly sat around in dance.

Janelle thought students who do not participate are "just lazy," although she included her self in this category: "I don't like really do it…I do it and then I'll get lazy and I'll sit on the floor and start talking." I was surprised with her description of the kind of school she would like to go to: "The kids that goof off and got low, low grades, I'd put them on one side of the school and other kids that work and get high grades on another side of school." She said failure to learn is the fault of the students, "because their teachers try to teach…if they [the students] pay attention they'll know [what they should learn]." Similarly, Audrey said that people don't participate because "They lazy or they just don't want to do it," either because "they don't want to learn or they just want to be in the same grade again."

Nicole was another student who said about herself, "I don't like to participate that much. Sometimes I'm just shy…sometimes I just don't feel like it…Sometimes you have troubles at home and then you just want to forget about it so you just don't participate. But then some days…you go to bed so late and you just feel so tired and weak." Of the days when she does really participate, she said, "It's really fun when you really really dancing. It's amazing." How ever, she acknowledged that such feelings do not motivate her to participate fully more often. Tykia offered another reason for sitting out: "Some people they think they just too much to participate… afraid they going to mess up their hair or sweat too hard." She claimed that she was "more of an off and on, sometimes I have my bad days and I don't want to do nothing, some days I just be ready to get into something."

In summary then, students who do not participate fully may sometimes blame the teacher, or the choice of activity or music, but often the reason comes from within themselves: Either they are tired or not feeling well, or just "don't feel like it," a comment that frustrates most adults who work with adolescents. From the perspective of these students, it would appear that their engagement has little relation to those factors which teachers can readily change. This does not imply that a different teaching strategy or some other environmental change might not stimulate students to feel more like participating, but that the students themselves do not appear to recognize what it might be.

18.3 Fun and More

Although there were non-engaged students in this study, I also met many highly motivated ones at each of the schools. It is helpful to look at those students as well, ones who found dance not only fun but useful and/or meaningful, in order to have a fuller understanding of why students are and are not engaged.

18.3.1 Stress Release

A number of students found dance helpful because "it gets your stress out." Agatha remarked that "Dance is like being at home, listening to the stereo," while Kim added, "It sort of like calms you down from being so grumpy about doing a lot of… written work." Winona cautioned, "It's sort of a nice let go feeling of aaahh, but you still have to pay attention and stuff."

Certainly the stress-releasing effect of exercise is no secret. However, some students noted that dance gave them a temporary vacation from their troubles. Katie stated, "You go to dance, you kind of relax, you forget about stuff." Similarly, Nike stated, "If I have a problem I just dance around…. When I'm dancing it just seems to take my mind off a lot of things." Charlotte told me, "I thought it [dance] might

stress you some, but it just takes your troubles and throws them away for the day." Tom stated, "If you've got like, a problem and you start to dance…you're just think-ing about dance, you're not thinking of anything else."

18.3.2 Focus and Concentration

A number of students expanded further on the kind of experience in which they are concentrating fully on dance, describing an intense involvement that was usually not labeled "fun." Zoe said she would describe dance as "fun [but] hard work… 'cause you really have to like concentrate in the class and you really have to…pay attention…you have to think a lot about how you want to make things up and work together with your partner."

Focus was particularly mentioned by students in a performance class at Greenway. Amy said it this way: "I noticed that you really can't go off your focus when you're still on the dance floor, even if you aren't doing anything, you always have to look focused." Lorax said that preparing for performance was "work, work, work, work, work, work, and there's no time for like playing off, if you play off, play off, play off, play off, then it's the day of the performance and you…can get really messed up." However, he indicated that it was fun to work that hard: "Yes, it is, I feel good about myself, to say that I worked really hard on this."

Students at the two other schools described this kind of experience as happening not every day, but on occasion. When Bill described one favorite day in dance, he said it was good because "I was more focused in, everything was focused on, the swing, rise and fall, everything." And when I asked some students what it felt like on the days when they were "really into it," Desiree said, "I forget everything else and I'm just concentrating on moving my body to the music." Lana said, "Your head's focused on that one thing." Students sometimes struggled to find ways to talk about the relationship between body and mind, moving and thinking. For example, Tim remarked that "dance involves a lot of physical activity…and I guess you use your mind too." Zoe was firmer in her claims: "You have to think a lot about it. You have to think a lot about how you're going to put it together…what movements you're going to do." Lauren described dance as "an art that takes up a lot of thinking into what you're moving." Tykia, however, replied that dance was easier than other classes because "we have to think about stuff [in dance], but you know we ain't got to like just really put our brains to it like solving problems or something like that."

18.3.3 Self

A large number of students mentioned self-expression as a value of their dance class. A small sample follows:

It's about showing your feelings and expressing to others how you feel without talk....
You get to express your feelings and show people how to do – your thoughts and stuff.
(Jennifer)

It's really wonderful because I get to express myself without really saying stuff. (Robin)

You can express your feelings. You can express that you might be feeling happy or sad.
Or you can express that you're not having a good day. Or you're feeling bad. (Ravon)

She lets us have a chance to express ourselves and show people our personalities through
dancing....it kind of like brings up everybody's personality...and she just gives us a chance
to be ourselves. (Agatha)

This opportunity to be oneself was mentioned by a number of students at
Greenway. As Yelnik stated, dance is "just getting to know yourself...if I get into
dance, I discover this whole new part of me...dance just kind of lets me out, gets me
to know myself." Winona concurred, "You find a different person that you didn't
know about yourself before...it really lets me explore my inner self, what I'm really
like, who I really am." Charlotte said, "I loved it more than anything else, I felt like
I could really be what I could be." Katie added, "I guess now it's sort of a part of
me." Amy told me that sometimes she closes her eyes when she dances, "just to
become more centered with myself.. ..you can really get somewhere when you're
centered because you can sort of drift off and become what you really are, who you
really are to yourself." Lauren said that in dance she was

learning a lot about myself.... I think lots of people get worried about showing something
that nobody's ever seen inside them come out into a dance, and they don't want others to
see, they sort of want to lock a part that they have, and I think bringing this out toward other
people is something you need to learn in your life.

Donetta, a Johnston student, added, "I can be my own self. I don't have to play a
role or anything, I just feel like I can do anything."

Self-expression seemed related to self-esteem for many students at all three
schools. As Lovena told me, "Everybody can express their feelings by dancing and
the more you express your feelings the more you will love yourself." Bill furthered
this idea: "I like dance because it gives me a respect for myself.... You make your-
self feel good 'cause you've accomplished...you like it even if there's no one to see
it, you like it then it makes you feel good." Kim saw her progress as being related to
self-esteem: "It makes you feel good about yourself to be...seeing yourself
improve." Bobby's self-esteem in dance was apparent when he boasted,

Some of the shapes – you just feel good when you do them because, *man*, this is awesome.
Nobody else can think of this stuff – I mean, some people can't even do it and you feel good
'cause you can do stuff that other people can't.

18.3.4 Freedom

The opportunity for movement and self-expression in dance gave students a sense
of freedom. Zoe revealed this view when she told me what she had learned in dance:
"Just let yourself be free and...dance how you want to and stuff." Yelnik also spoke
of freedom: "I can do whatever I feel like in dancing because there are no real

restrictions to it." Alyssa stated that "it feels like you're…free to do anything – like [the teacher] doesn't *make* you do something." Raksha liked dance because "I don't have to follow anyone else's rules," and Donetta, because "I feel free, I don't feel pressured into things."

Freedom was often cited as one way dance differed from other courses. Joseph clarified that "Some of the rules [in other classes] are the same as dance, but I think dance is more open." Dare noted that freedom in dance came from a sense of security: "You're just your own free person there, you can't feel embarrassed, 'cause everybody in there makes mistakes." Lauren spoke extensively when she told me that dance involves what she called "freethinking":

> Freethinking is an individual's thoughts that come from the mind, not a text book. It's spur-of-the-minute thinking. If you ever freethink, you can come up with any answer, but you have to think. You can say, well, "I really want to twirl around a lot in this because I feel like that." That's thinking but it's not coming up with the exact right answer. You can come up with any answer and it'll be right, but you're thinking in a way that appeals to you without feeling, "Is that the right answer, am I supposed to jump, will everybody think I'm stupid if I jump," so I think freethink has a lot to do with how you feel…There's a lot of freethinking here.

18.3.5 Transcendence

Some students alluded to experiences in dancing in which they transcended space and/or time. Lorax commented, "I just let dancing take me where it wants me to go," while Leslie added, "Once I start dancing, it feels like I'm wherever I want to be." Lovena said that place was "a world of imagination." Yelnik told me that "my goal, every time, is just to get in that zone where everything around me just seems to dance, and I can do anything I want." Bill explained that he has the same feeling when dancing that he gets in a special place in the woods, when he leaves "the normal":

> I got my favorite spot in the woods where all the leaves are on the ground and they're like gold and there's a lot of birch trees around there and they're all smooth, the bark and stuff… it's like just a whole forest of them down in the valley…I like to go down there and sit and stuff and just watch the squirrels and stuff 'cause they run around and play and there's a big wide tree that I sit next to and there's a big rock next to it I sit on…it's like a whole new world…after you go over both sides it's back into the normal…like you can go there and get away from everybody.

18.4 Discussion

The next step in my interpretation involved reflection on what the student responses meant to me as a dance educator, teacher educator, and curriculum theorist. In keeping with the interpretive research value of making the researcher visible, this

reflection may be more personal than some readers find customary. My first sense of these interviews was that they only reported the obvious: The students who liked dance did so because they got to move around, work with their friends, and make up stuff, and they described the feeling they got from it as *fun*. On one level, there is nothing at all remarkable about the desire of young people to have fun, or the expectation that they should find fun in an elective activity which seems to have no pragmatic value. The prioritizing of fun over achievement is one of those characteristics that marks immaturity at any age beyond early childhood, and does not surprise us in early adolescence. Most teachers and parents, although attempting to encourage mature behavior, seem to hold their breath and wait for young people to outgrow such childish ways. This is certainly true for me, now parenting my second adolescent and reminding him that weekends were made for more than sleeping late, watching television, and hanging out with friends. With a highly developed work ethic myself, I find that most of my own choices for leisure time involve what is easily recognized as productive activity.

Further, I am moved by Cornel West's concern about the American "culture of consumption" that "promotes addictions to stimulation and obsession with comfort and convenience…. [and] hedonism in quest of a perennial 'high' in body and mind" (1994, pp. 45–46). I do not wish to imply that dance study is about comfort and convenience. However, devoted dancers may be as addicted as obsessive runners to physical stimulation. I have both appreciated and sought the "high" that is possible through dancing.

Despite these cautions, listening to the passion of the young people in this study triggered something else for me. I began wondering why it is practically universal to celebrate play on the part of young children ("play is the child's work") but not for the rest of us. I considered why I have so little fun in my own life, filled with constantly increasing demands and responsibilities. I remembered my adolescent years, when, several years older than the participants in this study, I would close myself in the living room, put on music, and dance. I danced because it felt good to move and to make up my own ways of moving. In fact, it was this experience that motivated me to study dance. Further, the desire to recover something of this pleasurable experience, although in a social setting, undoubtedly was part of my motivation to do this research. Spending time dancing with kids (without the responsibility of teaching them) sent me back to my other responsibilities with aliveness and exhilaration, the same kind that I remembered from my own closet dancing and that some of my informants described.

My analysis of the words of my respondents was thus immersed in my own contradictory feelings about fun. I particularly noticed this the day that I interviewed Charlotte. I knew that Charlotte was a bright and highly motivated child after she had introduced herself in a dance demonstration by declaring how she liked to play with numbers, stating, "I *love* pre-algebra!" But later, during her interview, when I was trying to understand why she loved algebra and dendrology as well as dance, she looked me straight in the eye and said, "Having fun is the biggest thing in my life." Ordinarily we might expect this kind of comment from those individuals that Cornel West (1994) – and every schoolteacher – are worried about: the ones who

want the easy way out of everything. However, Charlotte did not find algebra and dendrology fun because they were easy, but because they were intrinsically satisfying.

Certainly, some things that students need to learn (or that we think they need to learn) are not fun, at least not fun for everyone. But how often we adults consider having fun to be something childish and unimportant, to be engaged in only when work is done. What might the world be like if more people thought about how to make our work more satisfying and pleasurable, rather than something to be endured before we could engage in leisure activities? What might school be like if we promoted learning as important because of its intrinsic pleasure (as it seems to be for young children), not just because of the need to pass a test, get into college, or get a job?

Yet I also have to acknowledge that, even in high school, I was not content with the pleasures I got from my closet dancing. I went on to take dance technique classes that were often frustrating as I struggled to learn alongside students who had begun their dance study at an earlier age and were more skillful than I was. What motivated my involvement beyond the point where it was just fun? And what is the motivation now for my not only dancing with kids, but also carrying out a study that has meant far more hours analyzing data than dancing? Since I am beyond the need to seek promotion, that extrinsic factor does not provide the motivation. What intrinsic factors make hard work sometimes more satisfying than that which comes more easily?

A number of scholars have contributed ways of understanding various kinds of human experiences that relate to fun. During the 1970s there was a great deal of theoretical interest in the topic of play among physical educators, particularly in terms of how play differs from work and whether or not sport can be considered a form of play. Carolyn Thomas reviewed much of this literature, as well as older theories, in a chapter in her 1983 publication. Although noting that play is first of all an activity which has certain objective characteristics, Thomas also affirms play as an attitude, or a way of approaching any activity. As an attitude, play involves choice (we play because we want to), freedom (the player maintains control), intrinsic rather than extrinsic rewards, and heightened focus or concentration. Thomas concludes that

> the play stance allows man to become, in a way, available to himself for understanding the world, others, and himself. It heightens awareness and requires that the player respond. Such awareness and response can then serve as the basis for a variety of knowledges. (1983, p. 75)

This kind of attitude seems to describe what I often experience in dance, and what many of my young informants seemed to find. Yet I also find it while doing research, as well as other engaging activities which are part of my work. Further, the noble understanding of play defined here ignores activities that we experience as "playing around" or "goofing off." I looked further for theorists who went beyond the work-play duality and described other ways of understanding different kinds of engagement in human activity.

Mihaly Csikszentmihalyi is one of the best-known theorists whose writing relates to this topic. In his 1975 work, he coined the term "flow" to describe experiences that are intrinsically motivating, and noted that such experiences were found "between boredom and anxiety," as a transcendent state. Flow experiences, in Csikszentmihalyi's view, can occur only in activities that involve challenge, but not so much challenge as to produce anxiety. Individuals need to feel in control of their actions and environment in order to experience flow. Further, such an activity is "autolenic," meaning that "it appears to need no goals or rewards external to itself " (1975, p. 47).

In Csikszentmihalyi's 1991 work, he explores "experience that makes life better" (p. 45), and identifies two kinds which he calls "pleasure" and "enjoyment." He notes that "most people first think that happiness consists in experiencing pleasure: good food, good sex, all the comforts money can buy...Pleasure is a feeling of contentment that one achieves whenever...expectations set by biological programs or by social conditioning have been met" (p. 45). Enjoyment, according to Csikszentmihalyi, goes beyond satisfying a need or desire, to achieve "something unexpected, perhaps something even unimagined before" (p. 46). He goes on to say that enjoyment is more difficult to achieve than pleasure:

> We can achieve pleasure without any investment of psychic energy, whereas enjoyment happens only as a result of unusual investments of attention.... It is for this reason that...the self does not grow as a consequence of pleasurable experiences. Complexity requires investing in goals that are new, that are relatively challenging. (pp. 46–47)

While drawn to Csikszentmihalyi's description, I am still concerned about a dualistic and hierarchical schema in which the lower category (pleasure) seems to be related to the body and the upper category (enjoyment) to the mind.

Elizabeth Hirschman (1983) describes three kinds of experiences, which she refers to as "aesthetic," "escapist," and "agentic" experiences. She defines aesthetic experiences as "those that absorb one's full attention and arouse one's senses and emotions to a state of transcendance [sic]" (p. 157). In her study, individuals in such experiences described themselves as being "carried off into it...sort of 'give myself up' to it" (p. 161). Escapist experiences were "sought as desirable substitutes for a presently anxious or unpleasant state" (p. 157). Agentic experiences were defined as "those that the individual uses in an instrumental fashion to acquire information or learning" (p. 157).

I find such a triangular model helpful in thinking about the lives and experiences of adolescents as revealed in this study. I will discuss below three kinds of experiences that roughly parallel Hirschman's three categories, attempting to integrate what I heard from students into a theoretical framework.

The first are the kind that we only do because they are a means to a desirable end (such as a job or a diploma). Hirschman described such activities as agentic; in everyday language, we usually call them work. In adolescent language, they are boring and no fun. My previous research with high school students (Stinson 1993)

supports the assertion that most school classes fall into this category for most adolescents. Many educators (and politicians) do not seem to object to this state of affairs, because they too view school as a means to an end. They blame the students for whom extrinsic motivation (grades and future jobs) is insufficient to lead to engagement and achievement.

As a liberal educator, it would be tempting to say that students should not have to do anything in school that is not fun, and that it is the teacher's job to make learning seem like play and not work. Yet I also know the experience of working with others who only want to do "the fun stuff," and who leave the rest to colleagues or partners. Cleaning the toilet and attending committee meetings are not intrinsically motivating for most people. I think all young people need to learn that there are some things we do not because they are intrinsically rewarding, but because each member of a community or family has responsibilities to others.

Further, I agree that adolescents need to learn that there are long-term goals for which immediate sacrifices are necessary. All too often, however, adults set the long-term goals and then expect students to automatically be willing to make the sacrifices. When even well-educated and hard-working middle class individuals still lose their jobs in massive cutbacks among major corporations, and the increase in new jobs is still primarily within the poorly-paying service sector, many students quite reasonably mistrust adult assurances that working hard in school is the ticket to a good job. Further, many young people lack adult role models in their communities who have achieved economic success and stability through hard work and staying in school.

The second category of human experience involves the goofing off, playing around kind, which we describe as fun or play, although this is not what sport sociologists usually refer to as play. These are the kind of activities that Cornel West (1994) cautioned us against, Csikszentmihalyi (1991) referred to as pleasure, and Hirschman (1983) referred to as escapist. In schools, teachers try to restrict such activities, and parents may try to do the same after school. We tell students they are a waste of time, and should be engaged in for only limited moments, even though they "feel good," meaning that they provide sensory, bodily pleasure.

Most people do not expect these kinds of activities to occur during school hours past elementary school, where we still indulgently have time for "recess." However, dancing is an activity that does feel good much of the time for many people who do it. Dennis Monk (1996) points out that there is a biological basis for pleasure in music; certainly the same is true for dance. Our culture's devaluing of sensory pleasure is one reason that all the arts have been devalued in education; the current emphasis on cognitive aspects of arts education is a reaction to that devaluing. At the same time, students who have danced in recreational settings outside of school, and who value dance because it feels good, understandably feel resistant when they encounter dance in educational settings where more is expected and not all of it offers what they know as pleasure. This resistance

may be enhanced when teachers attempt to motivate students by telling them that dance will be "a lot of fun."

I recognize that many activities in which young people find sensory pleasure may be considered not only a waste of time but also dangerous or destructive. However, I am not willing to give it up as an important source of meaning and value in human life. Those who have studied the creative process have long recognized that the "aha" moments themselves, while they must be preceded by productive work, most often come during times of relaxing or playing around (Ghiselin 1952). I also know that, as the stress in my own work has increased, I need a vacation that involves no productive work in order to recharge. While I think we need to look at why we have created a culture in which work is so stressful that we need to recover by doing nothing, I also think we need to teach young people the value of pleasure, and help them find nondestructive opportunities for it. Certainly, for at least some students, dance may be one of these opportunities.

The third category of human experience involves the kind that is challenging and engaging, where the boundaries of work and play break down. Csikszentmihalyi (1991) called this kind of experience enjoyment, while Hirschman (1983) used the term aesthetic. Most teachers would agree that this is what we most want students to experience in school. Yet students do not become engaged in all activities that are challenging and growth producing. The other conditions that theorists note as necessary for this kind of experience to occur are less likely to happen in school, particularly choice, freedom, a sense of control, and an emphasis on intrinsic motivation. As long as courses in school are about fulfilling a teacher's requirements rather than setting and meeting one's own, and as long as grades are held out as the most important kind of reward, flow experiences are likely to be rare.

18.5 Conclusions

In terms of this particular study, it appears that a number of students found dance to be challenging, engaging, and personally meaningful (the third category of experience described above: enjoyment or aesthetic experience). Although they may have participated in some activities more fully than in others, they seemed to understand that the best kind of experience took the most investment. There were students who experienced dance in this category at all three schools, although more students at the private school spoke of it. It was sometimes but not always called "fun."

Some students clearly approached dance as a way to "play around" (the second category: pleasure or escapist experience). For some, this kind of fun was all that dance was. These students seemed to participate as long as they "felt like it," and perhaps had occasional experiences that might fit the third category.

We must be cautious, however, in trying to categorize any particular student who simply says that dance is fun. I do not know that we can always tell whether

that student is referring to category two or category three. It is possible that some students may not have the language to describe transformative experiences or that they may be uncomfortable doing so.

Finally, some students found dance to be boring and no fun (the first category: work or agentic experience) and were not motivated to participate. Without the intrinsic motivators of pleasure or enjoyment, extrinsic ones become more important to facilitate engagement. Unlike required subjects at these schools, electives like dance did not have to be passed for students to be promoted to the next grade, so this extrinsic motivator was absent. While there can be other extrinsic motivators for dancing (physical fitness, for example, or being well-thought-of by the teacher), these students did not recognize or respond to them. Lacking both intrinsic and extrinsic motivators, students who experienced dance in this first category had no reason to be engaged.

Unfortunately, like all interpretive studies, this study cannot give us directions for making students like dance or take it more seriously. Any suggestions I have for engaging students come as much or more from my years of experience in the field than from this study. To begin with, there may be times when we want to use extrinsic motivators to promote dance activities that students are not likely to find engaging, but I think these should be rare. Some examples might be learning how to prevent injuries or attending to a peer's performance (even if it is boring) out of respect for the person. We need to avoid treating dance education like medicine that is good for students in order to make dance seem more like other school subjects.

I think that we need to acknowledge the significance of both pleasure and enjoyment in dance, and use strategies that make it more likely for students to experience dance as satisfying on both of these levels. For example, adolescents who do not know how to do a particular movement, and are thus not successful in performing it, will rarely find the experience a good one. Similarly, adolescents who are simply told to "make up a dance" without having any idea of how to go about doing it will not be likely to invest in the activity. We need to use strategies that give all students the best possible chances for success if they are to experience pleasure in moving and in knowing. We also need to make visible our own enthusiasm for dance. If we want students to go beyond pleasure to enjoyment, we need to do more, to challenge students beyond their current level of skill and knowledge while giving them the tools to be able to get there. We also need to give them choice, freedom, and a sense of control, so that they are motivating themselves, rather than depending on teachers to make it "fun." It may also be helpful for teachers to describe the three different kinds of experiences, and to confirm that all are important, but in different ways. I think it is relevant for teachers to share their hopes that students will find some experiences in dance that are challenging, engaging, and meaningful; at the same time, they must make clear that a teacher cannot make this happen unless students choose to invest in the experience.

While I think that skills in teaching, not just dancing, are essential if teachers are to get students to engage in dance, this paper is not the place to describe the

pedagogical skills needed to be a successful dance teacher. It is also clear to me that pedagogical skills may not be enough. Some students, despite our best attempts, will not like dance. While I recognize the implication that courses which are not required are not important, I would not want to see dance required for all adolescents. In fact, as I indicate below, I would be inclined to require very few specific courses for adolescents.

This study, however, speaks to far more than dance classes and to more variables than pedagogical strategies. It is clear that most schools have failed to motivate student engagement by drawing the sharp dichotomy between work and play, and by using extrinsic motivators to encourage students to sacrifice pleasure for the sake of more schoolwork. Some have tried the hopeful compromise of "balance" between work and play, using as much recess or as many elective courses as necessary to get students to tolerate their work. Certainly all educators want students to become more engaged in learning. Engagement is a necessary though not sufficient goal for education. We need to avoid romanticizing involvement as the solution to all the problems we see with schools and society. Activities in any of the three categories I have described above have the potential to be destructive or trivial as well as life-enhancing. Obsession with any activity, no matter how productive, pleasurable, or meaningful it is, can be problematic. Unless we also teach adolescents to reflect upon the gains and losses that come with each choice they make, simply offering more enjoyable activities will not be very helpful.

Ultimately, if we wish students to become more engaged in education and make more life enhancing choices, we need to rethink what is so important that it should be required, and how to convince students that it is important enough for them to learn. In disagreement with current practice, I would not require many subjects beyond the levels that students study in elementary schools. I agree with Nel Noddings (1992), a former math teacher, that algebra is not necessary for all students and that serious study in any discipline should be reserved for those who have the passion to make the necessary discipline rewarding. Noddings believes that caring for self and caring for others are among the areas that are so important they should be mandated for all students; she thinks that much of the current curriculum could be incorporated into a curriculum oriented around themes of care. I also agree with David Purpel (1989) that issues of social justice and compassion are important enough in a democratic society that we should make them central for all students.

Further, I agree with these authors that all students should have significant opportunity to find nondestructive activities in which they may become deeply engaged, if they are to avoid the aimlessness and despair that seems to characterize so much contemporary life. In order for such activities to be engaging, students must be allowed choice, freedom, and control, and there must be an emphasis on intrinsic motivation.

I think schools should put far more energy into encouraging adolescents to begin engaging in a lifelong search for what is meaningful and purposeful. This would focus not just on a future career, but on what makes life worth living, both individually and collectively. We need to help students reflect upon the choices available to them, and the gains and losses that come with each choice they make. This is no panacea, but I see little hope that most adolescents will ever become engaged in learning if we continue to teach them that important learning is something they are made to do (for their own good), while offering a few trivialized electives to make the "important" work of school more palatable.

As noted earlier, an interpretive study such as this one cannot give definitive answers regarding why some kids get "into it" more than others, or how teachers might predict or control student engagement in dance classes. Interpretive research typically raises more questions than it answers. For me, this study continues to generate questions regarding my own life choices. It has also raised questions about issues in arts education, particularly the current emphasis on cognition and standards, and the necessity to listen to the voices of young people as we make policy decisions that affect their lives.

Appendix 1

Sample Questions from Interview

How old are you? How long have you gone to this school?

Did you choose to take this class or get put in it? If you chose it, why?

Had you taken dance before? Where? If yes: How is this class like and different from other dance classes you have taken?

Describe a favorite experience from this class. Describe a least favorite experience.

Talk to me about how this class is like and different from other classes you take at school.

(At Lewisburg only): I've noticed that some kids get into dance, and some don't. Some get into it at some times but not others. What do you think makes a difference in terms of people getting into it?

Can you describe how it feels to really get into it, to really dance?

Do you live with your parents? How do they (or whoever else serves as guardians) feel about your taking dance at school? Tell me about your family.

How do your friends respond to your taking dance at school?

If a new student wanted to know whether or not to take dance at school, how would you describe it for them?

Have you learned anything? If yes, what have you learned? Is that important?

Should dance be required for everyone in middle school?

Appendix 2

Students Interviewed, by Grade Level, Race, and Gender

	wf	bf	wm	bm	om
Johnston school					
6th grade	5	0	3	0	1
8th grade	4	1	1	1	0
Greenway School					
5th grade	4	0	4	1	0
6th grade	2	0	2	0	0
7th grade	3	0	0	0	0
8th grade	1	0	0	0	0
Lewisburg School					
7th grade	2	4	1	1	0
8th grade	4	6	0	1	0
TOTALS	25	11	11	4	1

wf white females, *bf* black females, *wm* white males, *bm* black males, *om* other males

Commentary

I recall a moment of despair at the end of my first round of analysis of the data collected for this study, when I thought, "I've done all this work, and all they said was that dance is fun?" Indeed, one of the reviewers for the journal that published this paper was concerned that the theme of fun (so prominent in the title) simply played into stereotypes that so many people have about dance. But problematizing this stereotype is certainly the emphasis of the analysis and discussion, and it was published anyway. As indicated in the autobiographical comments at the beginning of the Discussion, the issues raised in this research were very important to me personally, and remained so, eventually culminating in the next chapter in this volume, highlighting student experience of effort and achievement in dance.

When I look back at this work now, I recognize another dilemma faced by dance education researchers, and indeed all arts education researchers. I used data from students studying one kind of art form, and this piece was published in a journal devoted to research in that art, in hopes that dance educators and scholars would read it. Such choices likely have meant that it has been read by very few outside of dance, even though the significance of the findings extends so much further. I expect that most of the language used by these dance students could be spoken by students in other art forms, especially performing arts. And, as the Discussion section makes clear, the issues raised are relevant for all arts educators, and indeed all those concerned with how we educate young people in schools.

References

Brandt, R. (1987/1988). On assessment in the arts: An interview with Howard Gardner. *Educational Leadership, 45*(4), 30–34.

Brandt, R. (1995). Overview. *Educational Leadership, 53*(1), 7.

Csikszentmihalyi, M. (1975). *Beyond boredom and anxiety.* San Francisco: Jossey-Bass.

Csikszentmihalyi, M. (1991). *Flow: The psychology of optimal experience.* New York: Harper Perennial.

Csikszentmihalyi, M., & Larson, R. (1984). *Being adolescent: Conflict and growth in the teenage years.* New York: Basic Books.

Donmoyer, R. (1985, April). *Distinguishing between scientific and humanities-based approaches to qualitative research: A matter of purpose.* Paper presented at annual meeting of the American Educational Research Association, Chicago.

Ghiselin, B. (1952). *The creative process.* New York: New American Library.

Hirschman, E. C. (1983). On the acquisition of aesthetic, escapist, and agentic experiences. *Empirical Studies of the Arts, 1*(2), 157–172.

Monk, D. C. (1996). Dionysus redux: Rethinking the teaching of music. *Arts Education Policy Review, 97*(6), 2–12.

Music Educators National Conference. (1994). *National standards for arts education.* Reston: Music Educators National Conference.

National Commission on Excellence in Education. (1983). *A nation at risk: The imperative for educational reform.* Washington: U.S. Department of Education.

Noddings, N. (1992). *The challenge to care in schools: An alternative approach to education.* New York: Teachers College Press.

Oakley, A. (1981). Interviewing women: A contradiction in terms. In H. Roberts (Ed.), *Doing feminist research* (pp. 30–62). New York: Routledge.

Purpel, D. E. (1989). *The moral and spiritual crisis in education: A curriculum for justice and compassion in education.* Granby, MA: Bergin & Garvey.

Stinson, S. W. (1993). A place called dance in school: Reflecting on what the students say. *Impulse: The International Journal for Dance Science, Medicine, and Education, 1*(2), 90–114.

Thomas, C. E. (1983). *Sport in a philosophic context.* Philadelphia: Lea & Febiger.

West, C. (1994). *Race matters* (1st Vintage Books ed.). New York: Vintage.

Chapter 19
"It's Work, Work, Work, Work": Young People's Experiences of Effort and Engagement in Dance (2007)

Karen E. Bond and Susan W. Stinson

Abstract This co-authored study is the second phase of a large project examining young people's experiences in dance education. It draws on multi-modal data from over 700 young people, diverse both demographically and in terms of degree and kind of dance experience. This phase focuses on data (words from young people, captioned drawings, and descriptions from trained observers) reflecting engagement and disengagement in dance, and illuminates them from a number of theoretical perspectives. The analysis found a variety of obstacles to active engagement in dance, including disinterest in the content, fear of failure, and lack of fit between individual skills and interests on the one hand and the content and demands of the class on the other. Students who find dance engaging and worthy of effort cite personal interest/emotional connection in activities and content, desire for challenge, and appreciation for autonomy in setting their own standards and assessing their achievements. Yet there is not always a clear distinction between engagement and disengagement; this is a continuum rather than a dichotomy. While recognizing the significance of a well-developed work ethic for success in school, the authors conclude by problematizing the tendency to blame lack of effort on student laziness and other personal failures.

Melbourne, Australia. 20 four-year-olds in an early learning center:

> Children sit clustered in one corner of a large open space framed with windows that reveal a panorama of moving clouds. Several flutter their arms as one boy takes a short flight, his hands forming claws. All eyes are on the teacher, who asks, 'Are you ready…are you ready to fly?' The group erupts into excited bouncing, flapping, and assorted birdcalls, but children show bodily restraint to stay in their corner. Along the sides of the space, several practice aspects of eagle dance. At the end of the session, children don't want to stop: 'I've got one more dance'…. 'Me too!'…'Me too!'…'Me too!' 'I've got one more dance…lots of dances.' 'I want another go. I want another go.' 'Can we do that ballet again?' (A)[1]

We use the word 'effort' as it is commonly employed in standard English to refer to exertion or expenditure of energy, not in its specialized use in Laban analysis.

[1] The source of each anecdote is identified by a participant code as well as a citation if the source is a thesis, dissertation, or other publication. The Appendix describes the different sources of data.

© Springer International Publishing Switzerland 2016
S.W. Stinson, *Embodied Curriculum Theory and Research in Arts Education*,
Landscapes: the Arts, Aesthetics, and Education 17,
DOI 10.1007/978-3-319-20786-5_19

Cambridge, Massachusetts, USA. Graduate students in chemistry:

> Suddenly there are no tests to ace, just a lab bench silently awaiting...some students jump for joy at this. 'Let me at it!'...They have found their field of play. It will be hard, serious, exhausting...They will bang their heads against the walls of undiscovered knowledge and come up empty again and again. They will curse their luck and worry that they will never find anything of significance. But they will love what they are doing anyway, because they will be following the force of their own curiosity. (Hallowell 2002, p. 112)

What are we to make of the above-illustrated episodes of engagement, which cross boundaries of age and subject matter: Is it work or is it play? Both young children and graduate students become excited and want to 'keep doing'...It must be play! However, they also exhibit self-discipline, inexhaustible curiosity, challenge seeking, and commitment to practice, qualities that characterize the human drive to learn, know, and create...It must be work! This article joins a long tradition of inquiry into the nature and meanings of work, in this case extending the discourse to students in dance education.

19.1 Background to the Study

As dance educators and researchers, we have long been committed to understanding how young people experience dance and what it means to them, and to bringing their voices into professional discourse. We met first in 1985 at a Dance and the Child: International (*daCi*) conference in New Zealand. As we continued to share our work over the next decade, we were intrigued by similarities between our individual findings, despite the different populations we had been studying. Karen's research focused on young children in Australia with and without disabilities, using multi-modal approaches that included videotaped classes, systematic on-site observations, conversations with children, and drawings about dance with captions spoken to teachers. Sue's research was based on in-depth interviews, supported by observations, with middle and high school students in North Carolina (USA).

By 1996, we had decided to initiate a collaborative project to extend our own work and try to understand whether there might be any common meanings of dance to young people that cross over demographic and other differences. At that time, we began to look at original data from colleagues as well as published and unpublished documents that describe the dance experiences of young people (ages 3 to completion of high school) and what they mean to them. To date we have gathered material from over 700 children and adolescents. Our collection includes diversity of gender, ethnicity, age, degree of dance experience, and country of origin. Despite this diversity, with most of the material from native English speakers, we know that we are leaving out large portions of the world. Further, most students had experienced only Western dance forms. We hope that colleagues in other countries will extend this work.

19.2 Methodological Issues

The project has been daunting in a practical sense, as we faced the challenge of dealing with large quantities of diverse material. We spent months in multiple readings and viewings, sorting and resorting data. The first phase of analysis became our study of young people's experiences of the superordinary in dance (Bond and Stinson 2000/2001). The study published here is based on material related to what we termed 'work' in dance. A third collection of material, dealing with relationships (to people and environment) in dance, still awaits analysis. Each section is important in understanding what has become a more refined quest, to both describe and understand the engagement (or disengagement) of young people in dance.

We also faced the same challenges as other researchers who study personal experience and meaning (Ellis and Bochner 1996; Denzin and Lincoln 2000; Gilbert 2001; Prasad 2005). Regarding interview data, for example, it is reasonable to question to what extent meanings of dance can be captured in words. Even though we draw on a variety of data sources including video and drawings, we know that we do not have, and can never have, the 'whole picture' of what dance means to any one child or collection of young people. Because it is constantly in the process of creation, meaning is always partial. This recognition allowed us to enter data analysis without concern for whether we had enough material or whether participants had been randomly selected. While not every possible meaning is being illuminated in this paper, we know that we are offering a broad representation of young people's experiences. At the same time, we acknowledge ourselves as both creators and discoverers of meaning. Finding many more examples than we could include here, we made choices based not only on a search for range of experience, but also on aesthetic criteria, illustrating themes with anecdotes that we found most vivid and engaging.

Despite the prevalence of qualitative studies in education, ours is unusual in several ways. One is the large number of participants drawn from such diverse sources. The original purpose of each study/source differs, so we cannot conclusively compare data from one population to another or draw conclusions about the different groups of young people represented. Nevertheless, the study's focus on phenomenological descriptions derived from the collective voices of many, systematically examined, projects a robust portrayal of 'working' in dance education.

In keeping with the phenomenological underpinnings of the study (Bond and Stinson 2000/2001), we did not begin analysis with a detailed conceptual framework. Instead, we immersed ourselves in data for some time before we began to search for literature about emerging themes.[2] The literature review may thus be found in discussion following the analysis.

[2] This is not to say that we entered this research as blank slates. We both have a strong inclination toward meaning making as a most significant aspect of what it means to be human, and have suggested in prior writings that this should be a critical aspect of education.

19.3 Student Experiences of Working and Not Working in Dance

The following thematic analysis is focused on young people's motivation to work hard in dance, and what inhibits hard work. Each statement and drawing is followed by a letter designating the data source from which it was drawn, as well as a standard citation if it was taken from a published source. In the Appendix, we have provided relevant demographic and bibliographic descriptions of each data source.

19.3.1 Obstacles to Hard Work

Although a large majority of our data report experiences of high motivation in dance, we begin with those that depict a variety of obstacles, including fear, lack of confidence, and dislike of hard work.

It's too hard or it's too easy. Some students perceive that dance is too difficult, or dislike the effort involved:

> Pointe looks prettier, but it's hard work and it hurts. How can they stand it? (N)
> When we do all those foot positions…that is *tiring*. Ballet—that gets you sore. Coming up on your calves…'cause you do so much with your *legs*. And it kind of tires your arm out. Ballet is hard to me. I don't see how they can remember all of it. I guess you have to be all into it. (U)
> Some dances I don't like to do…like African dances. There's too much to it. (P)
> In second grade I almost quit because I was getting tired of it and it was getting harder. (V)

Some students report that they exert themselves too much in dance, like the middle school boys who 'got tired' (Fig. 19.1) and 'got sick because I jumped too much' (Fig. 19.2) (G).

Fig. 19.1 I got tired

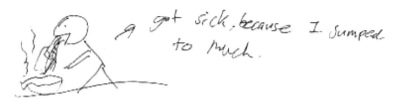

Fig. 19.2 Sick from jumping

Fig. 19.3 Imbarest and scared

In contrast, students who are motivated by challenge may be inhibited from invest-ing full effort if they perceive that the challenge is not sufficient to match their skills:

> Dance can provide a challenge, but not the way it's done here. (P)
> Most of the stuff I already know, and it's hard for me to keep doing it over and over and pull myself down to a lower level when I know I can do more than that. (U)

I'm afraid. Dance puts students' capabilities in plain view. Fear is probably the most powerful inhibitor for engagement in dance, especially fear of how others will respond:

> I felt imbarest because I was in funt of the class and scared to go up. I thalt I was going to get hert…I didn't want to go up because I thoght I couldn't do it. (Fig. 19.3) (C: Bond and Richard 2005, pp. 96–98)
> I didn't, like, have the whole dance done when you filmed it, so I didn't know what to do, and I was like a little freaked out, because I wasn't prepared. It was scary. (J: Giguere 2006, p. 96)
> When you're in front of people you don't know they laugh at you and make you feel uneasy. (Q)
> When we perform in class in front of everyone it gets you nervous and if you mess up your whole group gets mad. (Q)
> I'm nervous about the whole thing…I'm in the back, so I can kind of fake it, but that's still not good. (R)

I'm not good enough. Students confirmed in a variety of ways the statement by this student, for whom disliking dance was connected with lack of skill: "I like dancin' but not this kind of dance…I'm not real good at dance. (P)" These students voice frustration over failure to accomplish a goal, based on standards they have set for themselves:

> Sometimes I get upset 'cause I can't get the dance or I don't think I'm doing it right. (Q)

> I don't like too much competition in dancing, because if you are not excellent it takes all the fun out. (Z)
>
> I was so mad at myself for forgetting the dance. It wasn't that people knew I messed up, it was that I knew I messed up. (R)

The desire to achieve can create anxiety if students fear they will not achieve their goals, or even prevent them from trying:

> While trying to put the dance together you were like pulling your hair out because you didn't know whether the dance would turn out right or not. (Q)
>
> I don't feel I have enough basic knowledge of dance to be able to make up one that satisfies me. (U)
>
> I can't get anything right so I'm not even going to try...I wish I hadn't taken this class. (U)

It doesn't matter how hard I try. Students report that one's best efforts may not be enough, or limiting factors may appear beyond one's control:

> I think about something really pretty but when I go to do it, it doesn't come out right.... even if you worked the hardest you can possibly work. (N)
>
> Anything you could think of to go wrong, it went wrong.....I guess the biggest part of worst experiences is that you have such high expectations. (R)
>
> If you have a hurt foot, and you have to watch everybody dancing...you're like, 'I've got to get up there and dance!', but then you know you can't. Even if you did try, you couldn't do it. (P)
>
> Just because you can do 32 fouettés and keep your leg...does not mean you're going to do Sugar Plum Fairy. So that was hard for me.... I was thinking I'm working so hard and learning so much. Why can't I do the parts I want to? (V)
>
> It hurts that because the way your body is built, no matter how hard you try, you still can't do some things. (Z)

I'm trying too hard. Desire to improve can also have a negative impact. The first student quoted below indicates that trying *too* hard makes her less successful. The next two statements, from secondary school students, report that over-emphasizing improvement can reduce enjoyment:

> If I keep falling down, or losing my spot, I'll go, 'Oh well'.... Because the more and more I do it, the more and more and more I fail, and the worse and worse and worse it gets. So there's really no point. (T)
>
> Sometimes I start thinking a lot about correcting and improving, but...I just lose the enjoyment....Today I was willing myself to do the warm up 'cause I didn't have my center together. The more I concentrated, the more I lost it. (V)
>
> If I feel like I'm doing it really well then I enjoy it...But if I feel I'm not doing well then I'm concentrating on improving it so I can't really enjoy. (X)

Summarizing the above, students experience a range of personal disconnections within dance. Students also report that lack of commitment to hard work is an obstacle to achievement. We conclude this section with students commenting on their disengaged peers, describing states of uncaring, laziness, and lack of effort:

> If they were more serious, they could do a lot more. They play around and talk...If we could just concentrate, leave our lives outside the door, we'd learn faster. (U)
>
> Some people didn't put their heart into dance; you can tell the effort of certain people by the way they leap...and turn. (L)

Some people just don't like doing stuff that makes them work…and I don't think it's fair to me…the teacher…or any of the other people that try to work. A lot of people don't care. (P)

I don't think people who slack off should be in dance class…they're lazy. (P)

19.3.2 Experiences of High Engagement

As stated previously, a large majority of the data report experiences of high engagement. We begin this section with comments reflecting commitment to hard work in dance.

Get serious. Student comments reveal that many recognize qualities needed to succeed in dance. A middle school student asserts that dance is serious business: It's 'work, work, work, work…and there's no time for playing off' (P). The following three anecdotes offer advice from peer to peers found in a large study of children in a public elementary school program for those with artistic talent:

This is very serious and you must pay attention to learn your movements. (K)

Don't screw up…you are not here to waste other people's time.… Your parents pay taxes for this program. (K)

Do what your dance teacher says, don't fool around and don't get into trouble. Don't be discouraged if the teacher tells you it's wrong. (K)

Students also make self-statements about the importance of a serious attitude to working in dance:

In dance I can get a little bit more serious…like 'OK I gotta get motivated here, all right push it.' (H: Lazaroff 1998b, p. 83)

It's fun, it's hard work though…you really have to, like, concentrate and, like, be there and pay attention to know what you're supposed to do. (P)

Sometimes I get in one of those giggly moods.… It's not as much fun when I come out of dance class and say, 'Gee, I didn't learn too much today.' So I gotta work on that. (P)

Patience is similarly valued:

Teacher (to a group of four-year-olds waiting to begin creative dance class): Are you very patient? Children: Yes! (A)

You've got to be patient with dance…it doesn't just come; you can't just start doing all this stuff. (P)

In dance you work hard, you don't just come in there and throw something together. You have to learn how to do it. (U)

Although adults may tend to think that young children have short attention spans, their capacity for extended practice is evident in our data. A young child's persistence to carry out a 'plan' in dance is shown in two drawings (Figs. 19.4 and 19.5) made a week apart, with captions, 'This is my plan,' and 'That's me running and my plan' (A). Children in a multi-grade lower elementary dance class demonstrate strong motivation to rehearse for a performance through unison chanting: 'One more time, one more time!!' (F: Bond 1994b, p. 32). A high school student describes

Fig. 19.4 Plan one

what enables her to persist in dance: "The key thing that keeps me going is self-discipline. (T)."

The following students recognize that setbacks or failure are a natural part of the learning process and that effort over time is connected to success:

> If you make mistakes, don't pout or give up – keep trying. (K)
>
> Sometimes I say, 'That looks stupid!' But I say, 'Okay, let me try it again.' (U)
>
> You have this feeling inside saying, keep doing, keep doing, you'll get better…And you keep trying, and sometimes you won't get it, but sometimes you do. (T)
>
> I did one performance in lower school and I made one big mistake. I felt mad 'cause I messed up, and instead of working it into the dance, I just said, oh darn, and walked off. [Did that spoil performing for you?] No, because you can't let one mistake cut you down. (P)
>
> We had a lot of trouble with our ballet recital…we had to do it over and over again—it still wasn't right.… At the last performance it all pulled together and it was really beautiful. (P)
>
> I started going to dance in fifth grade…I couldn't dance, not even a little bit. Then sixth grade I was a little better and seventh grade I became co-captain of the dance troupe and then eighth grade I became captain. Before I was introduced to dance I thought you couldn't really learn how to do it; you had to have it in your body. But really, if you don't have the determination to dance in your head then you can't. But your body, it can be taught. (W)

We recognize that young people need the kinds of work habits and attitudes described above if they are going to persist through obstacles to find the satisfaction of accomplishment. Clearly some students make the connection between hard work and accomplishment in dance, but what is it that allows them to persist long enough to make that connection? Many report strong affective connections to dance or to a part of themselves they find in dance classes, both of which inspire hard work. Students describe finding 'love' in dance in terms of satisfaction and meaning, challenge and accomplishment, and the sense of personal autonomy.

"That's me running" and my plaw

Fig. 19.5 Plan two

I love to dance! An observer describes three young nonverbal children with impairments of vision and hearing and three adult participants as they delight in group dance: "Excitement and giggles…Everyone gets into it – rollicking, happy, laughing voices.… These people enjoy each other's happiness.… I see that adults are transformed here as well. (E: Bond 1991, p. 336)."

These students talk about dance with a sense of existential identification:

> I'm gonna dance'til death. (K)
> Dance is for me, 'cause I don't like nothing else. (U)
> When I came here, as soon as I heard the word dance I was like, I want it, I want it. Put me in there. I don't care what period—whenever. (W)

Emotional connection to dance may evoke total commitment:

> I hold nothing back. I don't let up and I give it my all. There's no point in giving less than my best. (Q)
>
> I worked like a demon in class. And at home I danced a lot in my living room. I worked so hard; I gave it 125 % all the time. (V)

This student experiences a direct relationship between emotional engagement and hard work: "Dancing to me means...commitment, fun excitement enjoyeble Learn Consertration hard working + I ♥ dancing. (Z)."

Some students reflect philosophically on the meaning dance holds in their lives:

> It depends on the movements and how you do them and why you're doing them...I mean if you really don't care about dance there's no reason to be doing it. (P)
>
> It's an important class, it's your time to be yourself and to learn about dance, and to learn about how your body works, like why your legs go a certain way and everything...you do learn in there, it's not just a fun time. (P)
>
> I sometimes have to make sacrifices and can't have fun with other friends or be in clubs at school. I guess that's okay because dance...will always be with me. Dance means a whole lot to me. (S)
>
> Obviously it means more than anything else...when I work hard for three hours a day, minimum, and four days a week. (V)

I love a challenge! For many students in dance, challenge itself is a motivator, and the greater the challenge, the greater the motivation:

> If it's hard, then I just want that much more to learn. (P)
>
> I like things that are challenging because when you're done with it, getting through it all, you've conquered something and know you can do it again. (P)
>
> I wasn't being challenged at my old studio. And fun, I kind of think that hard work and stuff is fun. (R)
>
> You have to be supple as well as have style and very few people have excellence in both of these, but you have fun and pain in trying to achieve them. (Z)
>
> It's like you're reaching for the sky. (V)

Many students enjoy the physical challenge of dance, as conveyed in the self-portrait of a child (Fig. 19.6) 'trying to do a bridge' (C). These young people describe hard physical work as intrinsically motivating:

> I get to do all that energy in dancing and I have like sweat dripping off my face. Sweat everywhere...it feels really good. I like working. Working is very good. (H: Lazaroff 1998a, p. 3)

Fig. 19.6 Trying to do a bridge

I like technique because you have combinations…you work real hard for those. You have to make sure your alignment's right and all that. They're fun. It's fast paced and you get a heavy sweat and get tired. I like challenge in dance. I guess I like it 'cause it feels like you're really dancing. (V)

Dance is not physical challenge alone. In Fig. 19.7, a student tells us that he likes dance class because 'moving is pretty tricky' (G). Young people describe many kinds of content motivators in dance education settings, including the inspiration of historical figures: "I just love hearing about Isadora Duncan…even though she's a little bit of a slut every now and then. (P)."

Fig. 19.7 Moving is tricky

Many, even the very young, describe awareness of cognitive aspects of their engagement. Here are examples from across the age groups:

> 'I've got a good idea!' 'I remember all the dances' (A)
>
> Improvisation was the first time I got to dance on my own without feeling I had to be perfect, and I could make stuff up that I wanted to do, so it gave me a larger field of vision to what dancing can be. (P)
>
> I want to listen and learn…'cause it's interesting. And when something's interesting to me, I like to listen and y'all shut up. 'Cause what she has to say I think will be very important. (P)
>
> If you make up a dance, you have to use your brain—think a long time. In dance, you have to put it all together…. It makes my brain grow bigger. (U)
>
> Improv is harder than technique because you have to think creatively. (V)

It's like I'm my own boss – I set my own standards. Autonomy and a sense of control are prevalent themes. This category is represented strongly by the young people from special education settings included in our study. This observation took place in a small group dance setting:

> Marc looked like a person who knew exactly what he wanted to be doing at all times. His partner commented, 'He is just opposed to any outside direction.' It seemed clear from the start that Marc was expressing personal standards…the exactness of his signature body shape…his postural and gestural focus. (E: Bond 1991, pp. 312–313)

Here are more examples of students setting their own goals and standards for achievement:

> It's basically like you can decide for yourself whether you want to make it hard or easy…because it's such an inner self thing. (P)
>
> My ballet teacher only expects me to do my best, but I always want to do more. (S)
>
> If you're just dancing for yourself, then…you don't have any guidelines because you've set your own. (V)
>
> I try to find at least one thing in every class I'm happy with, one thing I'm proud of. (V)
>
> When you dance a solo it is all up to you. There is no one else to rely on. (X)
>
> It's like I teach myself. It's like I'm my own boss. I get everything done and do it the way it is supposed to be done. (W)
>
> I'd proved not only to myself but also to others that I was every bit as good as I hoped I was and I was really glad because I'm enough of a perfectionist. Like I said, Little Miss Perfect. (V)
>
> I'm dancing towards an aim…that one day I'll be able to dance professionally. (Z)

Sometimes standards involve attention to detail:

> First I put my back up like this; well, that's what a turtle does! (Fig. 19.8) (A: Bond 2001, p. 48)
>
> If you're dancing with two people on stage, you can each be doing something individualized, but yet have it together. Like I don't think it would look neat if one of you was doing a slide, turn, twist, and the other was doing…lie down, then grow, and then doing leaps all over the room. It'd look like you were just messing around, but if you're both doing grow in a different way it looks neat. (P)
>
> I want to know exactly where my hand's going. (U)
>
> It's like when you stand in dancer/s stance, you focus on that one thing, like I'm getting ready to dance. Then you're more professional. You just don't do it any kind of way. (W)

When you're spinning you got to be on the ball of your foot, you got to remember to keep your balance, you've got to tighten your muscles, you've got to point your toes. Because your whole body got to be together.... Like you know how to hold your pose right or whatever and then it just makes your body tight so you don't look like you're all over the place when you're dancing, so you don't look like a slob. (W)

In order for a movement to have its full impact, there are so many subtle things you can do. (X)

Sometimes the standard is 'doing my best':

Who cares about how I dance? Because I am giving it all I got and who doesn't like it can lump it. (Q)

I felt good about it because we went up there and we did our best. (P)

If I don't do the best that I know I can, I get really mad at myself, if I do half a job. But if I do my best, then I don't get mad at myself. (R)

I might be irritated with myself when I am not doing, performing...up to what I know I can do. (V)

Fig. 19.8 Tortoise

I was flying and flapping and I was doing something very good

Fig. 19.9 Doing something very good

We are spinning around doing a very nice spider dance

Fig. 19.10 A very nice spider dance

I'm good at it. The following anecdotes from younger students share a common trait in their expression of an inner locus of positive self-assessment:

> I was flying and flapping and doing something very good. (Fig. 19.9) (A: Bond and Deans 1997, p. 368)
> We are spinning around doing a very nice spider dance. (Fig. 19.10) (A)
> I'm a very good dancer. (F: Bond 1994b, p. 32)

I can spin real, real, real, real fast too, but I can't walk on my hands. (B)
Don't be scared. There's nothing wrong with a little stage fright. It's time to see how good you are. (L)
Good dancers don't care if someone says they are good. (O)

Confidence (believing they are capable of success) is enhanced when students experience a sense of mastery. These older students reveal their belief that they are up to the challenge:

I know I can dance and I do it. (W)
I feel confident in that what I am showing is being understood. In that confidence I can put even more into it. (X)
If I see someone doing a triple, I say, 'Gee, I'd like to try one of those.' And then I go out there and attempt a triple. (T)
I feel…a little bit more confident. When you have a better attitude toward everything, you can work at it better. (U)
I'll think, 'That's a nice move, I want to try it out.' I try and try and try so I can get it… and I find out how I can adjust my body so that it does work that way. (U)

The feeling of mastery is pleasurable:

Knowing that I can do different things gives me a sort of satisfaction. (N)
When I am dancing I feel happy. It makes me feel good to know that in the end, I have come up with a magnificent dance. (Q)
We did this combination…and we finally did it enough times that I didn't have to worry about my placement or anything. I was just doing it for the fun of it. (V)
Dance can be the cause of frustration, pain and disappointment, BUT the bliss and happiness I feel when I have achieved something or reached a goal overrides the bad points. (Z)
Doing a dance myself, getting all the footwork right, and then the feeling of it, is one of the most challenging tasks I've confronted. However, the reward is infinite. No matter how precise the movement, when performing I feel free to soar. (Y)

Likewise, the feeling of pleasure can facilitate mastery: "More funner things you do better at. (U)."

For many students, the satisfaction of meeting personal standards motivates them to continue working:

It just comes and I know I'm doing it right…if I can do it once and do the exact same thing again, then it's my dance. (L: Current 1988, p. 22)
When you do get it, you feel really good. When you don't, you know you'll have to work harder. But, a lot of times you'll work hard because you want to be good at stuff. (T)
By the end of summer I was doing quadruples…someone who couldn't even do a single the summer before. They're a challenge because I could not do them for so long. I did everything you were supposed to do in my mind but I couldn't get it down to my body. So when it came to the performance…I wanted to do more than just the singles. I started doing double single and then single double double and double double…In the second performance I just got up there…and did a triple on stage.… I just threw it in. It was like, well, why not…show what I got. And that was a really neat moment. Just being able to say I can do it and doing it. (V)

Foreshadowing the next phase of our study, we conclude this section with comments from students whose personal satisfaction is enhanced by appreciation from an audience or teacher:

In dance you know you are doing good. It's a feeling that comes through your body...or somebody'll come up and compliment you. (L: Current 1988, p. 17)

If you do something really good, you feel really good about it...When we did that and everybody clapped and stuff that really helped because we felt better about our self. (M)

You feel so proud of knowing all these people are watching you and they think you're wonderful. (D: Brown and Wernikowski 1991, p. 154)

My day that stood out was the day we did the dance for the PTSA [Parent Teacher Student Association], because I'd never performed for people, not in front of like everybody's parents and my teachers and stuff...everybody really enjoyed it and our class was proud of ourselves, for what we'd thought up. (P)

I guess the satisfaction is greater 'cause you know without a doubt that they enjoyed it... and all your hard work wasn't just for your own self-satisfaction...You have to dance for yourself but it's nice to be appreciated. (V)

19.3.3 It's Not that Simple

The previous two sections of findings may imply dichotomies that oversimplify the complexities of effort and engagement in dance. We have considerable data revealing that dance is not just easy or hard, and standards are not simply met or unmet. Classification of students as either hard workers or lazy, fearful or confident, and interested or disinterested in dance, is similarly problematic.

For example, while many students find pleasure in hard work, this comment reveals pleasure in not working: 'You don't have to work in dance class. That was the part I liked' (P). Another student found dance easy, but does not explain why: 'Dance has been the easiest thing to learn in my life. If I had this for all my school years, I'd be in the grade I'm supposed to be in' (U). The next found difficulty in classifying dance as either one or the other: 'Well, it's just that it was hard. Like most people would say, 'oh that's really easy' but it isn't...it's really hard' (J: Giguere, 2006, p. 96). Further complexity is revealed by a student who realized that having worked in dance made performance easy, 'because you knew the dance and you were up there and you knew what you were doing' (J: Giguere, 2006, p. 96).

Although meeting personal standards seemed to contribute to positive engagement for many students, some suggested that being good at dance is not necessary for participation or satisfaction:

I always do bad but dance makes you feel good. (Q)
People can do dance even if they're awful or they might not be good at it. (N)

In other examples of complexity, we found reference to simultaneous experience of emotions that might be considered contradictory. As we see in Fig. 19.11, both fear (indicated by the caption, 'Help') and happiness (indicated by a smile) accompany the accomplishment of a physical challenge (C: Bond and Richard 2005, p. 97). Similarly contradictory emotions are expressed by this student: "I feel very. nervous and very happy. (I: Wu 2005, p. 148)."

Fig. 19.11 Help!!

While self-criticism can inhibit engagement, it does not have that effect in some highly motivated students:

> We have a weekly goal and a goal for each class. After class we evaluate ourselves. Like did we accomplish our goal and, if we didn't, how we plan to accomplish it in the next class. We have 1 to 10. I usually have a 4…I feel okay right now but if…I don't have a good performance level in the next class then I would definitely drop it down. (V)
>
> I've been thinking about turnout and where you put your heel, because my turnout is my Waterloo. I have zilch!! You saw them get on me today for cheating my turnout…I know I don't have it. I knew I was cheating…now I have to make myself stop doing it. (V)

In the following comments, a focus on improvement ('getting better') appears to be the motivator:

> I get all hot and fired up to learn even more and perform even better. (Q)
>
> You might forget something but you can make it look better…you have more chance when you're older. (N)
>
> I want the correction so I can get better at it.… It just makes me work harder. (T)
>
> I want to dance better and I don't want to stop dancing. We should have two-hour dancing. (U)
>
> There's some complicated things…I'm always trying to learn it better and so I get here and work on whatever I don't understand. (U)

Finally, students describe breakthroughs, despite fear or an inner critical voice:

> I hope next time I can still learn dance. I am still shy. I don't know if I will become less shy. But I still want to join. (I: Wu 2005, p. 147)
>
> I remember the first day of dance class in school…some people wouldn't dance. They were afraid…then one day they would just break out and dance. (L: Current 1988, p. 16)
>
> This is my chance to be a really good dancer! At first I didn't think I should be there, cuz I didn't know what I was doing, and I didn't think I could dance very well. (L: Current 1988, p. 20)
>
> I might have been too serious, a little bit hard on myself. At the end of class I was feeling a lot better…starting to dance more than just execute the steps. (V)
>
> It looks hard when you first get in there…you're like 'I can't do that.' But you end up doing it anyway. So that's neat. (U)

Our concluding comment is from a previously disengaged and disruptive student whose decision to make a full commitment was transformative:

> One day I decided to participate with 100 % effort.... Me and my partner made up a good dance and everybody liked it. I think I got a hundred for that day. That was my favorite class...the dance was a good dance too. Everything was focused on, the swing, rise, fall, everything. Giving 100 % you get a whole new outlook. (P)

19.4 Discussion

Through immersion in the words, drawings, and bodily expressions of young people collected in dance education settings, we have gained much insight into what engages students in the 'work' of dance, perhaps in any form of meaningful activity. We feel inspired by students' descriptions of complex emotional connections and challenges, habits of discipline and practice, autonomy and confidence, and the pleasure of accomplishment. It is also clear that not all young people in dance classes find them consistently engaging.

Our findings directed us initially to literature on intrinsic motivation, much of which clarifies and supports what we have learned from young people in dance education. One of the most significant sources is Csikszentmihalyi's (2000) pioneering work on what he called *flow*. Primary elements of the flow experience include control of one's actions and environment, clear feedback (not from external sources, but from one's own awareness), and autotelicity (needing no external rewards). In a study of people for whom intrinsic rewards overshadowed extrinsic ones as a reason for engaging in an activity, Csikszentmihalyi noted that the deeply satisfying state of flow is experienced only when opportunities for action are in balance with skills. As many less-engaged voices in this study make clear, if challenges are too great, one may experience anxiety or worry; but if skills are greater than opportunities to use them, boredom may result.

Recent studies by arts educators draw on Csikszentmihalyi's theory of flow. Lazaroff (2001) explored links between dance performance and motivation, finding that both internal and external motivation are developed by intense physicality, positive feedback from a teacher, and the acquisition of new steps; many students in her study reported flow states in preparation for performance as well as during performance. Custadero (2002) studied flow through observational studies of children in music education and music play settings, finding that both challenge and skill predict flow experiences. She suggests that pedagogical practice should attend to flow through provision of communal settings for learning, encouragement of student autonomy, and curriculum that is 'artistically and developmentally authentic' (p. 6). Reeve (1996) refers to Csikszentmihalyi to suggest how to facilitate intrinsic motivation through uniting challenge, feedback, and enjoyment. He finds, as we did, that students may not try to learn something when they perceive that their efforts will have little or no effect, or that they have low ability.

Lepper and Henderlong (2000) provide an extensive critical review of research on motivation. A key finding is that children tend to become less motivated as they progress through school, which continues to be reflected in sources on motivational strategies for middle and secondary school students (Sirota 2006; Theobald 2006).

Lepper and Henderlong attribute the increasing apathy to conflict between young people's growing desire for autonomy and schools' increasing control, and the emphasis on performance goals over learning goals with accompanying decrease in students' self-confidence. Performance goals focus on gaining favorable evaluations (looking good, proving competence, and doing better than others). Learning, or mastery, goals focus on seeking challenge, improving competence, and understanding something new (Reeve 2005).

The distinction between learning/mastery goals and performance goals is found throughout the literature on motivation; we propose that this conceptual framework has explanatory value for our findings as well. While these two orientations are typically described as dichotomous, Lepper and Henderlong (2000) observe that they often occur simultaneously with varied and complex effects, 'sometimes negative, sometimes positive' (p. 284). The authors assert, 'It is unfortunate that children appear to value [learning goals] less and less as they progress through school' (p. 284), since learning goals may be related to intrinsic motivation. Reeve (2005) suggests, however, that students oriented toward learning/mastery goals may become bored when their skills override the challenge of a task (echoing Csikszentmihalyi), while students with performance orientations enjoy easy tasks in which they can show high ability.

Students attribute school success and failure to a variety of causes. Wiseman and Hunt (2001) identify four: ability, effort, task difficulty, and luck (p. 43). Wigfield and Eccles (2002) also discuss how beliefs about ability may affect motivation. Children who come to see ability as fixed are less likely to think that effort makes a difference; further, the need for effort may be viewed as an indication of low ability. Failure may also be perceived as low ability rather than the need for greater effort. Students may also avoid effort in order to look smart or avoid appearing dumb. Reeve (2005) suggests that performance avoidance emanates from fear of failure: 'I just want to avoid doing poorly in this class' (p. 179). Clearly, such perspectives hinder positive engagement and learning. As described by several young people, 'doing poorly' in dance is difficult to hide.

Student interest is a current focus of research (Wigfield and Eccles 2002). Shen et al. (2003) examined the extent to which prior student interest (higher in girls) accounted for differences in learning between middle school boys and girls in a square dance unit. Because girls showed greater increase in skills and knowledge during the dance unit, it was inferred that their greater personal interest was the cause. It seems obvious that students will be more motivated to learn what they are interested in, yet students' interests may not be part of core curriculum.

Current brain research elucidating the role of emotions in learning and motivation (Damasio 1999, 2003; Kytle 2004; Ellis 2005; Reeve 2005) also supports many of our findings. Neurologist Damasio (1999) explains that reasoning and decision-making may be impossible without emotional triggers to the brain that integrate

goals, decisions and action. He suggests, 'Well-targeted and well-deployed emotion seems to be a support system without which the edifice of reason cannot operate properly' (Damasio 2003, p. 42). Reeve (1996, 2005) found that positive affect facilitates engagement through its influence on students' cognitive processes, persistence in the face of failure, efficient decision-making, and intrinsic motivation. Reeve (2005) synthesized 24 theories of human motivation to generate a model of engagement that sets out specific conditions of support for psychological needs of autonomy, competence, and relatedness.

Based on young people's experiential accounts and our review of scholarly literature on intrinsic motivation, it appears that the following may trigger the commitment to hard work necessary for success in dance:

- Emotional connection/personal interest/positive affect (*I love to dance!*)
- Challenge matched by skill, and a belief that effort matters (*I like a challenge!*)
- A sense of autonomy and personal control, especially in setting standards and assessing the degree to which they have been met (*It's like I'm my own boss. I'm good at it,* and/or *I'm getting better.*)

From his perspective as a child/adolescent psychiatrist, Edward Hallowell (2002) has generated a clinically based theoretical framework that links the above aspects of intrinsic motivation not only to learning but to the larger goal of 'happiness.' He identifies two primary sources of individual happiness: the ability to create and sustain joy, and the ability to overcome adversity. Hallowell describes five steps to developing these abilities that speak directly to our study of young people's experiences of work in dance, as well as our larger study of engagement[3]: (1) Connection (with parents and teachers, activities, the arts, and oneself); (2) Play (a requirement for ground-breaking in any field); (3) Practice (gives control of the environment and facilitates discipline); (4) Mastery (builds confidence to persist through obstacles); and (5) Recognition (the feeling of being valued by others). Echoing the anxious young people in our study, Hallowell writes, 'What holds children back the most is a fear of messing up' (p. 134), yet mastery can transform fear. Hallowell suggests also that if achievement is easy, students may not reach the satisfaction of mastery, which builds confidence to overcome future obstacles.

19.5 Summary and Reflections

In this phase of our study, we started with data that we classified as 'work,' later adding terms such as 'motivation' and 'engagement.' Through succeeding stages of analysis and reading of literature, layers of complexity were revealed. What have we learned? First of all, dance is not so different from other school subjects, in that some young people are more engaged than others and may find some parts of it more appealing than others. We also found consistency between our data about dance education and literature on motivation in general. There are a variety of

[3] They are displayed here as a linear path, whereas Hallowell draws them as steps in a continuous cycle.

obstacles to active engagement in dance, including disinterest in the content, fear of failure, and lack of fit between individual skills and interests on the one hand and the content and demands of the class on the other. Students who find dance engaging and worthy of effort cite interest in activities and content, desire for challenge, and appreciation for autonomy in setting their own standards and their ability to reach them. Yet there is not always a clear distinction between engagement and disengagement; this is a continuum rather than a dichotomy.

We discovered that many young people join adults in blaming lack of effort on laziness and other personal failures. This is a long-held human belief; many adults are concerned that students who do not work in school will get into mischief, and that 'an idle mind is the devil's workshop' (Ciulla 2000, p. 4). While we both possess a well-developed work ethic and believe in its importance if students are going to achieve long-term satisfactions (Levine 2005), we also question the 'myth of laziness' (Levine 2003) and the value of a work ethic that is indiscriminately applied to all activities. Like John Dewey,

> What we are after is *persistence, consecutiveness*; endurance against obstacles and through hindrances. [Yet] Effort regarded as mere increase of strain is not in itself a thing we esteem...Effort, as a mental experience, is precisely this *peculiar combination of conflicting tendencies*—dislike (it's stressful to have progress impeded by obstacles) and longing (for the goal). (1913, pp. 46–49)

Dewey added that the negative emotion one experiences with effort (like the frustration and pain described in our study) is not necessarily a reason to give up, but should generate questioning about whether the goal is worth it.

Like Noddings (2003) we question many character traits that generations have tried to instill into children through 'propaganda-style techniques' (p. 166). For example, Noddings reflects on the lesson of 'Always do your best,' asking, 'Should we always do our best in everything, or should we choose intelligently and bravely those tasks to which we will give our best?' (p. 166). Levine (2002) and Noddings (1992, 2003) encourage us to think about education as a way to identify and develop personal affinities and consider what makes for a meaningful life.

In short, we find that the issues arising from data and literature are complex. To speak simply of 'learning should be fun' or claim that all students need to do is work hard, seems simplistic. As noted by Ryan and Deci (2000),

> Despite the fact that humans are liberally endowed with intrinsic motivational tendencies, the evidence is now clear that the maintenance and enhancement of this inherent propensity requires supportive conditions, as it can be fairly readily disrupted by various nonsupportive conditions. (p. 70)

The next phase of our study will explore some of the supportive and non-supportive conditions (social and environmental influences) necessary for engagement in dance. Many educators might dismiss findings about engagement in dance as unimportant, assuming that it is irrelevant whether or not students are engaged in anything that is not assessed by standardized tests. There are many efforts in arts education to emphasize the arts as a way to teach core academic subjects (Arts Education Partnership 1999, 2002). Dance educators have focused on the importance of learning through movement for kinesthetic learners. We agree that

movement and the arts are likely to have value in teaching other school subjects; at the same time, we question the position that the arts should simply be taught as ends in themselves (Bond and Richard 2005; Stinson 2005). Both arguments (arts as instrumental, arts as ends in themselves) seem to leave out what matters most for young people as well as adults: the creation of a meaningful life, which includes but is not limited to work. We concur with Csikszentmihalyi (2000) that education should inspire an 'abiding interest...in what makes life worth living' (p. x) and with Aristotle that 'our real work in life is the work of being human' (cited in Ciulla 2000, p. 6).

We are heartened by the growing number of voices calling for education to engage students in experiences that will help them discover their passions and build on their strengths (hooks 1994, 2003; Csikszentmihalyi 1997, 2000; Vandenberg 1997; Bond 2000; Levine 2002; Noddings 2003; Bond and Richard 2005; Stinson 2005). We recognize that such a goal is complex, and that ideas about what kind of a life and what kinds of work are meaningful have changed throughout history and cultures (Meilaender 2000). These ideas also vary across individuals and throughout one's lifespan (Ciulla 2000). It is as easy to be reductionist with regard to meaning as it is with regard to motivation.

The voices and images of young people in this research have reminded us of our own complex relationship with work, especially as we persevered through frustrating and tedious aspects of this research. Like many of the students cited, we continue to tap into 'something about dance' that inspires us to 'give 125 %.' In closing, we suggest that the experiences of these young people in dance might have something to offer to *all* educators seeking to help students persist through boredom and frustration to find that place where work and play become one.

Appendix

Data from the following sources (arranged in order by chronological age of the young people) were included in this study. Studies where we used raw data, rather than or as well as a finished paper or publication, are indicated by an asterisk (*). In cases where multiple publications resulted from the same study, only primary publications are listed.

We have struggled with issues of demographic description for the data pools, in order to document our claim that these findings appear across diverse populations. We include specific information about age and gender, as well as country and type of dance setting that was available about each data pool. It is important to note that we are not attempting to imply causality to the demographic characteristics indicated, and specifically caution against this kind of use, and note that a description of the data pool does not necessarily indicate the age/gender of a particular source. (In many studies, individuals could not be described in order to maintain anonymity for the human subjects.)

We have elected not to include any information about race/ethnicity, even if it was described in other publications drawing on the same data pool. Earlier publications have described students by color (typically black or white), race (including the term *Caucasian,* which is now widely regarded to be as outdated as the terms *Negroid* and *Mongoloid*), and cultural group (especially Latino and African–American). We find all these ways of describing difference problematic in the twenty-first century, when scientists are still debating the biological, social, cultural, and political implications of findings from the Human Genome Project (McCann-Mortimer et al. 2004). Two or three shades do not accurately describe the range of skin hues we actually see, and various terms for culture/ethnicity are not universal and are only useful if they are self-descriptions. We can summarize by stating that most of the public school populations were described by the researchers either as culturally diverse or primarily individuals from minority groups, while most studio populations were described as white middle class.

A*: 38 children ages 3–5 (23 girls) from an early learning centre in Victoria, Australia (Bond and Deans 1997; Bond 2001).

B*: one boy age 4 from a Master of Education intergenerational performance project, Temple University, Department of Dance, Pennsylvania, USA (McGuigan 2002).

C: 25 children ages 9–10 (14 girls) in grade 3 charter school, Pennsylvania, USA (Bond and Richard 2005).

D: 23 students ages 9–16 from school and community settings in Canada (Brown and Wernikowski 1991).

E: 6 non-verbal deaf-blind children (4 boys) ages 6–9 in a residential educational facility, Victoria, Australia (Bond 1991, 1994a, 2008).

F: 14 children ages 5–8 (8 boys); public elementary school in Victoria, Australia (Bond 1994b).

G: 90 children ages 6–14 (gender balance); special education, upper elementary and middle school groups in a cultural arts project in Saipan, Commonwealth of the Northern Marianas Islands (Bond 1999).

H: Students in grades K-6 (primarily low-income Latino) from an after-school class in California, USA (Lazaroff 1998a, b).

I: 12 third graders (7 girls) from an elementary school in Taiwan (Wu 2005).

J: 16 5th grade children ages 11–12 (12 girls) in a public elementary school, Pennsylvania, USA (Giguere 2006).

K*: 192 3rd–6th grade boys and girls (diverse ethnicities) from a project for talented dancers selected from public schools in New York City (BrooksSchmitz 1990).

L: 3 boys ages 10–12 (diverse ethnicity and socio-economic class) from both public school and community setting in North Carolina, USA (Current 1988).

M: small number of 10–12-year-olds from a short-term project in urban Canada (Krohn 1995).

N*: 40 students ages 10–15 (80 % female) from school and studio settings in rural Canadian communities (data contributed by Ann Kipling Brown).

O: 4th and 5th grade boys and girls from a public school in North Carolina, USA (Waegerle 1997).

P*: 51 students (70 % female) from two middle schools (one private, one public) in North Carolina, USA (Stinson 1997).

Q: 11–14-year-old boys and girls from a large and diverse public school in North Carolina, USA (Mosteller and Davidson 2002).

R: 11 girls (ages 11–18) from a studio in North Carolina, USA (Kinzer 1997).

S: Middle school studio (Crabtree 1989).

T: 4 girls ages 12–13 from ballet studio in South Carolina, USA (Slowinski 1995).

U*: 36 students (33 girls, diverse ethnicities and socio-economic class) from a public high school in North Carolina, USA (Stinson 1993a, b).

V*: 7 16–18-year-old girls from dance studios in North Carolina, USA (Stinson et al. 1990).

W*: 6 students (4 girls) from public performing arts high school, New York (Koff 1995).

X*: One 17-year-old girl from a classical Indian dance company in Victoria, Australia (Vlassopoulos 1995).

Y*: UK high school student evaluating international dance conference.

Z*: Girls ages 13–18; raw data shared by a studio dance teacher in South Africa.

Commentary

As stated in the chapter, this work was part two of a long term collaborative project. When Karen Bond and I began work on part one, we experienced much of the "intellectual tension" (Wasser and Bresler 1996, p. 10) that make collaboration both exciting and challenging. We even ended up publishing that work (Bond and Stinson 2000/2001) with two different conclusions, reflecting our different perspectives. By the time we were ready to begin part two, we seemed to have worked through many of the challenges; it also helped, of course, that this time we were living in the same country and could have most of our passionate discussions in person rather than online! One of the more interesting differences we experienced with this project was the metaphors we used to talk about challenge. I thought challenge was like a mountain: Some students only want to attempt the climb if the mountain is high enough, while others would not try if they thought it was too high. Karen, in contrast, saw challenge as a horizontal space to be crossed. We eventually resolved our dilemma by deciding that neither metaphor was essential.

With both parts of this project, Karen and I developed Reader's Theater style performances (Donmoyer and Yennie-Donmoyer 1995) for multiple venues, including national and international conferences as well as University sites. We created a script and cajoled various colleagues and/or students as cast members, held one rehearsal to practice the movement, slide changing (for the visuals) as well as the text, and were ready to go. These presentations allowed the data to be experienced as theatre, which seems especially appropriate. With this study and

others using the words of young people, I always "fell in love" with the data, and frequently interrupted friends and family members as well as colleagues with a passionate, "Listen to this one!" So staged performances of the work allowed us to share with appreciative audiences.

References

Arts Education Partnership. (1999). Champions of change: The impact of the arts on learning. Retrieved 11 Oct 2006, from www.aep-arts.org.

Arts Education Partnership. (2002). Critical links: Learning in the arts and student academic and social development. Retrieved 11 Oct 2006, from www.aep-arts.org.

Bond, K. E. (1991). *Dance for children with dual sensory impairments*. Unpublished PhD thesis, La Trobe University, Bundoora.

Bond, K. E. (1994a). Personal style as a mediator of engagement in dance: Watching Terpsichore rise. *Dance Research Journal, 26*(1), 15–26.

Bond, K. E. (1994b). How 'wild things' tamed gender distinctions. *Journal of Physical Education, Recreation and Dance, 65*(2), 28–33.

Bond, K. E. (1999). Perspectives on dance therapy: The lived experience of children. In J. Guthrie, E. Loughlin, & D. Albiston (Eds.), *Dance therapy collections II* (pp. 1–7). Melbourne: Dance Therapy Association of Australia.

Bond, K. E. (2000). Revisioning purpose: Children, dance and the culture of caring. In J. E. LeDrew & H. Ritenburg (Eds.), *Extensions and extremities: Points of departure – Proceedings of the 8th Dance and the Child International Conference* (pp. 3–14). Saskatchewan: University of Regina.

Bond, K. E. (2001). 'I'm not an eagle, I'm a chicken!' Young children's perceptions of creative dance. *Early Childhood Connections, 7*(4), 41–51.

Bond, K. E. (2008). The human nature of dance: Towards a theory of aesthetic community. In S. Malloch & C. Trevarthan (Eds.), *Communicative musicality: Narratives of expressive gesture and being human* (pp. 401–422). Oxford: Oxford University Press.

Bond, K. E., & Deans, J. (1997). Eagles, reptiles and beyond: A co-creative journey in dance. *Childhood Education, 73*(6), 366–371.

Bond, K. E., & Richard, B. (2005). 'Ladies and gentlemen! What do you see? What do you feel?' A story of connected curriculum in a third grade dance education setting. In L. Overby & B. Lepczyk (Eds.), *Dance: Current selected research* (Vol. 5, pp. 85–134). New York: AMS Press.

Bond, K., & Stinson, S. W. (2000/2001). "I feel like I'm going to take off!": Young people's experiences of the superordinary in dance. *Dance Research Journal, 32*(2), 52–87.

BrooksSchmitz, N. (1990). *Young Talent Research Project: An analysis of the effect of arts-in-education programming on the motivation, academic performance and personal development of inner city youth involved in the Young Talent Project*. Unpublished manuscript.

Brown, A. K., & Wernikowski, C. M. (1991). What I want to say: The child speaks. In S. W. Stinson (Ed.), *Proceedings of the 1991 conference of Dance and the Child: International* (pp. 151–158). Salt Lake City.

Ciulla, J. B. (2000). *The working life: The promise and betrayal of modern work*. New York: Times Books.

Crabtree, K. (1989). *Understanding the dance teacher-student relationship as told by adolescent dancers*. Unpublished manuscript, University of North Carolina Greensboro.

Csikszentmihalyi, M. (1997). Assessing aesthetic education: Measuring the ability to 'ward off chaos.' *Arts Education Policy Review, 99*(1), 33–38.

Csikszentmihalyi, M. (2000). *Beyond boredom and anxiety: Experiencing flow in work and play* (25th anniversary edn). San Francisco: Jossey Bass.

Current, J. S. (1988). *The meaning of dance for young public school dance students: An interpretive inquiry.* Unpublished masters thesis, University of North Carolina Greensboro.

Custadero, L. A. (2002). Seeking challenge, finding skill: Flow experience and music education. *Arts Education Policy Review, 103*(3), 3–9.

Damasio, A. R. (1999). *The feeling of what happens: Body and emotion in the making of consciousness.* New York: Harcourt Brace.

Damasio, A. R. (2003). *Looking for Spinoza: Joy, sorrow and the feeling brain.* London: Harcourt.

Denzin, N. R., & Lincoln, Y. (Eds.). (2000). *Handbook of qualitative research* (2nd ed.). Thousand Oaks: Sage.

Dewey, J. (1913). *Interest and effort in education.* Boston: Houghton Mifflin.

Donmoyer, R., & Yennie-Donmoyer, J. (1995). Data as drama: Reflections on the use of readers theater as a mode of qualitative data display. *Qualitative Inquiry, 1*(4), 402–428.

Ellis, C., & Bochner, A. P. E. (Eds.). (1996). *Composing ethnography: Alternative forms of qualitative writing.* Walnut Creek: AltaMira.

Ellis, R. D. (2005). *Curious emotions: Roots of consciousness and personality in motivated action.* Philadelphia: J. Benjamins.

Giguere, M. (2006). *The mind in motion: An examination of children's cognition within the creative process in dance.* Unpublished PhD dissertation, Temple University, Philadelphia.

Gilbert, K. R. (Ed.). (2001). *The emotional nature of qualitative research.* London: CRC.

Hallowell, E. M. (2002). *The childhood roots of adult happiness.* New York: Ballantine.

hooks, B. (1994). *Teaching to transgress: Education as the practice of freedom.* New York: Routledge.

hooks, B. (2003). *Teaching community: A pedagogy of hope.* New York: Routledge.

Kinzer, A. (1997). *An interpretive study of female adolescent dancers: Their perceptions of the dance competition experience.* Unpublished manuscript, University of North Carolina Greensboro.

Koff, S. R. (1995). *Meaning making through the arts: Description of an urban high school's arts-based program.* Unpublished doctoral dissertation, Temple University, Philadelphia.

Krohn, J. M. E. (1995). *Exploring an arts education partnership through interpretive inquiry.* Unpublished masters thesis, University of Regina, Saskatchewan.

Kytle, J. (2004). *To want to learn: Insights and provocations for engaged learning.* New York: Palgrave Macmillan.

Lazaroff, E. M. (1998a). *Children's experiences in dance education.* Unpublished manuscript presented at annual conference of American Educational Research Association, San Diego.

Lazaroff, E. M. (1998b). *Thinking on their feet: A study of children's experiences in an elementary school dance course.* Unpublished doctoral dissertation, Stanford University, California.

Lazaroff, E. M. (2001). Performance and motivation in dance education. *Arts Education Policy Review, 103*(2), 23–29.

Lepper, M. R., & Henderlong, J. (2000). Turning 'play' into 'work' and 'work' into 'play': 25 years of research on intrinsic vs. extrinsic motivation. In C. Sansone & J. Harackiewicz (Eds.), *Intrinsic and extrinsic motivation: The search for optimal motivation and performance* (pp. 257–310). San Diego: Academic.

Levine, M. (2002). *A mind at a time.* New York: Simon & Schuster.

Levine, M. (2003). *The myth of laziness.* New York: Simon & Schuster.

Levine, M. (2005). *Ready or not, here life comes.* New York: Simon & Schuster.

McCann-Mortimer, P., Augostimos, M., & LeCouteur, A. (2004). 'Race' and the Human Genome Project: Constructions of scientific legitimacy. *Discourse & Society, 15*(4), 409–432. Retrieved 13 Oct 2006, from http://das.sagepub.com/cgi/reprint/15/4/409.

McGuigan, V. (2002). *Urbanites.* Unpublished master of education thesis, Temple University, Philadelphia.

Meilaender, G. C. (Ed.). (2000). *Working: Its meaning and its limits.* Notre Dame: University of Notre Dame.

Mosteller, T. H., & Davidson, A. (2002). *Free to be me, free to find me: Dance education and the adolescent search for identity.* Unpublished manuscript, University of North Carolina Greensboro.

Noddings, N. (1992). *The challenge to care in schools: An alternative approach to education*. New York: Teachers College Press.

Noddings, N. (2003). *Happiness and education*. Cambridge: Cambridge University.

Prasad, P. (2005). *Crafting qualitative research: Working in the postpositivist traditions*. Armonk: M.E. Sharpe.

Reeve, J. (1996). *Motivating others: Nurturing inner motivational resources*. Boston: Allyn & Bacon.

Reeve, J. (2005). *Understanding motivation and emotion*. New York: Wiley.

Ryan, R. M., & Deci, E. L. (2000). Facilitation of intrinsic motivation, social development, and well-being. *American Psychologist, 55*(1), 68–78.

Shen, B., Chen, A., Tolley, H., & Scrabis, K. A. (2003). Gender and interest-based motivation in learning dance. *Journal of Teaching in Physical Education, 22*(4), 396–409.

Sirota, A. J. (2006). *The heart of teaching: Creating high-impact lessons for the adolescent learner*. San Francisco: Jossey-Bass.

Slowinski, C. (1995). *Mastery learning goals: Interpreting motivations of adolescent ballerinas*. Unpublished manuscript, University of North Carolina Greensboro.

Stinson, S. W. (1993a). Meaning and value: Reflecting on what students say about school. *Journal of Curriculum and Supervision, 8*(3), 216–238.

Stinson, S. W. (1993b). A place called dance in school: Reflecting on what the students say. *Impulse: The International Journal for Dance Science, Medicine, and Education, 1*(2), 90–114.

Stinson, S. W. (1997). A question of fun: Adolescent engagement in dance education. *Dance Research Journal, 29*(2), 49–69.

Stinson, S. W. (2005). Why are we doing this? *Journal of Dance Education, 5*(3), 82–89.

Stinson, S. W., Blumenfeld-Jones, D., & Van Dyke, J. (1990). Voices of young women dance students: An interpretive study of meaning in dance. *Dance Research Journal, 22*(2), 13–22.

Theobald, M. A. (2006). *Increasing student motivation: Strategies for middle and high school teachers*. Thousand Oaks: Corwin.

Vandenberg, D. (Ed.). (1997). *Phenomenology and educational discourse*. Johannesburg: Heinemann.

Vlassopoulos, K. (1995). *Perceptions of transformation in Mohiniattam: An educational perspective*. Unpublished master of education thesis, University of Melbourne.

Waegerle, M. (1997). *The rational and transcendent in bodily-kinesthetic intelligence*. Unpublished manuscript, University of North Carolina Greensboro.

Wasser, J., & Bresler, L. (1996). Working in the interpretive zone: Conceptualizing collaboration in qualitative research teams. *Educational Researcher, 25*(5), 5–15.

Wigfield, A., & Eccles, J. (Eds.). (2002). *Development of achievement motivation*. San Diego: Academic.

Wiseman, D. G., & Hunt, G. H. (2001). *Best practice in motivation and management in the classroom*. Springfield, IL: Charles C. Thomas.

Wu, Y. (2005). *Dancing with Little Spirits: Towards enhancement of pedagogical relationship and inter-subjectivity between teacher and students in a third grade setting in Taiwan*. Unpublished PhD dissertation, Temple University, Philadelphia.

Part III
Finale

Prelude to Part III

Three aspects of my life—the art in which I found a home, teaching young people and prospective teachers, and doing research—have all influenced each other so much that it becomes difficult to separate them. The concluding chapter of this volume acknowledges their connection. While on the one hand, it is about my own life, I trust that it speaks well beyond my personal journey. May it help to light the way for discoveries by the next generation of arts educators and scholars, ones I have not even imagined, as we all venture into the unknown.

Chapter 20
Dance/Teaching/Research: The Practice of Living (2015)

Susan W. Stinson

Abstract In her transition from a long professional career in dance education and research to an unknown future, the author questions, "How do we create what we will become out of what we have been?" She finds that the significant life roles in her past have not so much been abandoned but rather transformed into the person she is becoming in the next phase of her life. In this essay, she shares reflections on how her life in dance became part of her teaching, how both became incorporated into her understanding of research, and how all are related to the larger project of living.

Transitions usually offer a time for reflection, and my own life is a case in point. In 2012, I stopped teaching after more than three decades at my university, becoming an interim dean and then retiring a year later. I had planned the date of my retirement for some years, but when it arrived, I had only a general sense of how to respond to colleagues who asked, "Now what?" I knew that I wanted to make the next chapter of my life something different, rather than continuing to do the same work on a less intense basis: Some underdeveloped parts of myself were calling me. I was ready to make a change, and yet the person who arrived at this point in time had been significantly shaped by the activities of the majority of my years, especially in the academic triad of teaching/research/service, and the specific discipline of dance. How do we create what we will become out of what we have been?

I hoped my own transition to retirement would be made easier by the fact that different facets of my professional work have always felt like parts of the same whole. My research most often grew out of challenges encountered in teaching, so that being a teacher and being a scholar were extensions of each other. Often I began a study because I found insufficient research by others on a topic I was teaching. While I engaged in reflexive and action research in which I explicitly examined my own teaching (e.g. Stinson 2001, 2005; Dils and Stinson 2009), issues I encountered in the classroom whisper, at least, in most of my work. Beginning early in my career and continuing throughout, I wrote about my moral struggle in creating curriculum and pedagogy that were consistent with my values, ones I continued to question,

© Springer International Publishing Switzerland 2016
S.W. Stinson, *Embodied Curriculum Theory and Research in Arts Education,*
Landscapes: the Arts, Aesthetics, and Education 17,
DOI 10.1007/978-3-319-20786-5_20

especially when I found I was making decisions which contradicted them. In recent years, with the increasing emphasis on outcomes-based assessment in teacher education, I reflected deeply on ethical issues in assessment (Stinson 2009, 2013, 2015).

Further, my approach to questions I pursued in research and teaching usually had a great deal to do with my life outside of the academy. Having been inspired by Madeline Grumet's work (1988) while a young scholar and mother, I found stories from my life with children informing my scholarship, and the insights I gained in my work enhanced my parenting and grandparenting. For example, reflecting on my children's intrinsic motivation to master physically challenging skills (Stinson 2002) made me rethink my own neglect of such skills in dance education in favor of creativity and "self-expression." My growing interest in *challenge* bloomed in a larger study examining young people's experiences of effort and achievement in dance (Bond and Stinson 2007). I hear the voices of kids in that study now when I encourage my grandson to "keep going even when it's hard," wanting him to experience the satisfaction of mastery.

But as I contemplated my transition, I was less certain about my own desire to "keep going" with the professional issues I had been dealing with for so many years. Just before I retired, I reluctantly accepted an invitation to guest lecture on dance research for a few days at an institution beginning a new graduate program.[1] I feared inauthenticity if not incompetence, wondering how I could legitimately teach about research when I had initiated no new research in over a year. And because my research agenda was so connected to my teaching, I could not imagine continuing the former without the latter. But as I prepared for these lectures, I realized that my understanding of research, so deeply informed by my understanding of dance and teaching, was still alive, continuing to guide my thoughts about how to live a meaningful life, whether retired or not. Being an artist/educator/researcher has given me a way of being a person-in-the-world which I take with me, because it has become so much of who I am. The significant life roles in my past have not so much been abandoned but rather transformed into the person I am becoming in the next phase of my life. In this chapter, I will share reflections on how my life in dance became part of my teaching, how both became incorporated into my understanding of research, and how all are related to the larger project of living.

20.1 Lessons from Dance

When people ask me if I "still dance," I tell them that I stopped performing and making dances many years ago. But as a former dancer—or perhaps a forever dancer—I found that I could have similar experiences outside the dance studio, in teaching, research, and more. Here are some of the lessons from dance that I took with me into other parts of my life:

[1] Dans-och cirkushögskolan, DOCH, now part of Stockholm University of the Arts.

20.1.1 Dance as a State of Consciousness

I came to this understanding through teaching dance to children, and asking myself what the difference was between dancing and just moving around. Since I called myself a *dance* teacher and not a *movement* teacher, I wondered how I could facilitate more of the former, i.e., more dancing than just moving. Eventually I came to understand dancing as being more of a state of consciousness than an activity. The state is one of being fully present in the moment, paying attention to what the movement feels like on the inside (something we now call somatic awareness) as well as what it looks like on the outside. In my teaching of children, I was quite explicit about the difference between just moving and dancing, and I found that even 3–5 year olds could make the distinction (Stinson 1988, 2002).

In this state of consciousness I call dancing, I am more attuned not only to who I am, but to others and the world beyond. For example, I notice curves and angles around me while feeling them inside myself, perceiving the world through my whole body, not just my eyes. Similarly, basic movements of advancing and retreating, rising and sinking, tensing and relaxing, bending/straightening/stretching, closing and opening, balancing and falling—all are basic organizing principles in the physical world, which I can see around me if only I notice. Paying attention to my internal state while experiencing these principles as a mover, offers me further understanding of how they are working in other aspects of my life. For example, exploring the need to go off balance and then fall in order to move beyond where I am physically, helps give me courage to experience the risk of doing so in other ways. I know in my body that taking a single step requires going off balance: We can't go anywhere unless we are willing to fall. Through reflection on these experiences, I came to know my body as a laboratory for learning not just about myself but also about the world, and about connecting inner and outer.

But I learned far more in the art I lived in for so long. Through dancing, I experienced the joy of feeling fully alive—"wide awake," in the words of Maxine Greene (1978)—reminding me that such states are possible and worth cultivating, and not just while dancing. One can easily go through life on automatic, as though anaesthetized to joy as well as other feelings, and the aesthetic experience can be a powerful wake-up to consciousness.

I do not wish to imply that all of my dancing was joyful, for there were also times of struggle and even despair, as in other parts of life. It required courage to make myself vulnerable and publicly visible as a dancer. I admit I loved the hard physical work of dancing, and took pleasure in achieving greater strength and flexibility through discipline and commitment, even when I did not achieve the unrealistic goal of "perfection." Because of my strong work ethic, a harder lesson for me to learn was to stop pushing long enough to *allow* change to happen in my body, trusting that my inner body sensibility would work things out even when I did not consciously understand and could not make them happen through force of will and training.

Through dance I also learned to value the sense of security achieved in following directions from an authority as well as the freedom of "making it up as you go along," and that greater creativity can result when improvising within boundaries or a structure of some sort. I appreciated the community I experienced in dancing with others, as well as the times of solitude. I learned from good teachers, mentors, and colleagues, and also the inner teacher I had to cultivate within myself.

20.1.2 Dance as Creating

Going beyond dancing to choreography, there were additional lessons that I took into my life as an educator and researcher. The process for creating a dance is quite similar to that used in other human creations, such as lesson plans or a research project. As a choreographer, I often went into an empty studio with some ideas, but without a clear sense of either form or content; if either *is* initially clear, it often changes before the work is complete. One pays attention to the movement created or generated by dancers, and makes decisions about what does and does not fit. This is a time of trying out, false starts, unfinished phrases. One looks for relationships, decides what is important, and eventually both form and content, and ultimately meaning, become clear. There is a good bit of messiness along the way, all trial and error. One hopes for patient dancers and for a muse that will speak as quickly and as clearly as possible. But it was indeed an act of faith to go into the studio, trusting that a dance would result from my labors.

As in dancing, a choreographer must pay attention throughout, so there is a heightened state of awareness during the process of creating original work. If work is to impact others, the awareness is a connection between inner and outer: A good choreographer avoids falling too much in love with a creation and knows when to use the external eye of a critic. There are times of joy, but also struggle and despair; I recall moments when I questioned whether I was creating anything of value. There is a need for disciplined commitment and hard work (having dancers scheduled to show up at a definite time for rehearsal is a powerful motivator for doing one's homework), as well as setting the work aside so that the subconscious can resolve the "stuck" places.

20.1.3 Dance as Interpretation

In more recent years of my dance education career, with changes in the state-mandated curriculum for public school dance, I started to pay more attention to the practice of critically and reflectively *watching dance* as a member of an audience. An engaged observer invests a certain kind of attention. Some works are highly visceral and grab my attention, but with others, I have to choose to engage, to look for the treasures I might find, even with no guarantee that they will be there. In some

dances, meaning is readily apparent, but with others I have to make a conscious decision to raise my own questions in seeking to make sense of what is before me. Sometimes I have to accept my lack of understanding. Listening to meanings found by others in the same work, and questions they asked in order to find them, adds to my own efforts. The practice of watching dance performance especially attunes me to the need for rhythm: There are times for being in the present moment, feeling myself *in* the dance as I watch it, and times for reflecting. Like dancing and dance-making, it is a way to understand ourselves, others, and the world we share—which is also a good way to describe research.

20.2 Lessons from Teaching

Building on what I knew from my dance experiences, becoming a teacher expanded who I was in ways that impacted my research and my life as a whole. I was still dancing in the traditional sense when I began teaching, but found, upon the arrival of a second child and a university tenure track position, that I could not do everything. I "stopped dancing," but really didn't. Instead, I created a life as an educator that was still about a heighted consciousness, being as fully present in my body/mind as I was when performing. Before class, I put many hours into preparation, trying to create a time together that I hoped would satisfy my aesthetic sensibility (see Grumet 1989) as well as help students learn. I found that the discipline and hard work of preparation allowed for spontaneity in the moment: I could put aside my lesson plan because I had done so much thinking and imagining ahead of time. As in improvised dancing, structure and boundaries gave me the security to improvise.

This, however, was a level of understanding I grew into. Initially I felt like I was playing dress-up as a teacher, certain that I didn't know enough myself to teach others. Indeed, I became better at a variety of dance skills in the process of figuring out how to teach them. By the time I reached my mid-30s, I began to feel more legitimate in teaching children, but still felt like a fraud teaching university students about teaching. Gradually I came to understand that my identity as a university dance educator was not about being an expert with all the answers, but being a fellow traveler with my students: perhaps one who has been there before, but seeing with new eyes and thus seeing new things. Such seeing, of course, is critical for a researcher.

Even as this definition of my professorial role gave me more confidence, I continued questioning myself about everything I taught, recognizing all I did not know and would never know. This kind of reflection became the core of my life as a curriculum theorist and researcher. At some point, I became more accepting of not-knowing, and rather liked it. In fact, I started defining good teaching as being more about having questions than having answers. Being certain I was right, like being perfectly in balance, would mean staying stuck in the same place (and never needing to do more thinking or research).

Teaching also opened in me greater respect for differences, for appreciating skills and knowledge my students had that I didn't. Once I no longer needed to feel like the ultimate expert, I could learn from them, a critical awareness for the relationships I would have with research participants. Akin to what I was discovering as a parent about the same time, teaching became not about reproducing myself but rather helping students become who they chose to be. I regret that my ego sometimes got in the way, dressed up as the caring savior: When seeing my students struggling with problems for which I had already found a good answer, there were times I too readily shortchanged their opportunities to make their own discoveries.

20.2.1 Teaching as Moral Praxis

Even beyond specific pedagogical skills and techniques such as team-based and problem-based learning, I attempted to be the kind of educator I hoped my own children would have in college, and the kind of person I wanted to live with. My previous experience teaching in a Quaker school had helped me value cultivating the inner teacher within every student. During my doctoral work, I drew inspiration from Martin Buber (1955, 1958), and became conscious of the difference between treating students as subjects and as objects, a consciousness that extends to research participants as well. (See Bresler 2006, for an especially thoughtful application of these ideas to research.) This led to even more intense questioning as to whether or not I was teaching—and thus living—in accordance with my values. While I often came up short, I valued the humility which resulted from this consciousness; such humility was a constant companion in my teaching and research.

I came to know the concept of Praxis through the work of Brazilian educator Paulo Freire (1983), as *reflection and action upon the world in order to transform it*. I saw my teaching of prospective educators as a way to transform the world of dance education, especially by bringing to light moral issues embedded in how we teach, as well as how young people experienced dance. While I frequently taught and wrote about social justice issues in dance education (e.g., Stinson 1985; Risner and Stinson 2010), however, I often wondered to what degree I was avoiding dealing with larger issues of social justice, hiding out in my own safe world of dance education.

20.3 Research as the Practice of Dance, Teaching, and Living

My research life started when I began my university tenure track position. As a mother of young children and committed teacher/mentor, I had to find ways to make research integrated into my life as a whole person. Research for me was always another way to practice all the lessons I have described thus far.

20.3.1 Research as a State of Conscious Awareness

For me, being a researcher, like being a dancer, has to do with how we perceive the world. Choreographers find ideas for dances everywhere, and the same carried over to my research. Unlike many researchers, I never had to shape my agenda around what grant money was available so had the luxury of selecting my own questions, based on what seemed important. I found potential research questions everywhere, appearing in such disparate circumstances as when teaching a class, talking on the phone with an adult child, or getting lost. Here are some examples:

> How should I respond to this intriguing question asked by a student during class, one I have never thought about before? Do I feel the need to be an authority, or can I be a fellow seeker? How does my answer relate to my pedagogical values?
>
> How can I as a parent get better at keeping my mouth shut when I just need to listen to this young man—now an adult, but still my child? How does this skill relate to teaching? To art-making?
>
> How am I responding to getting lost? Is it a cause for anxiety, or excitement at the possibility for adventure and discovery? What does my response tell me about being an educator, an artist, a person? How do others respond to getting lost?

Any of these would make intriguing research questions for arts educators. And any of them could be missed if we do not stay open to finding them while doing other things.

But selecting a research topic cannot be just about satisfying my own curiosity; I tried to remain conscious of the moral implications of my work. The easy part of this is following ethical guidelines for dealing with research participants. I found unexpected challenges, however, in research involving interviews with young people. It was a dilemma when some revealed stories and interpretations that shed negative light on their teachers, the very ones who had been so helpful in arranging the interviews.

A research focus prompting these interviews began with what felt like an ethical position, a mission to bring the then-absent voices of young people into the dance education research literature through listening to and then respectfully analyzing the stories of their experiences in dance. But the work of some critical social researchers, such as Jean McNiff (2013), makes me question myself. McNiff writes that any kind of research in which one person attempts to speak on behalf of another is unethical. She grounds this position in a value for human rights, including those of people who have a long history of having things done to them by those who think they know better, whether the "experts" are military invaders, so-called "benevolent" dictators, physicians who make patronizing decisions for their patients—or well-meaning educators. While recognizing the complexity of this issue and the value of listening to and sharing the voices of others, I wish now that I had not just collected stories from young people, but also given them an opportunity to participate in interpretive stages of the research. Fortunately, research consciousness continues to evolve, both on an individual level and in the field as a whole.

20.3.2 Research as Disciplined Practice: Making Time for What Matters

So maintaining consciousness, of possibilities and also of ethical issues, is the ground from which a life in research springs. At the same time, incorporating such consciousness into everyday life doesn't mean that there is no need for disciplined, committed work. I have always been impressed by stories of professional novelists who go daily to a special writing place, engage in their chosen rituals and sit down to write as an act of faith, even if the words that come out are drivel on any particular day and end up in the trash. Similarly, yoga practitioners take their mats and water bottles to their places of practice even when tired, and choreographers schedule rehearsals even when not feeling inspired. When actively engaged in a particular project, I think this discipline is necessary for researchers, too. Work doesn't get done for most of us unless it gets scheduled into our calendars as an activity that matters, not as something to do in an hour here or there when nothing else is going on.

I might be able to *find* a research question while folding the laundry (e.g., "when is order important and when does it get in the way?") but I can't make decisions about how to pursue it without the discipline of sitting down to write. If my research question takes me out into the field to observe or interview others, I of course will have a pre-determined schedule of dedicated time. But all too many research projects get aborted after collecting data (the fun part that involves observations, interviews, or other meaningful interactions with others). After that, unless working collaboratively, it can get really lonely, and *hard*.

20.3.3 The Rhythm of Research

When doing the difficult work—wading through dense literature, or puzzling through mounds of data searching for what is meaningful and what patterns may lie hidden—the disciplined commitment to practice can get us through. So can getting up and taking a break (that's really what folding the laundry can be good for!), as long as we are committed to returning.

So there is a rhythm to research just as there is to choreography and teaching, because we do the work on more than a conscious level. Once we are really engaged, the work does not end just because it is now noon, the end of one's dedicated time, with a meeting to attend. Life as a researcher is not lived within carefully kept boundaries. One morning, I may have reviewed literature on my topic for 3 hours and thought I found nothing of significance, but when walking to the afternoon meeting about something totally different, I got a flash about how both the literature and the walking were related to my research. As I read a bedtime story to my grandchild that night, an insight about the main character somehow seemed connected. In other words, once a research project is begun, *everything* seems related. And of course, rhythm is about relationships.

Through this rhythm—flowing between the hard work, the "pushing on" during dedicated time and the open "allowing" outside the boundaries—we find breakthroughs. This is especially true when it has to do with the interpretive part of research. What does this data mean? Is there anything of significance? What *is* going on here? When writing, I often have an intuitive sense that it is going to come together before I can say how, but have to return to the computer and the work of writing before it can take shape. This doesn't happen just once, at least for me. I experience being stuck multiple times, but with commitment to the process, the breakthroughs come. And of course, I have to stay alert to avoid being seduced by thinking I have "the answer," listening carefully to my inner critic (while making sure she does not paralyze my thinking).

20.3.4 Body Knowing

In my own research, my lived body has been a powerful source for understanding my data and discovering theoretical frameworks. I have written previously (Stinson 1995, 2006) about how I found the theoretical framework for my dissertation through my body:

> I was struggling with a very abstract topic: the relationship between the ethical and the aesthetic dimensions of human existence as they related to dance education. All of my attempts to figure out my theoretical framework felt disconnected from the concerns that had initially propelled me into the study. At the suggestion of my advisor, I began to write a series of pieces describing moments that seemed important in my life, regardless of whether I knew why they were important. These stories were full of sensory language, because it was in my senses that my memories were stored. Some were stories of dancing, while others came from other parts of my life as a child, a mother, a student, a teacher, a friend. As I tuned in to these experiences, my awareness of everyday life was heightened. One day, still searching for my elusive framework—the form that would reveal the content—I went for one of those long walks that were a necessary part of my thinking process. When I returned, I lay down to rest and instantly became conscious of how differently I perceived myself and the world when I was standing compared to when I was lying down. Within moments I knew my framework, which was based upon a metaphor of verticality (the impulse toward achievement and mastery—being *on top*) and horizontality (the impulse toward relationship and community—being *with*). I noticed how lying horizontal felt passive and vulnerable, while the return to vertical made me feel strong and powerful; these feelings offered important insights as to why we value achievement so much more than community. Once I had identified this dual reality in my own body, I found it in the work of others: in Fromm (1941), who spoke of freedom and security; Bakan (1966), agency and communion; and Koestler (1978), self-assertion and integration. While I had read each of these authors previously, I had to find my framework in my own body before I could recognize its connection to the issues with which I was grappling. (Stinson 2006, pp. 206–207)

Any kind of activity—especially ones that involve movement—can be equally generative. Because, at some level, everything in life is, I think, deeply connected; it's just that we are usually unaware of the relationships.

20.3.5 Cultivating Companions

I have already mentioned the community nature of much of my experience of dance. We usually think about research as a solo endeavor, and indeed there are times when I experience it as a lonely, individual activity. But collaborative research is increasingly becoming the norm, and most of my best experiences in research have been collaborative. And although I have not experienced the kind of research team described by Wasser and Bresler (1996), I share with them the recognition that all research is in some way collaborative. Our cited sources, and all others whose ideas and images we have absorbed into our own consciousness, allow us to create what feels like new work.

Even when I was a solo author, the participants in my research felt like companions, as I listened to their voices over and over, seeking to understand what they were telling me. I have had other valued traveling companions in projects primarily conceived of as solos. They are ones who gave me not just critique, but also courage. For new researchers, a mentor or teacher is essential, but eventually, one becomes one's own teacher and most rigorous critic. However, someone outside our own minds, someone we trust to be honest, can help keep us out of the minefields of self-indulgence, faulty logic, and overly-dense expression. I have always cherished being able to share a work in progress with a colleague, with a request to be critical enough to save me from embarrassing myself. I learned that I needed to cultivate such treasures by being willing to do the same for them, and not to abuse them by asking too much or too frequently. I was fortunate that some of them became collaborators on later projects, where we negotiated the new challenges of writing as a duet.

20.3.6 Research as the Practice of Persistence and Courage

For me, starting to write a scholarly paper is just as much an act of faith as is creating a dance, and the process is just as messy. Initial drafts are a kind of written improvisation, a time of trying out with many false starts and unfinished sentences. I experience the frustrations of trying to get ideas down before they disappear, of trying to figure out how the puzzle goes together even before I know what picture the puzzle makes. It is important not to fall too much in love with my own words or those of my respondents, because large amounts of this material may get thrown away, or at least thrown away from this project when it turns out to be heading in a different direction than originally expected. There are times when I wonder if it ever will become something worth keeping. This is the inner part of writing, the part a reader never sees.

Preparing a research report or presentation involves a different kind of courage and much more discipline. In teaching, one needs to think not only about oneself, but also about the impact one hopes to make on others. Similarly, in research as well

as choreography, good practitioners look critically at the outcome of their work and shape it so it will mean something to others, not just themselves. This is called *editing*, but it's really about the relationship between the inner and outer, between self and others. We can think about this time as preparing the work, like a growing child, to go out into the world without us there to explain or defend. I also think of writing as a kind of performance, so read my work aloud over and over again, thinking about rhythm as well as content and grammar and transitions. Perhaps because I began as a dance artist and educator, I have always wanted my work to *move* those who read it.

20.3.7 And Then?

Just as when a novel reaches its conclusion, or a choreographic work comes to an end, we can have a satisfying sense of completion upon finishing a particular research project. But of course, reaching completion is only a temporary part of the practice of research.

In any one project, I have always generated more questions than I could answer, and often told my students that this was one hallmark of a good piece of research. In other words, it keeps going, this rhythm—of staying open to possibilities, tolerating the discomfort of having unanswered questions—in fact, loving the questions, loving the journey, not just reaching a destination. This kind of uncertainty has become part of how I experience being fully alive, along with all of the other lessons I have learned in my professional career: Paying attention. Reflecting on my own lived experiences and finding meaning. Making time for what matters, but allowing space for the unexpected. Listening and attending to relationships (internal ones and those with others). Practicing courage and humility. Trying to make a difference. At this point, being a researcher is not just something we do, but who we are, even if we have retired.

Indeed, those ways of being I developed as a dancer/choreographer, educator, and researcher seem just what is called for in creating the next chapter of my life. As in beginning any creative work, including research, I am experiencing the uncertainty of not knowing what it will look like and how it will end. But I am comforted by the knowledge that I have, in a sense, traveled here before.

References

Bond, K., & Stinson, S. W. (2007). "It's work, work, work, work": Young people's experiences of effort and engagement in dance. *Research in Dance Education, 8*(2), 155–183.

Bresler, L. (2006). Embodied narrative inquiry: A methodology of connection. *Research Studies in Music Education, 27*, 21–43.

Buber, M. (1955). *Between man and man* (M. Friedman, Trans.). Boston: Beacon.

Buber, M. (1958). *I and thou* (2nd ed.) (R. G. Smith, Trans.). New York: Scribner.

Dils, A. H., & Stinson, S. W. (2009). Teaching research and writing to dance artists and educators. In T. Randall (Ed.), *Global perspectives on dance pedagogy: Research and practice. Proceedings of the Congress on Research in Dance 2009 Special Conference* (pp. 151–165). Leicester: DeMontfort University.

Freire, P. (1983). *Pedagogy of the oppressed* (M. B. Ramos, Trans.). New York: Continuum.

Greene, M. (1978). *Landscapes of learning.* New York: Teachers College Press.

Grumet, M. R. (1988). *Bitter milk: Women and teaching.* Amherst: University of Massachusetts Press.

Grumet, M. R. (1989). The beauty full curriculum. *Educational Theory, 39*(3), 225–230.

McNiff, J. (2013). *Action research: Principles and practice* (3rd ed.). London: Routledge.

Risner, D., & Stinson, S. W. (2010). Moving social justice: Challenges, fears and possibilities in dance education. *International Journal of Education and the Arts, 11*(6). Retrieved 19 Nov 2013, from http://www.ijea.org/v11n6/

Stinson, S. W. (1985). Curriculum and the morality of aesthetics. *Journal of Curriculum Theorizing, 6*(3), 66–83.

Stinson, S. W. (1988). *Dance for young children: Finding the magic in movement.* Reston: American Alliance for Health, Physical Education, Recreation and Dance.

Stinson, S. W. (1995). Body of knowledge. *Educational Theory, 45*(1), 43–54.

Stinson, S. W. (2001). Choreographing a life: Reflections on curriculum design, consciousness, and possibility. *Journal of Dance Education, 1*(1), 26–33.

Stinson, S. W. (2002). What we teach is who we are: The stories of our lives. In L. Bresler & C. Thompson (Eds.), *The arts in children's lives* (pp. 157–168). Dordrecht: Kluwer.

Stinson, S. W. (2005). Teaching ethical decision making to prospective dance educators: An action research project. In L. Overby (Ed.), *Dance: Current selected research, 5* (pp. 1–58). Brooklyn: AMS.

Stinson, S. W. (2006). Research as choreography. *Research in Dance Education, 7*(2), 201–209.

Stinson, S. W. (2009). Music and theory: Reflecting on outcomes-based assessment. In T. Randall (Ed.), *Global perspectives on dance pedagogy: Research and practice. Proceedings of the Congress on Research in Dance 2009 Special Conference* (pp. 194–198). Leicester: DeMontfort University.

Stinson, S. W. (2013). What's worth assessing in K-12 dance education? [8 pp.]. In S. W. Stinson, C. Svendler Nielsen & S. -Y. Liu (Eds.), *Dance, young people and change: Proceedings of the daCi and WDA Global Dance Summit.* Taiwan: Taipei National University of the Arts, July 14th–20th 2012. Retrieved 19 Nov 2013, from http://www.ausdance.org

Stinson, S. W. (2015). Rethinking standards and assessment. In S. Burridge & C. Svendler Nielsen (Eds.), *Dance education around the world: Perspectives on dance, young people, and change* (pp. 107–116). Abingdon: Taylor & Francis.

Wasser, J. D., & Bresler, L. (1996). Working in the interpretive zone: Conceptualizing collaboration in qualitative research teams. *Educational Researcher, 25*(5), 5–15.

Printed by Printforce, the Netherlands